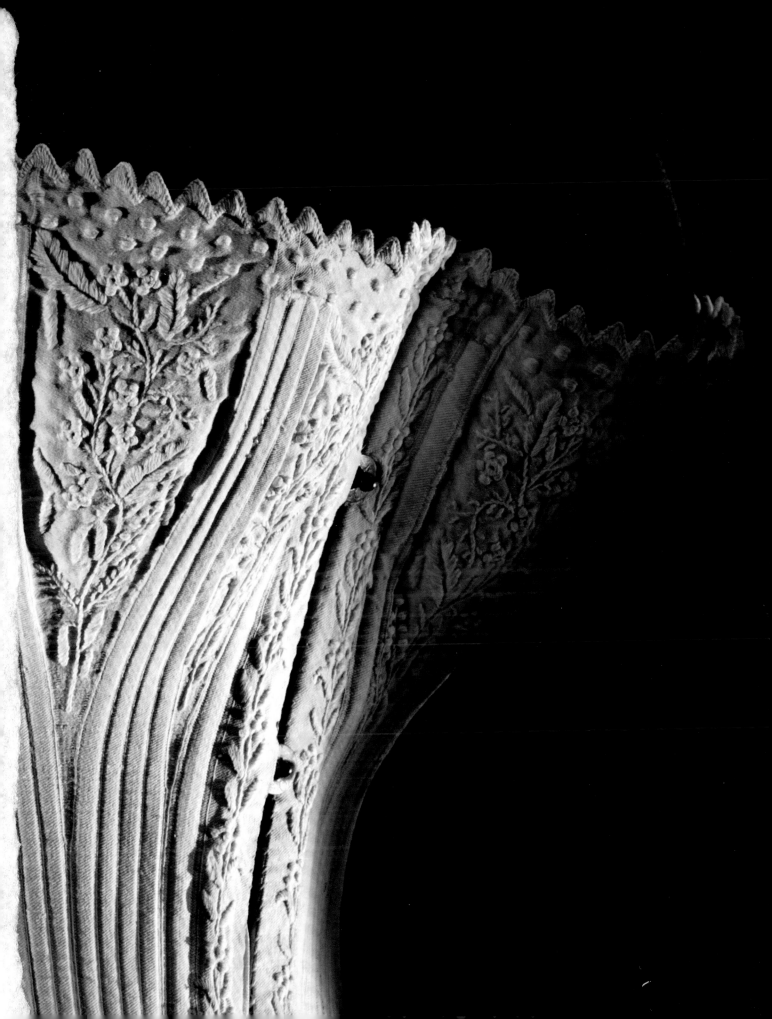

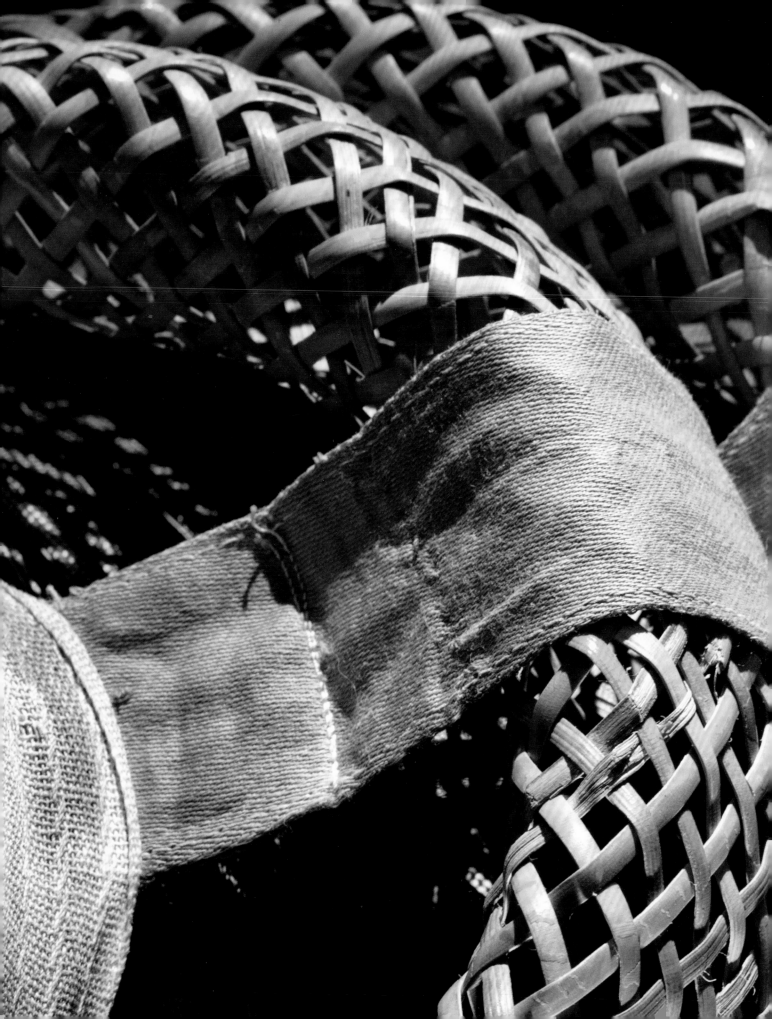

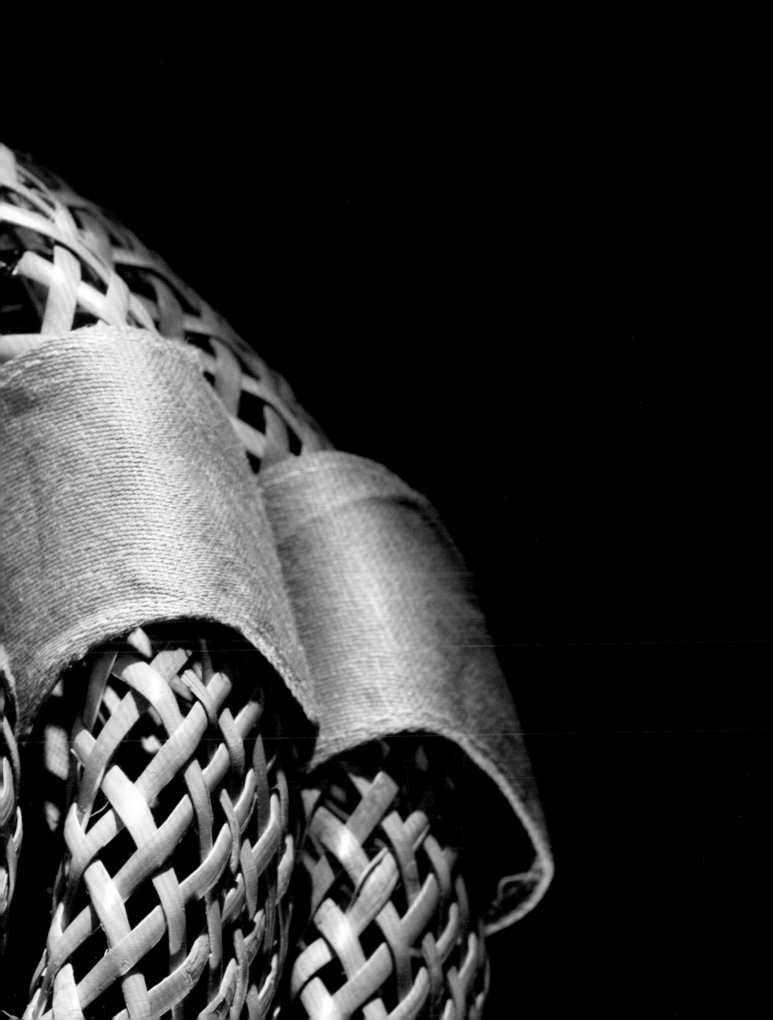

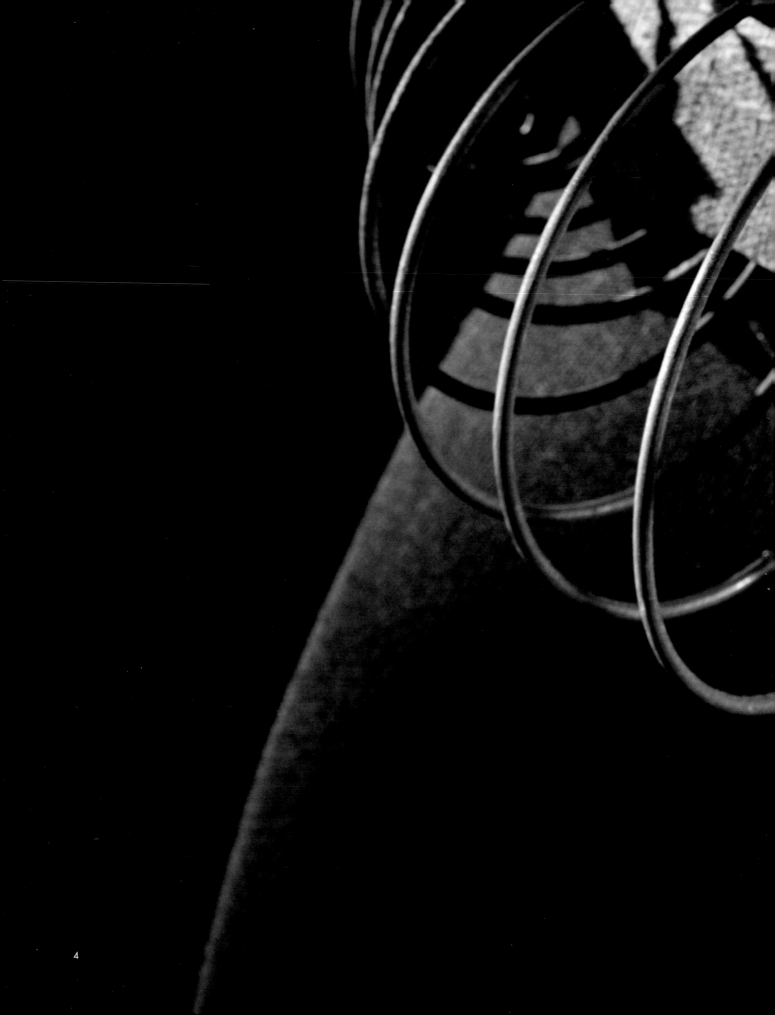

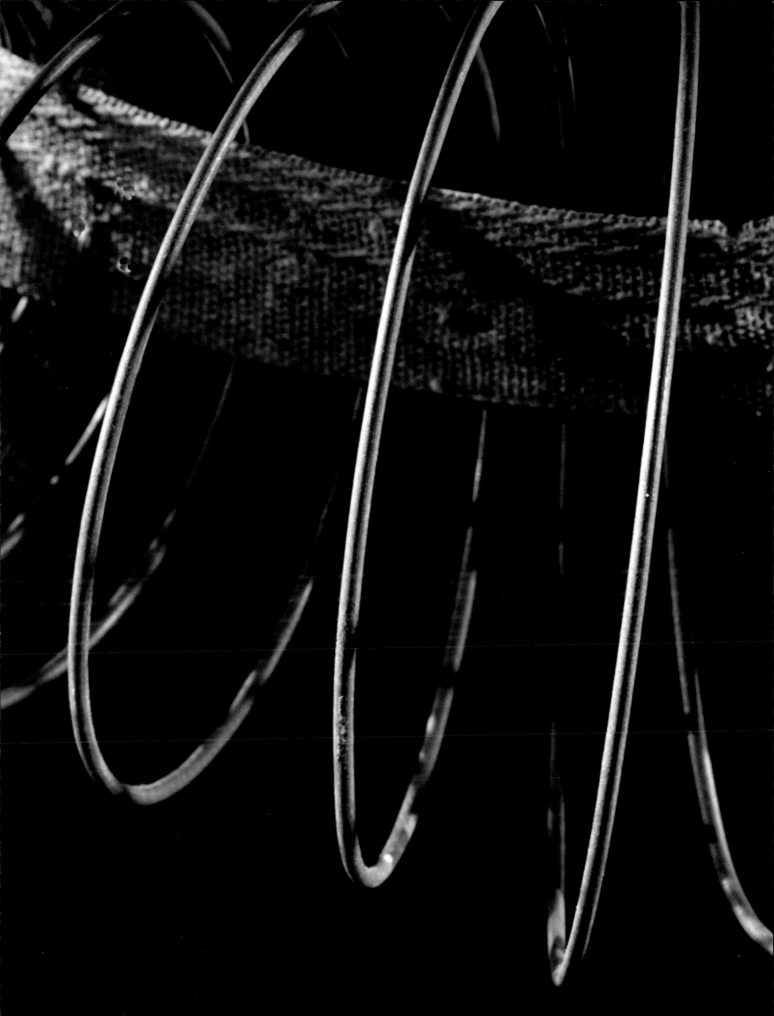

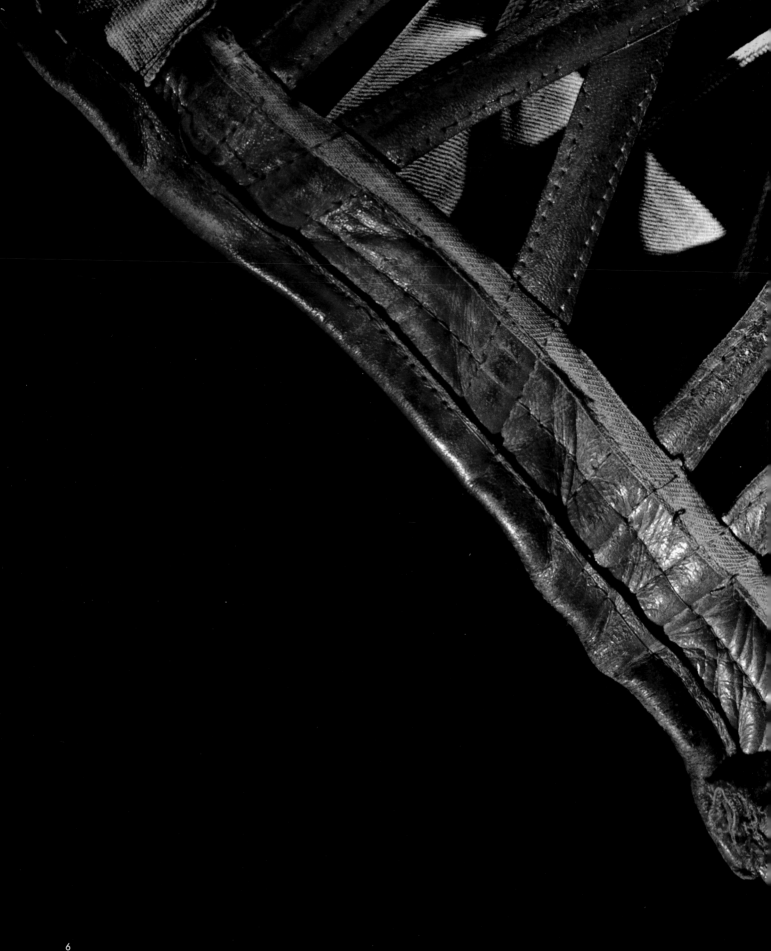

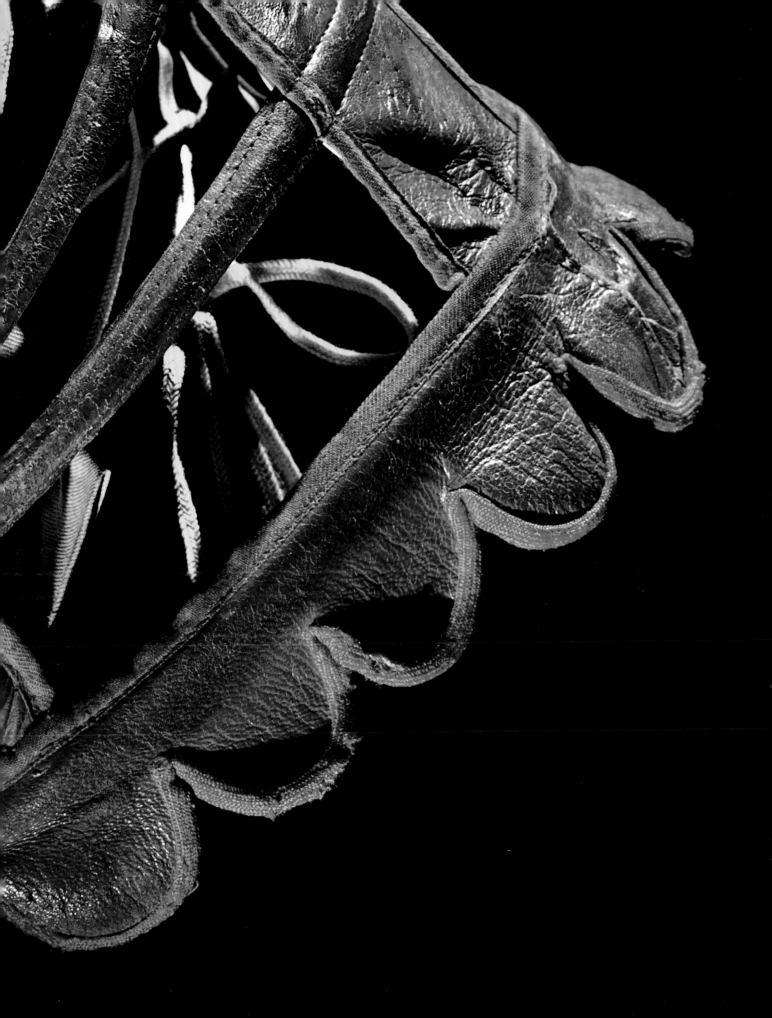

FASHIONING
THE BODY

an intimate history
of the silhouette

Edited by Denis Bruna

published for
Bard Graduate Center
Decorative Arts, Design History, Material Culture • New York
by **Yale University Press • New Haven and London**

Fashioning the Body: An Intimate History of the Silhouette is made possible in part by The Coby Foundation, The Selz Foundation, Liliane and Norman Peck, and other generous donors.

 THE COBY FOUNDATION, LTD.

Published in conjunction with the exhibition *Fashioning the Body: An Intimate History of the Silhouette*, held at the Bard Graduate Center, New York, April 3 to July 26, 2015.

Exhibition curated and realized by Les Arts Décoratifs, Paris; organized in the United States by the Bard Graduate Center.

Exhibition curator: Denis Bruna
Curator, Musée des Arts Décoratifs, Fashion and Textile Department, pre-nineteenth-century collections

Catalogue design: Agnès Dahan
Catalogue photography: Patricia Canino
Printed by Conti Tipocolor SrL, Florence

Library of Congress Cataloging-in-Publication Data

Mécanique des dessous. English
 Fashioning the body : an intimate history of the silhouette / Denis Bruna (editor).
 pages cm
 Translation of: La mécanique des dessous : une histoire indiscrète de la silhouette.
 Includes bibliographical references and index.
 ISBN 978-0-300-20427-8
1. Foundation garments--History. 2. Fashion--History.
3. Clothing and dress--History. I. Bruna, Denis, editor. II. Title.
TT677.M4313 2015

 746.9'2--dc23

 2014042609

Cover illustration
Whalebone stays, France, ca. 1740–60
Articulated pannier with hoops, France, ca. 1770.
See figs. 60, 61

(p. 1)
1. Corset (detail)
United States, ca. 1860–70
Cotton interwoven with stays of wood, whaleboning, embroidered with cotton thread, metal busks and eyelets
Collection of Melanie Talkington, Vancouver

(pp. 2–3)
2. Bustle (detail)
Europe, 1880
Woven rattan, cotton satin, metal
Collection of Melanie Talkington, Vancouver

(pp. 4–5)
3. H. F. Eaton,
Bustle (detail)
United States, 1886
Metal spring, calico fabric
Collection of Melanie Talkington, Vancouver

(pp. 6–7)
4. Bustle, known as a "strapontin" (detail)
France, ca. 1883
Armature of steel covered in leather, wool galloon, cotton straps, and laces
Falbalas collection, Paris

(pp. 8–9)
5. Brassiere (detail)
Argentina, 1920s
Pekin rayon (satin and taffeta)
Collection of Melanie Talkington, Vancouver

Acknowledgments

We are grateful to owners and institutions, who,
thanks to their generous loans, have contributed
to this exhibition.

Museum of Fine Arts, Boston
Cora Ginsburg LLC, New York: Titte Halle
Melanie Talkington, Vancouver

We thank the following for their contributions
at Les Arts Décoratifs:
Anne Foray-Carlier, Sophie Motsch (17th-
to 18th-century department)
Réjane Bargiel, Romain Lebel, Michèle Jasnin
(Publicity department)
Marie-Sophie Carron de la Carrière, Pamela Golbin,
Éric Pujalet-Plaà, Hélène Renaudin (Department of
fashion and textiles)
Jérôme Recours, Stéphane Perl, Annick Quinquis
(Exhibitions office)
Sylvie Bourrat, Dominique Régnier, Nadine Hingot
(Registrar's office)
Florence Bertin, Joséphine Pellas, Emmanuelle
Garcin, Myriam Teissier (Conservation service)
Chloé Demey (Publications office)

and at the Bard Graduate Center:
Nina Stritzler-Levine, Marianne Lamonaca,
Ann Marguerite Tartsinis (Curatorial department)
Alexis Mucha (Rights and reproductions)
Stephen Nguyen, Ian Sullivan (Exhibition design and
installation)
Eric Edler (Registrar's office)
Kate Dewitt, Alex Hills, Han Vu (Graphics and media)
Bruce White (Photography)
Barbara Burn (Editorial)

Denis Bruna particularly thanks Arnaud de Coninck
and Axel Moulinier for their valuable assistance.

Olivier Gabet

Director, Musées des Arts Décoratifs de Paris

Every day the history of fashion is enriched with new insights. Monographs of the great designers—which, when they go beyond simple name-dropping, can become valuable resources, playing the same role as the great retrospectives of painters and sculptors, inspiring research in sources and archives relating to material and visual culture. This approach to the history of fashion design is often an ambitious enterprise, all the more so when it is embodied in an exhibition. In that case, it becomes necessary to seek out the works that will clarify for the public the significance of original ideas. In the field of fashion, such a step is as complex as it is crucial, because surviving historic artifacts are so rare, precious, and delicate. Nevertheless, their very fragility is what gives the fashion exhibition its excitement and what constitutes the primary challenge to its realization. Supported by connoisseurship, which is the result of the careful study and analysis of documents and images, these exhibitions and the publications that accompany them can seem at first glance rather difficult to comprehend. However, they can also arouse the enthusiasm and curiosity of an ever-increasing audience motivated by a thirst for knowledge and a love of surprise. As powerful as these ideas are in popular culture, the distinguishing features of the great names in haute couture and style never fail to present fashion in a new light, just as they whet the appetite of readers and visitors.

The popular and critical success of the exhibition *La Mécanique des dessous*, when it was presented at the Musée des Arts Décoratifs in Paris in the fall of 2013, represents a perfect example of this approach, proof that scientific rigor and intellectual clarity are as relevant in the field of fashion as popular opinion and success. The dispensing of this level of information is the perfect antidote to the rambling nature of our contemporary society. Conceived and realized in an original presentation by Denis Bruna, a medievalist and historian specializing in the representations of the body and the uses of clothing, who is curator in charge of the fashion and textile collections from before 1800 in the Musée des Arts Décoratifs, *La Mécanique des dessous*, or *Fashioning the Body* in its American venue at the Bard Graduate Center, establishes the foundation for a cultural history of the human body and a new way to investigate the formal and structural evolutions of clothing from the Middle Ages to our own times. Both the exhibition and the catalogue assemble objects of surprising, often radical and almost disturbing design as tools in the manipulation of the body, both male and female. Although the idea of fashion conveys a sense of superficiality and mere appearance, this project explores its hidden face, its underside, its

context, what lies behind it. In addition, the catalogue of this groundbreaking exhibition dresses itself in magnificent, complex words drawn from an archaic French rich in sensuality and charm. The authors of the essays have scanned treatises of savoir-vivre, literary and historical memoirs, and the commercial catalogues of the great department stores. The result is a delightful exploration of eroticism and sensuality, libertinism and light-hearted banter, although it also submits to the bourgeois discipline of controlled bodies and domesticated figures. In sum, this is an education for our eyes as well as our bodies. From corsets to crinolines, from codpieces to doublets, what is brought to light here are centuries of fashion history and the complex connection between fashion and the body—the social body as well as the physical one—taking us all the way to new interpretations from Christian Lacroix to Jean Paul Gaultier, from Hussein Chalayan to Iris van Herpern.

This exhibition, like its accompanying catalogue, made its mark in the field of fashion history. As both a professor at the École du Louvre and a museum curator, Denis Bruna brought together in this project many eminent names from the history of fashion and promising young scholars in the field, providing them with a forum to explore for the first time many different aspects of a fascinating but rarely examined subject. We thank him warmly for his commitment, his enthusiastic generosity, his innate knack for striking a resonant chord, and his concern for communicating ideas.

For all these reasons, the Bard Graduate Center could not help but be drawn to this unusual project, which dovetails brilliantly with the spirit of openness that Susan Weber, its founder and director, has instilled. For over twenty years, the BGC has repeatedly taken risks in order to bring legitimacy and excitement to new intellectual fields. After *Cloisonné: Chinese Enamels from the Yuan, Ming, and Qing Dynasties* in 2011 and *Swedish Wooden Toys* in 2014, *Fashioning the Body* represents the fourth exhibition project shared by our two institutions. I remember attending numerous conferences at the Bard Graduate Center in the fall of 2003, when I was a Focillon Fellow at Yale University, and we spoke of E. W. Godwin and Thomas Jeckyll. It is therefore with keen and sincere delight that I express my thanks and friendship to Susan Weber for her confidence, as well as to Nina Stritzler-Levine for her involvement, in realizing the New York phase of this very Parisian yet universal project.

INTRODUCTION

Denis Bruna

Our perception is that the clothes we wear are simple and supple, reflecting our mobile, dynamic, liberated way of life. Nowadays our garments, we believe, are free from artifice and constraint. Our clothes highlight the body to make the most of it, and the relationship ends there. But nonetheless we sometimes find little plastic stiffeners in shirt collars, which serve to keep the ends firm and pointed. Epaulettes and shoulder pads are still part of the sartorial repertoire. These small artifices hidden beneath the fabric straighten out a garment and thus modify the silhouette.

After the Salon International de la Lingerie was held in Paris in 2012, a number of journalists announced the return of the girdle. "An indispensable fashion accessory" for some, "the trendy new feminine accessory" for others, the girdle sometimes "sculpts the figure even while being sexy and comfortable," while at other times these "sexy articles present a flat tummy, a sensual small of the back, and a slim waist." After reading such critiques extolling the virtues of the undergarments like so many advertising pitches, and closely examining these garments, one could conclude that the girdle (born around 1930, at its peak in the 1950s, and gradually abandoned around 1970 with a shift toward bodies liberated of all constraints), is indeed back. Except that the name is not the same. The word "girdle" (*gaine* in French), indicating an accessory our grandmothers used to wear, was not used at the Salon. Instead we now speak of "shapewear" and even "smart garments"—that is, undergarments that know exactly where they're supposed to act.

Of course, "shapewear" and other "smart garments" fall well short of the distorting effect of the corset, whose tyrannical reign lasted through most of the nineteenth century, in response to the demand for a slim waist.

Nowadays, cosmetic surgery, with its prodigious silicone breasts and lipo-suctioned tummies, as well as sports clubs, fitness programs, and diets, seems to yield more effective results on the body than a corset.

Our objective here is to treat undergarments not only as underwear or lingerie, but also as structures, materials, and scaffolds deliberately dis-simulated under the wearer's clothing. These artifices form what we may call "mechanical garments." The notion of mechanics is at the very center of this study, since these articles were used to produce transformation as well as movement. The point is thus to explore these "machines," which, when placed under a person's clothing, were supposed to transform the body so that it could meet the demands of fashion, etiquette, or morality.

Our investigation centers around undergarments both female and male, including whalebone stays, hoopskirts, corsets, crinolines, bustles, stomach belts, girdles, push-up bras, and other clothing structures that were—and in some cases still are—supposed to shape the body through the use of whalebones, busks, hoops, and padding, as well as laces, hinges, drawstrings, pulleys, springs, retractable mechanisms and elastic fabrics. When applied to different parts of the body, often rendering it immobile or at least restricting its movements, these mechanisms modeled the body, making it possible for anyone to attain the ideal of beauty of a given his-torical period.

This exploration is all the richer in its discoveries because these articles of clothing are not limited to the nineteenth century, as one might have imagined. Indeed, the earliest structures of bodily dissimulation date from the fourteenth century, and the practice continues up to our time. The sub-ject can therefore be conceived of as a long history of clothing and fashion, as seen "from the wings," and one that brings to light a surprising diversity of mechanisms. Because, while forms may evolve and techniques become refined over the course of history, the purpose of the mechanical garment is constant: to suppress the stomach, to squeeze the waist in order to exag-gerate its smallness, to support the chest, lift up—or sometimes flatten—the breasts, round off the hips, and so on. In the end, comfort often gives way to appearance.

A number of principles guided our research. Both men and women—but women to a considerably greater degree—have long been attentive to these demands. It was therefore crucial to treat women's and men's fash-ions as equally as possible. The subject in question, moreover, cannot be separated from the history of clothing and fashion, though we do not deal here with any medical devices (prostheses, orthopedic braces, corsets for scoliosis) or reinforced sports outfits that distort the figure—such as

American football jerseys and the shoulder pads underneath. Lastly, only Western culture is explored here.

Presentations of historic clothing and fashion have shown little interest in these artifices, which are usually considered frivolous or vulgar. In fact, they are an entry into the worlds of morality, intimacy, and, of course, eroticism. It was important to us to approach the history of fashion from a different angle, far from the conventional narrative of the evolution of forms, of folds in the backs of dresses, of skirts whose breadth increases over time then begins to recede, and to present a history of fashion as it relates directly to the body.

For over twenty years, the body has been at the center of historical studies. It felt right to make our own contribution to this trend by analyzing the ever-present connections between body and garment. In most cases, we have chosen examples from the history of these garments in France, hence the majority of designs and advertisements illustrated come from French sources, but one should keep in mind that there is a wider story to be told for garments produced elsewhere in Europe and in the United States.

These hidden fashion garments are an integral part of the clothing and the figure they help to shape. Moreover, when these articles are removed from the person wearing them, they look like carcasses, like bodies foreign to the body they dressed. Without a body, the garment has no reason to exist; it is merely a lifeless mass of fabric, a soulless hide. In short, fashion makes the body; the garment is a tool of bodily modification. The conclusion is unavoidable: there is no natural body, but only a cultural body. The body is a reflection of the society that presided over its creation.

For this book, inspired by the related exhibitions in Paris and New York, a group of well-established scholars—Michel Delon, Maximilien Durand, Georges Vigarello, and Anne Zazzo—were kind enough to accept this invitation to contribute. With them are texts by a number of my Master's-degree students in the history of fashion, clothing, and textiles from the École du Louvre, whose seminars are held in the Musée des Arts Décoratifs. We had started to explore the subject of the mechanical garment, artifice, and structural underwear in the previous year of university study. They have here written their first articles for publication, and some of them intend to continue their research on relations between the human body and its garments.

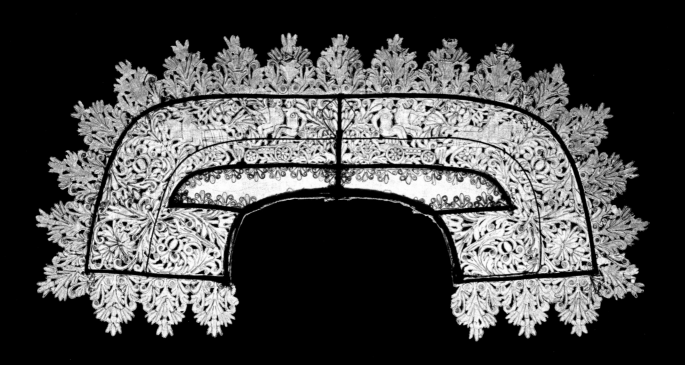

14th — 16th
CENTURY

Codpiece — Busk — Whalebone stays
Iron corset — Padded peascod belly — Doublet
Supportasse — Farthingale

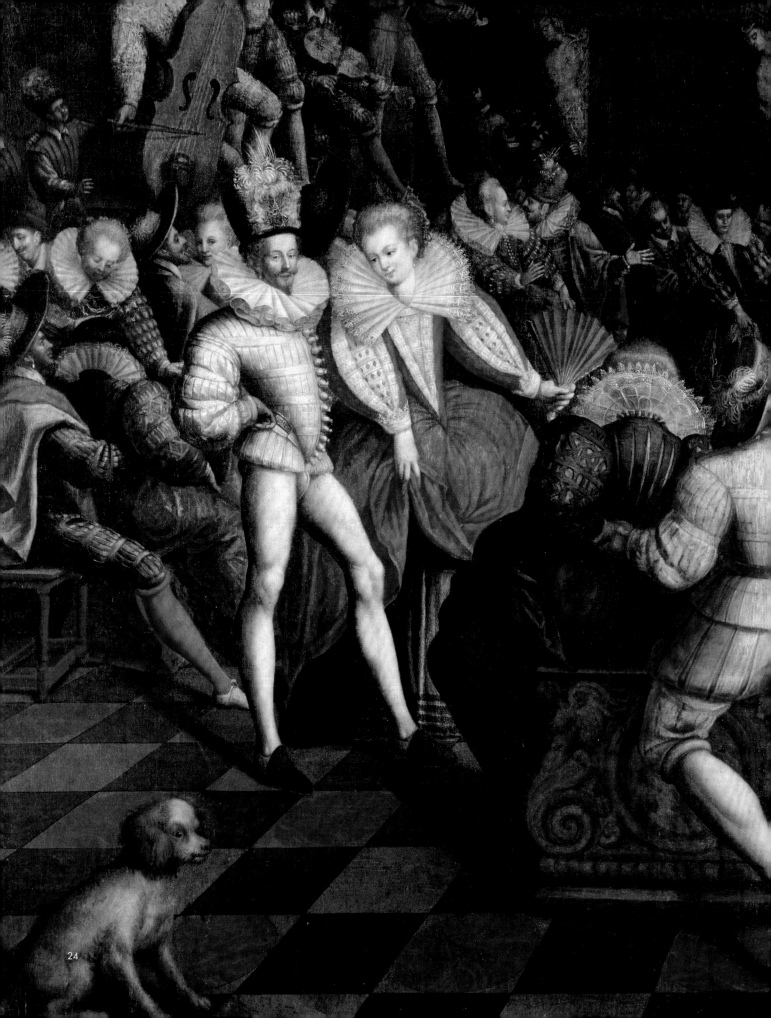

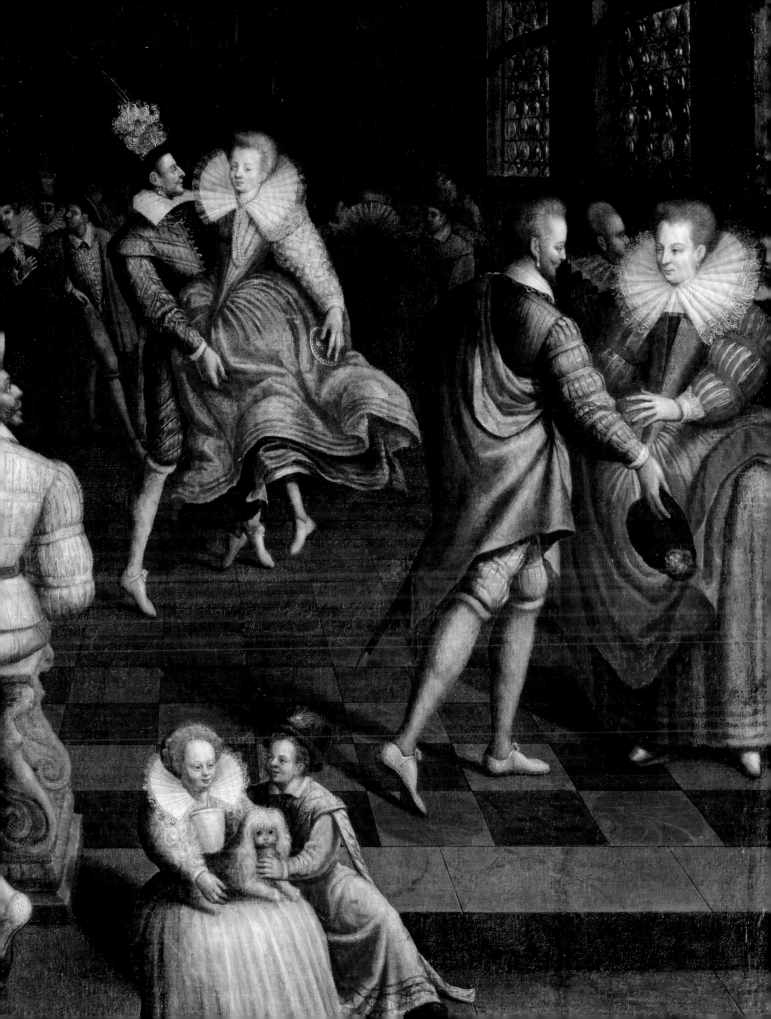

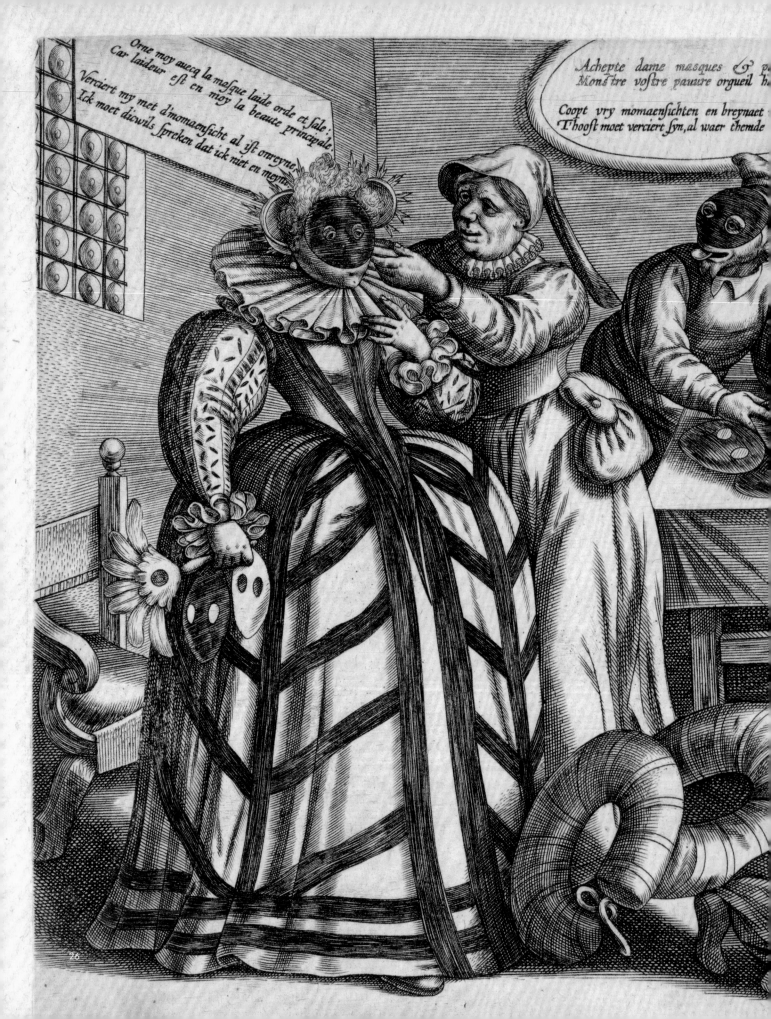

Orne moy auecq la mosque laide orde et sale,
Car laideur est en moy la beaute principale.
Verciert my met d'momaensicht al ist onreyne,
Ick moet dicwils spreken dat ick niet en meyne.

Achepte dame masques & p...
Monstre vostre pauure orgueil h...

Coopt vry momaenschten en breynaet...
Thooft moet verciert syn, al waer themde...

26

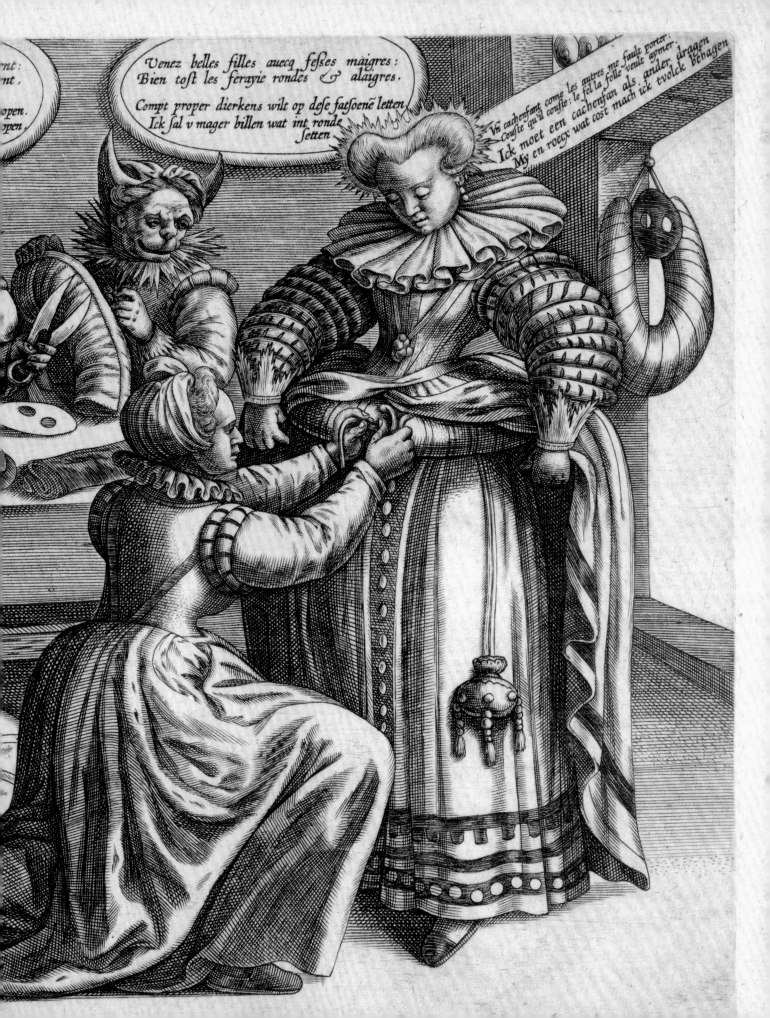

parole il fet aussit con sil de ce ne seust rie
et se retrait un poi ariere aussi con tout esbai
Coment sire fet il estes uos dot li roi Feramot
Oil sire fet il serai. sui ge. Eno deu fet li roi
Arti. qat uos li roi Feramt. estes. uos soies li

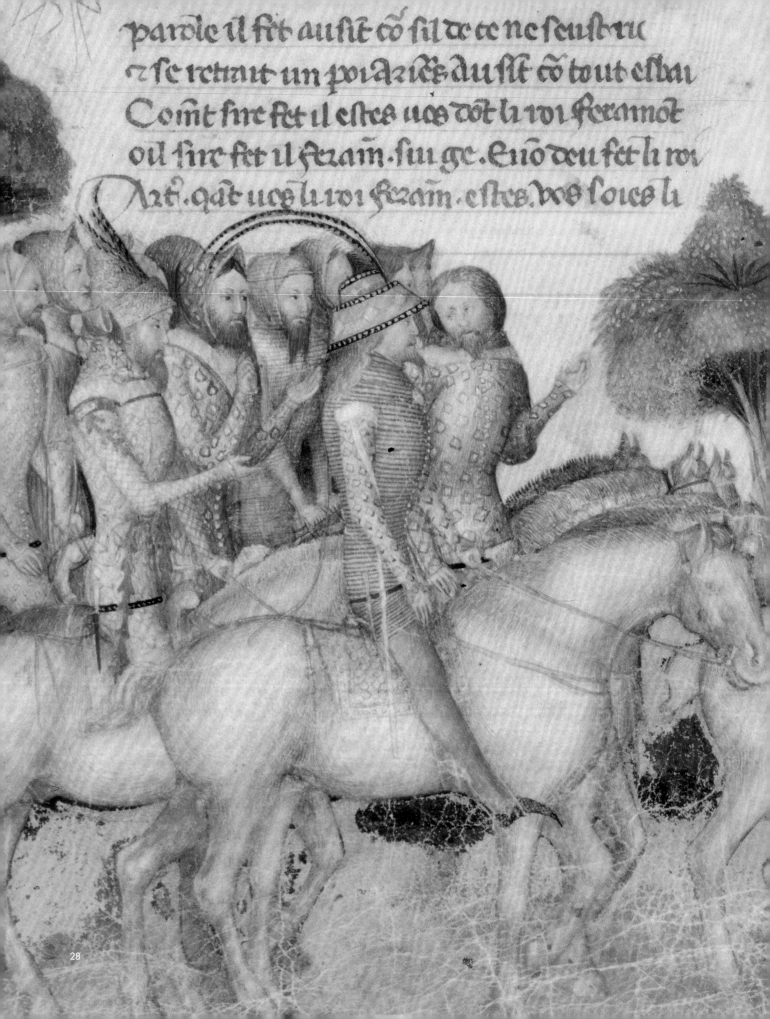

28

Prioneusse, deuant qeuos venisies au deptir.
mes dilor le uos deisse. et fessoie adonc uoutre
volunte. ou du aler. ou du remanoir. Voi aie
Biau dist li roi Feramot. qe est ce qe uos di
tes oreentroit. puet ce estie qe uos me gurssiez.

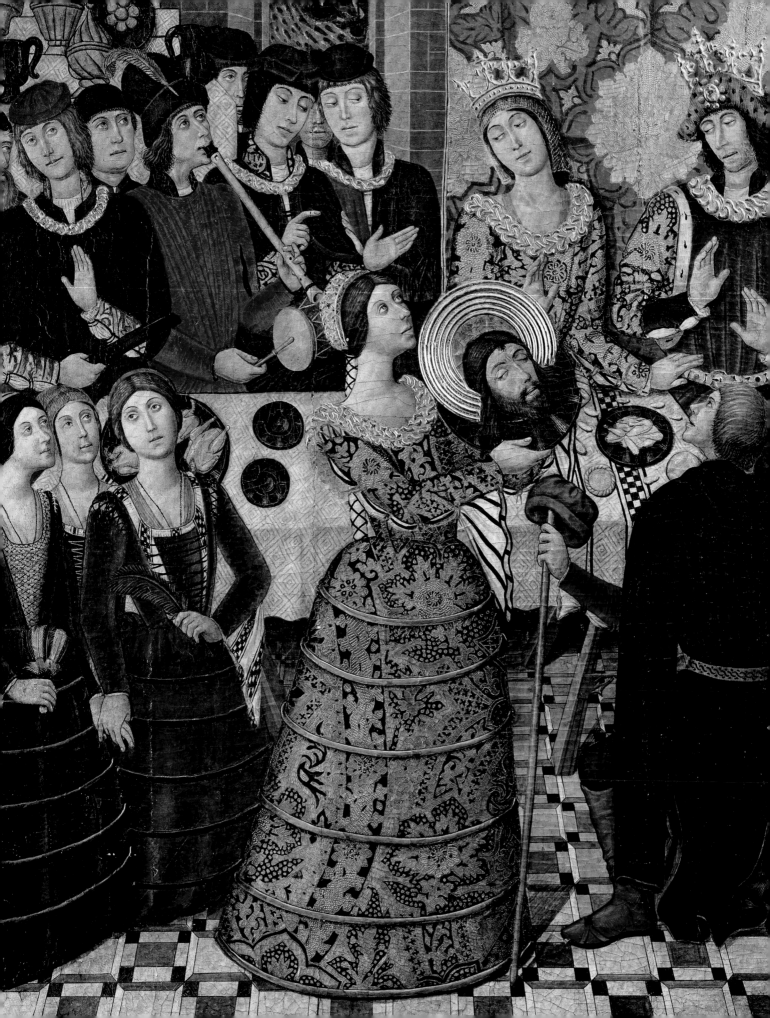

MEDIEVAL FASHIONS, BODIES, AND TRANSFORMATIONS

—

Denis Bruna

It is not uncommon to read that fashion was invented in the Middle Ages, and more specifically in the fourteenth century. Although a few long-lived novelties of dress from that time might indeed confirm this hypothesis, it can sometimes seem more like an assertion. By the fourteenth century there existed a clear differentiation between clothing for men and women, and there had emerged a distinct silhouette that metamorphosed and evolved over time, thereby revealing a specific manner of dress at any given moment. But we should temper our enthusiasm, however, for if it is possible to raise the fourteenth century to the noble status of precursor, this is at least partly because it is characterized by an unprecedented number of written documents, and even more pictorial ones, which enable an assessment of the various changes in a given garment, as well as noteworthy evolutions in the silhouette. Certain older texts, less numerous and less prolix, lead us to suspect marked upheavals of dress that could eventually move the history of fashion back by a few decades, if not a century.

In his book *L'Europe au Moyen Age*, Georges Duby, basing his remarks on young noblemen with sumptuous garments and mannered gestures in the illuminated calendar of the *Très Riches Heures du duc de Berry*, painted by the Limbourg brothers between 1410 and 1416, speaks of "elegant" men and women, "frills," "refinements," sophisticated and extravagant outfits, and even haute couture. The historian is right to affirm that this haute couture—which we should consider instead a new concept of dress, to guard against the dangers of anachronism—"disguises the body, enveloping it in unreality, masking the attributes of men and women alike."[1] It is precisely at the end of the Middle Ages, more than at any time before then, that one can measure the extent to which the clothing envelops, disguises, and masks the body.

Once adjusted, the medieval garment could faithfully and formally reveal the body, like a glove that fits the hand and conforms to its anatomy. However, rather than revealing the shapes of bodies by following their labyrinths of curves and countercurves, these garments often suggested different shapes by falsifying the body supporting them. The garment removes a bit here, adds a bit there; in short, it creates a new body.

Thus the natural body no longer exists; what we have is a cultural body, emerging through a silhouette characteristic of a moment in time. This is perhaps the place to elaborate on the idea of fashion in the late Middle Ages, not as the emergence of a new type of dress, but rather as the development of a more concrete awareness of the figure and a new concept envisioning the garment as making the body. Of course this idea did not originate in the Middle Ages—women in Roman antiquity bound their breasts with bands of fabric known as a *mamillare*—but this impulse appears to assume a new reality in the fourteenth and fifteenth centuries. Moreover, the epoch matters little, as without the body, clothing does not have a shape of its own, other than that of a corpse or a mass of lifeless cloth. Some examples are quite eloquent, such as the Roman toga, the Indian sari, the loincloth, or the Eastern turban, to cite but a few examples, which, without the supporting body, are simply pieces of cloth of greater or lesser length, given shape and life through skillfully applied wrapping, folding, and tying.

This idea of the body as sculpture and clothing as its modeling is further expressed in medieval times by the emergence of a whole series of garments, some visible and others hidden, that were intended to modify the silhouette. In the female wardrobe, the *bliaut*, for example, emerged at the end of the twelfth century—a long, ample robe so fitted at the waist, by means of laces either in front or behind, that it supported and lifted the breasts.[2] The iconography of the time indicates the existence of belts or bands that compressed the waist and were wide enough to support the breasts. The rigid and vertical silhouette, often attributed to the sixteenth century, achieved by the excessive use of whalebone stays by the aristocracy, found its first tools in the medieval era.

In the thirteenth century, in the *Roman de la Rose*, Guillame de Lorris and Jean de Meung evoke the role of the wide, adjustable band used to support the breasts:

(p. 22)
6. Rebato
France or Northern Europe, ca. 1625–30
Weighted, cut silk, linen, cardboard, metallic thread
Musée des Arts Décoratifs, Paris, département Mode et Textile, PR 2013.10.2

(pp. 24–25)
7. Anonymous,
Ball at the Valois Court (detail)
ca. 1580
Oil on canvas
Musée des Beaux-Arts et d'Architecture, Rennes, 1794-1-135

(pp. 26–27)
8. Attributed to Maerten de Vos,
The Vanity of Women: Masks and Bustles (detail)
The Netherlands, ca. 1600
Engraved paper
The Metropolitan Museum of Art, New York, Purchase, Irene Lewisohn Trust Gift, 2001 (2001.341.1)

(pp. 28–29)
9. "Kings Arthur and Féramont with their retinue of knights" (detail)
Illuminated manuscript page illustrating the romance of Rusticiano da Pisa, *Guiron le Courtois*
Milan, ca. 1370–80
Bibliothèque nationale de France, Paris, Ms. occ. NAF 5243, fol. 8

(p. 30)
10. Pedro García de Benabarre, *Herod's Banquet* (detail)
Spain, ca. 1470
Tempera on wood
Museu Nacional d'Art de Catalunya, Barcelona, 064060-000

And if her breasts are too big,
A band will help them out,
Stretching over her bust,
Cinching in her waist,
To attach, sew or stay them,
So she can go out to play.[3]

The word *corset* appears in the fourteenth century, but it did not have the same form or purpose then. It was soft and less constraining than the nineteenth-century version and designated a dress with a fitted bodice worn over a shift. In the middle of the fifteenth century, the bodice worn by the Virgin in the Melun diptych by Jean Fouquet provides an eloquent example of this.[4] Closely nipped in at the waist, with laces at the front, the corset stiffened the torso and highlighted the beginning of a skirt or the lower half of a flared dress. Thus, by introducing the cinched waist, raised breasts, and rounded hips, the Middle Ages invented the prototype of a woman's figure in the West, shaped over the centuries, like a long and almost unchanging reign, by myriad artifices: whalebone stays, corsets, and girdles on the top, farthingales, hoops, and crinolines on the bottom. Today the same result might be achieved by surgery.

The figure cut by the medieval man played as decisive a role in the history of the Western silhouette. In the second half of the fourteenth century, the doublet enhanced the chest by means of layers of padding, and even armor, offering the first documented examples that enable us to trace the long history of the addition of breadth across men's shoulders. Over time, this became the bold, padded peascod belly of the sixteenth century, the justaucorps, a knee-length coat, quilted across the chest of the eighteenth-century man, and the padded waistcoats of the nineteenth-century dandies, to cite but a few examples.

In the Middle Ages, and thereafter, such new garments provoked criticism and indignation. The commentaries are manifold. Some of them mocked the new fitted dresses of the fourteenth and fifteenth centuries, which raised the breasts up to the edges of outrageously low-cut necklines with deliberate erotic intent. Around 1460, Georges Chastellain penned a rather unflattering portrait of Agnès Sorel, who was so concerned about her appearance that, in his opinion, there was "no more lavishly adorned princess than she. . . in all of Christendom."

The dresses worn by Charles VII's favorites are synonymous with "ribaldry" and "dissolution," for "the shoulders [were bare] and the breasts too, as far down as the nipples."[5] During the second half of the fourteenth century, the poet Eustache Deschamps reviled:

Dresses newly cut,
With nipples and bust
By the manner of the décolleté
So enhanced
All the more to suggest
Pleasure and the desire
With them to bed[6]

The short and fitted doublets worn by men did not escape the acerbic pens of certain authors who often deemed them to be "dishonest" and "shameless." In the fourteenth century, Geoffrey Chaucer noted that they could be so short "they did not even cover men's shameful parts, begetting bad thoughts."[7] The garment could in this way transgress the established order and become dangerous.

Faced with such novelties—seen as subversive by one and all—moralists, chroniclers, and other scathing witnesses called for appropriate measures to be taken. Nevertheless, the novelties of dress concealed a different kind of upheaval. For to apply a certain kind of artifice here or there did not simply modify the garment; it entailed *in fine* the deformation of the body. Indeed, the doublet puffed out the chest, the padded peascod belly hid the belly, the whalebone stays cinched in the waist, the farthingale widened the hips, and the codpiece augmented the penis.

Similarly, garments that were too long and endowed with various extensions, such as flowing sleeves, an oversized train, and fringes were also criticized. For example, Chastellain deplored the fact that Agnès Sorel wore "trains a third longer than any princess in this kingdom."[8]

By giving another shape to the body, the garment offended God. In the medieval West, the body was considered to be the work of God, the Creator's creation, the mirror of the Almighty, so much so that to undermine the body of man was thought to intervene in that of God. Around 1440, the poet Martin Le Franc reproached outrageously dressed women with "transfiguring" the "well-shaped work of God."[9]

This might seem outmoded, and we can well imagine some readers shrugging their shoulders and dismissing the Middle Ages as "medieval." But the deformation of clothing and the body has often been criticized, although it has ceased to be synonymous with an outrage against God. In the seventeenth century, when petticoat breeches were in vogue in the court of Louis XIV, Molière described this ample garb that looked like a short skirt as "folly,"[10] In our own time, baggy jeans, which are falling out of favor with teenagers, are somewhat akin to petticoat breeches.

Of course, except for the voluminous nature of both garments, they really seem to have nothing in common: one originates from a style recently imported from the United States—in homage to prisoners whose belts had been confiscated—and which is still popular in certain French schools; while the other is believed by many to have been imported to the French court by the count of Salm during the seventeenth century. Still, these garments have suffered the same accusations once leveled against the petticoat breeches three hundred years ago.

Like an echo of the shameless medieval doublet, baggy pants worn today by our teenagers are sometimes the objects of criticism and prohibition, since they show the underpants or boxers. Since 2009, several towns in Florida have passed laws forbidding them to be worn in public, and offenders risk a hundred and fifty dollar fine.[11] In New York, a police officer recently ticketed a man from the Bronx because he was wearing his pants "way below the waist." We may in passing thank the judge presiding over the case for concluding "that justice has nothing to say when it comes to fashion."[12] In France, there have been no cases against baggy pants brought before the courts, but many high schools and middle schools have banned them. Of course, people deplore visible and indiscreet boxer shorts, but that's not all: baggy pants transgress because they "hinder walking," one journalist explains.[13] Thus they join the petticoat breeches, which Molière described as "large rolls wherein the legs are put every morning, as it were into the stocks," making the wearer "straddle about with their legs as wide apart as if they were the beams of a mill."[14] These two garments, separated by more than three hundred years, are not merely obstacles to walking. They disturb the established order as they make no mystery of what lies between the legs, transforming their bearers and modifying their bodies. And while there is no longer any offense to God, these garments transfigure the anatomy and confer a disproportion to the silhouette, which can still upset certain sensibilities.

1. Georges Duby, *L'Europe au Moyen Âge: Art roman, art gothique* (1981; Paris: Flammarion, 1984), 211.

2. Fernand Libron and Henri Clouzot, *Le Corset dans l'art et les moeurs du XIIIe au XXe siècle* (Paris: F. Libron, 1933), 1–7.

3. Guillaume de Lorris and Jean de Meung, *Le Roman de la Rose, édition accompagnée d'une traduction en vers . . . par Pierre Marteau* (Orléans: H. Herluison, 1878), 3: 237.

4. Antwerp, Musée Royal des Beaux-Arts.

5. Georges Chastellain, *Chronique: 1461–1464, publiée par Joseph Kervyn de Lettenhove* (Brussels: Heussner, 1864), 4: 366.

6. *Le Miroir de Mariage*, in Eustache Deschamps, *Oeuvres complètes, publiées d'après le manuscrit de la Bibliothèque nationale par le marquis de Queux de Saint-Hilaire et Gaston Raynaud* (Paris: Firmin-Didot, 1878–1903), 9: 49.

7. Geoffrey Chaucer, *The Canterbury Tales.*

8. Chastellain, *Chronique*, 366.

9. Martin Le Franc, *Le Champion des dames*, ed. Robert Deschaux (Paris: Champion, 1999), 2: 106–7; 11: 6769–76:

> Vous peut la femme plus haïr,
> Que quant despitant la figure,
> De Dieu pour mieulx envahir,
> Refait, recree et refigure,
> Non refigure ains transfigure
> Ce qui n'estoit deffiguré ?
> Non transfigure ains deffigure
> L'oeuvre de Dieu bien figuré.

10. Molière, *L'École des maris* (The school for husbands), act 1. scene 1; act 2, scenes 35–40.

11. "Cachez ce caleçon que je ne saurais voir," *www.lemonde. fr*, April 24, 2009; see also Alain Constant (with AFP), "Les pantaloons baggys des ados interdits en Louisiane," *www. lemonde.fr*, October 23, 2007.

12. "USA: les pantalons taille basse ne sont pas hors-la-loi à New York," *www.lepoint.fr*, July 30, 2010.

13. Marie-Estelle Pech, "Mode à l'école: les proviseurs serrent la vis," *www.lefigaro.fr*, October 13, 2009.

14. Molière, *L'École des maris*, act 1, scene 1.

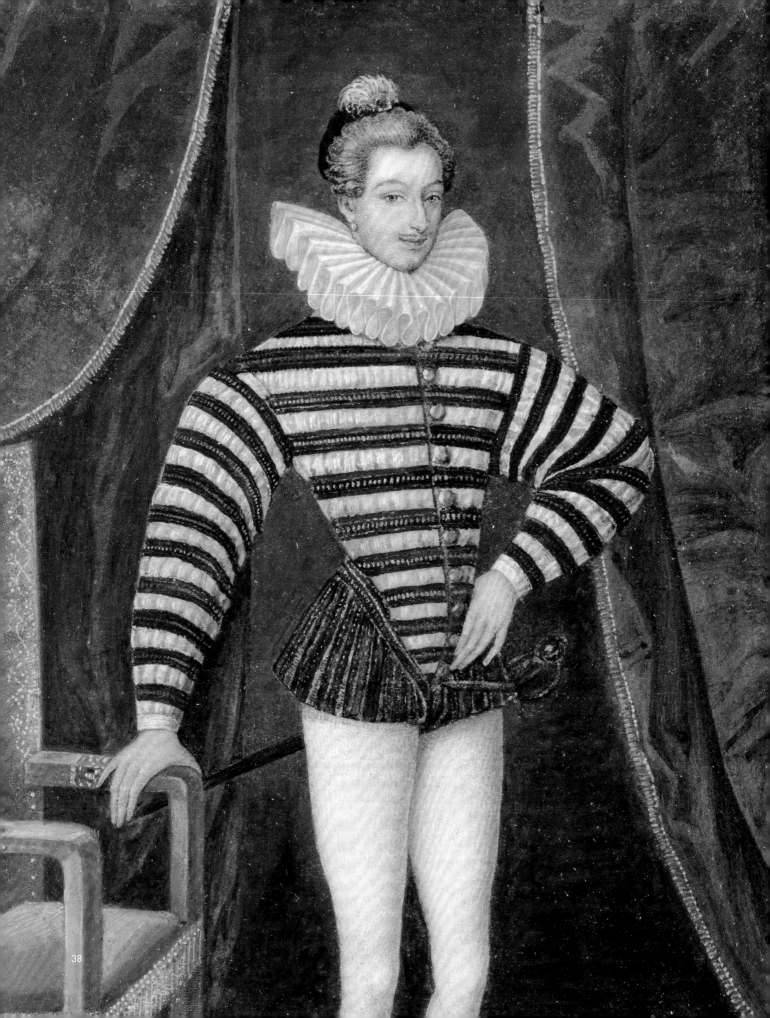

38

Denis Bruna

PUFFED-OUT CHESTS AND PAUNCHED BELLIES: THE BROADENING OF MEN'S BODIES FROM THE FOURTEENTH TO THE SIXTEENTH CENTURY

One often imagines that only women's bodies, the upper body in particular, used to be constrained by clothing. Seen simply in contrast to those of women, men's bodies would appear to have escaped all sorts of restrictions. While the one was fettered, however, the other was hardly any freer.

Illuminated manuscripts, frescoes, panel paintings, and sculptures created during the second half of the fourteenth century show a variety of scenes from everyday life, each one more precise than the last, offering us a better understanding of medieval dress and its evolution.

One type of garment worn by knights and men-at-arms is emblematic of men's fashion at the time of Charles V: the pourpoint, or doublet.[1] The word comes from the Old French *pour-poindre*, a garment meant to be stitched. In fact, this garment, which covered the torso to just below the waist, was made out of several layers of cloth, between which padding made out of cotton or silk cocoon scraps was added and held in place by means of stitching. The doublet is a lined or "double" garment, as it was made of several layers of fabric and padding, giving us the origin of the English word "doublet," still used to designate both medieval and modern garments.

Between 1360 and 1380, illuminated manuscripts depict a great number of these garments. In the *Grandes Chroniques de France de Charles V*, a manuscript copied and illuminated in Paris between 1375 and 1379, men-at-arms, servants, loyal followers of the king, craftsmen, and even hangmen are dressed in doublets, which would appear to have been considered highly fashionable, given the sheer number of these images.

Let us look specifically at the example of the scene of the banquet held by Charles V for the Holy Roman Emperor Charles IV and his son Wenceslas in 1378 (fig. 13). In the foreground, in front of a table set for princes and church dignitaries, three men are dressed in this emblematic garment, short and closely fitted at the hips. The waist is clearly delineated by an addition to the doublet: a belt, low-slung and just barely held up by the curve of the hips. It is the outsized padding of the torso that constitutes the essential originality of this garment, however, during the last decades of the fourteenth century. This protuberance could only be achieved through hidden artifice or, in other words, padding. Cotton or wadding could be used to augment the volume of any given part of the garment, in this case the torso.

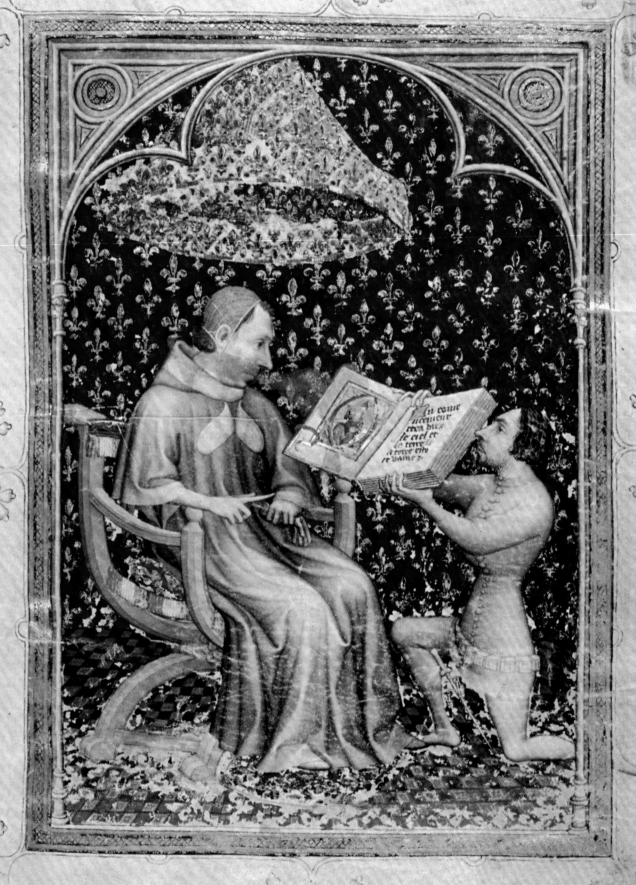

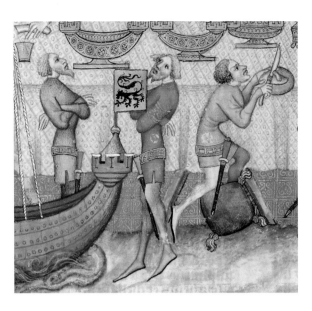

Narrow at the bottom, broader above, the doublet hugs the body as well as modifying it. This playful contrast creates a silhouette we find, for example, in the image of Jean de Vaudetar, adviser to Charles V, as he is depicted in the frontispiece of the Bible he gave to the king in 1372 (fig. 12).[2] On the left, Charles V wears the long and outmoded surcoat (we know that the king, afflicted with rheumatism, preferred voluminous clothing) while to the right, Jean de Vaudetar is dressed in a short and padded doublet. The lines of the garment are not unlike the doublet of Charles de Blois, made in the late fourteenth century[3] (fig. 15). Here it was not the cotton padding held in place by stitching that created the visible cambering.[4] It was more likely the doublet worn underneath, or even a convex metal breastplate, that created the desired distension.[5] On the front, the prominent line created by the numerous buttons accentuated this ostentatious protuberance.

Before it was recreated as an overgarment, the civilian doublet originated in military dress, where it was an undergarment covered with armor. Well before the fourteenth century, knights already wore various padded garments beneath their breastplates; aside from the doublet, often padded with silk or cotton, there was also the aketon, filled with cotton, or the gambison, filled with hemp.[6] These articles of padded clothing, covering the torso and thighs, were worn as protection in sword-fighting.

During the last third of the fourteenth century, the doublet was increasingly worn as a civilian garment, over hose but no longer beneath armor. The French-English conflict, urban uprisings, and the ravages of widespread military actions led to hordes of armed men and mercenaries flooding the towns and countryside. It is probable that this keen interest in the padded doublet originated in the daily cohabitation with soldiers, whose breastplates already boasted such aggressive protuberances.[7] This silhouette, with a pronounced chest and constricted waist, was all the rage.

Moralists and chroniclers have left a record of their sharp opinions of this disturbing novelty. In Prague in the year 1367, the canon Benesch of Weitmühl mentioned the new garb, which he considered so strange that he assumed it must have been foreign. The torso, swollen with thick cotton padding, looked, according to the ecclesiastical dignitary, like a woman's bust (*mamillas mulierum*). Later on, Benesch of Weitmühl

compared men with such tight waists (*constricti*) to greyhounds.[8]

Around 1400, the doublet lost its convexity. The houppelande, a long and voluminous over-garment, continued a moderate exaggeration of the chest area, notably with wide sleeves and an emphasis placed on the layering of garments. The overly long sleeves and tapered trains also lengthened the figure.

In the middle of the fifteenth century, the male silhouette was again broadened, not with chest padding this time, but by expanding the chest with *maheutres*, a kind of cylindrical roll placed around the armholes. Furthermore, the lightening of the lower body, often covered with fitted hose, and tapered poulaines (a type of shoe), also contributed, by visual contrast, to broadening the upper body. A comparison of the portrait of Charles VII by Jean Fouquet, from around 1450, with that of François I by Jean Clouet, from around 1530, shows little formal evolution of the male form over the course of those decades (figs. 15, 16). Nonetheless, the broadening of the shoulders of François I is due to a *chamarre*, a new outer garment with puffed sleeves. The great originality of the sixteenth century, in the formal evolution of men's bodies through dress, lay

in the return of the padded doublet. During the reign of Henri III, the attention was no longer on the shoulders, but rather the abdomen, with the appearance of the peascod, an ingenious padding distended with supports sculpting the front of the garment in a hanging paunch. The peascod was quite visible at the time, as men wore small capes on their shoulders, more like collars than coats, leaving their chests and paunches in full view.

During the course of its brief history (between 1570 and 1590), the size of the peascod tended to vary. In extreme cases, it assumed the curved and pointed shape of a falling horn, happily dipping below the waist. The engraving of the standard-bearer, executed by Hendrick Goltzius in 1587, illustrates this extravagance, which was not spared by the pamphleteers (fig. 14). One of them, Philipp Stubbs, in *The Anatomie of Abuses*, published in 1583, "finds no beauty in the men who wear them." Further on, his virulence toward this fashion, colored by exaggeration, prompts him to say that men outfitted with such artifices are "so stuffed, wadded, and sewn that they can't even bend down to the ground."[9] That same year, Blaise de Vigenère, in his French translation of Titus Livy, rails against the new men's fashions

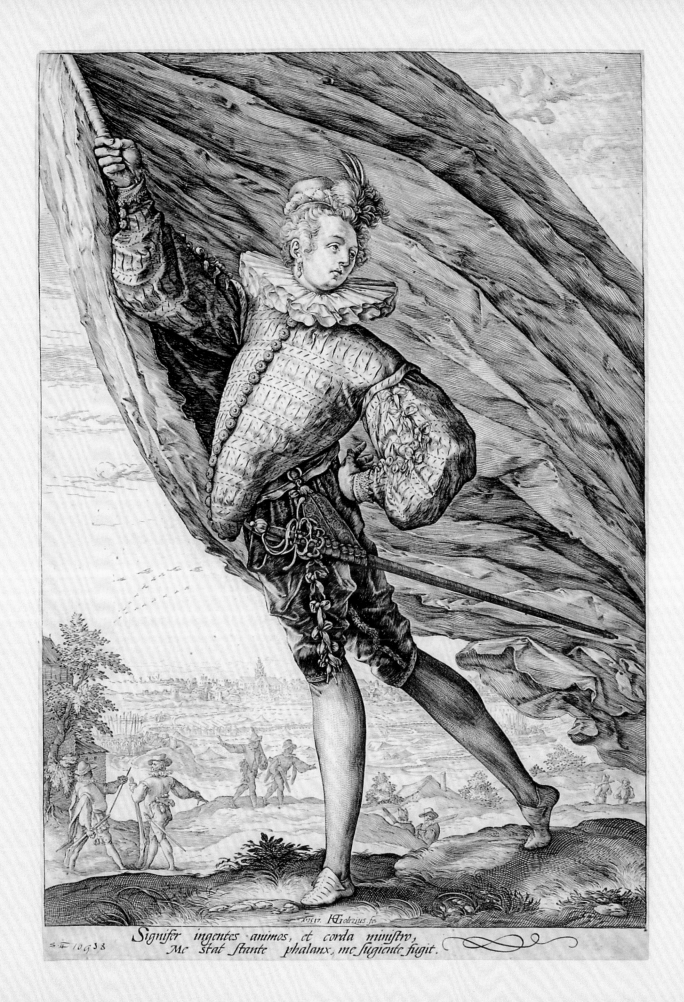

Signifer ingentes animos, et corda ministro,
Me stat stante phalanx, me fugiente fugit.

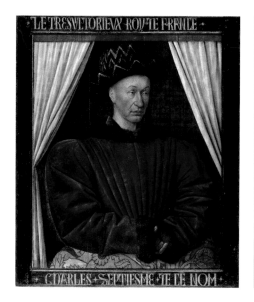 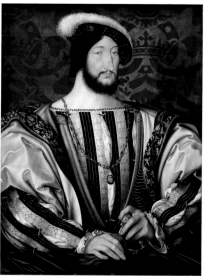

to underscore, in his opinion, the sobriety of the Romans in their "manner of dress." He delivers the following assessment of the new doublet: "the *poulaine* peascod: wadded, stuffed, stopped-up, embossed, rounded, and padded like the pack-saddle of a mule."[10] The *poulaine* peascod described by Blaise de Vigenère supposedly displays the presumed Polish origin of the garment, believed to have been brought back from Poland by Henri III.[11]

All sorts of dense materials, easily packed together, were used to create the doublet's bulk: horsehair, wool, cotton, tow, rags, and even bran.[12] Nonetheless, the hieratic portraits of aristocratic men between around 1570 and 1590 show the appendage protruding so much that even the cleverest padding would not have been enough to support it. In order to create the center ridge, which divided the lower part of the wearer's abdomen with a symmetrical axis, a pronounced busk, made out of wood or metal, or even a triangular armature, was necessary. Maurice Leloir, in his *Dictionnaire du costume*, mentions the use, in addition to the central busk, of strips of shaped cardboard or beaten leather.[13] Such a mechanism created the doublet's bulk, without folds or wrinkles, maintained the rigidity expected in the

aristocratic figure, and consecrated the "triumph of the upper body."[14]

The military origin of the *bombé* doublet of the fourteenth century engendered a rigid garment, inaugurating the history of the restrictive men's garment, which the sixteenth-century peascod and other padded frock coats of the following centuries perpetuated. Although the garment could be fitted, by the end of the Middle Ages it no longer reflected anatomical lines and volumes faithfully. Padding, metal pieces borrowed from military dress, busks, and other hidden armatures contradicted basic human anatomy, creating another.[15] Fabric and its embellishments imposed a distorting effect. In the same way that a woman's form could be changed through the use of farthingales and other artifices, a man's body presented itself as a volume refashioned by its garments.

(opposite, left)
15. Jean Fouquet,
Charles VII, King of France
ca. 1445–50
Oil on panel
Musée du Louvre, Paris, 9106

(opposite, right)
16. Jean Clouet,
François I, King of France
ca. 1530
Oil on panel
Musée du Louvre, Paris, 3256

—

1. On the subject of the doublet, see Odile Blanc, "Pourpoints, gilets et corsets: invention d'une plastique du Moyen Âge au XIXe siècle," in Danielle Allérès, *Mode, des parures aux marques de luxe* (Paris: Economica, 2003), 106–10.
2. The Hague, Museum Meermanno-Westreenianum, MS 10 B 23, fol. 2.
3. Lyon, Musée des Tissus, MT 30307. See the essay in this volume by Maximilien Durand, as well as the bibliographical material in note 1 of the essay.
4. Concerning the padding and quilting of medieval and modern garments, see Alexandre Fiette, ed., *L'Étoffe du relief: Quilts, boutis et autres textiles matelassés*, exh. cat. (Paris: Somogy, and Geneva: Musée d'Art et d'Histoire, 2006), 92–93.
5. Traces of rust on the lining lead one to think that the doublet was worn over a metal armor plate. I thank Maximilien Durand, director of the Musée des Tissus et des Arts Décoratifs of Lyon, for providing this information.
6. Françoise Piponnier and Perrine Mane, *Dress in the Middle Ages* (New Haven and London: Yale University Press, 1997), 63–64.
7. Blanc, "Pourpoints, gilets et corsets," 72.
8. "Circum parecordia de bombace magnam spissitudinem, ut mamillas mulierum habere viderentur. Circa ventre mita constricti erant, ut canes venatici, qui veltres dicuntur, esse viderentur,"

Scriptores rerum Bohemicarum . . . (Prague, 1784), 2: 367.
9. Phillip Stubbes, *The Anatomie of Abuses* (London, 1583); sig. E2r, E2v, quoted in Susan J. Vincent, *The Anatomy of Fashion. Dressing the Body from the Renaissance to Today* (New York and Oxford: Berg, 2009), 49.
10. Blaise de Vigenère, *Les Décades qui se trouvent de Tite-Live . . .* (Paris: Jacques du Puys, 1583), 917.
11. This origin is evoked specifically in the glossary in *Paraître et se vêtir au XVIe siècle* (Saint-Étienne: Publications de l'université de Saint-Étienne, 2006), 285.
12. See also on this subject Fiette, *L'Étoffe du relief*, 93.
13. Maurice Leloir, *Dictionnaire du costume et de ses accessoires, des armes et des étoffes, des origines à nos jours* (Paris: Gründ, 1951), see "panseron."
14. Georges Vigarello, *Histoire de la beauté: le corps et l'art d'embellir de la Renaissance à nos jours* (Paris: Le Seuil, 2004), 20.
15. Concerning these ideas, see Odile Blanc, *Parades et parures: L'invention du corps de mode à la fin du Moyen Âge* (Paris: Gallimard, 1997), 79.

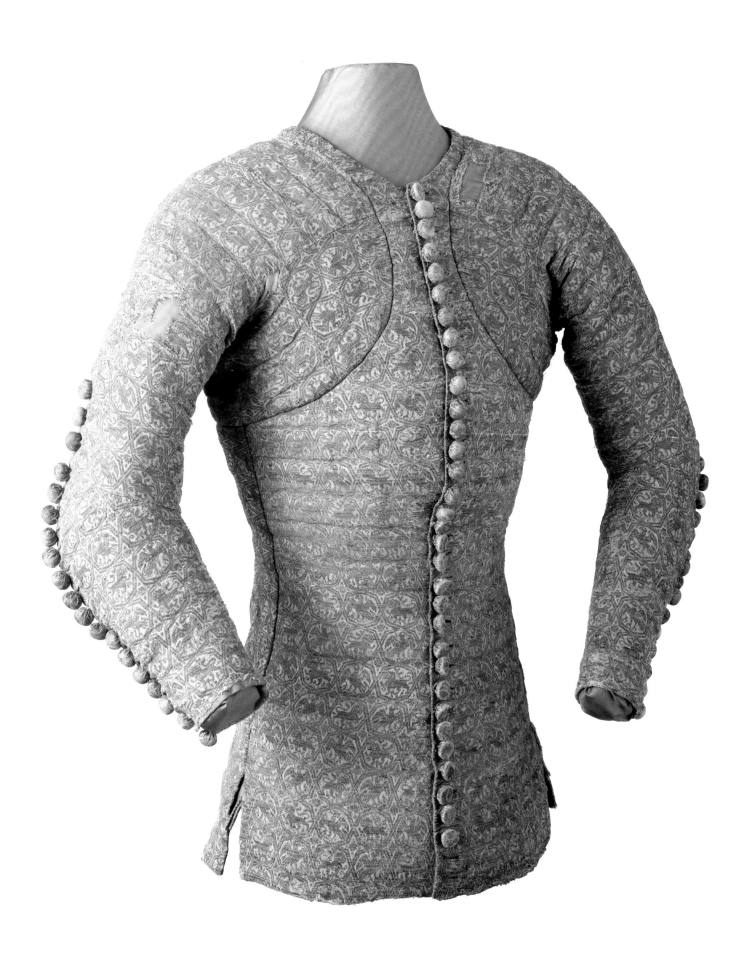

Maximilien Durand

THE POURPOINT OF CHARLES DE BLOIS

Since the end of the fourteenth century, tradition has it that this pourpoint, or doublet, belonged to Charles de Blois, pretender to the duchy of Brittany who was killed in battle at Auray on September 29, 1364.[1] Up until the time of the French Revolution, it was preserved as a relic in the treasury of the Carmelites of Angers. The two missing buttons at the bottom and a few missing areas in the silk and lining material attest to its veneration; these were probably given away to pilgrims of rank.[2]

With the exception of these missing areas, the doublet has not suffered the least alteration. The stitching is original, with the same type of linen thread used for both the sewing and the quilting. Made up of twenty-seven assembled pieces, the pourpoint was perfectly form-fitting.[3] Mid-thigh in length, with two slits on the sides for ease of movement, it nipped in the waist and compressed the stomach, broadening across the chest to enlarge the torso. It was put on like a jacket, opening at the front, and was fastened with a row of buttons. The button at the neck is round and flat, as are the sixteen on the lower half of the garment, across the stomach. The fifteen buttons on the chest and the twenty buttons along each sleeve are spherical.[4] The "assiette"

armholes were cut out up to the neck and under the arms, halfway down the ribcage. Triangular gores of added fabric on the front, back, and underarms enlarge the armholes and facilitate movement. At the waist and inside the garment, seven points were used for tying hose.[5] Each element of the pattern was cut and quilted separately, before the construction of the garment. The precious silk from which it was cut, a *lampas* with an ivory satin ground, is patterned with gilt *baudruche*. The design consists of octagons and stars with alternating eagles displayed and lions passant. The technical characteristics of the silk indicate that it was woven under the Mongol Empire, in western Iran or Iraq, in the style of other imported fabrics belonging to the "panni tartarici" or "tartaires."[6] These "tartar cloths," in vogue in European courts during the thirteenth century, were particularly luxurious, as was the cotton used as wadding in the quilting of the pourpoint, between the silk and the linen lining.

The garment must have been part of a ceremonial wardrobe, given its excellent state of conservation as well as the stiffness of the buttonholes trimmed with green silk, manifestly little-used during the lifetime of its owner. Contemporary with Charles de Blois and

recognized as early as the fourteenth century as having belonged to him, the doublet in the Musée des Tissus de Lyon was evidently destined for an important person, given the quality of the materials and attention paid to its construction. The research undertaken with a view to the canonization of Charles de Blois and the inventories associated with him indicate that the prince and his wife, Jeanne de Penthièvre, honored the sanctuaries of the duchy of Brittany with their generosity on a regular basis. Prominent among their donations were precious fabrics such as velvet set off with gold and silver embroidery, "sendals," and other colored silks, as well as cloth from England, Bruges, and Arras and textiles from Reims.[7]

17–19. Doublet belonging to
Charles de Blois
Cloth: Iraq or Iran, late
fourteenth century
Doublet: lampas on satin
weave; silk, embroidered with
gilt thread wrapped on linen
core; unbleached linen,
cotton padding,
Musée des Tissus, Lyon, Gift of
Julien Chappée, 1924, 30307

——

1. Two signed notes on parchment are sewn into the garment. The older one bears an inscription from very shortly after the death of Charles de Blois: "c'est le pourpoint et de la haire / de mons. sainct charlie de bloys." The "haire" is the hair shirt of the blessed Charles, which his confessor, Geoffroy Rabin, preserved after attending Charles de Blois in the last moments of his life. By the 17th century, the garment is no longer documented in the Carmelite treasury. The 14th-century inscription was supplemented, probably in the 17th century, by the specification "tué a la bataille / d'Auray par Jean de Monfort son / compétiteur au duché de Bretagne" ("killed at the battle / of Auray by Jean de Monfort, his / competitor for the duchy of Brittany"). The other parchment bears an inscription from the second half of the 17th century: "C'est le pourpoint de Saint Charles de Blois tué à la bataille d'Auray par Jean de Monfort son compétiteur au duché de Bretagne le 29 septembre 1364." (This is the pourpoint of Saint Charles de Blois, killed at the battle of Auray by Jean de Monfort, his competitor for the duchy of Brittany, on September 29, 1364.)

See Louis de Farcy, *Le Pourpoint du Charles de Blois: Collection J. Chappée* (Le Mans: Benderitter, 1910), 11–12, fig. p. 10; Odile Blanc, "Le pourpoint de Charles de Blois: une relique de la fin du Moyen Age," *Bulletin du CIETA* 74 (1997), 74. Concerning the pourpoint itself, see *Les Fastes du gothique: le siècle de Charles V*, exh. cat. (Paris: Reunion des musées nationaux, 1981), 399–400 (with bibliography); Lisa Monnas, "The Cloth of Gold of the Pourpoint of the Blessed Charles de Blois: A Pannus Tartaricus?" *Bulletin*

du CIETA 70 (1992): 116–29; Blanc, "Le pourpoint de Charles de Blois," 65–82; Marie Schoefer, "Le pourpoint de Charles de Blois: Remarques faites au cours de sa restauration," *Histoire et Images Médiévales Thématiques* 6 (2006): 79–82.
2. Six samples were taken from the lining that were quite different from the tear at the back of the collar, which was crudely mended, and from the cuts made at the shoulder, the bottom of the back, and the borders of the wrists. The document written relating to the canonization of the Blessed Jeanne Marie de Maillé indicates that she had obtained at Angers a fragment of Charles de Blois's hair shirt, toward which she felt great devotion; see Blanc, "Le pourpoint de Charles de Blois," 77.
3. And not thirty-two, as Odile Blanc states in *Guides des collection: Musée des Tissus de Lyon* (Lyon: EMCC, 2010), 129. See the survey conducted by M. Schoefer, head of the restoration workshop at the Musée des Tissus.
4. One is missing from the right sleeve, which has only nineteen.
5. There are three anchor points midway down the back, two on the sides, above the vents, and two midway down the front, one on each side. They are all linen cords, attached to a reinforced linen trapezoid, except for the tie in the middle of the back, which is made of leather.
6. Monnas "The Cloth of Gold."
7. François Dom Plaine, "Le B. Charles de Blois Duc de Bretagne, Protecteur des Arts au quartorzième siècle," *Revue de l'art chrêtien*, ser. 2, 2 (1875): 284–87.

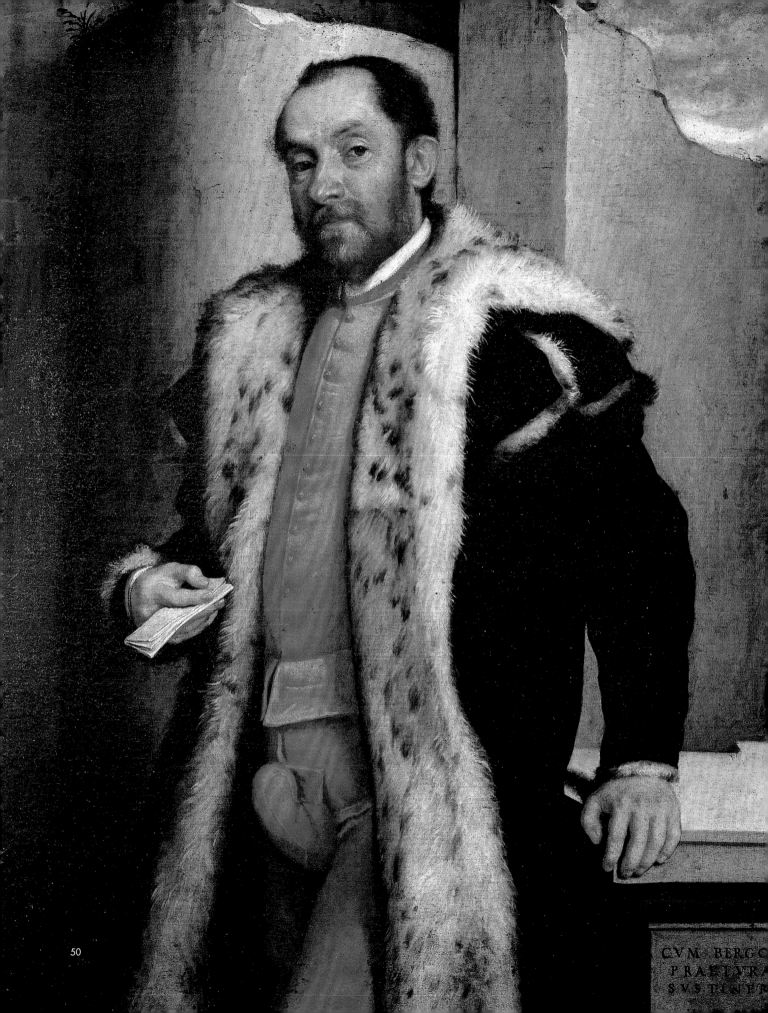

50

Denis Bruna

"FALSITY AND PRETENSE": STUFFED CODPIECES

During the sixteenth-century, men's clothing, particularly that of the nobility, became increasingly geometric. The body's natural angles were highlighted, exaggerated, even invented. Winglets sprouting from the shoulders, collars standing straight up, or, as we saw earlier,[1] padded peascod bellies that distort the abdomen by means of an unexpected, descending point are examples of the protuberances typical of men's fashion at this time.

The codpiece is one such protuberance that cannot be ignored, given how frequently it was adopted at the time by all social groups, from peasants to emperors.[2] By the sixteenth century the French already called it a *braguette* (a modern term for "fly" or "zipper") but it was a far cry from the opening we have in the front of our trousers today. In fact it was a pouch, quite visible, often stuffed and sewn to the crotch, aimed at highlighting the penis and simulating an erection.

In the Romance languages, such words as the French *braguette*, the Spanish *bragueta*, and the Italian *braghetta* probably derive from the Latin *bracae*; that is, breeches or loose-fitting hose that were rolled up around the waistband. In the present context, *braguette* therefore alludes to

the article of clothing to which the stuffed pouch was attached. The English term codpiece derives from the word *cod*, which in Middle English meant scrotum. Thus in English it referred to the body part to which it drew attention.

Before becoming the buttressed protuberance jutting out in sixteenth-century painted portraits, the codpiece was, in the previous century, a more or less triangular piece of cloth, part of which was sewn to the crotch of the trunk-hose and attached by buttons or aglets. In this position the article was supposed to envelop the genitals and be visible, since short doublets were the fashion at the time, as attested in 1467 by Jacques du Clercq, lord of Beauvoir-en-Ternois, in his *Mémoires*: "At this time ... men took to dressing in shorter garments than they had ever done before, so that one saw their behinds and their fronts."[3] Despite this transgression against the established order, the fifteenth-century pouch gained in size to become the typical codpiece of the subsequent century, an appendage protruding at the crotch. As proof of this we have the exceptional hose of the monastery of Alpirsbach (Bad-Wurttemburg), which were discovered along with other garments between the top of a ceiling vault and the wooden floor

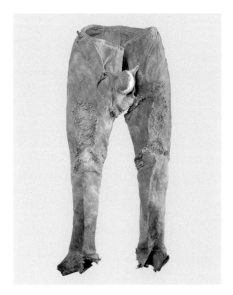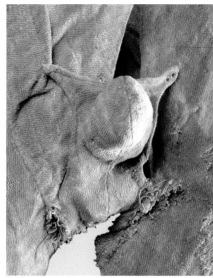

of the attic above, near the cloister (figs. 21, 22).[4] Dating from the first third of the sixteenth century, these hose, probably worn by a traveler passing through or by an abbot's valet (but not a monk), are endowed with a codpiece. Seen from the front, it is almost as round as a ball; but it is from the side that we can measure how prominent it is, even though it is not stuffed or even doubled in fabric. It would appear that the linen from which the codpiece was cut was thick and stiff enough to give it the desired shape.[5]

In the sixteenth century, codpieces grew in size and sometimes attained considerable dimensions (fig. 25). As a result, stuffing the pouch or layering it with stiff fabric became a necessity to make the apparent appendage resemble a swollen male sex organ. In his *Essays*, Michel de Montaigne actually described the codpiece as "silly . . . uselessly modelling a member" that served to increase its "natural size through falsehood and imposture."[6]

By the time Montaigne published his *Essays* (between 1580 and 1588), the codpiece was already on its way out. In spite of this, a few decades later, it appeared in all its prominence in the painted portraits of men puffed up with the confidence of their rank. In these paintings, sometimes the tassets (overlapping plates) of the subject's armor are open to allow the codpiece to protrude, sometimes the ample volume of the breeches or trunk hose (the balloon-like leggings of the age) grants only a little space for the virile protuberance. At times we find it matched with the doublet or hose, or, on the contrary, in a different color, its brilliance clashing with the otherwise dark outfit; at other times it overdoes itself in volume and extravagance through the use of embroideries, ribbons, puffy fabrics, and color emerging from the slashes. On suits of armor of the same period, which faithfully reproduce civilian dress, the metal codpieces are equally protuberant, and therefore impossible to miss, as their counterparts made of fabric (fig. 26).

In short, due to its slow but no less decisive growth in size, the codpiece went from being conspicuous to ostentatious, like the one that François Rabelais created for Gargantua along with other garments "cut and tailored according to the fashion popular at the time." And indeed, this codpiece, correctly compared by the author to a "flying buttress," was adorned with "two beautiful gold buckles with enamelled clasps, each of which gleamed with a large emerald,

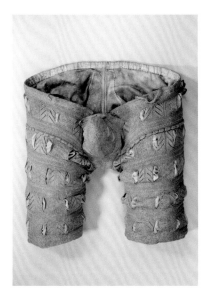
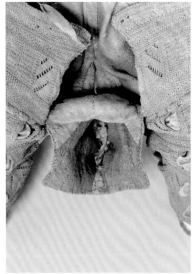
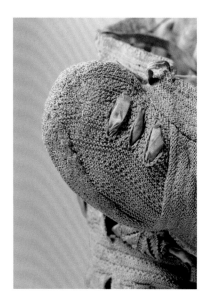

fat as an orange. . . this stone has an erective as well as soothing effect on the natural member."[7] Rabelais also points out that "sixteen ells per segment" of cloth were used to fashion this codpiece, which equals—by our calculations—almost 19 meters of fabric! That certainly makes for a huge phallic appendage, but let us not forget that Gargantua was a giant!

In this colorful description of Gargantua's hose, Rabelais doesn't give any details of the underwear beneath the codpiece, namely the stuffing probably needed to maintain the firmness of a sartorial excrescence of this sort. To learn more of the background, however, one may sometimes borrow information from studies conducted on the rare sixteenth-century outfits still equipped with their appendages. But we must add that few surveys have been made of the intimate stuffing of these costumes, which are rightly considered untouchable relics. As a result, the contents of certain codpieces remain a mystery.

The Museum of London owns several sixteenth-century codpieces made of a durable fabric of woolen serge, all unearthed from urban archaeological contexts.[8] One of them consists of ten thick pieces of coarse woolen cloth, cut

up and carefully assembled to create a spherical protuberance (fig. 27). These London specimens appear to represent more specifically the stuffing of the more elegant codpieces. The bulbous, camouflaging articles rendered the visible codpiece vertical and firm.

Again it was a woolen cloth—now disintegrated—that formed the phallic appendage of the outfit of Cosimo I de' Medici with which he was buried in Florence in 1574.[9]

The collection of the Cathedral of Uppsala contains the doublets and breeches with codpiece worn by Svante Sture and his sons Erik and Nils when they were assassinated in 1567 on the orders of Erik XIV of Sweden.[10] We owe the preservation of these three sixteenth-century outfits to Marta Leijonhufund, Svante Sture's widow, who deposited her husband's and sons' clothing in an iron chest near their tombs in the cathedral. The chest was opened in 1744 and the clothing exhibited, which explains their fragility. Be that as it may, we are now familiar with two of the three codpieces. That of Erik Sture (fig. 27) looks like a leather shell covered with black velvet and trimmed with large silk ribbons and other decorations. Most likely the stiffness of the leather itself sufficed to keep the frontal piece

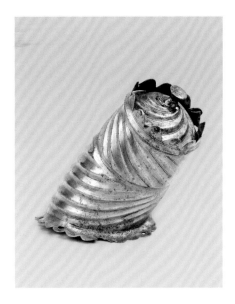

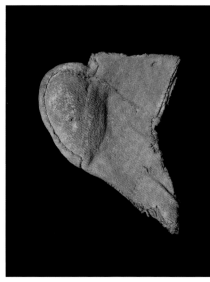

vertical.[11] On the other hand, some remnants of straw have been found inside the upper part of Svante's codpiece (fig. 29). These were probably part of the original stuffing.[12]

Lastly, let us look at the example of the breeches of the elector August of Saxony, from around 1552–55 (figs. 23–25).[13] The codpiece isn't exactly stuffed, but its shell is made up of three superimposed materials that grant it the desired rigidity. Progressing from the article's center to the outside, we have a piece of yellow wool, a silk taffeta of the same color—some fragments of which appear on the surface, between the slashes—and a knitted cloth made of yellow silk threads covering the codpiece's entire surface. The nature of the artifice is of little importance; what matters is the result obtained. The fashion historian Valerie Steele correctly points out that "through its form and decoration, the codpiece makes the penis the central point of male dress."[14]

The codpiece disappeared by the late sixteenth century. Virility's attributes were thereafter lost in the petticoat breeches, the famous puffed-up breeches in vogue during the age of Louis XIV (fig. 71). All the same, we sometimes encounter the old protuberance from the age of Rabelais and Montaigne in the breeches known in French as *culotte à pont* in use between 1730 and the French Revolution. The *pont* or "bridge" of the garment is that piece of fabric sewn onto the front and lowered and raised as need be. But while one cannot ignore certain similarities, the *pont* is rather timid compared to the audacious codpieces of earlier times. And today in the ever-growing inventory of "shapewear" and push-up briefs, in which the front pouch is reinforced or equipped with a phallic shell, one can detect an allusion to the codpiece of the past and its assertion of virility.

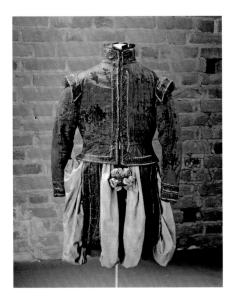
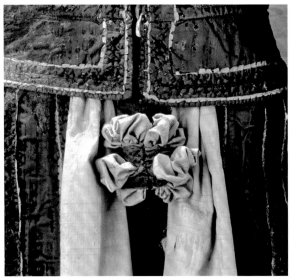

1. See the essay "Puffed-out Chests and Paunched Bellies: The Broadening of Men's Bodies" in this volume, pages 39–45.

2. The bibliography for codpieces is rather limited and rarely of good quality. The best article on the subject is Thomas Luttenberg, "The Cod-piece: A Renaissance Fashion between Sign and Artefact," *Medieval History Journal* 7 (2005): 49–81. Concerning the iconography, see Colette Gouvion, *Braguettes, une histoire du vêtement et des moeurs* (Rodez: Rouerque, 2010).

3. There is an edition of Jacques du Clercq's *Mémoires* in *Chroniques d'Enguerrand de Monstrelet...*, vol. 12, ed. J. A. Buchon (Paris: Verdiere, 1826), 79.

4. Ilse Fingerlin, "Seltene Textilien aus Kloster Alpirsbach im Nordschwarzwald," *Waffen und Kostümkunde* 29 (1997): 99–127.

5. Ibid, 102.

6. Michel de Montaigne, *Essays*, trans. M.A. Screech (London: Penguin), 45.

7. François Rabelais, *Gargantua and Pantagruel* (New York and London: W. W. Norton: 1991) 24.

8. At the Museum of London, we studied the following 16th-century codpieces: A 26604, A 26859, and A 26901. We thank curators Beatrice Behlen and Hilary Davidson for giving us access to their collections. On the subject of the codpiece paddings discovered in London, see Alex Werner, ed., *London Bodies: The Changing Shape of Londoners from Prehistoric Times to the Present Day* (London: Museum of London, 1998), 78–79.

9. Today it is in the Palazzo Pitti in Florence. See Janet Arnold, *Patterns of Fashion 3: The Cut and Construction of Clothes for Men and Women, c.1560–1620* (London: Macmillan, 1985), 55.

10. The bibliography for the garments of the Svante family at Uppsala is considerable. I have mentioned only two outstanding references: Arnold, *Patterns of Fashion 3*, 16–18, 57–68; and Inger Estham, "The Sture Garments," in Lena Rangström, *Modelejon: Manligt Mode 1500-tal, 1600-tal, 1700-tal* (Stockholm: Livrustkammeren, 2002), 302–5.

11. Arnold, *Patterns of Fashion 3*, 62.

12. Ibid., 59.

13. Dresden, Rüstkammer, Staatliche Kunstsammlungen, inv. no. i.0057. On this subject, see Jutta Bäumel and Gisela Bruseberg, "Eine gestrickte Seidenhose des Kurfürsten August von Sachsen-unikaler Beleg für die fürstliche Strickmode im 16. Jahrhundert," *Jahrbuch der Staatlichen Kunstsammlungen Dresden* 22 (1991): 7–14. I would like to thank Dr. Jutta Charlotte von Bloh (née Bäumel), author of the above-mentioned article, for all the information she brought to my attention concerning this magnificent garment.

14. Valerie Steel, *Fashion and Eroticism: Ideals of Feminine Beauty from the Victorian Era to the Jazz Age* (Oxford: Oxford University Press, 1985), 40.

sedistin
pero.
p e symu
â tan do
nana/e
p q todos
sta el ae
gora bos
bos fazia
Dietra

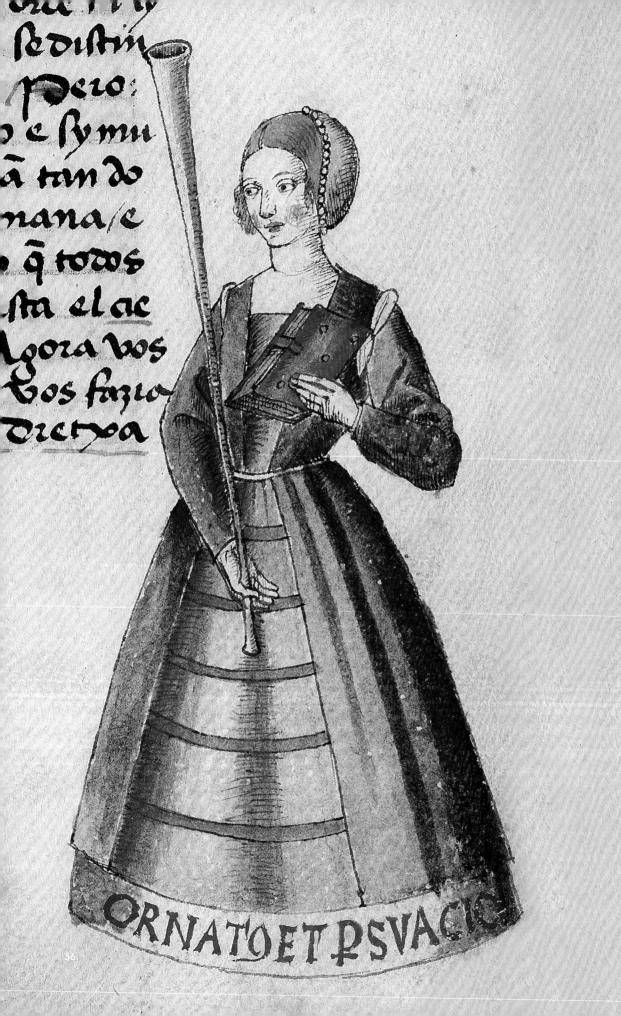

ORNATO ET PSVACIC

Axel Moulinier, Sophie Vesin

WOMEN'S UNDERGARMENTS AND THE SUBMISSION OF THE BODY IN THE SIXTEENTH CENTURY

"There is no excellent beauty, that hath not some strangeness in the proportion."[1] This is how the philosopher Francis Bacon summed up the duality manifest in the evolution of the concept of beauty in his day. At the dawn of the sixteenth century, Europe underwent an upheaval in the notion of beauty in elite fashion as a woman's body came to be considered the pedestal upon which rested the most important element: her head.[2]

At the same time, men's bodies were expected to express the virility believed to be inherent in their nature.[3] A dichotomy evolved in the way the human figure was viewed: a woman's figure became more elongated, while that of a man was made just as unnaturally wide. During the fifteenth century, the female body underwent its first moments of restriction. To this end, various elements hidden beneath the visible garments were gradually modified to give shape to the medieval "limp body." In the sixteenth century, the lower half of the body flared out while the upper was elongated, and both became more rigid, with the head highlighted at the top.

The evolution of women's petticoats at the end of the Middle Ages was part of a casting off of the rounded shapes and heavy draperies with

which the figure had been adorned up until that point. While the short jackets worn by men were intended to underscore their virility, one had to wait until the mid-fifteenth century before the farthingale appeared. These two phenomena, one in men's fashion, the other in women's, are similar in their desire to transform the overall silhouette, yet opposite in their desired effects. The farthingale did not seek to expose the body, but rather to hide the shame of its carnal parts, and thereby to magnify its more noble aspects, such as the head and the line of the shoulders.[4]

The farthingale first appeared in 1468, when Queen Joan of Portugal sought to hide her adulterous pregnancy.[5] Such skirts presented a major innovation: they were circular and made the figure much fuller.

The first farthingales, or *verdugados*, were not yet undergarments. The hoop, called *verdugo* in Spain,[6] was fashioned out of various and quite different types of materials, such as whalebone, rattan, reeds, and even cord, and remained visible (figs. 10, 30). An aesthetic effect was sought, notably in the play of the relief, but also in the use of contrasting colors and textures. While none of these early farthingales has survived, paintings from the time are a good source of information.

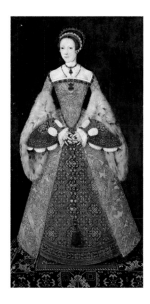
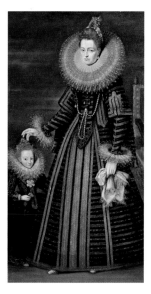

In the *Banquet of Herod*, painted by Pedro Garcia de Benabarre around 1470–80, now in the Museu Nacional d'Art de Cataluña in Barcelona, we see three of these early types of farthingales, with visible hoops made out of six armatures situated at regular intervals (fig. 10).

At the very end of the fifteenth century, the farthingale took on a new importance with a slight modification: the hoops became inserted into the underskirt. The farthingale was no longer a skirt, but an undergarment. Nonetheless, images of Spanish princesses indicate the persistence until the seventeenth century of a single hoop on the lower edge of the dress, admittedly quite narrow, yet still present on the overskirt. Could it be something intended to weigh down the skirt, or is it just a reminiscence of earlier skirts?

The farthingale thus became one of the first undergarments aimed at transforming the general silhouette of the body, worn under a skirt that diminished the visibility of the ribs of the hoops on the overskirt. It created a sense of uniformity and imparted a certain softness to the shapes, as seen in contemporary paintings (fig. 31). "Spanish farthingales" gave a specific shape to the lower body, like a cone, or bell, becoming very wide at the base.[7] An extant pattern made in 1589 by a Spanish geometer-tailor, Alcega, shows the different elements and general shape characteristic of the farthingale. This pattern was studied by Janet Arnold in her reference book on European clothing of the sixteenth century.[8] The flared shape was created by the positioning of rounded armatures of increasingly wide diameter toward the bottom. They were inserted horizontally in the casings sewn on for this purpose, and placed at regular intervals on the skirt. The farthingale gradually became wider and wider, so wide that Charles IX of Franch promulgated a law in 1563 limiting it to: "one ell and a half in circumference,"[9] or 1.80 m (5 ft., 10 in.). The farthingale spread across Europe in this guise: we find it on the occasion of the marriage of Catherine of Aragon to Arthur Tudor in London in 1501, and it is mentioned the same year in the marriage trousseau of Lucretia Borgia, under the title of "Spanish-style skirt." The latter dominated the fashions of the times throughout the first half of the sixteenth century.

The vogue of the Spanish farthingale faded somewhat at the approach of mid-century without altogether disappearing. At the same time a new style emerged: the top of the skirt became enlarged in turn. At the top of the hips, a circular

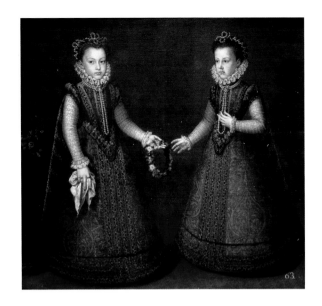

33. Alonso Sánchez Coello,
*The Infantas Isabel Clara
Eugenia and Catalina Micaela*
ca. 1575
Oil on canvas
Museo Nacional del Prado,
Madrid, P01138

padding appeared, given various names across Europe (including *bumroll, hip-roll, hausse-cul, cul*). This type of farthingale was called the "French farthingale" at the time. The new silhouette highlighted the upper body to an ever greater extent. Unfortunately, no example of this type of padding has come down to us. Nonetheless, a contemporary engraving depicts a woman having this type of roll affixed to her hips, over her skirt (fig. 8). This padding can be seen as a transition to the third era of the farthingale, the "barrel" (or "wheel' or "drum") farthingale, which made its first appearance in England. Elizabeth I was said to have worn one for the first time on April 12, 1578, for a wedding ceremony.[10] We can consider this type of farthingale the culmination of its evolution. This type of streamlined skirt, shaped literally like a barrel, was not necessarily worn by all court women, or on every occasion. While it has been confirmed that Elizabeth I wore them, we must keep the importance of this style in perspective and not forget that the conical Spanish farthingale had not yet disappeared. These two lower-body elements co-existed for fifteen years or so, in European courts at least, as is shown in the work by Frans Pourbus the Younger depicting the Infanta Isabella Clara Eugenia, the

archduchess of Austria, around 1600, now at Versailles (fig. 32). Isabella is wearing a typically conical Spanish farthingale, while the dwarf to her right is wearing a drum farthingale similar to the ones seen in portraits of Elizabeth I.

It was in fact in England that the farthingale underwent a last transformation. Its large platter tipped forward by a busk,[11] corresponding visually to the high collars worn by the European queens in the early seventeenth century. Westminster Abbey has an example of one of these platters used to create a barrel silhouette (fig. 35). While this example is somewhat particular (as it was used on the funerary effigy of Elizabeth I), it deserves our attention partly because it is one of the very few that has come down to us, and partly because it clearly shows that the Spanish farthingale and the barrel farthingale are not the same thing. The former is a hoop skirt, the second a padded shelf. The best illustration of the spread of the barrel farthingale appears in the representation of Marie de Médicis by Frans Pourbus the Younger, now in the Louvre in Paris, dated 1609–10 (fig. 36). The dress is broad, with a busked torso hidden by a massive stomacher in the shape of a fleur de lis. This painting bears witness to the speed with which the new canons

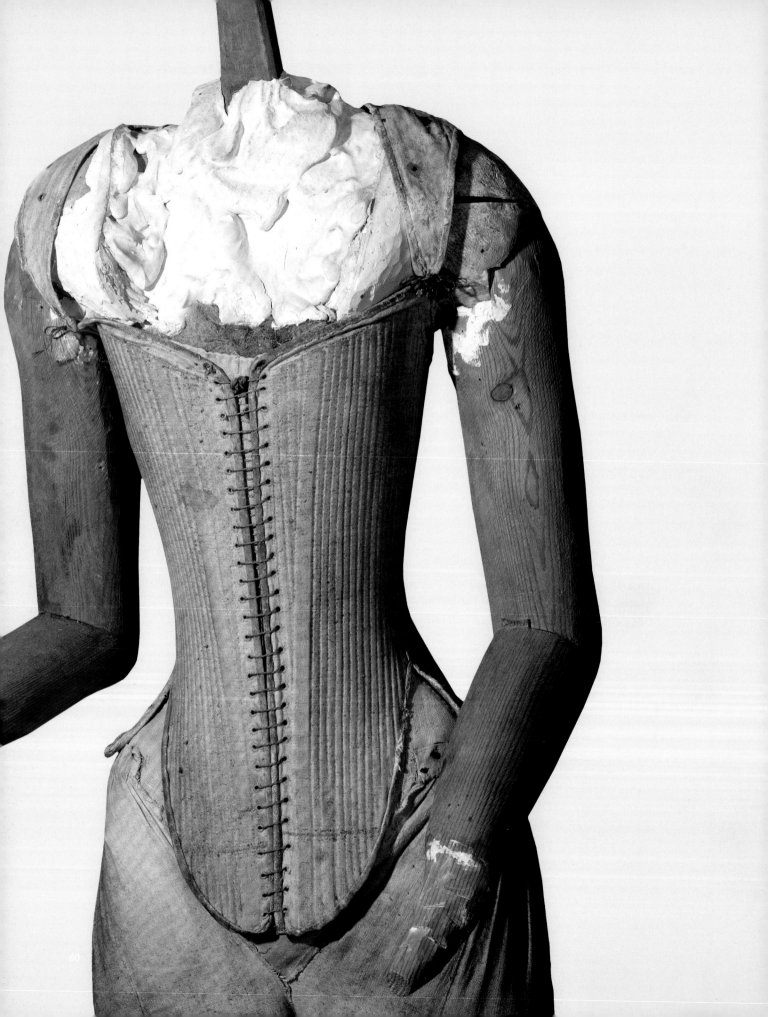

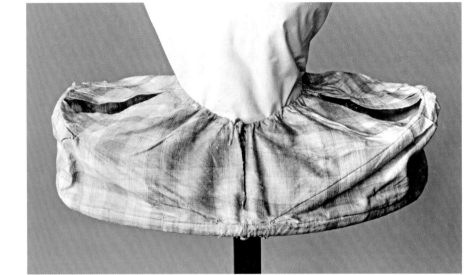

(opposite)
34. Stays of the royal effigy
of Queen Elizabeth I
1603
Dean and Chapter of
Westminster, London

(right)
35. Hip platter or farthingale
of the royal effigy
of Queen Elizabeth I
1603
Dean and Chapter of
Westminster, London

of beauty conquered all the nobility of Europe. The styles born in the early sixteenth century were accentuated and pushed to such extremes that the body became completely remodeled by the garment. Appearing in the 1580s, the busk actively participated in the transformation of the body.

And yet the busk was merely an element of a larger ensemble: the stays also contributed to the pedestal shape, which consisted of a stiff garment that forced women of high society to hold themselves upright. The main function of the stays was to contain women's bodies. They were worn over a chemise and were sometimes perforated with eyelet holes on the lower edge (around the waist) to allow for the attachment of a skirt (or farthingale) with aglets. In fact, at this time the various elements of dress were independent of each other and needed to be assembled for each wearing. In this way, the same pair of sleeves could be attached to several different bodices, and one could likewise vary the skirt below them. During the course of the sixteenth century, the bodice, like the farthingale, underwent more or less important variations, always evolving toward the greater rigidity of the female figure.

Westminster Abbey and the Bayerisches Nationalmuseum in Munich have two rather similar stays from the late sixteenth century. The one in the German museum belonged to the Palatine princess Dorothea Sabina of Neuberg, who died in 1598 at 22. Her waist measured 50.8 cm (20 in.), and her bust 71 cm (28 in.)—measurements which seem to indicate that the princess's body had known the constraints of stays throughout the course of its physiological development. The representation of the Infantas Isabella Clara Eugenia and Catalina Micaela, daughters of Philip II, and his third wife, Isabelle de Valois, painted by Alonso Sanchez Coello, well illustrates that the bodies of aristocratic girls were constrained from an early age, most often from birth[12] (fig. 33). The two young girls, barely ten years of age, were already wearing the combined stays-farthingale. The busk is clearly delineated on Isabella's torso (to the left), further highlighted by a long necklace. Princess Dorothea's stays are laced at the back, and includes tassets (pieces of triangular fabric of varying lengths and widths, creating basques), whose presence was almost mandatory with the style of the whalebone stays and farthingale. Derived from military dress, they fulfilled the same function in daily use, granting

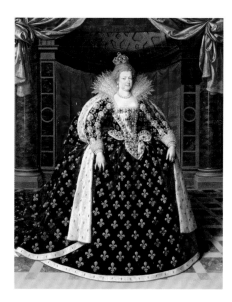

ease of movement to restricted torsos, coming into their own in sixteenth-century women's clothing. The adaptation of practical elements from military dress, such as tassets, indicates that tailors of the time were aware of the difficulty in wearing such styles. Dorothea's whaleboning, and the inner lining, did not survive her burial, but the stitching lines for the whalebone are still extant, and if it is considered from the perspective of a stomacher dating from the early seventeenth century now in the Rocamora Collection in Barcelona, one can well imagine the original whaleboning. The latter still bears traces of a busk in its central area, forming a deep V-shape toward the base. On either side of the central axis were baleens made out of reeds.

In the 1590s, whalebone stays known as "French stays" made their first appearance. It is certain that Princess Dorothea wore one of these.[13] The best-preserved whaleboned bodice to survive to this day is the one from the royal effigy of Elizabeth I in Westminster Abbey, which originally accompanied the platter farthingale mentioned above (fig. 34). Dated 1603, the bodice was made of three pieces, two in front and one behind, which implies frontal lacing. The piece is entirely whaleboned; the stitching is

visible, and one can easily make out the whaleboning beneath the fabric. While the whalebone stays were not yet made completely rigid, the garment was certainly lined and stiffened, notably by the use of buckram (thick cloth), glued on the fustian (a simple textile armature of cotton and linen), as well as cotton or linen canvas.[14] This stiffening might seem slight, but this is hardly the case, if we recall that clothing was layered and tightly laced.

In the early sixteenth century, Spain reigned supreme in fashion. Clothing became more and more decorated with gold and precious fabrics, while women's stays became increasingly rigid. After her marriage to Henri IV, Marie de Médicis, Princess of Tuscany, brought a new type of outer garment to France, known as the Spanish doublet.[15]

In the painting by Peter Paul Rubens in the Musée du Louvre, depictiing Marie de Médicis arriving in Paris, made between 1621 and 1625, the artist depicts the queen in a cream-colored Spanish doublet, opened to reveal a dress of the same color and a busked bodice (fig. 37). The Musée des Arts Décoratifs in Paris holds an exceptional piece dated from the very late sixteenth century, or possibly the very early seventeenth

century: a Spanish doublet recognizable by its sleeves, which are semicircular on the back and split vertically on the front, as well as its small, high collar and *basquines* (fig. 39). Its shape, which to some degree echoes the garment worn by Marie de Médicis in the Rubens painting, shows that women's bodies had become more rigid in all their garments. Closer study of this piece, on the occasion of the present exhibition, has made it possible to show that the doublet is entirely reinforced, from the raised collar to the bottoms of the sleeves and the *basquines*. The different thicknesses of rough cloth (some of it coated) clearly indicate the most important parts of the body to be supported. The epaulettes mounted above the armholes, as well as the basques on either side of the opening are the most rigid parts. Next come the two parts of the doublet's front, perfectly fitted to the shape of the body, which was contained in the bodice by two laces at the bottom of the back, one to the right, the other to the left. A system of hooks and eyes firmly closes the garment, and the laces make it possible to shape the entire abdomen. The high stand-up collar puts the head on display.

The restriction of women's bodies continued on this course, parallel to the concept of beauty, well beyond the end of the sixteenth century. The demands of appearance were again transformed in the seventeenth and eighteenth centuries. New silhouettes of equal complexity emerged, manipulated by means of new undergarments such as whalebone stays and hoopskirts, perpetuating the notion of "structured beauty."

(left)
38. Diagram of the internal structure of the doublet.
1 Very light layer of fabric
2 Slightly thicker layer
3 Thick layer of supple fabric
4 Very thick layer of stiff fabric

(opposite)
39. Woman's doublet, known as the "Spanish doublet"
Spain, ca. 1590–1610
Frieze velvet, edged in ribbon; silk taffeta lining, internal linen reinforcement
Musée des Arts Décoratifs, Paris, département Mode et Textile, gift of Félix Doistau, 1907, 13631

1. Francis Bacon, *Essays* (1597) (Cambridge, MA: Harvard University Press, 1909–14), chap. 43, "Of Beauty."
2. Georges Vigarello, *Histoire de la beauté: Le corps et fort d'embellir de la Renaissance à nos jours* (Paris: Le Seuil, 2007), 21–24.
3. Ibid., 29–30.
4. Ibid., 21.
5. Amalia Descalza, "La Permanence du panier dans les cours européenes," *Fastes de cour et cérémonies royales: Le costume de cour en Europe, 1650–1800*, exh. cat. (Paris: Réunion des musées nationaux, 2009), 72.
6. François Boucher, *A History of Costume in the West* (London and New York: Thames and Hudson, 1987), 205.
7. Janet Arnold, *Patterns of Fashion 3: The Cut and Construction of Clothes for Men and Women, c. 1560–1620* (London: Macmillan, 1985), 8–11.
8. Ibid., 7.
9. Diderot and d'Alembert, *Encyclopédie ou Dictionnaire raisonné des sciences, des arts et des métiers* (Paris: 1751), 9: 674.
10. Herbert Norris, *Tudor: Costume and Fashion* (New York: Dover, 1997), 604.
11. Boucher, *History of Costume*, designates the busk as a thin piece of wood, metal, or whalebone that holds firm the front of a corset, or whalebone stays (see glossary under "busc").
12. On the subject of whalebone stays and corsets for children, see, in this catalogue, the essay by Anaïs Biernat, pages 129–41.
13. Janet Arnold, *Queen Elizabeth's Wardrobe Unlock'd* (Los Angeles: Costume & Fashion Press, 2001), 147.
14. Ninya Mikhaila and Jane Malcolm Davies, *The Tudor Tailor: Reconstructing Sixteenth-century Dress* (Los Angeles: Costume & Fashion Press, 2006), 22.
15. Arnold, *Patterns of Fashion 3*, 7.

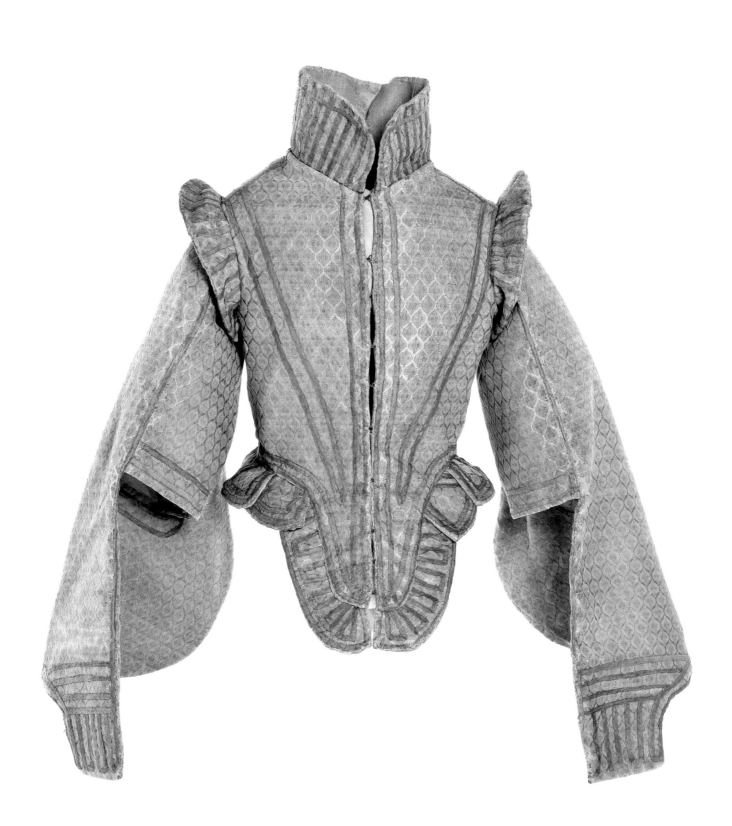

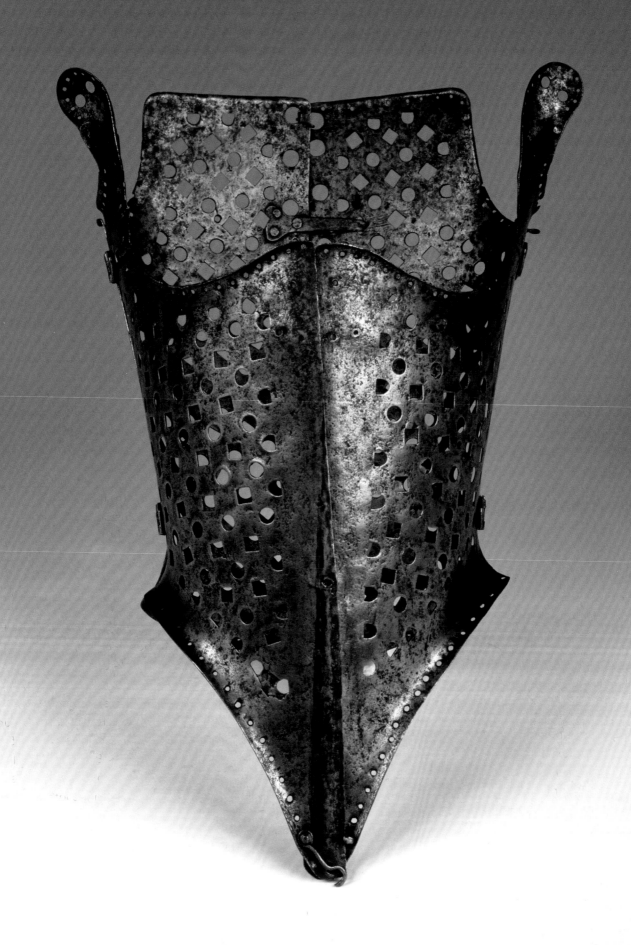

Denis Bruna, Sophie Vesin

THE ENIGMA
OF THE IRON CORSET

Without any claim to having made a comprehensive survey, we have counted some ten metal, often iron. corsets in various museum collections.[1] Although they are indeed corsets and thus adapted to the human form as clothing, these objects are more closely related to metalwork than to textiles. Some are found in armor collections.[2] At times compared to "instruments of torture,"[3] these corsets attracted the attention of nineteenth-century collectors.[4] Kept in curiosity collections reminiscent of that of Balzac's Cousin Pons, these objects, no doubt displayed alongside chastity belts, evoked a strange mixture of fascination and obscurantism in days gone by.

Close examination of their shapes, decorations, and other details reveals that most of these surprising pieces date from before the nineteenth century. Some could even be dated to the sixteenth and seventeenth centuries. Since each piece possesses an intrinsic value relevant to the context of its creation, let us look more closely at these most ancient versions of the corset.

All are made out of metal, composed of three, four or eight parts, opened with hinges, most often soldered on the sides, and fitted with a system of closure sometimes on the front, sometimes on the back. Some of the sharp ridges still bear traces of velvet edging. All are pierced, which might at first appear to be decorative, but in reality provided a considerable technical advantage in reducing the weight, as all of them weigh between 800g (1 lb., 12 oz.) and 1 kg (2 lb., 3 oz.).

Opinions differ as to the uses of these strange corsets: some believe them to be objects of fashion, while others consider them orthopedic devices. Let us state outright that everyone agrees that these pieces were meant to be worn on the body, and that their dimensions, (breadth, waist measurement, and chest measurement) seem to suggest such use. All, moreover, were constructed specifically for women's bodies,[5] echoing the shapes of the whalebone corsets contemporary to them, which were made out of silk, linen, and most often baleen, and which, in the seventeenth and eighteenth centuries were worn exclusively by women. Documents confirm the use of such objects as early as the sixteenth century. In 1549, at the age of twenty-seven, Eleonora of Toledo ordered two iron corsets from her armorer, a certain Master Lorenzo.[6] And in the late sixteenth century Marguerite of Navarre, "in order better to shape her waist . . . put white iron on either side of her body."[7] Another example appears in

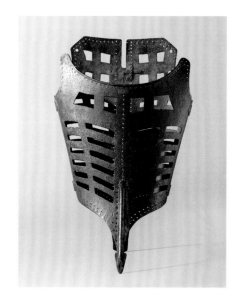 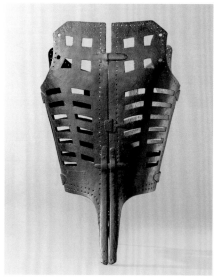

(p. 66)
40. Corset, known as an
"iron corset"
Sixteenth century
Pierced iron
Museo Stibbert, Florence,
n. 14147

(left)
41, 42. Corset, known as an
"iron corset" (obverse and
reverse)
France, late seventeenth, early
eighteenth century
Ironwork
Musée national de la
Renaissance, Château
d'Écouen, Écouen E.Cl.2860

L'Histoire de la marquise-marquis de Banneville by l'abbé de Choisy (1695). The young marquis's mother decides unequivocally to raise her son as a daughter, given her fear that he would die in battle like his father. The writer describes the child's figure, adding that "at twelve years of age his waist was already defined, as it was true that from childhood it had been somewhat restrained by iron corsets, in order to create hips and a bust on him."[8] Metal corsets thus were used specifically to refine the silhouette.

The corsets may well have served a medical function too. Ambroise Paré, in 1575, in a chapter on braces and prostheses, mentions iron corsets that were used for the "curvature of the spine" of "flaccid" girls, "who [had become] hunch-backed because instead of their backbones being straight, they were arched or S-shaped. Such accidents happened because they had had falls or injuries, or because their crazy mothers ... had taught them to curtsey by bending the spine. . . . And many girls became hunch-backed

and deformed because their bodies had been squeezed too tightly in their youth. . . . And in order to repair or hide such flaws, they were made to wear unbound iron corsets, which were pierced so as not to weigh so much."[9]

Ambroise Paré's text suggests that we must not preclude an orthopedic, corrective use of metal corsets, but we must nevertheless recall that the above-mentioned princesses who ordered iron corsets were not known to be "flaccid" or to have "curvature of the spine." Thus the exact use of these pieces remains problematic, for iron corsets were apparently used both to diminish the waist and to right a faulty backbone. But fashion and orthopedics are not always in opposition to each other, for they embody ideas that run in tandem, even merging at times. Orthopedics, which are today exclusively a branch of medicine, were principally a social art in former times. Holding oneself erect, and staying that way, was a preoccupation of the upper classes, and the iron corsets furthered this aim.

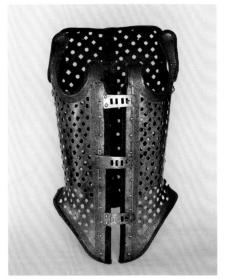
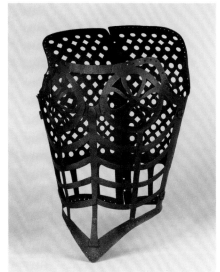

(left)
43. Corset, known as an
"iron corset"
France, late sixteenth century
Ironwork, velvet, fringe
Musée de la Ferronnerie
Le Secq des Tournelles, Rouen,
LS 3936(3)

(right)
44. Corset, known as an
"iron corset"
France, late sixteenth
century (?)
Ironwork
Musée de la Ferronnerie
Le Secq des Tournelles, Rouen,
LS 3963(2)

1. Écouen, Musée National de la Renaissance; Florence, Museo Stibbert; Kyoto, Kyoto Costume Institute; London, Victoria and Albert Museum; London, Wallace Collection; Milan, Museo Peldo Pezzoli; New York, Fashion Institute of Technology Museum; Paris, Musée Galliera; Rouen, Musée Le Secq des Tournelles (three corsets).

2. Such is the case, notably, with the specimens from the Museo Stibbert in Florence and the Wallace Collection in London.

3. This comparison can be found in Fernand Libron and Henri Clouzot, *Le Corset dans l'art et les moeurs du XIIe au XXe siècle* (Paris: F. Libron, 1933), 21.

4. According to Ernest Léoty, maker of corsets and author of *Le Corset à travers les âges...* (Paris: R. Ollendorff, 1893), 38–39.

5. Corset LS 3944 in the Musée Le Secq des Tournelles, Rouen, is the only garment of those studied here not fitted for a female breast.

6. Roberta Orsi Landini and Bruno Niccoli, *Modo a Firenze 1540 -1580: Lo stile di Eleonora di Toledo e la sua influenza* (Florence: Pagliai Polistampa, 2005), 131–32.

7. Gédéon Tallemant des Réaux, *Historiettes (XVIIIe siècle)* (Paris: Gallimard, 1967), 60.

8. François-Timoléon de Choisy, *Histoire de la marquise-marquis de Bonneville (1695)*, in *Nouvelle du XVIIe siècle* (Paris: Gallimard, 1997), 973.

9. Ambroise Paré, *Oeuvres complètes* (Lyon: Pierre Rigaud et Antoine Lullerian, 1652), 457.

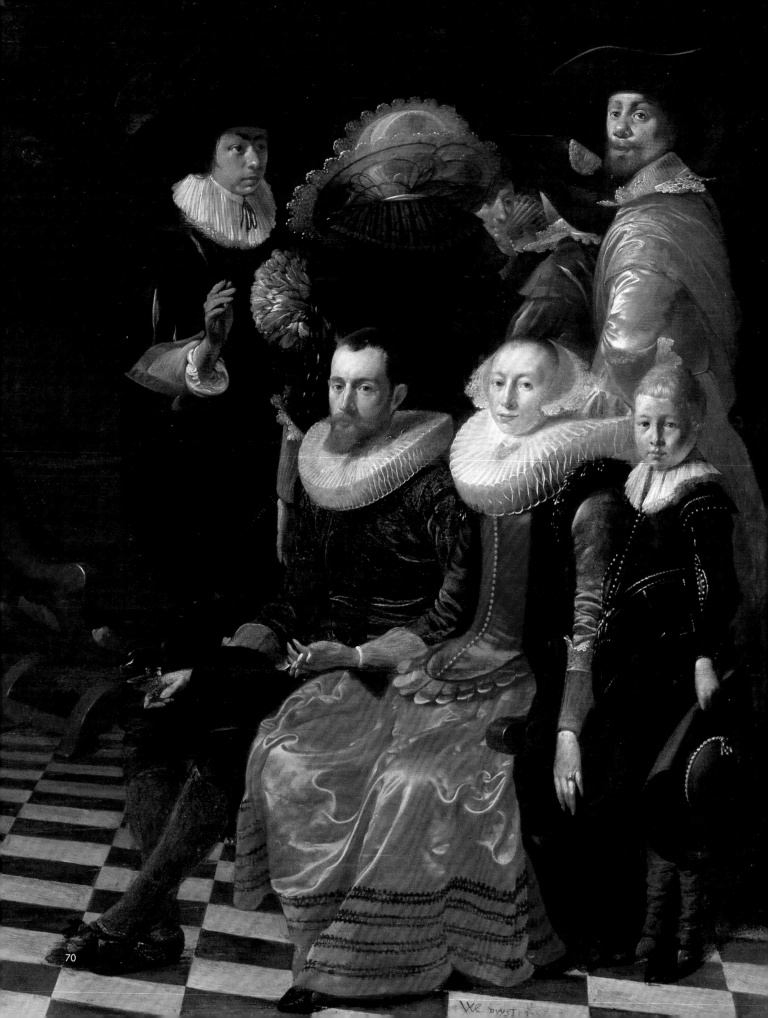

Denis Bruna

UNDER THE RUFF

Many portraits painted at the end of the sixteenth century, and even more in the first decades of the seventeenth, depict men, women, and even children of the aristocracy dressed in dark clothing, highlighted by ruffs of white linen and more discreet cuffs of the same fabric. Such was the role of the ruff: to highlight the face, and amplify its pallor. It was, so to speak, the platter upon which the head was served, alone, as a lordly centerpiece.

The ruff is emblematic of the aristocratic desire for austerity and inflexibility of dress and, consequently, the rigidity of the figure. Comfort appears to have been superseded by dignity and display. Outfitted with a circle affixed between the shoulders and the chin, a man found his movements were so restricted that he could not undertake any sort of activity; the ruff is nothing if not an aristocratic privilege. The origins of such dazzling extravagances remain obscure. They may have come from India or Ceylon, where large muslin collars starched with rice water had been in vogue since the beginning of the sixteenth century. Westerners engaged in trade in these far-off countries apparently brought back not only such ornaments but also the recipes for starch to the Netherlands, England, and Spain.[1] However,

since it is difficult to substantiate this hypothesis, one might also recall that the formal evolution of the ruff, as with many articles of clothing, is strictly Western. It began as a small ruffle at the neck, pleated or sometimes gathered in a narrow band, worn as part of the chemise emerging from the straight collar and buttoning onto the doublet or dress. But it did not take long for this timid piece of ruching to expand, both in height and in width, becoming the ruff, an ornamental collar not only voluminous but also complex.

The shapes, styles, and ornaments are manifold and vary by country. Judging from portraits, the ruff was tallest in Flanders and widest in the Netherlands, where it was decorated with lace and often made of many superimposed layers. In France, under Henri III, the broadest examples spread out in a single row of figure-of-eight pleats of varying heights. England would appear to have produced the most elaborate ruffs, including ones that were scalloped and embellished with lace, circling the face to create a surprising halo effect. All were made of long strips of lawn or batiste, folded, joined together, and assembled in small figure-of-eight pleats to form the collaret, which was stitched to a linen neckband. An examination of most of the ruffs

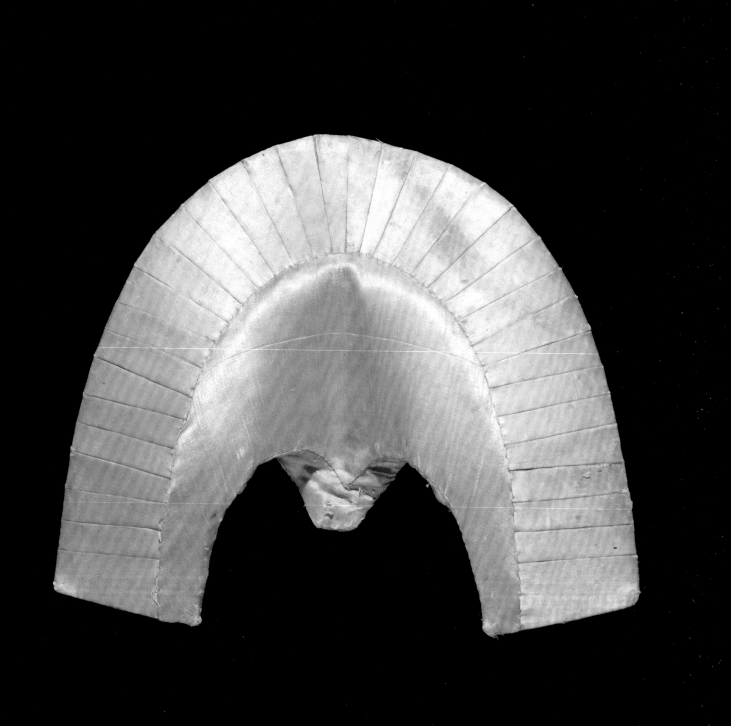

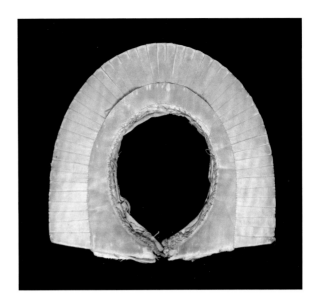

that have come down to us—and reconstructions of certain models known from portraits of the time—show that even the most modest ones employed more than 1m (3 ft., 3 in.) of cloth, and up to 17m (18.5 yards) were used for the boldest[2] (fig. 53). Indeed, some of them were made from as many as seven superimposed layers.

Though the length of the cloth certainly determined the definitive appearance of the ruff, it was not enough to transform a limp strip of linen into a veritable piece of radiant architecture around the neck. The talent of the laundress and her ability to handle the goffering iron on the starched linen were skills necessary for the creation of a ruff. Even if the lawn or batiste had been treated in baths of dressing or with other starchy preparations, ruffs needed more support. Hence one discovers a whole arsenal of hidden collars, supports, and cleverly braided metallic armatures used as underpinnings and known by various names: the *supportasse*, pickadil, or rebato. A ruff might be first of all held up by a pickadil, a frame made out of cardboard covered in silk satin. Two of these are in the collection of the Victoria and Albert Museum (figs. 46, 47). Dated between 1610 and 1620, these supports were made out of molded cardboard, similar to papier mâché.

Thus shaped, the undercollar followed the exact contours of the neck, which was cushioned by padding made of cotton or wool, all of which was covered with silk satin.

Such details lead us to imagine that these objects were most probably the work of tailors. U-shaped, they did not cover the throat and were no doubt used to support an open ruff, with the two ends apart, or an open collarette of linen or lace. Two roughly cut perforations made on the bottom of the point hanging from the back part allowed for the fastening of the cardboard collar, by means of laces, pins, or sewing, to the neck of the doublet or dress. Thus affixed, only the underside of the support collar was visible, with its radiating, horizontal strips of fabric upon which rested the ruff.

Contemporary with these examples is another type of open support, more modest in appearance, but just as useful[4] (fig. 48). This one was made of several layers of linen sewn together. Inside, it was stiffened with whalebone stays radiating out from the neckband to the outer edge of the piece, stitched down separately, in the manner of whalebone stays. However the baleens were not the only armatures of this support: paper and metallic thread, both visible in

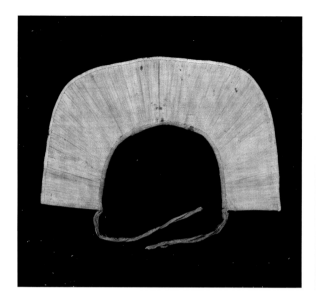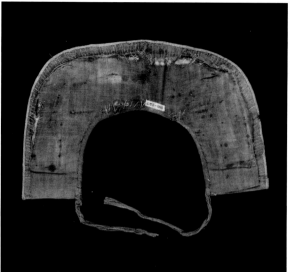

places, provided the piece with sufficient horizontal rigidity to support the ruff. On the underside at the center of the support, two holes were aligned with two more on the collar of a dress. In this way the ruff and the dress were fitted together. Finally, in order to assure the best hold, the support was also tied around the neck with a silk ribbon.

As useful as these proved to be for the first collars attached to doublets, stronger support was required for the outsized ruffs of the 1620s to 1640s. Recipes for starching lawn, even the most elaborate among them, were of little help in maintaining the volume of the neck ornaments worn at the time, known by such evocative names as "Saint John's platters"—an allusion to the head of Saint John the Baptist presented to Salome on a platter—"haystacks," or "cartwheels."[5] The damp climate of the Northern countries where the ruff was particularly popular did not favor the maintaining of its much-desired vertical positioning. Therefore, in order to prevent the ruff from hanging limply across the shoulders, new supports, crafted from the skillful braiding of metal, and whose diameters often exceeded 30cm (11.8 in.), made their appearance about 1620. In this way the ruff was maintained around the neck without

touching the shoulders by supports totally hidden beneath the figure-of-eight pleats and other swirls of linen.

These supports were very popular during the first decades of the seventeenth century, given the large ruffs in vogue at that time, but very few examples have come down to us. A thorough, but not exhaustive, survey revealed just three. The first of these, now in the Rubens House in Antwerp, is made of iron (fig. 52).[6] The second, in the collection of the Bijlokemuseum in Ghent, is copper.[7] Both are furnished with hook-and-eye closures sewn onto the neckband. The metallic threads forming the large, openwork disc of these ruff supports are carefully wound around the edges. The scalloped perimeter, shorter at the back than the front, radiates out from the center.

The third ruff support, published in 1969, is still no doubt in the private collection where it was discovered at the time of its publication.[8] Its silver openwork semicircles are decorated with various geometrical motifs. The two halves are joined by a hinge so that they could be placed around the neck when the ruff-support was opened. Opposite the hinge, a hook and eye fastens the two halves together. This ruff support is

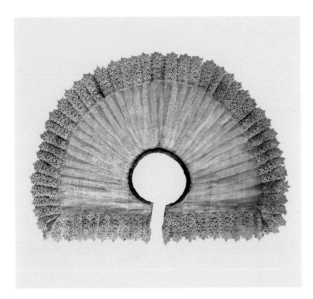

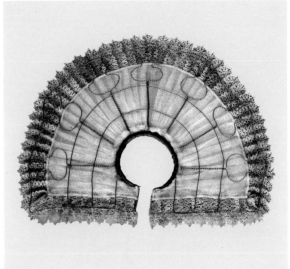

striking; the material from which it is made, the delicacy of the design, and its general appearance make it seem more like a necklace or an ostentatious jewel than an accessory of clothing hidden beneath a ruff. And yet, if we read an inventory made in Antwerp in 1604, we find that precious ruff frames were apparently quite common. The document mentions ruff supports covered with silver and black lacquer or embellished with ribbons alongside the more modest pieces made of iron.[9]

Although few ruffs have come down to us, we can still imagine them, thanks to portraits from the late sixteenth century and, to an even greater extent, the early seventeenth century; and genre paintings in which the subjects are depicted from the back are particularly informative (figs. 7, 45). Such works show how the ruff, so essential to the manner of dress of the time, could exist only with this support.

The category of collars known as the rebato was made out of bobbin lace—or bands of linen or cotton—directly sewn or glued onto metallic armatures with delicate geometric or floral designs.[10] The shapes made from wire (iron, often covered with silk, brass, or silver-gilt thread) are particularly well suited to the subtle motifs of the

lace (figs. 50, 51, 55, 56). The nature of the lace openwork and the delicate weaving of the linen or cotton bands meant that these armatures were visible and must have constituted a decoration in and of themselves. Unlike the collars and their supports discussed earlier, the rebato is both an ornament and a support.

Without their delicate network of twisted metal wire, these semicircles of lace could not radiate out beneath the faces of their owners, as we see in the portrait of Anne of Denmark, painted around 1617 by Paul van Somer and now in Lamport Hall in England (fig. 54). The metal armatures of the rebatos are perhaps less decorative than the one we see in this portrait, but were nonetheless useful.

Proof of this lies in a piece now in the Musée des Arts Décoratifs in Paris. It is a woman's rebato, open at the front, and dating from around 1625–30 (fig. 6). On the upper side it has a symmetrical, complex design made out of very fine linen ribbon glued, perhaps with wax, onto a heavily starched openwork silk or linen cloth or gauze. This imitation lace depicts Poseidon on a chariot with Amphitrite; he is armed with a trident and the scene is set in an exuberant botanical décor. The textile decoration rests on a simple

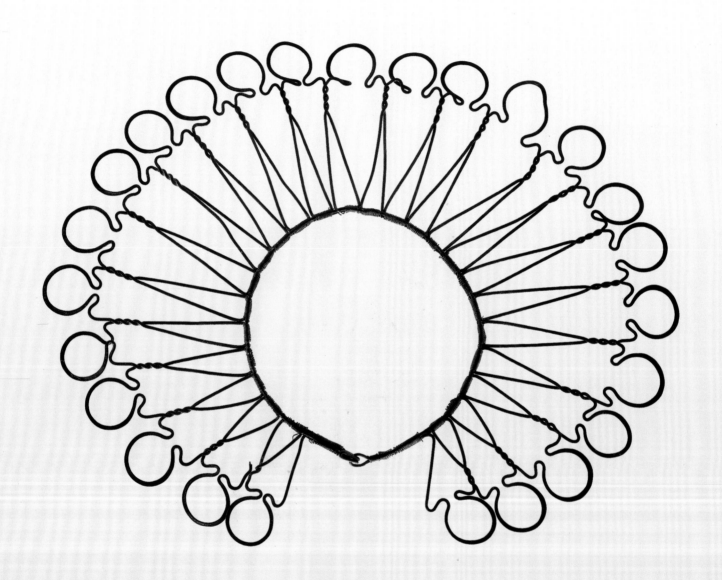

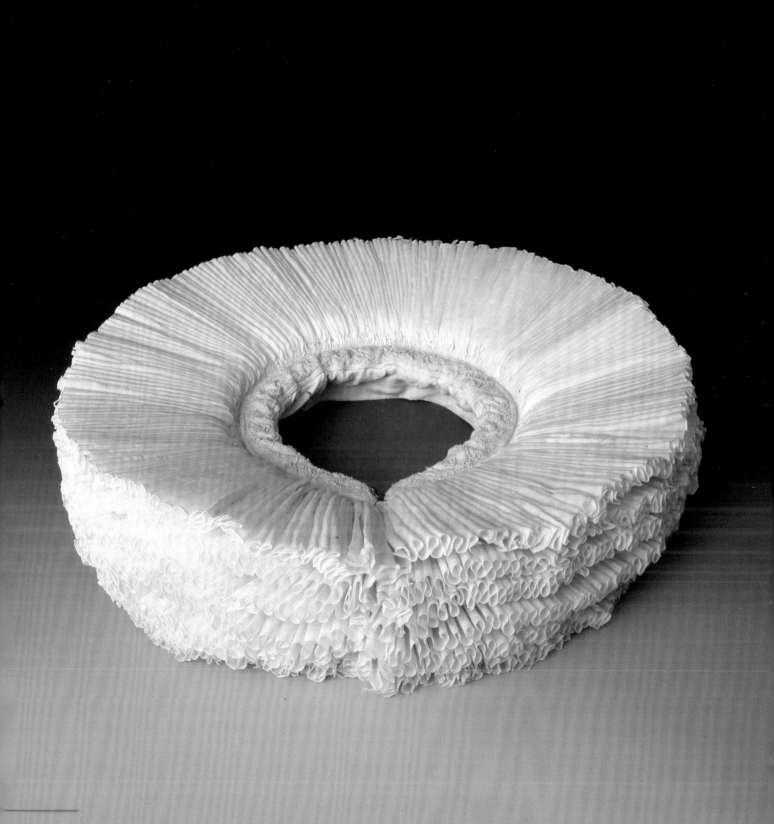

and efficacious armature of silk-wrapped wire and a few strips of cardboard that are visible on the underside. To attach it to the neckband of the dress, two holes were made on the edges of the central curve of this rebato. It is quite likely that the collar was also attached at the front by means of ribbons, now lost.

In the history of fashion ruff supports made of cardboard, whalebone, or even metal wire were accessories that were as indispensable as they were discreet. Without such a support beneath, the ruff, that most emblematic collar of the early seventeenth century, could not have radiated so magnificently.

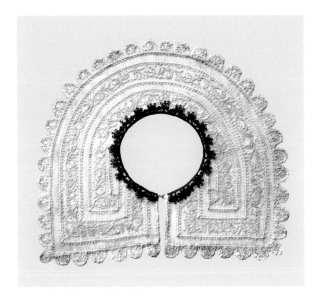 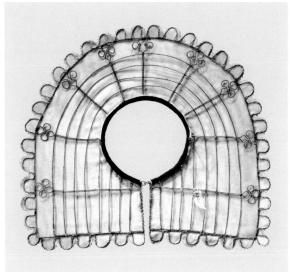

1. This hypothesis is presented in most works devoted to the history of Western clothing. We find it specifically in François Boucher, *A History of Costume in the West* (London and New York: Thames and Hudson, 1965; rev. ed. 1987), 197.

2. Janet Arnold, *Patterns of Fashion 4: The Cut and Construction of Linen Shirts, Smocks, Neckwear, Headwear and Accessories for Men and Women c. 1540–1660* (London: Macmillan, 2008), 10. This study is by far the best documented concerning ruffs and other collar supports.

3. Victoria and Albert Museum, London, inv. 192-1900 and T. 32-1938. On this subject, see the study by Arnold, *Patterns of Fashion 4*, 32–34. One may likewise consult the entries on these two objects on the Victoria and Albert Museum's website: http://collections.vam.ac.uk/item/O137824/supportasse/ and http://collections.vam.ac.uk/item/O110596/supportasse/.

4. Victoria and Albert Museum, London, inv. T. 62-1910. See Arnold, *Patterns of Fashion 4*, 32, and the entry on the Victoria and Albert Museum's website: http://collections.vam.ac.uk/item/O137834/supportasse/.

5. James Laver, *Costume and Fashion a Concise History* (London: Thames and Hudson, 2002), 91.

6. On the subject of the Antwerp ruff support, see Jan Walgrave, *De mode in Rubens'tijd* (Antwerp: Provincial Museum Sterckshof, 1977), 24; and Frieda Sorber, "Clothing in Antwerp Archives in the First Half of the Seventeenth Century," in Johannes Pietsch and Anna Jolly, *Netherlandish Fashion in the Seventeenth Century*. Riggisberger Berichte, 19 (Riggisberg: Abegg-Stiftung, 2012), 51–52.

7. On the Ghent museum specimen, see *Textilia. Kostuums en accessoires uit eigen bezit*, exh. cat. (Ghent: Bijlokemuseum, 1986), 125; *Haute Nouveauté: 300 jaar modecreaties 1600–1900*, exh. cat. (Leuven: Stedelijk Museum Vander Kelen-Mertens, 1992), 19; Arnold, *Patterns of Fashion 4*, 10.

8. Frithjof Willem Sophi Van Thienen, "Een silvre portefraes. Een zeventiende-eeuws kostuumonderdeel," *Antiek* 3 (1969): 482–87.

9. Erik Duverger, *Antwerpse kunstinventarissen uit de zeventiende eeuw*, vol. 1: *1600–1617* (Brussels: Koninklijke Academie voor Wetenschappen, Letteren en Schone Kunsten van België, 1984), 113 ("portefrazen").

10. On these rebatos, see again the study by Arnold, *Patterns of Fashion 4*, 34–38.

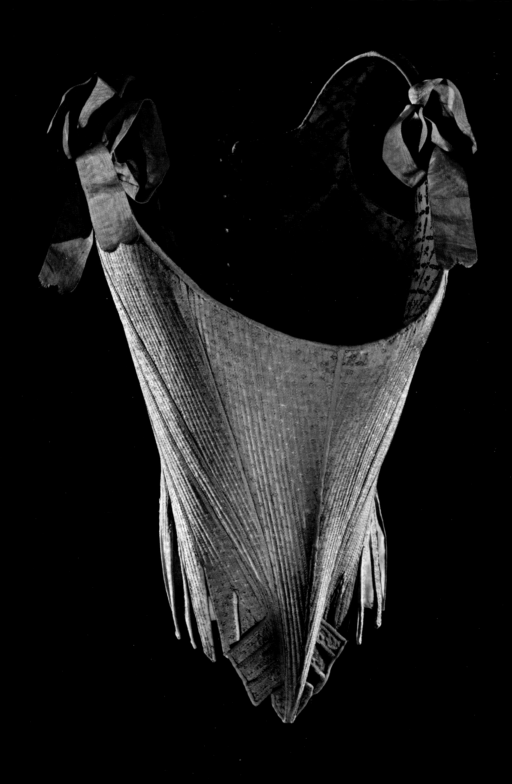

17th—18th
CENTURY

Busk
Whalebone stays — Whalebone bodice
Panniers — Padding

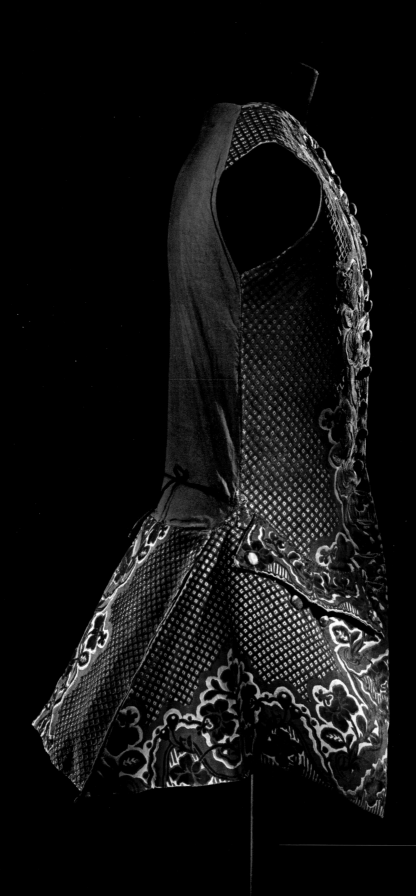

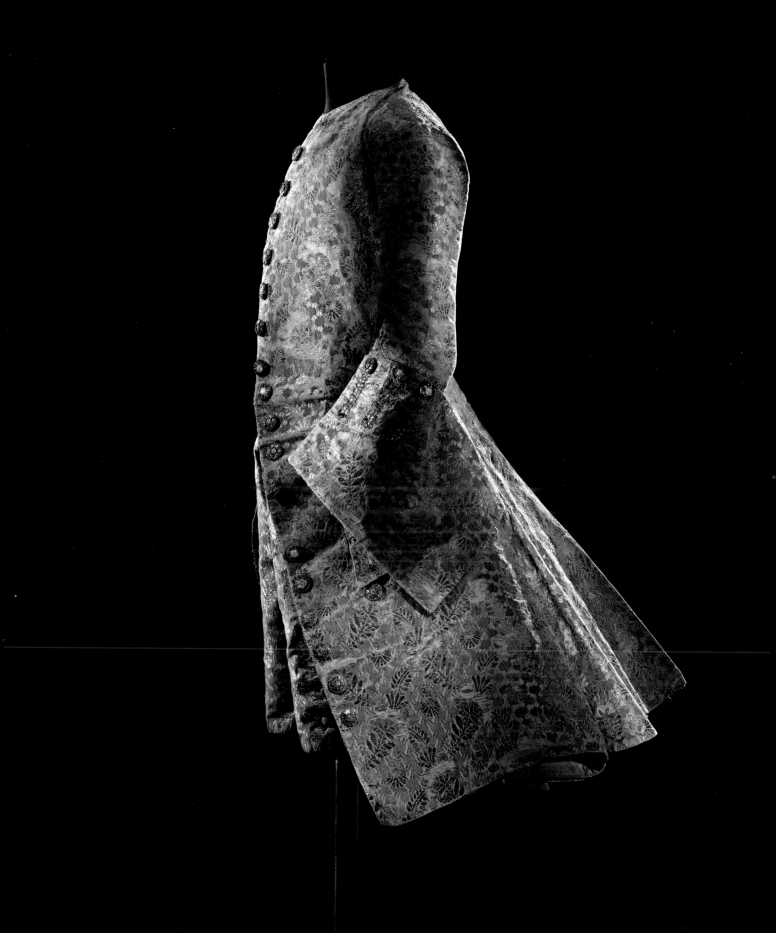

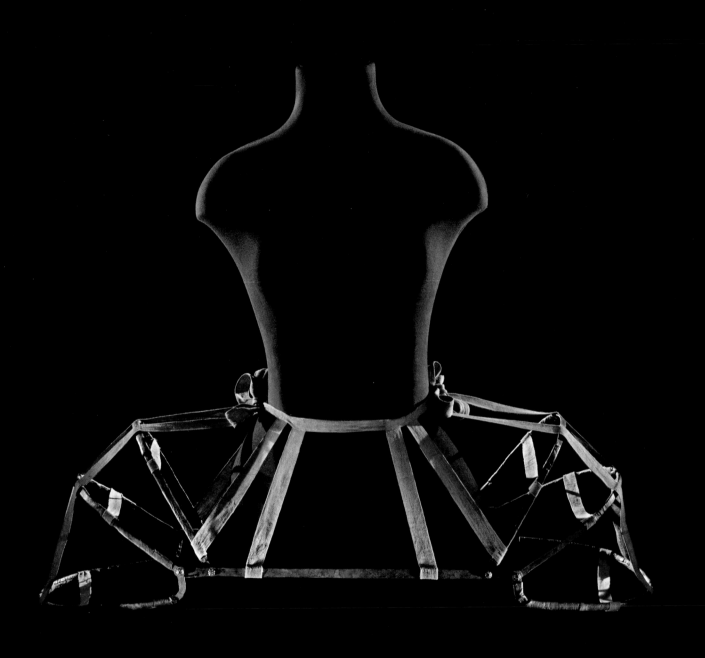

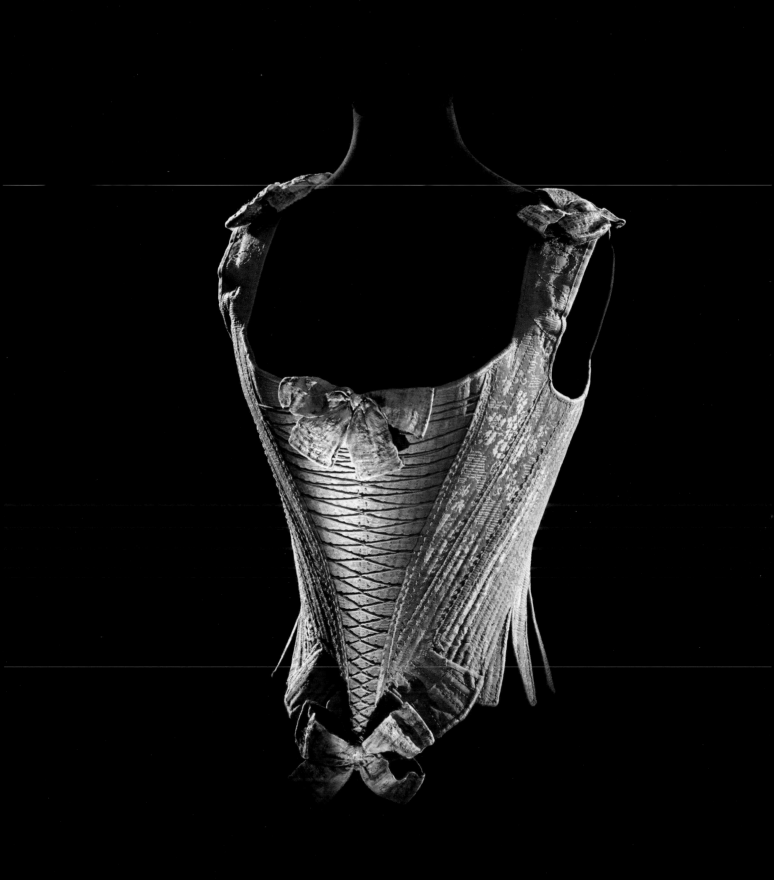

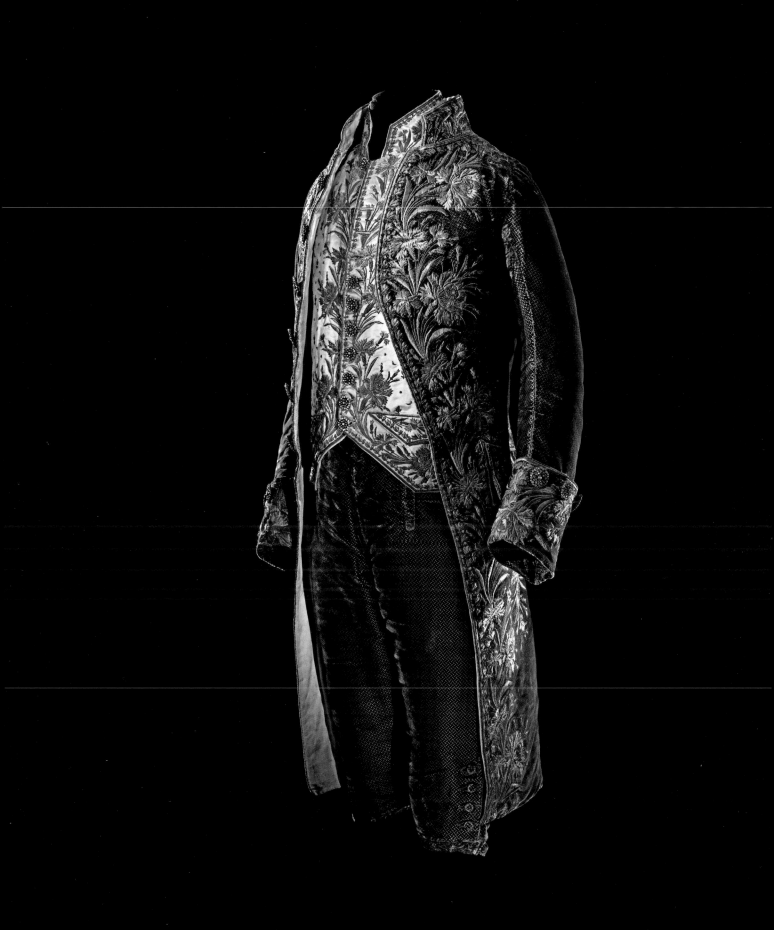

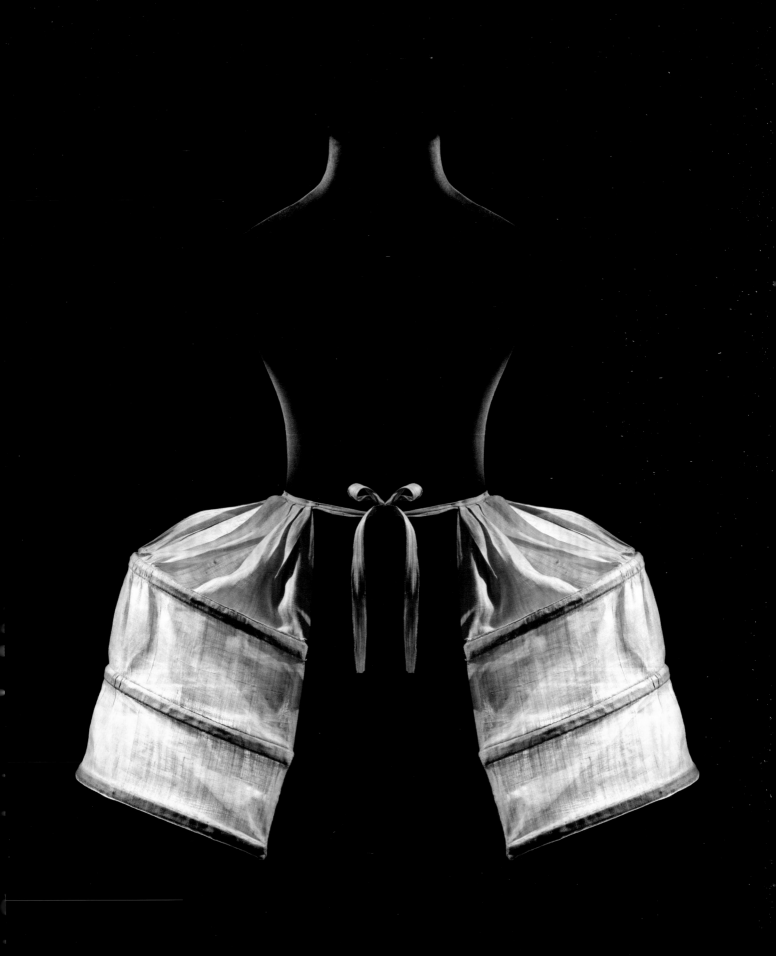

THE ANCIEN RÉGIME OF THE BODY

Michel Delon

A taste for freedom found expression in all domains during the eighteenth century. Public opinion grew impatient with the houses built on bridges, which impeded the circulation of air, and with the customs houses and tollbooths that slowed commerce down along the country's roads. People likewise got tired of clothing that fettered the body and the censorship that prevented the open debate of ideas. They wanted free circulation of goods and opinions; they wanted bodies and cities to breathe. Such wishes are quite evident in the repeated criticisms of the whalebone stays, which were not yet called a "corset."

In 1741, the anatomist Jacques Bénigne Winslow published his *Mémoire sur les mauvais effets de l'usage des corps à baleines* (Memoir on the negative effects of the whaleboned body). In it he revealed the health risks caused by the prevention of proper breathing, circulation, and digestion.[1] He challenged the physical as well as moral ideal that granted medicine and education the right to discipline the body and soul, according to which the body would be misshapen if left to itself and the heart corrupted by original sin. The one had to be corrected through orthopedics, the other purified through religion. In the eighteenth century, however, people began to place increasing trust in nature and instead grew alarmed at anything that prevented its full flowering and could be considered to be burdened with the weight of prejudice and the past. Winslow's medical argument found new resonance in the rhetoric and fame of the naturalist comte de Buffon and, later, the philosopher Jean-Jacques Rousseau. Buffon compared the customs of many civilizations that left newborns free, with the Western habit of constraining the baby: "No sooner does the infant emerge from the mother's womb, no sooner does he begin to enjoy the freedom of movement, than we shackle him with new fetters. We wrap him

in swaddling bands."[2] Buffon likened this swaddling to the imprisonment of young women in whalebone stays, since it stemmed from the same philosophy: "Swaddling bands can be likened to the whalebone stays we make girls wear when growing up. This sort of cuirass, this uncomfortable garment—which was conceived to support the waist and prevent it from losing its shape—actually creates more discomfort and deformity than it prevents." Free exercise strengthens a body without need of external reinforcement.

From the very first pages of Jean-Jacques Rousseau's *Émile, ou De l'éducation* (Emile, or on education), the swaddling in which the newborn is wrapped is compared to the shroud wound around a corpse. It becomes a metaphor for the social institutions constraining the individual. "Civil man is born, lives, and dies in slavery. At his birth he is sewed in swaddling clothes; at his death he is nailed in a coffin."[3] Rousseau then quotes Buffon at great length. The imposition of culture was traditionally considered an external support that should be applied to a weak body. But Rousseau vaunted the natural body as able to grow from within, thanks to its own action. The last book of the treatise is devoted to the upbringing of Sophie, Émile's future companion. Rousseau praises the flowering of bodies in ancient Greece and Rome, where artists sought out ideals of beauty. In modern society, they are unable to find any, because the bodies are all constrained and deformed: "They [the Ancients] had none of these Gothic fetters, these endless bonds that keep our limbs in a bind from all sides; they had not a single one of them. Their women knew nothing of the use of whalebone stays by which our own women do not so much highlight as counterfeit their waists."[4] A striking image hammers home this denunciation: "It is by no means pleasurable to see a woman cut in two like a wasp."

These themes spread throughout society, asserting the need to struggle against infant mortality and the bad health of society women. What the nation needed was a crusade against the imprisonment of the body in the name of the population. In 1768 Joseph Raulin denounced the wearing of whalebone stays during pregnancy:

> If pregnant women want to protect themselves from various sorts of accidents, it is imperative that they completely cease to wear whalebone stays. These devices are hard, stiff, and almost inflexible; they are a kind of torture favored by women, because they preserve the beauties of the waistline normally diminished by pregnancy, when the abdomen is allowed the necessary freedom to expand. These whalebone stays are pernicious in pregnancy, since they harshly compress the middle and lower parts of the chest and the entire circumference of the pelvic area.[5]

In a more polemical vein, the very title of Jacques Bonnaut's 1770 pam-phlet denounces *La Dégradation des espèces humaines par l'usage des corps à baleines* (The degradation of the human species through the use of whalebone stays).

With all the authority of its folio editions, the *Encyclopédie* (1751–72) joined the fray on the side of free organisms. Under the heading "Man (*Nat. Hist.*)," Denis Diderot took up Buffon's arguments, which became a slogan of the new philosophy: "The moment he emerges from his mother's womb, his captivity begins. He is swaddled, a barbaric custom practiced only by highly civilized peoples."

The *Supplément* to the *Encyclopédie* in 1776 featured two new articles: "Whalebone stays (*Garment*)" and "Whalebone stays (*Anatomy*)," which are even more insistent. The first explains: "It is quite the custom in France and in parts of Europe to make small children wear stays: boys until they start dressing in breeches, and girls and women for nearly their whole lives. It is claimed that this garment is fit to preserve the beauty of the waistline, but all anatomists claim that it is far more likely to deform it." The second entry bases its arguments on Winslow: "The human waist was designed by nature, and its finest manifestation is without question the one that nature gave it. To wish to make it more elegant is to distort it."[7]

We have a good example of the concrete influence of these sorts of theoretical propositions in the correspondence between two lovers whose affair in the 1770s had caused a scandal. The comte de Mirabeau kid-napped Marie-Thérèse-Sophie Richard de Ruffey, the wife of the marquis de Monnier. They fled together and after months on the run were arrested. The count was imprisoned at Vincennes, while she, pregnant by then, was placed in a reformatory where she delivered a baby girl. After the child was born, Mirabeau became concerned for the health of the mother and daughter, who was put with a wet nurse. Neither must wear any whale-bone garments, enjoined the count: "You certainly have no precise or even approximate idea of how dangerous whalebone stays are." He advanced the argument that it was imperative that nature should take precedence over artifice:

> It is clear that nature, which did not give women a girdle-like body
> [*corps de gaine*], had no desire to make them prodigiously more slen-
> der from the bottom. What is so contrary to her laws must make [the
> body] uglier and, what's worse, distort or destroy it. Indeed this diaboli-
> cal cuirass, which harms and deforms the body from without, exposes
> the inner organs to unfortunate accidents.[8]

The situation of these two lovers adds a particular urgency to the demand for unfettered bodies liberated from their social as well as sartorial shackles.

Fiction also embraced the theme, providing a number of libertine variations on it. When, in *Les Liaisons dangereuses*, Madame de Merteuil disparages la présidente de Tourvel after she slapped Valmont, she describes the woman as having "always ridiculously dressed with her bunches of neckerchief on her breast and her bodice up to her chin!" Valmont responds to this urban portrait with a counter-portrait of la présidente in the country, freed of the constraints of worldly high society: "thanks to the extremely hot weather we've been having, a morning-dress of simple linen allows me to see her round supple figure. Her breasts are hidden by a single fold of muslin and my furtive but keen glances have already spied out their enchanting shape."[9] The whalebone stays epitomized all moral constraint. Madame de Tourvel was released from hers once she was away from Paris, and she was finally delivered from all such constraint when she surrendered to Valmont. The marquis de Sade took matters further, imagining an incestuous father rearing his beloved daughter according to Rousseauvian principles before inculcating her with a permissive, libertarian morality. He raises her with two companions and encourages them to play outside for two hours a day:

> Dressed comfortably, according to the weather. Nothing constricted their waists; they were never enclosed in those ridiculous corsets which are equally dangerous to the stomach and to the chest, and which, hampering a youg girl's breathing, necessarily attack her lungs.[10]

The absence of "corset," to use the modern term, is the absence of moral constraint.

If it was Rousseau who gave particular resonance to the medical argument, he was also the one who eroticized these much-excoriated and yet much-worn whalebone stays. In *Julie, ou la Nouvelle Héloïse*, Saint-Preux makes his way into Julie's chamber, where he finds his mistress's garments. He itemizes them in detail as an imaginary presence of the beloved body:

> This happy neckerchief of which at least once I shall not have to complain; this elegant and simple dishabille which so well states the taste of her who wears it; these dainty slippers which fit easily on your little feet; this slender corset that touches and enfolds … what an enchanting shape … two slight curves in front … oh voluptuous spectacle … the whaleone has yielded to the forms pressed into it.[11]

The fichu tells of the chest, the mules tell of the feet, which are often a metaphor for sex, and the stays tell of the waist and the stomach without any

metaphors. Whalebone stays are no longer an artificial armor violating the flesh; they become a locus of contact, of a negotiation between fabric and skin. They are no longer so much an external object that supposedly distorts the waist as a permanent embrace that bears the signs of an individual body. What will soon be called the "corset" bears the impressions of the person as bedsheets retain, in their folds, the traces of a presence.

The reverie over this "corset" goes hand in hand with the denunciation of the ancien régime of the body.

1. The exposé quickly became an authoritative source in medical circles. See "Question de médecine proposée dans les écoles de la Faculté de médecine de Paris, le 12 avril 1753, sous la direction de M. Macquar, dans laquelle on fait savoir combien il est dangereux d'emmailloter les enfants, et de faire porter des corps de baleine aux filles," *Collections de thèses médico-chirurgicales* (Paris: M. le baron de Haller, 1760), 5: 302–32.
2. Comte de Buffon, *De l'homme*, ed. Michèle Duchet (Paris: François Maspéro, 1971), 57.
3. Jean-Jacques Rousseau, *Emile: Or, On Education* (1762; The Floating Press, 2012), 21.
4. Ibid., 705.
5. Joseph Raulin, *De la conservation des enfants, ou moyens de les fortifier, de les préserver et guérir des maladies, depuis l'instant de leur existence jusqu'à l'âge de la puberté,* (Paris, 1768), 1: 431–32.
6. *Encyclopédie*, vol. 8, col. 257 b.
7. *Supplément*, vol. 2, col. 615 b.
8. *Lettres originales de Mirabeau, écrites du donjon de Vincennes, pendant les années 1777, 78, 79 et 80*, ed. P. Manuel, citizen of France (Paris, 1792), 2: 348.
9. Pierre Choderlos de Laclos, *Les Liaisons dangereuses* (Paris: Le Livre de poche, 2002), 55, 58.
10. Marquis de Sade, "Eugénie de Franval," in *The Crimes of Love* trans. Lowell Blair (Pennsylvania: Bantam, 1993), 11.
11. Jean Jacques Rousseau, *Julie, or the New Heloise*, trans. Philip Stewart and Jean Vaché (Hanover and London: University Press of New England: 1997), pt. 1, 120.

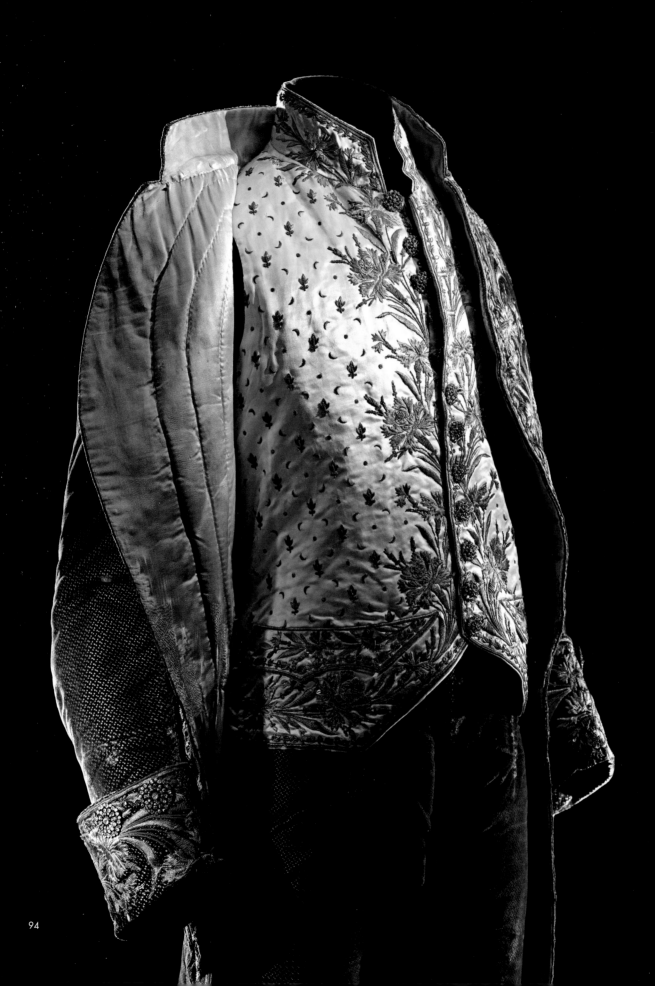

Aurore Pierre

FROM THE DOUBLET TO THE JUSTAUCORPS: THE MALE SILHOUETTE IN THE SEVENTEENTH AND EIGHTEENTH CENTURIES

During the seventeenth and eighteenth centuries, appearance became extremely important at court. Every courtier had to pay attention to it, however great or small his interest in fashion or his physical attributes. Intelligence was often valued less by the aristocracy than other qualities such as deportment, a good figure, or good manners. The game of posturing, studied gestures, and perfect carriage trumped all others. Many men devoted themselves to their looks, developing a true "art of appearance." More moderate types found themselves obliged to follow suit, for fear of falling out of favor at court. Judgments, indeed, were often severe and based on certain details that must at all costs be respected. Falling short of these implicit rules, as well as having physical flaws, often provoked harsh criticisms that could damage one's popularity.

The priority given to appearance was paramount, and the silhouette was completely transformed during the seventeenth and eighteenth centuries. It was constructed first and foremost according to the tastes and the customs of the times, evolving according to the various reigns and the sways of fashion. Clothing was used to create new shapes on and around the body. But it could also act upon the body itself by various

means in order to create from scratch an artificial silhouette conforming to current trends.

EVOLUTIONS OF THE SILHOUETTE

The fashionable silhouette evolved a great deal between the beginning of the reign of Louis XIII in 1610 and the end of that of Louis XVI in 1792. The reign of Louis XIII (1610–43) witnessed a true transformation of the silhouette, abandoning sixteenth-century tastes for new seventeenth-century fashions. From around 1610 to 1630, fashions were still quite similar to those of the reign of Henri IV, during which men wore doublets and hose (fig. 66). The doublet, covering the upper body, was rigid and came to a point at the waist. It was worn with short, puffy breeches or with trunk-hose, a type of breeches that were short and fully padded. The legs were covered with silk stockings worn under high, narrow boots or low-heeled slippers. A few accessories completed the silhouette: ruffs, falling-bands, and gloves. A large, broad-brimmed hat was turned up in the front.[1]

As fashion evolved from 1630 on, the doublet became less rigid, breeches were replaced by knee-breeches or "slops," an article of clothing that appeared at the time of Henri IV, becoming

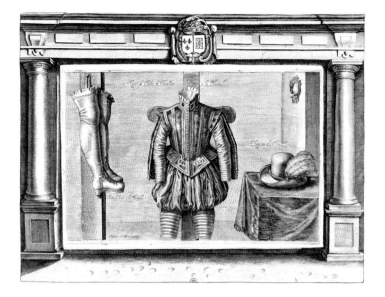

(p. 94)
65. French outfit
France, ca. 1775–1800
Justaucorps: figured, cut silk,
padded
Waistcoat: satin silk, gold and
silver thread, bullion embroidery
on padding, paillettes and small
decorations in cut white glass
Breeches: figured cut silk, embroi-
dered in gold and silk thread
Musée des Arts Décoratifs,
Paris, département Mode et Textile,
Gift of Félix Doistau, 1907, 13630.ABC

(left)
66. Crispin de Pas,
"Figure de l'habit de chevalier",
Engraving for Antoine de
Pluvinel, Le Manège royal (The royal
riding school), 1623
Bibliothèque nationale de France,
Paris, Est. KE-7-FOL

elongated and less puffy. Men also wore cloaks, thrown over one shoulder, *à la Balagny*,[2] or secured at the waist (fig. 68). A wide-brimmed hat with an enormous plume completed the outfit, along with gloves, collar, and cross-belt, or baldrick. This second silhouette, weighted down with many layers of clothing worn on top of each other, lasted until the beginning of the reign of Louis XIV (1643–1715). The doublet was buttoned only at the top, showing a ruffle of shirt underneath. The breeches were knee-length and straight, sometimes tied at the bottom with ribbons. Subsequently, this silhouette underwent a radical metamorphosis. The doublet was shorter, becoming a kind of short-sleeved vest, under which the shirt puffed out. As for the breeches, they were progressively replaced by the Rhinegraves or petticoat-breeches, so ample that it became hard to see the separation between the two legs, and covered with ribbons called *petite oie* (fig. 71).

This new silhouette, laden with galloons and lace, was transformed again in 1660 with the appearance of the justaucorps in civilian dress (fig. 69). Formerly reserved for military use, it came down to the knee and was split at the back and sides to facilitate horseback riding. The tight

doublet, worn underneath, became known as a vest. Petticoat breeches were slowly replaced by shorter and less ample breeches; wigs made their appearance at the same time, while heels often reached vertiginous heights.

The two silhouettes in fashion during the reign of Louis XIV were therefore quite different from each other. The first was exuberant, heavy with fabric and clusters of ribbons. The line it created on the body was broken by a multitude of bulges. The line of the second silhouette appeared more solemn, due to the heavy, stiff material of the justaucorps. As in the beginning of the reign of Louis XIII, long thin legs in silk stockings contrasted with the mass of the richly adorned torso.

The three essential articles of clothing at the end of the seventeenth century, the justaucorps, vest, and breeches, continued to be in fashion during the reign of Louis XV, from 1715 to 1774, and were influenced by the more relaxed atmosphere prevalent after the death of Louis XIV in 1715. During the regency of Philippe d'Orléans (1715–23), they became less precisely defined (fig. 72). The justaucorps became more ample. The pleats at the hips became wider, "like hoops," to borrow the expression used for women's gowns. The sleeves became wider, ending in

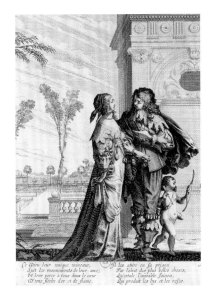
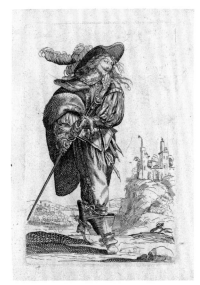

enormous cuffs; the vest was cut longer and its sleeves protruded a little under the justaucorps. Heels became lower, and the imposing wigs of the end of the century were replaced, as of 1730, with the Louis XV wig, which was much smaller. Only the breeches did not change. Then around 1750, this silhouette diminished in size. The jus-taucorps lost volume, with the sleeves modified accordingly, and the front panels cut away toward the back. The vest also shrank to match the whole and lost its sleeves.

The reign of Louis XVI (1774–92) witnessed further refinement of the silhouette. The skirts of the justaucorps, now called a *habit*, became angled toward the back, and the pleats at the hips were eliminated (figs. 74–78). The vest became a waist-coat, short and without sleeves. The silhouette of the head remained small with less coiffing, and wigs were worn with the hair pulled back. New coats appeared, inspired by English fashions, such as the frock coat and the dress coat. The silhouette of the last part of the century was very narrow. The skirts of the coat, angled farther and farther back, exposed the chest and arched the back. The body took on an S-curved shape, puffed out in front when seen in profile. Head-on, a man looked very slender, with tiny hips and shoulders. His legs remained the least voluminous part of his body, as had been the case for more than two centuries, with breeches so tight his body looked all the more narrow.

CLOTHING THAT MODIFIES THE SHAPE

Clothing played an important role in the creation of the silhouette. It could create new shapes to enhance the body. Padding, in particular, made it possible to change its form. At the beginning of the reign of Louis XIII the doublet, which was very rigid, came to a point in front, suggesting comparison with a breastplate.[3] This rigid effect was most often created by the insertion, in the lining, of two or four triangular pieces of cardboard,[4] placed on either side of the central opening of the pourpoint, at stomach level.[5] The reinforcing triangles could also be made of several layers of linen glued together,[6] or heavy fabric reinforced with whalebones. The doublet was padded at the shoulders and around the armholes. The breeches were sometimes padded around the thighs.[7] Added to the lining, they made the breeches quite ample. Trunk-hose owed their puffiness to horsehair padding.[8]

During the 1630s less padding was employed, making the silhouette slimmer. Since breeches

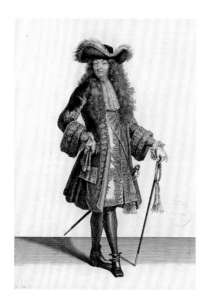

69. Antoine Trouvain,
"*Louis le Grand Roy de France*"
(Louis the great king of France)
Late seventeenth century
Etching
Bibliothèque municipale de
Versailles, Res in fol A 31 m

were less full and longer, they did not require the additional emphasis. The doublet became softer, literally speaking, definitively losing its resemblance to a breastplate.

In the reign of Louis XIV fashions involving padding remained basically unchanged. But during the next reign the use of padding became more pronounced. The large spans of clustering pleats on the justaucorps, for example, were created by the insertion of a small horsehair pillow at the top of the pleat, to exaggerate its volume. The cloth used for the pleats and the front of the justaucorps was often stiff, due to a backing of heavy material that was added to the lining to create the fashionable silhouette. They corresponded to an overall demand, and were added to all outer garments at the time. But other forms of padding were used to camouflage certain physical flaws, helping the silhouette conform to the standards of beauty of the period. The fashionable silhouette could only be constructed on a body through the correction of its defects. François-Alexandre-Pierre de Garsault explained the role of the tailor in making such corrections: "as for physical flaws, his art consists of palliating them by means of backings with linen, wool, or cotton, etc., and for more drastic examples, one

creates a proportionally stiffened case, opened and stuffed with mattress horsehair."[9]

As well as enhancing the torso to create the puffed-out chest sought by courtiers, calves might also be discreetly padded in order to appear shapely when displayed in silk stockings (fig. 163). In the *Dictionnaire critique, pittoresque et sentencieux* (Critical, picturesque, and sententious dictionary) Louis-Antoine de Caraccioli confirms this phenomenon, stating that "fops were not averse to padding when nature had not favored them." Inevitably, documentation is rare, as this sort of padding was a private matter. It was not made to be noticed, unlike the conspicuous horsehair pillows around the hips. Both corrective and decorative padding might be used on the same article of clothing.

The practice of padding continued into the late eighteenth century, under the reign of Louis XVI, as seen in the *habits* now in the Musée des Arts Décoratifs, Paris. In the upper part two types of padding are employed. The first is quite thin and contained by tight rows of quilting. The second is thick, within spaced, quilted bands.[11] These were used to shape the silhouette, while the tighter padding was used to stiffen the silhouette. We can therefore conclude that some padding

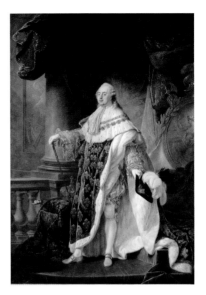

70. Antoine-François Callet,
Louis XVI revêtu du costume royal (Louis XVI in Royal Dress)
1779
Oil on canvas
Châteaux de Versailles et de Trianon, Versailles, MV 3890

was used to amplify the silhouette, accentuating the importance of the torso, while some simply stiffened the fabric to give it a better shape.

Padding had different functions, different ways of being used, but it was not the only means of modifying the silhouette with clothing. A garment could bypass padding to transform the silhouette by itself taking on shapes distinct from the natural lines of the body; in fact the cut of the material was even more effective in this respect. The coronation robe is the most striking example of an independent garment that created new lines around the body.[12] Under its heavy traditional mantle, only the sleeves heavy with lace and the legs sheathed in white silk stockings peep out; they alone find the means of being seen (fig. 70). But in reality the splendor of the garment obliterates the body, which functions only as support for the fabric, with no regard for the natural lines and contours of its silhouette.

Other garments worn more frequently at court similarly modified the silhouette. Thus the ample cut of the knee-breeches and the cloak thrown across the chest created the heavily laden look of the second Louis XIII silhouette. There was no need, moreover, for additional padding to expand and obscure the Louis XIV

silhouette. The body was camouflaged by an accumulation of accessories and ample fabrics. Wigs became gigantic, shirts puffed out, the petticoat breeches were so large as to hide the space between the legs; all conspired to dissimulate the lines of the body, to negate a man's real silhouette, recreating another, completely artificial one.

Under Louis XV, the large wigs and hips continued this modification of a man's natural silhouette. At the end of his reign, and under that of Louis XVI, clothing seems to have been more fitted to the body rather than transforming it to suit fashion's fancy. Padding was used to hide certain flaws by giving the coat more or less the shape it would have on a "perfect" body. We see here a reconstruction on the body, used as a basis with which to elaborate a new silhouette; far from dissimulating the body, padding embellishes it, making it more attractive.

A STUDIED CARRIAGE

In this aristocratic society, where appearance played such a large role, good carriage was of crucial importance in the construction of a silhouette. Deportment was taught at schools by means of dance lessons, equitation, and theater.

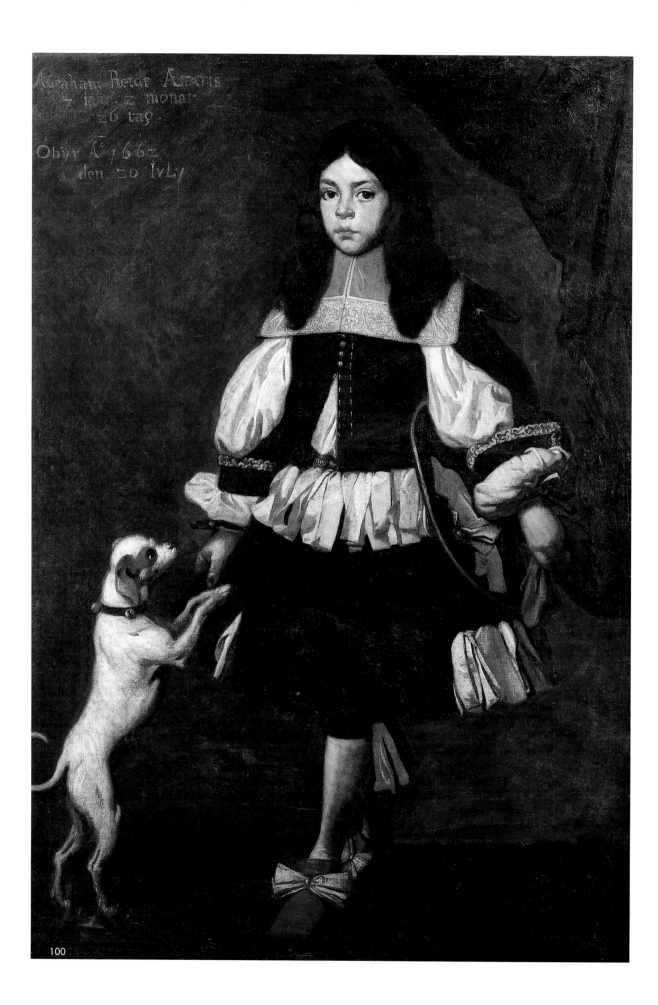

71. Dutch school,
Abraham de Reidt
ca. 1660
Oil on canvas
SVV Thierry de Maigret, Paris,
2009

From the start of the seventeenth century, the Académie royale d'équitation (Royal riding academy) placed great importance on this idea. Founded by Antoine de Pluvinel in 1594, it taught young gentlemen the arts of horsemanship, dance, and fencing. Pluvinel's advice to his students concerned proper apparel as well as a good seat on a horse, two elements that were considered essential in order to make a good impression. He recommended that a horseman should carry himself in the same way as he stands, "with his shoulders forward, his chest even more forward, curving the spine slightly at the waist."[13]

Good carriage was also taught through dance. Instruction was given in various institutions, such as the abbey of Port-Royal des Champs.[14] Its purpose was to transmit elegance and deportment, and some adults took private courses with this objective. Samuel Pepys records his first dance class in his diary on May 4, 1663: "by and by the dancing-master [Mr. Pembleton] came. . . . I did begin, and then was obliged to become his Scholler. The truth is I think it is a thing very useful for any gentleman, and sometimes I may have occasion of using it."[15]

As for the theater, it was formative in the art of attitude and good carriage suitable for the court.[16] Students learned how to develop their voices, gait, expression, and elegant gestures.[17]

Good carriage was part of good breeding, whose rules were outlined in a number of manuals, notably *Les Règles de la bienséance et de la civilité chrétienne* (Rules for good breeding and Christian decency) by Jean-Baptiste de la Salle,[16] which includes detailed entries on how best to respect the rules of good breeding on a daily basis. As evidence of its crucial importance, the first chapter concerns good carriage. One must avoid any sign of affectation or discomfort, hold the body erect, and avoid moving the limbs unnecessarily. Dragging the feet is also discouraged, as is pressing the knees together too tightly, or placing them too far apart. La Salle likewise gives advice on cleanliness and proper attire.

FASHION AND GOOD CARRIAGE, AN UNBREAKABLE BOND

Clothing reinforces good carriage, making it more noticeable by accentuating it, modifying it, or even influencing one's gait. For example, the rigid doublet forced the wearer to hold himself

erect. Through the point formed at the lower abdomen, it placed all the more emphasis on this part of the body; the stomach, as Antoine de Pluvinel notes, was thrust forward when the back was arched.

In the 1680s, heavy, luxurious fabrics crushed the body and forced it to remain static, as dictated by good breeding. The padding of the Louis XV justaucorps accentuated the arching of the back and no longer highlighted the stomach in the silhouette, but rather the buttocks, which were thrust prominently backwards. The role of the coat *habit* in a man's overall carriage becomes further emphasized under Louis XVI. The coat *habit* was indeed very fitted, and the fashionable justaucorps was even tighter. The sleeves, cut high, narrowed the shoulders, forcing them backwards and arching a back already squeezed by the *habit*. Breeches during the reign of Louis XVI played a part in the forced carriage of the body. They became so tight that only limited movements were possible to avoid ripping them. Apparently each morning the count of Guiches's manservant would ask his master if he planned to sit down that day, in order to avoid embarrassment due to an inappropriate pair of breeches.[19]

Shoes also played an important role in one's gait. In the mid-seventeenth century, the eccentricity of fashion required that shoes be worn a lot larger than the size of the foot. This was called *pied de marais* (marsh foot). The philosopher François de La Mothe Le Vayer mocked this fashion in his *Opuscules* in 1643: "There are people in France who find nothing more elegant than a foot of monstrous length, a *pied de marais*, to use their own term."[20]

The fashion for long feet did not last into the second half of the seventeenth century, when fashion tended more toward small feet. Shoes, at any rate, were made without any distinction between left and right: according to François-Alexandre-Pierre de Garsault, which made walking all the more difficult.[21] The massive "boot cuffs" fashionable around 1640 also caused problems: the top of the boot, at the knee, became so wide that it impeded walking and looked inelegant.[22] This new fashion did not last long; it was replaced later in the century by enormous shoe buckles that could deliver a glancing blow to the opposite ankle. The count of Vaublanc gives his impressions on the subject: "Men wore enormous silver buckles, so big that they dragged along the ground on either side, often hurting

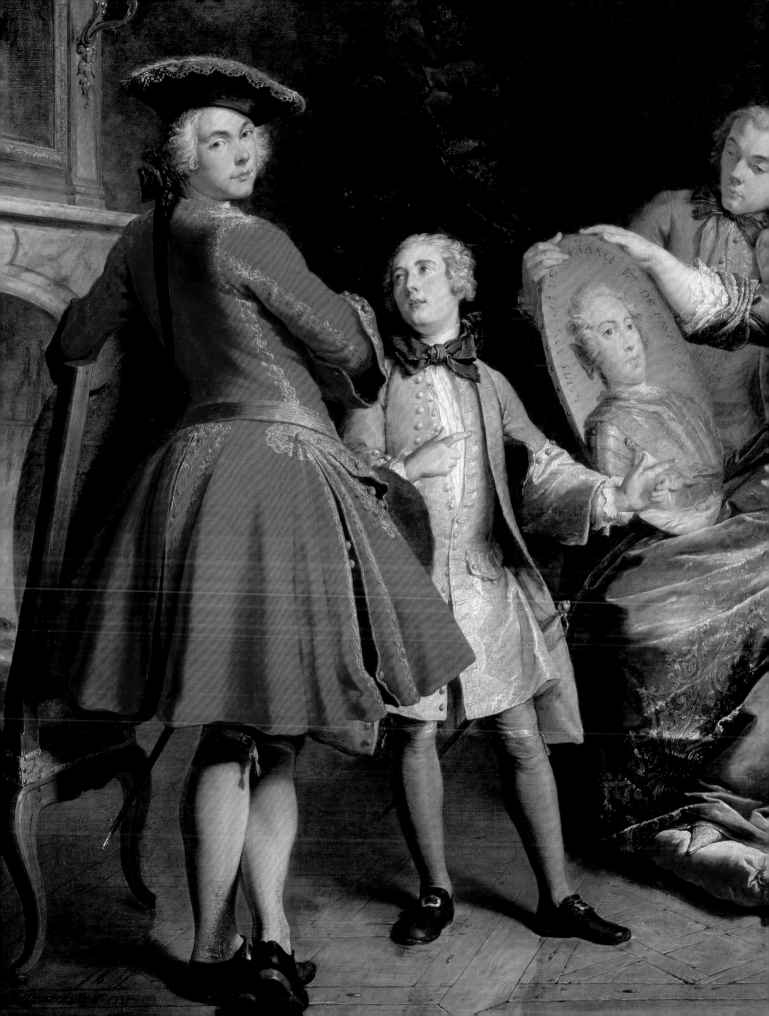

the ankles; and if the blow was violent, it caused real injury. This was often repeated by successive blows, and produced a painful wound."[23]

All of these elements of fashion limited movements, but high heels made walking especially difficult. During the reign of Louis XIV heels reached prodigious heights, up to 10–12cm (3 or 4 in.). Already by 1642, Fitelieu criticized these "heels so high they seem designed to scale the Heavens."[24] Such high heels forced the back to arch even more, tipping the pelvis forward. The buttocks were therefore pushed backwards in order to maintain equilibrium, while the shoulders were thrust back as well. Hence the new dynamic of stability created by the high heels modified the whole carriage, including the gait, as steps became lighter and more delicate. Certain accessories also modified the deportment of the head and body, such as the ruff and other collars in fashion at the time of Louis XIII,[25] or the enormous hats of the same time, for example. The large wigs of the 1680s made a rigid neck and studied movements necessary. Each accessory played its part in creating the fashionable silhouette. The slightest change could alter the balance, either through its shape or the attitudes it imposed.

THE SILHOUETTE, MUCH MORE THAN A MATTER OF FASHION

The efforts devoted to defining the silhouette were proof of its importance at court. Men and women alike were subject to its demands, and all possessed the same tools for abiding by this art of appearance: sumptuous, fashionable clothing, accessories governing one's shape and carriage, as well as the care given to gestures and attitudes. But while the silhouette was principally modified and created through fashion, such was not its sole objective. It was in reality an important element of high-society life.

The main role of the silhouette was to indicate social rank. For members of the aristocracy, fashion was a way of confirming one's nobility. La Bruyère demonstrates this in his *Caractères* (Characters): "There are some places where every person shows himself, and where you will be admitted or refused admittance according as your gold lace is broader or narrower." The aristocratic silhouette was distinguished notably by elegant deportment, which differentiated it from that of peasants. The latter damaged their bodies and health in order to produce the resources required to feed society, while the nobles, who were charged with defending the territory, must

remain supple, powerful, and in good health. It was therefore a matter of natural distinction that evolved from the particular activities of the different social classes. This distinction was nonetheless cultivated and then accentuated in order to represent the various classes. The silhouette was a means by which to demonstrate superiority over the lower social classes; it could also be used to demonstrate superiority over nature itself.

Fashion allowed for the amplification or reduction of certain characteristics, and hence it acquired a reputation among its detractors for being a means to trump nature.[27] Man took his silhouette into his own hands, modeling his appearance according to the desires of the times. The nobleman thereby marked a distinction not only between himself and the workers of the lower classes, but also the limitations of the natural order of things.

The silhouette was a way to integrate oneself into one's social class. It bestowed the air of nobility necessary to court life and enabled one to appear equal to one's neighbor. The padding of garments could hide certain flaws or, more simply, physical defects. The silhouette was therefore used not so much to impress, as to conform to the norms of appearance, creating physical equality within a social class.

The silhouette of the aristocratic man was created for another eye, that of the aristocratic woman. There was no intention to create an abrupt divide between the sexes, as between the noble silhouette and that of the peasant, nor the uniformity one finds among the men at court. Men's and women's fashions evolved differently, but were not independent of one another. Certain similarities existed between them, and an article of clothing designed for one sex could find itself adapted for the other. Various ornaments such as ribbons, long hair, long slender legs, and refined perfumes gave a striking similarity to the two sexes. The silhouette nonetheless made a clear distinction between them and swung between similarities and contrasts. At all times, for example, men's legs were exposed, in clear contrast to the full skirts hiding the legs of their companions. But engravings by Abraham Bosse clearly demonstrate the similarities between the two sexes. In *L'Adolescence*, the lace-covered falling band worn by the young man is echoed in the young woman's shawl, while the rigidity of her torso in a bodice that comes to a point in front mirrors the young man's pourpoint (fig. 67). Under Louis XV,

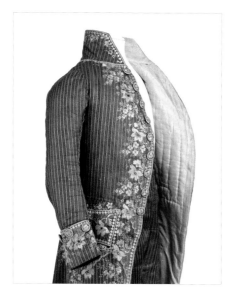 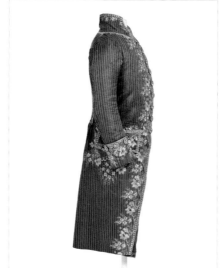

a man's justaucorps, in its width, seems to want to rival the ample form of a woman's pannier. In the second half of his reign, and during the reign of Louis XVI, the narrowness of a man's silhouette contrasts with the extreme width of a woman's ceremonial gown.

While *le grand habit*—or court dress—for women became extraordinarily ample, their day-to-day clothing grew simpler with the *gaulle* or *chemise* dress and the *robes à l'anglaise*. Men's outfits were in far greater harmony with this simple attire.

The silhouette enabled the sexes to be differentiated and clearly distinguished, while it also neatly characterized them as belonging to the same social sphere and class. This indication of social class was perhaps its most important function. All the effort put into modifying and shaping the silhouette was to define this belonging to the aristocracy. It allowed aristocrats to distinguish themselves from the lower classes and to recognize each other, regardless of sex, as equals.

1. The part of the hat that encircles the bottom of the crown and shades the face.

2. From the name of the inventor of this fashion.

3. Maurice Leloir, *Histoire du costume de l'Antiquité à 1914*, vol. 8, *Époque Louis XIII (de 1610 à 1643)* (Paris: Ernst, 1933), 10.

4. Hippolyte Roy, *La Vie, la mode et le costume au XVIIe siècle, époque Louis XIII. Étude sur la cour de Lorraine, établie d'après les mémoires des fournisseurs et artisans* (Paris: E. Champion, 1924), 197. A mourning pourpoint created by the haberdasher Henri Philippe: "Sendal pourpoint, open at the sleeve and behind; lined in Genoese sarcenet; . . . lastly, on the inside, a piece of canvas and two sheets of cardboard; for the price of 50 francs, 5 gros, and 8 deniers."

5. Norah Waugh, *The Cut of Men's Clothes, 1600–1900* (London: Theatre Arts Books, 1964).

6. Janet Arnold, *Patterns of Fashion 3: The Cut and Construction of Clothes for Men and Women c. 1560–1620* (London: Macmillan, 1985).

7. Antoine de Pluvinel, *Le Manège royal* (1623; Paris: Bibliothèque des Introuvables, 2004), 29.

8. Michèle Beaulieu, *Contribution à l'étude de la mode à Paris: Les transformations du costume élégant sous le règne de Louis XIII* (Paris: R. Munier, 1936).

9. François-Alexandre-Pierre de Garsault, "L'Art du tailleur," in *Les Arts du cuir* (Geneva: Slatkine Reprints, 1984).

10. Inv. UF 65-44-7A.

11. Inv. 13630A.

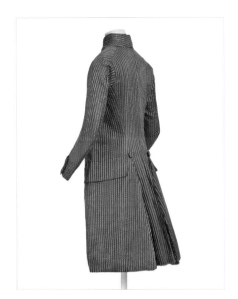

(opposite)
76, 77. Coat
France, ca. 1785–95
Striped silk Pekin, edged and embroidered, lined in silk satin, quilted (detail)
Musée des Arts Décoratifs, Paris, département Mode et Textile, Gift of Félix Doistau, 1907, 13629.AC

(right)
78. Dress-coat
France, ca. 1790
Silk Pekin (gros de Tours and satin), linen lining
Musée des Arts Décoratifs, Paris, collection Union française des arts du costume, purchase, 1975, UF 75.19.7

12. John Carl Flügel, *Le Rêveur nu: de la parure vestimentaire* (1930; Paris: Aubier Montaigne, 1982), 148.

13. Pluvinel, *Le Manège royal*, 38–9.

14. Nicolas Fontaine, *Mémoires pour servir à l'histoire de Port Royal* (Paris, 1726), 2: 481; quoted in Georges Vigarello, *Le Corps redressé: Histoire d'un pouvoir pédagogique* (Paris: Editions Jean-Pierre Delarge, 1978), 53.

15. Samuel Pepys, *Diary*, transcribed by Robert Latham and William Matthews (London: G. Bell and Sons: 1971), 122.

16. Jacques Bénigne Bossuet, *Maximes et réflexions sur la Comédie, 1694–95*, vol. 8, quoted in Georges Snyders, *La Pédagogie en France aux XVIIe siècle et XVIIIe siècles* (Paris: Presses universitaires de France, 1965), 142–43.

17. Jean Croiset, *Heures et règlements pour messieurs les pensionnaires*, quoted in Alain Corbin, Jean-Jacques Courtine, and Georges Vigarello, eds., *Histoire du corps*, vol. 1, *De la Renaissance aux Lumières* (Paris: Le Seuil, 2005), 259.

18. Jean-Baptiste de La Salle, *Les Règles de la bienséance et de la civilité chrétienne, à l'usage des écoles chrétiennes des garcons: Nouvelle édition augmentée des Maximes de la sagesse, de la Profession de foi, des Actes de foi, d'un Abrégé de la grammaire française, et d'une Instruction sur la manière d'écrire les lettres* (Vanne: J.-M. Galles, 1788).

19. Maurice Leloir, *Histoire du costume de l'Antiquité à 1914*, vol. 12, *Époque Louis XVI et Révolution, 1775 à 1795* (Paris: Ernst, 1949), 17: "When having him choose what clothes he wished to wear in the morning, M. de Guiches' valet de chambre would ask him whether he would be sitting or standing; for if, while wearing breeches for standing he tried to sit down, he risked a catastrophe."

20. François de La Mothe Le Vayer, *Opuscules ou petits traictez*, vol. 6, *Des habits, & de leurs modes differentes*; vol. 7, *Du secret, & de la fidelite* (Paris: Sommaville et Courbé, 1643), 252–53.

21. See Maurice Leloir, *Histoire du costume de l'Antiquité à 1914: Époque Louis XV, de 1725 à 1774* (Paris: Ernst, 1938), 11: 23.

22. La Mothe Le Vayer, *Opuscules ou petits traictez*, 255–57.

23. Comte de Vaublanc, *Mémoires de M. le comte de Vaublanc* (Paris: Firmin Didot, 1857), 139.

24. Sieur de Fitelieu, *La Contre-mode de monsieur de Fitelieu, sieur de Rodolphe et du Montour* (Paris: L. de Heuqueville, 1642), 156–57.

25. See "Under the Ruff" by Denis Bruna in this volume: pages 67–69.

26. Jean de La Bruyère, *Les Caractères de Théophraste traduits du grec avec Les Caractères ou les moeurs de ce siècle* (1688; Paris: Garnier-Flammarion, 1965), 278.

27. Fitelieu, *La Contre-mode de monsieur de Fitelieu.*

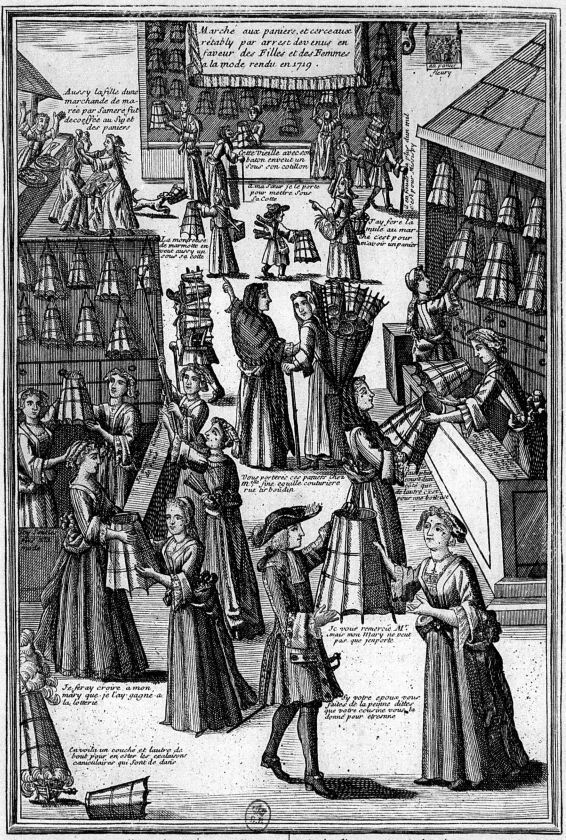

Dans cette estampe l'on fait revivre enfin,
De notre ancien temps, les grands vertus gradin
l'invention n'en n'est elle pas fort jolie
Puis que sous un sy grand cotillon on cache les petits

Laisséz dire vos maris dont les erreurs paniques
Contre vos amoureux leurs font chercher mil rubriques
Cenest que pour rompre par leurs importunitez
Tout ce que pour la galanterie vous avez inventé.

Paris Chez C. Guérard rue de petit pont proche la rue de la huchette à l'image de Notre Dame

Anne-Cécile Moheng

WHALEBONE STAYS AND PANNIERS: THE MECHANICS OF GOOD CARRIAGE IN THE EIGHTEENTH CENTURY

In 1818 Madame de Genlis reported that to be fashionable, an eighteenth-century woman must "squeeze herself excessively into whalebone stays" and "dress herself in a pannier three ells wide, and walk on stilts"; she concludes that "a woman could be attractive these days with less cost and certainly less fuss."[1] While the panniers and whalebone stays were indeed the necessary armatures for the *robes volantes* and later the *robes à la française* worn by high-society women throughout the century, they were not meant simply to make a woman of high birth attractive; they also allowed her to be recognized as such in her mastery of the necessary carriage and gait, which in turn indicated her social status. Panniers and whalebone stays were therefore essential tools in the construction of a fashionable silhouette, but they also confirmed the rank of the woman who wore them.

Our knowledge of these undergarments remains vague on many points, even though they have been well documented and researched and are widely represented in museum collections and constitute the object of numerous pamphlets, satires. and various studies. We must therefore establish a precise chronology and typology of both whalebone stays and panniers—and with that in mind, this text will propose several trains of thought.

DIFFERENT "STAYS IN USE"

"Stays are an article of clothing placed directly over the chemise, enveloping only the torso, from the shoulders to the hips." This is how François-Alexandre-Pierre de Garsault defined whalebone stays in *L'Art du tailleur* (The tailor's art), a work he published in 1769 in his *Description des arts et des métiers* (Description of arts and crafts). This undergarment, which had existed ever since the sixteenth century, was characterized by vertical whaleboning that made it very rigid, accentuated by a busk, a concave plate of metal, horn, or whalebone, inserted across the front and intended to make the torso even more erect (figs. 80, 81). While some authors assert that whalebone stays at some point became widespread throughout society, including country women, it is most likely that during the eighteenth century they were worn only by women of the most affluent classes, as the constriction of the torso was ill-suited to a life involving physical labor.

There is nonetheless a typology of whalebone stays, understood chiefly thanks to Garsault's work, which constitutes an invaluable source for the study of these objects. The author lists the "different stays in use" in his time, set out in minute detail as his work was first and foremost

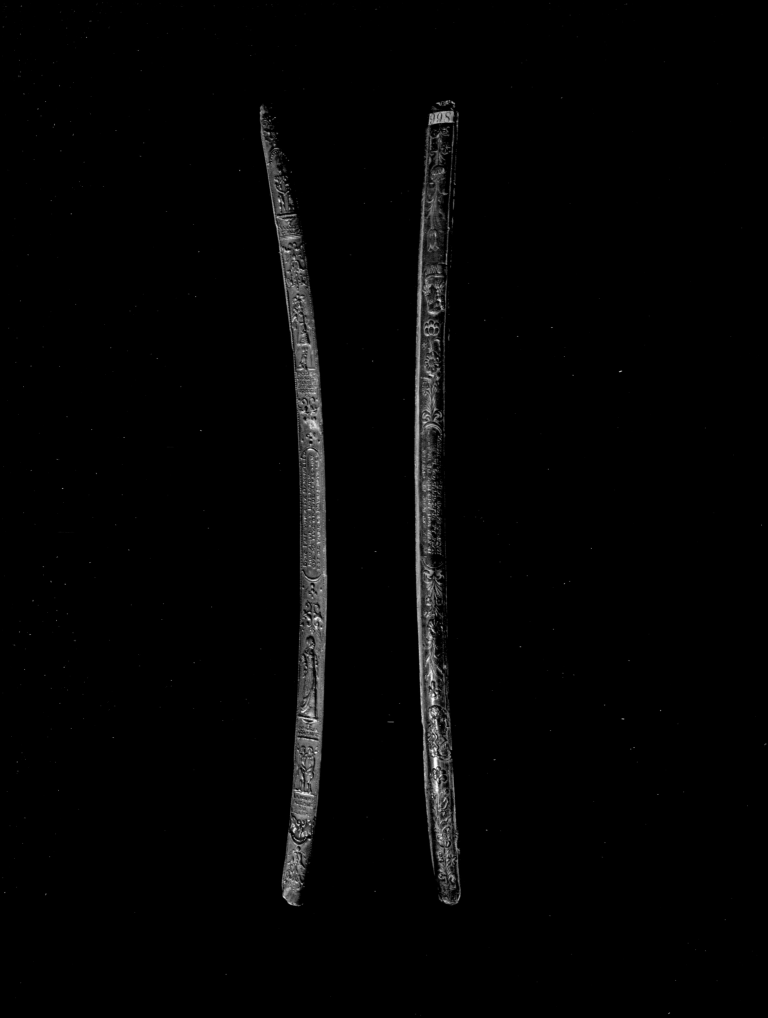

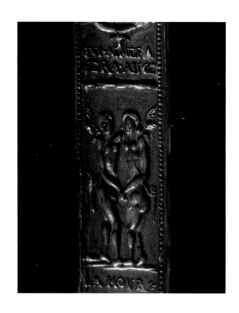

technical. Indeed he was addressing the "tailors of stays for women and children," a category distinct from that of general tailors since 1665, as it entailed "an art that requires great precaution, skill, and precision." Garsault first distinguishes "two types of stays, closed stays and open stays," the former being entirely closed in front, held in place by the busk at the center, while the latter were open and included a busk on either side of the opening. Moreover, *L'Art du tailleur* enables us to identify several types of whalebone stays "currently in use," citing "stays for maternity wear," "for women who ride horses, either for hunting or otherwise," and "stays for court or *grand habit*." This relatively short list suggests that whalebone stays were undergarments reserved for women of the most affluent classes.

The stays for maternity wear were characterized by supplementary lacings on each side, which allowed a woman to "unlace her stays on the sides when laced too tight" (fig. 82). This type of stays, also illustrated in the plates of the *Encyclopédie*, featured whaleboning as tight as in ordinary stays. The Musée Arlaten in Arles holds just such an example of closed whalebone stays equipped with supplementary lateral laces, and all the more interesting because it can be unhooked on either side of the bosom, possibly for the purpose of breastfeeding (fig. 83). This type of adaptation is found on a number of stays in museum collections. One such example in the Musée des Arts Décoratifs in Paris has two cutout flaps on the front that could be opened for the purpose (fig. 85). However detailed, Garsault's work makes no mention of these types of stays. Indeed, the existence of such adaptations might have seemed surprising: breastfeeding was not common among high-society women who might wear whalebone stays; the countess of Genlis confirms that at the time of the birth of her daughter (in 1765), it was more common to place the child with a wet nurse than to nurse one's own child.[2] The need to create two openings to facilitate access to the breasts was dictated by

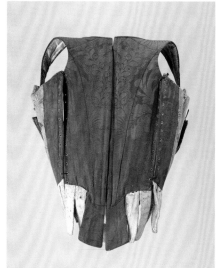

the fitted shape of the front of the stays in the first half of the eighteenth century. An engraving in the *Galerie des modes et costumes français* (Gallery of French fashions and costumes) in 1780 shows a young woman breast-feeding her child,[3] but the fashion of this period, with an even deeper cut-out for the bosom, made such openings unnecessary. "Nursing stays" are therefore to be considered with a certain amount of skepticism.

Conversely, "riding-habit" stays, described in detail by Garsault, remain difficult to identify among the stays that have come down to us: were they an uncommon type, or have all examples of them been lost? Extant stays with the shortened front necessary for the rider's forward tilting posture are rare. Lastly, Garsault describes in his work "stays for court or *grand habit*, worn only by women when they visited the king or queen, etc." These were one element of *grand habit*, a codified outfit including, aside from the stays, the skirt and the train.[4] Courtly formal dress was characterized by a plunging neckline, extending into the widely spread shoulder straps pulled toward the back. The shoulders, thus bared, were more compressed than in ordinary whalebone stays, while the torso was more constrained than ever,

because of the particularly dense whaleboning. The courtly stays that have come down to us are striking in their narrowness, the extreme slenderness of the waists, and the exaggeratedly low cut of the necklines (figs. 88, 89).

THE EVOLUTION OF WHALEBONE STAYS DURING THE EIGHTEENTH CENTURY: AN ATTEMPT AT CHRONOLOGY

While it seems possible to identify a typology of whalebone stays in the eighteenth century, establishing a chronology of these undergarments is more problematic. On the one hand, their shapes remain virtually unchanged over the course of the century: stays do not appear to have been systematically adapted to the shapes of the garments worn over them. The *robe volante* (worn during the first third of the eighteenth century), for example, was worn over whalebone stays even though it was not fitted at the waist, which was hidden by ample folds. Conversely, the *robe à l'anglaise* popular at the end of the century was sometimes worn without stays, although fitted to the torso.

This apparent disassociation between the overgarment and the whalebone stays leads us to attempt to establish a chronology of the latter

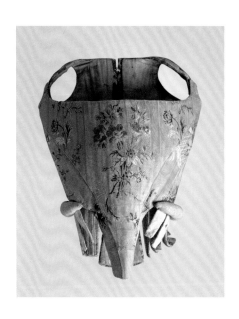

(right)
84. Whalebone stays
France, ca. 1750–60
Bullioned, figured, brocaded
silk; taffeta chiné à la branche;
whalebone, linen lining
Museon Arlaten, Musée
départemental d'ethnogra-
phie, Arles, 2002.0.36

(p. 114)
85. Whalebone stays for nursing
France, ca. 1750–70
Silk faille damask, metal demi-
hoop, leather, lined in linen
Musée des Arts Décoratifs, Paris,
collection Union française des
arts du costume, Gift of Lucien
Libron, 1970, UF 70.52.3

(p. 115)
86. Whalebone stays
Italy(?), ca. 1740–60
Silk taffeta, metal demi-hoop
whalebone stays, linen lining
Musée des Arts Décoratifs, Paris,
collection Union française des
arts du costume, Gift of Lucien
Libron, 1970, UF 70.52.4

based on the techniques of construction. *L'Art du tailleur* (The art of the tailor), published in 1769, notes that stays of the time were "cut from just six pieces, including the shoulder straps," while "formerly it was made from ten pieces, count-ing the shoulder straps as two." Norah Waugh has suggested that tailors simplified the mode of fabrication of stays in the second half of the eighteenth century by improving the position-ing of the whalebones and thereby decreasing their number.[5] (fig. 87). Another technical innova-tion, "shaping baleens," provide a further key to dating them: two (or sometimes more) curved pieces—most often made of metal—were placed horizontally across the front of the stays in order to keep the rounded form and to give more full-ness to the bust. It is likely that this evolution during the second half of the century followed the fashion for increasingly ample bust lines, accentuated by low-cut necklines pushing up the breasts.

In 1775, *Lady's Magazine* reported that stays were "quite low before, and the bosom much exposed"; in 1776, they are again "exceedingly low." This fashion continued; in 1793 the *Times* noted that "the fashion of dressing, at present, is to appear 'prominent,' and the stays are made

accordingly." And the *Morning Herald* confirmed that in the 1790s, "the bosom, which Nature planted at the bottom of her chest, is pushed up by means of means of wadding and whalebone."

Indeed, among the whalebone stays found in various collections, some have a broadened neckline, whose shape is rounded to the point of creating a sort of basin corresponding to the "pigeon breast" in vogue during the last quarter of the eighteenth century[7] (fig. 57). This would explain the presence of two pockets sewn into the front lining of some whalebone stays, per-haps intended to hold padding, further lifting up the bosom (figs. 86,90). Other examples have only one central pocket, whose function is less clear—perhaps allowing for small bouquets of flowers to be stuck into the plunging neckline, as one sometimes sees in portraits. Garsault's work does not mention this type of adaptation, which was possibly added by women themselves, according to the ways in which they used their stays.

These types of stays appear to have been an individual choice, another difficulty that needs to be kept in mind when dating them. Aileen Ribeiro has suggested that social class as well as cus-tom determined the type of neckline worn.[8] The

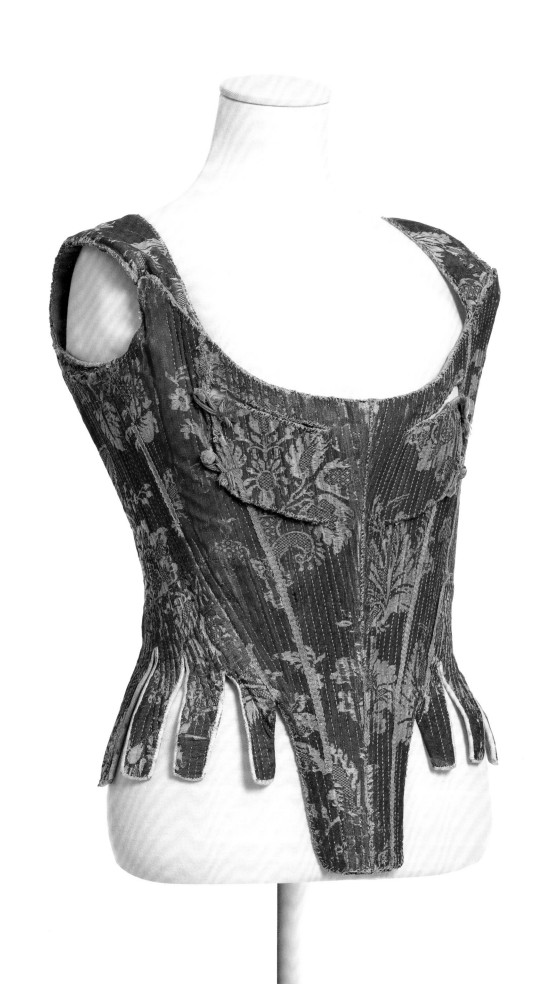

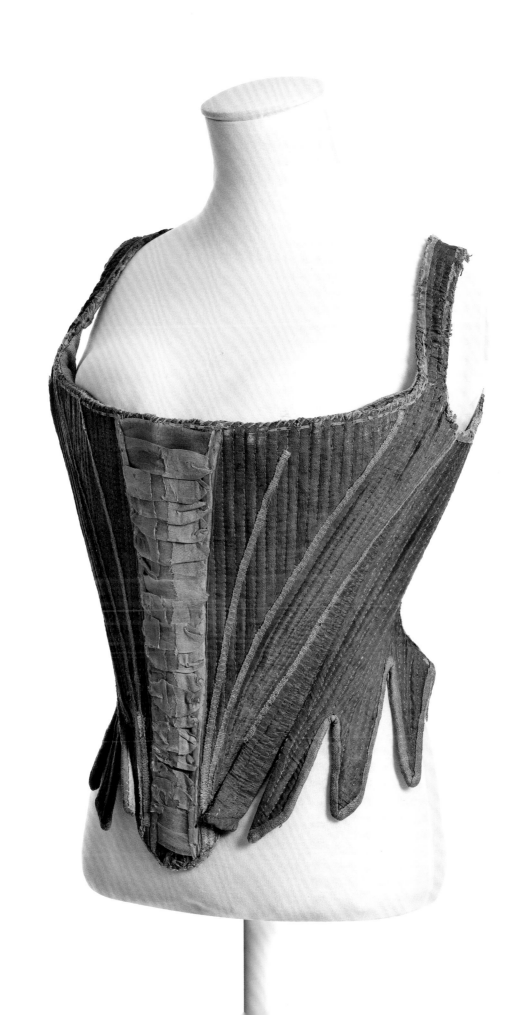

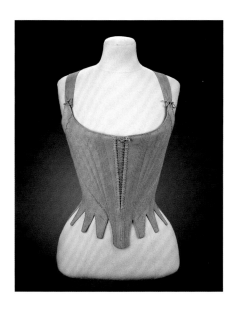

example of la présidente de Tourvel is illuminating in this regard; she is described in *Les Liaisons dangereuses* (1782) as wearing "her bodice up to her chin," to emphasize, apparently, her devout nature.[9] In *Julie, ou la Nouvelle Héloïse* (1756–58), Saint-Preux notes that Parisian women "know that the notions of decency and modesty are deeply etched into the minds of the people. ... They saw that an uncovered bust is a scandal to the public; they have considerably lowered their necklines."[10] Whalebone stays with a plunging neckline were a fashion limited to high society, setting the wearer apart from the more austere bourgeoisie.

"CETTE BIZARRE MACHINE, QU'ON A TRÈS-BIEN NOMMÉE *PANIER*"[11]

The same difficulty necessitates a nuanced approach to the study of panniers in the eighteenth century, whether we are defining a typology or establishing a chronology. Contemporary pamphlets, satires, and prints mocking or denouncing the fashion complicate the issue even further due to their sheer number, their often fantastical nature, and the distorted images they present. This compounds the problem, given that there is no technical manual for the fabrication of panniers similar to Garsault's work on whalebone stays.

While the literature and plentiful iconography produced during the century suggests that "not even a servant girl would scurry to the marketplace without her pannier,"[12] it is most likely that this type of undergarment, like whalebone stays, was not worn either in the countryside or by the less privileged classes. It is nevertheless probable that the pannier worn by a bourgeois woman was different from that worn by an aristocrat, who certainly would have owned many types of panniers, whose shape and volume would have varied according to her various occupations and the time of day. This is hinted at by the character of Harlequin in *Les Paniers, ou les vieilles Précieuses* (Panniers or old *precieuses*) (1724): "I have hampers, hoops, panniers, flounces, criardes, quilted paddings. ... And I have every sort, *à l'anglaise, à la française, à l'espagnole, à l'italienne*. I make barrel hoops for plump waists, 'hampers' for slim waists, and 'lantern shapes' for the flatter type of Venus lacking 'posterior cushioning'."[13] While the poetic license here exaggerates the variety of panniers worn, it does seem as if the typology was diverse. Even the *Encyclopédie* echoes this breadth by making a

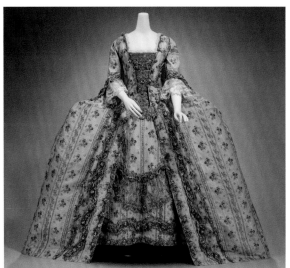

distinction between a pannier and a "jansenist," the latter being "a small hoop used by modest women" and hence the name "jansenist."[14]

Other contemporary sources differentiate what was known as a *considération*; the countess of Genlis in this light notes that "the small pannier one puts on in the morning" is called "a *consideration*." A happy medium between ceremonial wear and the decency of the simple *considération*, this pannier with a reduced circumference, in which a woman could "go here and there where respect is not an issue,"[15] is abundantly cited in inventories,[16] although its actual shape remains imprecise. Defined as "small armrests or truncated panniers that do not go all the way around the hips, but merely make them three or four times wider than nature makes them in her most ample structures,"[17] these *considérations* were perhaps themselves akin to the small panniers, both round and flat, now found in some museum collections (fig. 91).

For a grand ceremony, a "grand pannier"[18] was obligatory and more easily recognizable (fig. 93). Its fullness certainly was conspicuous: the skirt of a formal court gown required 22 ells of fabric, or about 25m (82 ft.). This type of pannier was worn by ladies of the court and Louis XV's daughters, when they were present for the ceremony of "removing the king's boots," for which they "wore enormous panniers holding up skirts bedecked with gold and embroideries."

Although many types of panniers existed at the same time, it is nonetheless possible to establish a plausible chronology, as the panniers were necessarily adapted to the shape of the dresses they supported. In the first decades of the eighteenth century, the still narrow skirt was worn over a conical pannier, an underskirt made out of cloth shaped by hoops (fig. 79). With the emergence and development of *robes volantes*, women wore "very large panniers,"[20] whose hemispheric shape became progressively modified (fig. 92). "Made as a skirt, of heavy unbleached taffeta , to which whalebone hoops were attached,"[21] the pannier presented a variety of effects during the first third of the eighteenth century. As *Le Mercure de France* notes in March 1729, "the pannier of today is very wide at the top, while last year's model was very wide at the bottom."

Indeed, the progressive transformation of the *robe volante* into the *robe à la française* (which appeared around 1740) necessitated a flattening of the front and back of the pannier, so

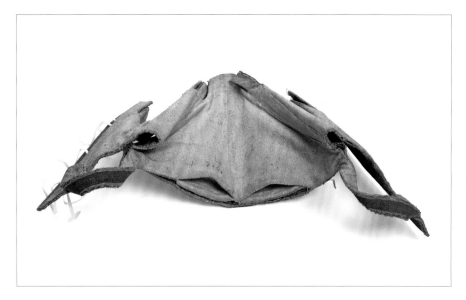

90. The inside of whalebone stays, showing pockets Italy(?), ca. 1740–60
Silk taffeta, metal demi-hoop, whalebone stays, linen lining
Musée des Arts Décoratifs, Paris, collection Union française des arts du costume, Gift of Lucien Libron, 1970, UF 70-52-4

that the folds that fall from the shoulders across the back lie harmoniously flat down to the hem. As the width of the dress was henceforth shifted to the hips, the pannier became shorter and then split in two around the middle of the century, adopting the shape of two whaleboned sacks tied around the waist, known as pocket hoops in England (fig. 57). The *robe à la française* was used as a ceremonial gown up until the Revolution, and etiquette required a woman to have a pannier of this type in her wardrobe until the end of the century, as is indicated by a precisely dated pannier from 1778, now in the Victoria and Albert Museum.[22]

Lastly, there exist today a few examples of a particular type of pannier that seems to have made its appearance during the second half or the last third of the century. It consists of a steel armature attached to the waist by ribbons, and fitted on the sides with hoops articulated by means of a system of hinges: this mechanism allowed for the raising up of the sides of the armature in order to be able to walk through doors or sit more comfortably in a carriage. Oblong and very narrow in shape, these cages were most likely worn under *robes à la française* (fig. 94).

THE RECREATION OF A WOMAN'S BODY: TOWARD AN ABSTRACTED SILHOUETTE

The figure of a woman of means wearing whalebone stays and a pannier was created almost entirely by her undergarments. Naturally, these items contributed first and foremost to shaping the silhouette according to the norms of beauty of the day: a slender waist and "a high and well-rounded bosom"[23] being two essential features. But these undergarments were also conceived in such a way as to entirely reconfigure a woman's body, by proposing contours that could be qualified as abstract in the extent to which they erased her natural forms. Whalebone stays and panniers in the eighteenth century are characterized by their clean, almost geometric lines. Whalebone stays are, in particular, a far cry from the "morphological" shape of nineteenth-century corsets. The natural fullness and hollows of the body, the rounded lines of its curves, are not taken into account in the construction of eighteenth-century undergarments, which efface the natural volumes of the body, molding it instead into a shape that can be characterized as artificial in its apparent absence of reference to the real body it conceals.

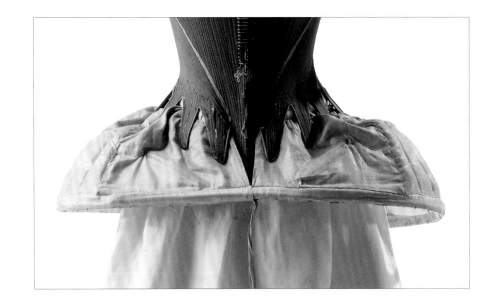

91. Small pannier
ca. 1775
Polished cotton, rattan,
padding
Collection of the Kyoto
Costume Institute, Kyoto
AC 7682 93 1-4

Garsault goes so far as to qualify whalebone stays as "civilian armor," explaining that "they must not bend, yet nonetheless have enough give to lend themselves to the movements of the body they enclose, without losing shape."[24] The majority of the stays that have survived in fact have preserved a rounded appearance, obtained by the careful positioning of the horizontal shaping baleens as well as the vertical ones. At the front of closed stays, the busk formed a ridge reminiscent of those found on a cuirass, worked in such a way as to trace a curve; this essential piece in the shaping of the body made it appear convex. No apparent care was taken to recreate the natural curves of the waist, breasts, and belly. Moreover, the whalebones were ironed inside out . . . both to give unity and to create the required shape and form."[25] In this way, rather than remodel the bosom in order to suggest embellished contours, the whalebone stays aimed to conceal "the delightful curve that appears under a naturally raised bust"[26]; "a smooth and polished structure with no natural lines whatsoever," and "a massive and closed breast-plate."[27] Eighteenth-century stays aspired less to naturalness than to the reinvention of a woman's silhouette.

Whalebone stays were an essential element for the correct fit of the garment that was worn over them. The latter was not conceived in terms of the natural lines of the body, but rather in terms of the shape of the undergarment, which constituted the armature over which it was spread. Whalebone stays were endowed with "aglets or laces on the sides with which to attach the skirt," and sometimes "two hooks on the front and as many on the back with which to busk the skirts, meaning to fix them lower in the front and back than on the sides, in order to emphasize the waist"[28] (fig. 84). Furthermore, wearing a pannier was made necessary by the shape of the *robe à la française*, whose ample folds needed to be able to unfurl properly down the back. Hence women who abandoned the pannier in the 1750s were confronted with the problem of surplus material without means of support: Mrs Delany remarked in 1754 that Lady Coventry wore "a black silk sack made for a large hoop, which she wore without any, and it trailed a yard on the ground."[29] The portrait of Lady Alston by Thomas Gainsborough in the Louvre also illustrates this delicate problem, which he resolved in this case by draping a panel of her skirts under her arm.[30]

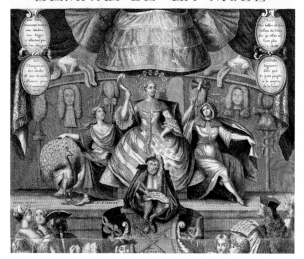

Whalebone stays and panniers were there-
fore means of effacing a woman's natural shape
and remolding it into a fashionable body entirely
distinct from natural forms and anatomical
curves. "Everyday beauty is not yet that of the
body's natural lines,"[31] and this was all the more
evident in the fact that eighteenth-century fash-
ion constrained a body's movement as well.

PROPER CARRIAGE IN THE EIGHTEENTH CENTURY: THE CHALLENGE OF DISTINCTION

Up until the last third of the century, undergar-
ments made a woman's body into "a framework
upon which the fabric determines another struc-
ture: a fantasy body that speaks in the place of
the real body, endowing it with other accents."[32]
Clothing was capable of exerting a permanent
constraint over the body by imposing a carriage
and gait peculiar to the eighteenth-century sil-
houette. Wearing whalebone stays first and fore-
most constrained the posture; throughout the
course of the century it included a high, straight
back, with straps behind the shoulders that were
intended to narrow and flatten the back. Designed
in such as way so as not to bend, they made the
wearer squeeze her shoulder blades together,
"forcing her to twist the shoulders back," thereby
"crossing the shoulder-blades one on top of the
other to such an extent that one could put two
fingers into the hollow they formed along the
spine."[33] The countess of Genlis reports that the
stays "expanded chests prodigiously by keeping
the shoulders back."[34] Furthermore, the busk con-
tributed to the rigidity of the carriage; women
were "truly straight-laced when wearing them,
and one could almost imagine them as plumb
lines with which to trace a vertical line."[35] The rod
that descended below the waist prevented the
bending of the upper part of the body, maintain-
ing a rigorously straight posture, captured in the
portraits of the time.

"Have you noticed, Milord, the young automa-
tons strolling in the public gardens, whose mus-
cles are already sheathed in whalebone breast-
plates, and who, oppressively bound by their
uncomfortable attire, still confer the elastic move-
ment of a bouncy step to panniers much bigger
than they are?"[36] The gait wittily described by
this observer in 1778 was considered typical at
this time—due as much to the wearing of whale-
bone stays as the pannier, and to the shape of
the shoes in fashion at the time, whose heels
were so high that they forced women "to thrust
their bodies backwards in an attempt to keep

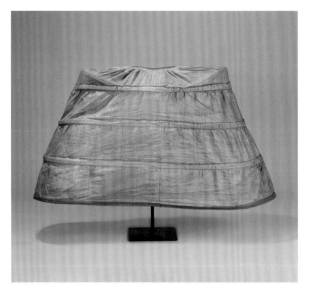
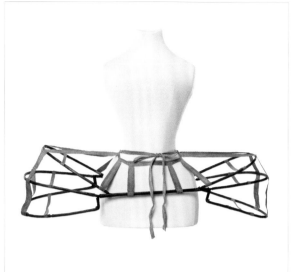

their balance in struggling against the natural inclination that propelled them forward."[37]

Fashion periodicals of the last quarter of the eighteenth century also suggest the decline of the incommodious whalebone stays and panniers by highlighting the ease and lightness afforded by the more flexible fashion "where amiable freedom, sweet abandon, and increased ease reigned."[38] "One felt how ridiculous it was, under the pretext of ornamenting Nature, to stifle her, so to speak, under garments frankly pompous and overwhelming by their weight, shape, and ligaments. All discomfort was banished . . . and French women, free beneath their garments, recovered at last an ease no less necessary to good health as it was favorable to the development of beauty."[39]

To walk with ease was therefore a skill that an elegant eighteenth-century woman was required to master. This entailed, on the one hand, keeping her balance, and, on the other, avoiding the nasty pitfalls dutifully noted by various writers, all the while demonstrating that she belonged to the upper classes. A woman's carriage was a science of distinction, giving the impression that "the shackles on the body were not binding, that the forms brutally pasted to her body were fitted to her contours and extended them without discomfort."[40] As the countess of Genlis underlines, this art of bearing was not innate: "I was quite surprised when I was told that I was to be given a master to teach me what I thought I knew perfectly well—how to walk." It was from the most tender age, "when the body still possesses the flexibility of childhood," that the training began. And the countess of Genlis recounts, "I was given whalebone stays that squeezed me excessively . . . and for the first time I was made to wear a pannier; and to rid me of my provincial airs, I was given an iron collar"[41]; she was around six years old at the time. To maintain an elegant and graceful gait, though constrained by uncomfortable undergarments, was thus the distinctive mark of a well-born woman who had received a refined education. La présidente de Tourvel, who was not from the higher echelons of the aristocracy, apparently suffered from her modest birth, since in passing the collection plate at church, she was "always teetering with her pannier four ells wide forever on someone's head." Eighteenth-century whalebone stays and panniers were complex things in many regards: they were essential accessories to the construction of a fashionable silhouette, and they imposed a gait

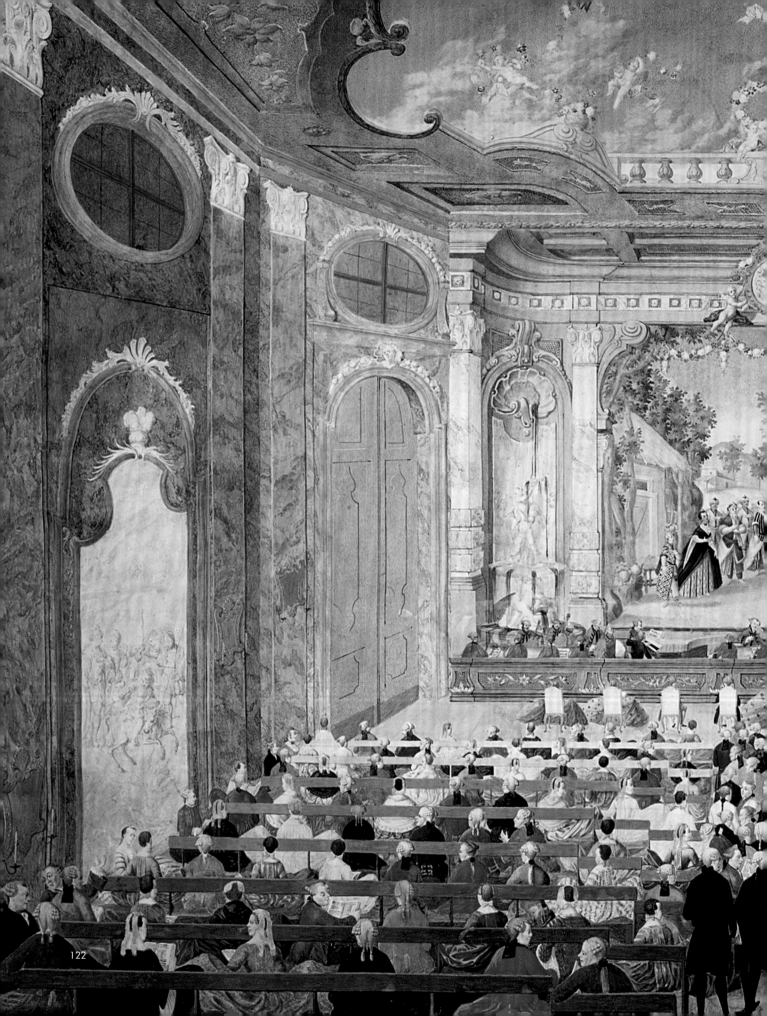

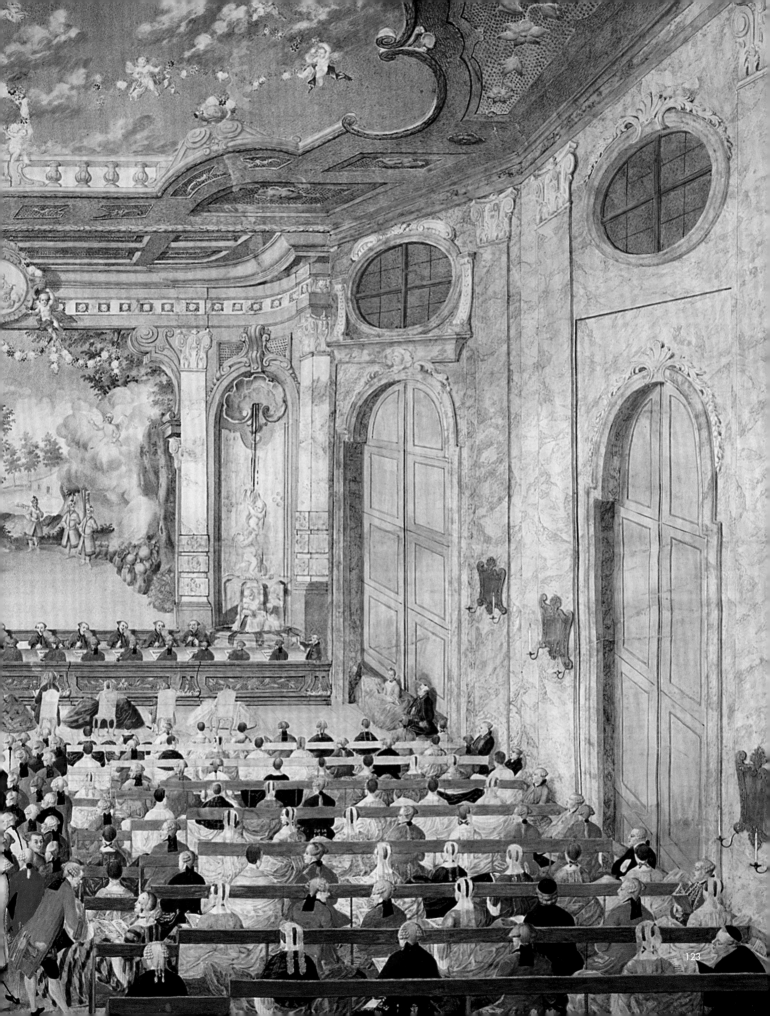

A Modern Venus,

or a Lady of the PRESENT Fashion in the state of Nature, 1786.

This is the Form, if we believe the Fair,

Of which our Ladies are, or wish they were.

Published as the Act directs by E. Yardley, New Inn Passage, Clare Market.

and bearing that were of essential importance in ancien régime society.

The privileged classes thus consciously played up the particular distinction conferred by the mastering of such demanding undergarments, and in this regard it is not surprising that the French Revolution at the end of the century sought to renovate French attire, declaring that "our clothing is made of iron, and represents the invention of centuries both barbarous and gothic. We must break these fetters if we are to be free and happy."[42]

1. Stéphanie-Félicité Ducrest, comtesse de Genlis, *Dictionnaire critique et raisonné de la cour, des moeurs, et des usages du monde* (Paris: P. Mongie aîné, 1818), 2: 41.

2. Stéphanie-Félicité Ducrest, comtesse de Genlis, *Mémoires inédits de madame la comtesse de Genlis, sur le dix-huitième siècle et la Révolution françoise, depuis 1756 jusqu'à nos jours* (Paris: Ladvocat, 1825), 1: 239.

3. Pierre-Thomas Le Clerc, "Jeune dame se faisant porter son enfant," *Gallerie des modes et costumes français...* (1780).

4. On this point, see the article by Pascale Gorguet-Ballesteros, "Caractériser le costume de cour: propositions," in *Fastes de cour et cérémonies royales: Le costume de cour en Europe 1650–1800*, exh. cat. (Paris: Réunion des musées nationaux, 2009), 54–69.

5. Norah Waugh, *Corsets and Crinolines* (London: B. T. Batsford, 1954; London: Routledge, 1990), part 2, chap. 1, "The stays."

6. Quotations from *Lady's Magazine*, *Times* and *Morning Herald*, cited in Waugh, *Corsets and Crinolines*, 67, 72.

7. See Aileen Ribeiro, *Dress in Eighteenth-Century Europe 1715–1789* (London: B. T. Batsford, 1984), 140, 149–60.

8. Ibid., 118–19.

9. Choderlos de Laclos, *Dangerous Acquaintances*, trans. Richard Aldington (London and New York: George Routledge & Sons, 1924), 72 .

10. Jean-Jacques Rousseau, *Julie, or the New Héloïse* (Lebanon, NH: University Press of New England, 2010), 219.

11. "SUITE des Lettres d'une jeune Etrangère, sur quelques modes et usages de France (Cette Lettre traite de l'origine et des progrès du panier en France)," *Le Mercure de France* (April 1765): 1: 29.

12. "Modes," *Le Mercure de France* (March 1729).

13. Quoted in Waugh, *Corsets and Crinolines*, 56.

14. This is more a question of modesty of manner than of revenue. Thus we read in the October 1730 issue of *Le Mercure de France* that "some very modest ladies, but very few in number, have restricted themselves to skirts padded with horsehair, which do not create much volume."

15. "SUITE des Lettres d'une jeune Etrangère," 33.

16. On this subject, see Aurélie Chatenet-Calyste, "Pour paraître à la cour: les habits de Marie-Fortuné d'Este, princesse de Conti (1731–1803)," *Apparence(s)* [on line], no 4, 2012, Feburary 14, 2012; and Pascale Gorguet-Ballesteros, "Petite etude du grand habit à travers les mémoires quittancés de la comtesse d'Artois, 1773–1780," in Isabelle Paresys and Natacha Coquery, eds., *Se vêtir à la cour en Europe: 1400–1815*, minutes of international conference, Château de Versailles, June 3–5, 2009 (Lille: Villeneuve d'Ascq, 2011), 197–212.

17. "SUITE des Lettres d'une jeune Etrangère," 33.

18. Ibid., 34.

19. Madame Campan, *Mémoires sur la vie privée de Marie-Antoinette reine de France et de Navarre, suivis de souvenirs et anecdotes historiques sur les règnes de Louis XIV, XV et XVI* (Paris: Mongie aîné, 1822), 1: 69.

20. *Le Mercure de France* (February 1726).

21. Ibid. (October 1730).

22. Inv. T.120-1969.

23. Alphonse-Louis-Vincent Leroy, *Recherches sur les habillemens des femmes et des enfans ou Examen de la manière dont il faut vêtir l'un et l'autre sexe* (Paris: Le Boucher, 1772), pt. 2, chap. 3, "De l'origine des corps et de leurs différentes espèces," 184.

24. François-Alexandre-Pierre de Garsault, *Art du tailleur, contenant le tailleur d'habits d'hommes: les culottes de peau; le tailleur de corps de femmes & enfants: la couturière & la marchande de modes* (Paris: Imprimerie L. F. Delatour, 1769), 38.

25. Ibid., 42.

26. Leroy, *Recherches sur les habillemens*, pt. 2, chap. 7: "Combien les corps nuisent à la beauté," 242.

27. Ibid., 241.

28. de Garsault, *Art du tailleur*, 44.

29. Mrs. Delany, *Autobiography and Correspondence of Mary Granville, Mrs. Delany, 1861–1862*, vol. 3, 300–301, quoted in Aileen

Ribeiro, *The Art of Dress: Fashion in England and France, 1750–1820* (New Haven and London: Yale University Press, 1995), 62.

30. Inv. RF1947-1. See Ribeiro, *The Art of Dress*, 62.

31. Georges Vigarello, *Histoire de la beauté: Le corps et l'art d'embellir de la Renaissance à nos jours* (Paris: Le Seuil, 2004), 109.

32. Philippe Perrot, *Le Travail des apparences: le corps féminin, XVIIIe–XIXe siècles* (Paris: Le Seuil, 1984), 74.

33. Leroy, *Recherches sur les habillemens*, pt. 2, chap. 7, 236.

34. Ducrest, *Dictionnaire critique et raisonné de la cour*, 99.

35. Leroy, *Recherches sur les habillemens*, pt. 2, chap. 7, 240.

36. *Le Babillard* 2, no. 38 (July 10, 1778), quoted in Perrot, *Le Travail des apparences*, 83.

37. Comte de Vaublanc, *Souvenirs* (Paris, 1838), quoted in Perrot, *Le Travail des apparences*, 75.

38. *Cabinet des modes* 15 (June 15, 1786), 113–14.

39. *Gallerie des modes et costumes français*, 1779: "Robe à la Levantine garnie en hermine."

40. Perrot, *Le Travail des apparences*, 83.

41. Ducrest, *Mémoires inédits*, vol. 1, 13.

42. B.-C. Faust, *Sur le vêtement libre, unique et national à l'usage des enfants* (Paris, 1792), 1–2, quoted in Perrot, *Le Travail des apparences*, 103.

Anaïs Biernat

WHALEBONE STAYS AND CORSETS FOR CHILDREN FROM THE SEVENTEENTH TO THE NINETEENTH CENTURY

A BODY TO SHAPE, A BEING TO FORM

It seems obvious to us today that children should be dressed in different clothing from their parents. Children's clothes are comfortable, adapted to various activities, and easy to wash. This approach to dressing children is, however, relatively recent. It was not until the twentieth century that children began to wear clothing truly distinct from that of adults. The evolution of dress went hand in hand with a child's status; previously considered "an adult in miniature," children gradually came to be seen as "future adults."

From the seventeenth to the nineteenth century, children wore clothing very similar to their parents, but with reduced proportions (fig. 97). Like their parents, children's bodies were constricted by a hidden frame consisting of whalebone stays or a corset that formed a rigid structure around the torso. At the end of the eighteenth century, however, Jean-Jacques Rousseau and the other authors of the *Encyclopédie* propounded a return to natural forms and the shedding of the whalebone stays. This rejection of an overly constrained body was expressed in the silhouette for children as well as adults: revolutionary and Empire fashions were characterized by their fluid lines and much less constraint.

Although a shaped body came back into fashion in the 1830s and 1840s with the appearance of the corset, for children it would appear that Jean-Jacques Rousseau's theories on "natural" education continued to hold some weight.[1] This is seen in the appearance of stomach bands, a type of bodice made of thick cloth, while corsets for children in the nineteenth century were less constricting than the whalebone stays of the preceding century (figs. 99–101). However criticized, the wearing of stomach bands and corsets remained the norm up until the First World War.

THE CHILD: A FRAGILE AND MOLDABLE BEING

Making a child wear whalebone stays or a corset was evidence, in the context of the times, of the care lavished upon him or her. The infant was considered to be weak, fragile, and incomplete. "Childhood is the life of a beast," wrote Bossuet in the seventeenth century,[2] and to make him into a human being required several steps. The molding of the body began at birth, with the head and nose shaped by the midwife. Once the body was shaped, it was necessary to maintain it and support it as it grew. Hence the baby was swaddled, bound in cloth and swaddling bands from head to toe, including the arms, and then, "to give more consistency to the whole, one tied the child and

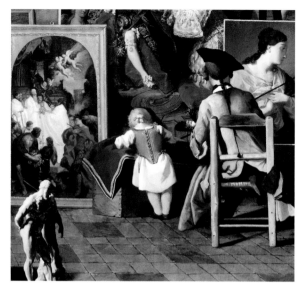

his swaddling clothes with strips of cloth, which one was careful to make as tight as possible."[3] He or she was then placed in a narrow cradle. The aim of swaddling, which was employed until the baby was around six months old, was two-fold: to keep the infant warm, and to encourage him or her to "grow straight." The ultimate aim was the erect posture that distinguishes man from beast. To achieve this it was considered necessary to support the child's body. In 1694, Francois Mauriçeau wrote on this subject in his *Traité des maladies des femmes grosses et celles qui ont accouché* (Treatise on the ailments of pregnant women and those who have already given birth): "[the child] must be swaddled in order to give his small body the erect carriage most decent and most appropriate for a man; for otherwise he might walk on all fours, like an animal."[4]

This attention given to the erectness of the body continued after the suppression of swaddling. As the infant mastered the art of standing up, learned how to walk, the work on good carriage continued, remaining a concern throughout adulthood. The whalebone stays of the seventeenth and eighteenth centuries, followed by the stomach bands and the corsets of the nineteenth century, accompanied the child's training by assuming a support function.

THE WHALEBONE STAYS AND THE CORSET IN THE SERVICE OF ORTHOPEDICS

"The corset, an unusual type of garment, or more of an undergarment, has all the characteristics of an orthopedic device."[5] The first aim of the child's whalebone stays and corset was not, therefore, the construction of an aesthetically pleasing silhouette. In childhood the role was first and foremost functional and could be compared to preventive orthopedics. Furthermore they kept the child warm and facilitated the fastening of the skirts or stockings. Several corsets or stomach bands that have come down to us have small buttons on the front or sides, intended for this use.

Functionality trumped aesthetics: most whalebone stays and corsets were made of modest fabric, undyed linen or cotton. Color and ornamentation seemed superfluous as these garments were not seen, worn over the shift and under the dress. This layering is visible in a painting by Pierre Subleyras, *L'Atelier du peintre* (The artist's studio), now in the Gemäldegalerie in Vienna, one of the rare visual examples of whalebone

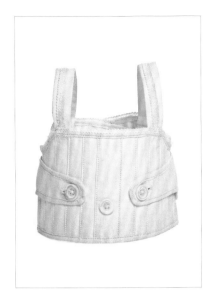
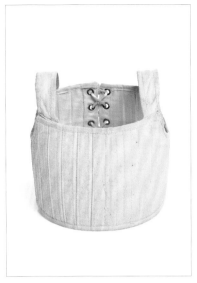
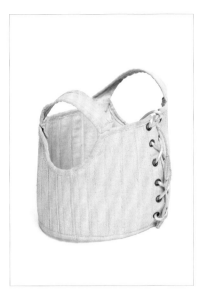

stays worn by a child (fig. 98). Sometimes the whalebone stays and the outer garment were combined in a single piece, the whalebone bodice. In this case the visible parts were made out of a more costly and ornamented fabric, seen in a Provençale bodice dated between 1750 and 1760, now in the Musée Arlaten in Arles (fig. 102).

After their swaddling clothes, boys and girls alike wore dresses over whalebone stays or a corset. One such corset dating from around 1770–90, now in the Philadelphia Museum of Art, was, for example, intended for a child of about eighteen months or two years of age. In the nineteenth century the wearing of corsets was sometimes replaced by that of the stomach band for very young children. Nonetheless, catalogues from department stores, which developed during the second half of the nineteenth century, are filled with corset models for young children (fig. 104). From around the age of six, a distinction took place: little girls continued to wear whalebone stays and corsets, while little boys gave them up. Corsets for girls slowly evolved into the corsets they would wear as adults. Young girls were thought to be still at risk of deformation, as indicated by Doctor Collineau at the end of the nineteenth century: "At a certain moment

during adolescence, a young girl lacks support and closes in on herself, rounding her shoulders forward, letting her shoulder blades thrust back, keeping her spine perpetually curved to one side or the other."[6]

BALEENS, REINFORCEMENTS, LACINGS, AND STRAPS: SUPPORTING A CHILD'S BODY

Over the course of the three centuries covered by this chapter, many means were used to support a child's body: elements inserted into the fabric, heavy fabric, special kinds of weaving, or the cut of the garments.

Baleens were the symbol par excellence of the restrictiveness of the whalebone stays and the corset. Whalebone stays worn by children in the eighteenth century were extremely rigid. The whalebones were separated from each other by simple stitching, with no spacing between them, until the stays formed a cylindrical shell. This rigidity is visible in the paintings of the time, as in the *Portrait de Catherine Coustard, marquise de Castelnau avec son fils Léonor* (portrait of Catherine Coustard, marquise of Castelnau with her son Léonor), painted around 1699 by Nicolas de Largillière.[7] This painting also shows the similarity between the silhouette of the mother

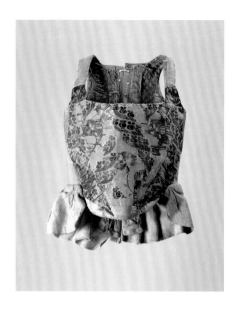

(left)
102. Whalebone stays for a girl
France, ca. 1750-60
Figured silk taffeta, quilted on
cotton batting, polished cotton
lining
Museon Arlaten, musée dépar-
temental d'ethnographie, Arles
2007.15.8

(opposite)
103. Whalebone stays for a
boy, five to seven years old
worn by Francis Harmer, born
in 1725
England, ca. 1730-32
Wool serge, whalebone, lining
of printed, polished cotton
Manchester City Galleries,
Manchester M6821

and her son. Nonetheless, we should note that the whalebone stays for children show certain adaptations compared to those for women: they were generally shorter, had no busks, and sometimes had triangular pieces added to the sides for greater ease of movement. In the case of whalebone bodices, in which the whalebone stays were combined with the outer garment, there was no less constraint. The bodice worn by Francis Harmer around 1730-32, now in the Gallery of Costume in Manchester Art Gallery, includes many whalebones even in the tassets.

In the nineteenth century, corsets had baleens, but the restriction was of a different order. Fewer baleens were used, and corsets made for children had, for the most part, two baleens at the front, on either side of the buttons or hooks, as well as two at the back, on either side of the lacings. Although reduced in number, they bothered the child if he or she did not hold himself or herself erect, thus encouraging good posture. Some models were even more restrictive, notably those intended for adolescent girls, with as many as ten or twenty baleens.

Baleens were not, however, the sole means of restriction and support. Stomach bands were not boned and yet operated on the same principle.

They were a kind of band of cloth enveloping the child's torso, an extension of the swaddling clothes, used to warm and reinforce the body. They were therefore made of sturdy material first and foremost, such as cotton or linen cloth. Quilting, stitching, or even ribbons inserted into the fabric in some cases were used as reinforcement. Sometimes the whalebone bodices were reinforced by various means. Such is the case with two bodices from the eighteenth century now in the Musée des Arts Décoratifs in Paris. One is reinforced with cardboard, and the other with cloth stiffened with glue, inserted in both cases between the outer fabric and the lining (figs. 106, 107).

In the nineteenth century support was created through the shape of the corset and its cut. When made to measure, it fitted exactly to the torso and was held in place by straps. Shoulder straps crossed in the back of a corrective corset, dated around 1908 and now in a private collection, gave support to the back and shoulders of the young girl who wore it (fig. 105). The lacings also contributed to the good posture it enforced.

While restrictiveness was not in and of itself the primary objective of the whalebone stays and the corset, it might certainly have been

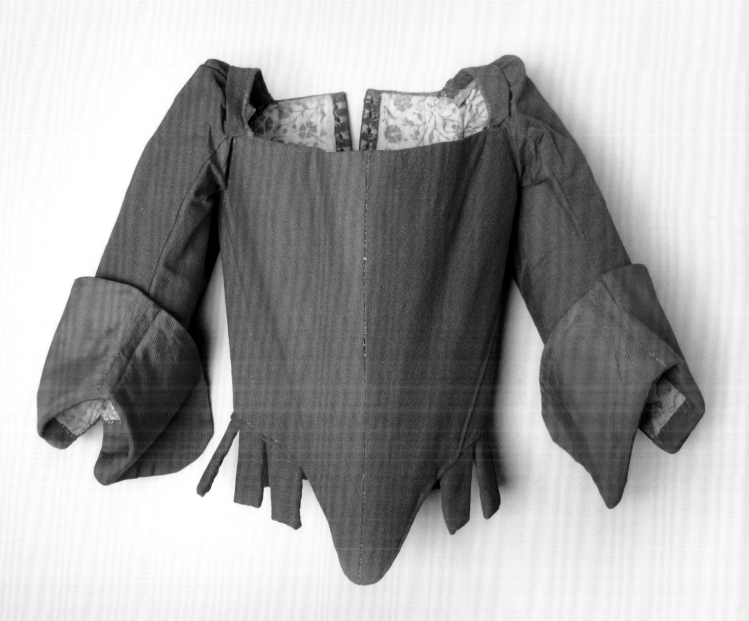

de la flanelle entre l'étoffe de dessus et la doublure.

On coupe deux morceaux d'après chacune des figures 1, 2 et 5, un morceau entier d'après chacune des figures 3 et 4, qui représentent seulement la moitié du morceau ; on complète au préalable le côté replié de la figure 4.

La manche est coupée d'après celle du corsage avec fichu simulé (voir le n° 25).

On fait les pinces de la poitrine ; on pose sous le bord des devants, depuis l'encolure jusqu'à la taille, une bande ayant 5 centimètres de largeur ; on pose les boutons, on fait les boutonnières, on assemble tous les morceaux en rapprochant

CORSET COURT.

coupée en biais. Ceinture et nœud en ruban assorti ou gros-grain de même teinte, coupé à la pièce et orné de velours.

Col en mousseline avec nœud.

Ce col se compose d'une bande de mousseline coupée en droit fil, plissée, bordée d'une dentelle ayant 2 centimètres de largeur. Sous la bande on en pique une autre unie, coupée en biais ; une brisure rattache ce col à une chemisette. On le complète par un nœud fait en mousseline plissée et dentelle ; il se compose de quatre parties en forme d'éventail ; pour

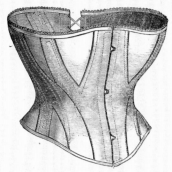

CORSET EN COUTIL BLANC.

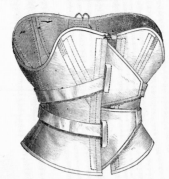

CORSET PARESSEUX.

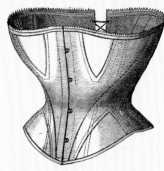

CORSET EN COUTIL GRIS.

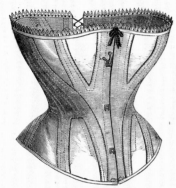

GRAND CORSET EN COUTIL BLANC.

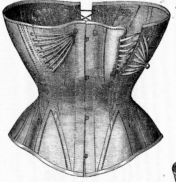

GRAND CORSET EN COUTIL GRIS.

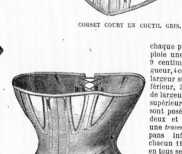

CORSET COURT EN COUTIL GRIS.

les chiffres pareils. On coud ensemble le col (fig. 5) ; au milieu par derrière on le garnit, on le fixe sur l'encolure en rapprochant les chiffres pareils. La basque (fig. 4) se rattache à la basque de devant (qui a été coupée avec les devants), depuis 4 jusqu'à 6. On forme les plis, sur le bord supérieur, en fixant chaque croix sur un point, puis on attache la basque au dos et aux côtés ; les remplis de cette couture sont cachés sous une bande de lustrine

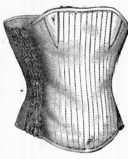

CORSET POUR PETITE FILLE DE 8 A 10 ANS.

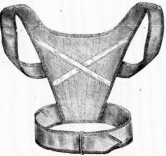

CORSET POUR ENFANT DE 1 A 2 ANS.

chaque partie on emploie une bande ayant 9 centimètres de longueur, 4 centimètres de largeur sur le bord inférieur, 3 centimètres de largeur sur le bord supérieur ; ces bandes sont posées deux par deux et réunies par une *traverse*. Les deux pans inférieurs ont chacun 11 centimètres en tous sens ; les deux pans de dessus sont de 2 centimètres plus petits que les précédents ; on les plisse, on les coud sous le nœud.

CORSET POUR FILLETTE DE 12 A 14 ANS.

(Les explications des figures de cette page se trouvent sur la planche de patrons.)

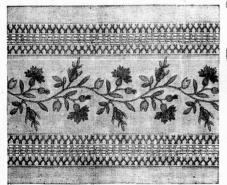

BRODERIE DU TABLIER EN NANSOUK POUR PETITE FILLE DE 3 A 5 ANS.

CORSET EXTÉRIEUR (VU A L'ENVERS) POUR PETITE FILLE DE 8 A 10 ANS.

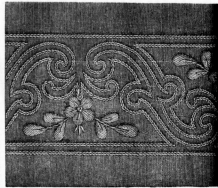

BRODERIE DE LA VESTE SANS MANCHES.

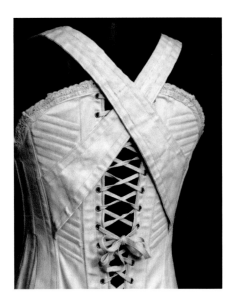

perceived as such by the children who wore them. In 1793, Elizabeth Ham, an English girl, aged ten, recounted the pain she felt when wearing her first semi-whaleboned corset: "The first day of wearing them was very nearly purgatory, and I question if I was sufficiently aware of the advantage of a fine shape to reconcile me to the punishment.."[8]

Drastic measures were sometimes taken. In 1835, Antoine-Martin Bureau-Riofrey commented on whalebone stays "whose pointed tips would touch the part of the body that bent forward, thereby forcing young girls to continual vigilance to avoid feeling pain."[9] The use of this type of device, which was uncommon, might have seemed necessary at the time to respond to the demands of erect posture tied to social status.

SECURING A PLACE IN SOCIETY

Indeed, aside from their role of support, the whalebone stays and the corset helped define the child as an individual and assign him or her a place in society. The passing of various "stages" punctuating the child's life defined his or her future adult status. The whalebone stays and the corset were part of this evolution, especially for little boys. The moment when swaddling clothes were replaced by whalebone stays marked the first stage. This represented the age at which the child was capable of standing alone, even though it was considered necessary to offer artificial support for his posture. Little boys and girls wore the same clothing: a dress over whalebone stays or a corset, which situated them in a female world. Numerous portraits show the similarity between the clothing worn by little boys and little girls, but also between their clothing and their mother's clothing. The whaleboned bodice worn by the young Francis Harmer at five to seven years of age bears witness as well to the construction of a young boy's body.

The second stage in the life of the child was the differentiation of the sexes at around six years of age. While a young girl continued to wear a dress over whalebone stays or a corset, a small boy was thereafter dressed in breeches or pants and no longer wore body-shaping undergarments. This change of wardrobe was not anodyne; it was celebrated in diaries and memoirs as the moment a boy became a man. A young girl continued to wear a dress over shaping undergarments. The whalebone stays and the corset therefore fully participated in the construction of gender. While a small boy "became a man," a

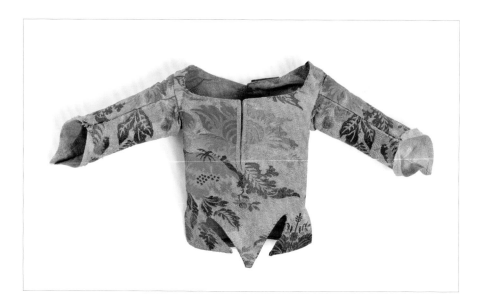

young girl was characterized as a woman from birth.

This distinction between early childhood, when little boys and girls were both dressed in whalebone stays or corsets, and the age of reason, during which only young girls continued to wear them, is clearly reflected in the department store catalogues and fashion magazines of the nineteenth century. While corsets for very young children were described as being for "children," those for children aged seven or eight or more were for "little girls."

The little girl wore increasingly restrictive whalebone stays or a corset as she grew. Getting accustomed to having her body constrained was thus a gradual process, from early childhood into adulthood. Educational establishments made these undergarments obligatory. Madame de Maintenon, addressing the Ladies of Saint-Louis, noted: "I would like as much care with whalebone stays to be taken in order to preserve their waistlines, no matter the cost."[10] The preoccupation with the silhouette, while not the primary focus, was nonetheless important and became predominant once a young girl became a woman. Many examples of corsets for young girls are remarkably similar to those worn by adults. They were

sometimes dyed and decorated with lace, with distinct waistlines and bustlines. A woman wore clothing that shaped her body for her whole life, and there was an evolution in the undergarments worn by a little girl, but it was slower and less distinct from that of little boys, who were considered adults from an earlier age, reflecting their changing status.

The undergarment also helped situate the child within the social hierarchy. In the collective imagination, the whalebone stays and the corset were associated with the aristocracy and bourgeoisie. Indeed, their use would appear incompatible with the lives of working people. Nonetheless, the structuring of children's bodies was based not on constraint, but rather on the idea of protection and care. This concept is profoundly anchored in the collective psyche, as seen in the widespread practice of swaddling at all levels of society. Source material concerning the lower classes is sadly lacking and offers only a partial understanding of their customs. But despite this some uses have been documented. A child of a painter or his apprentice is depicted wearing whalebone stays in the abovementioned work of Pierre Subleyras. Moreover, the clothing allocated to foundlings in 1780 included

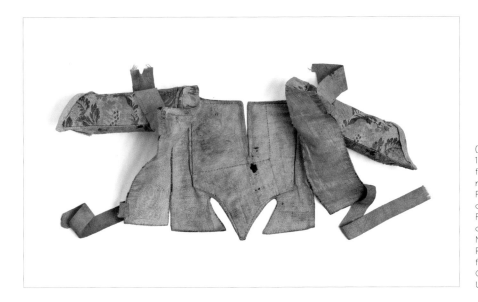

(Opposite and left)
106, 107. Reinforced bodice
for an infant (obverse and
reverse)
France, mid eighteenth
century
Figured, brocaded silk, coated
cloth, silk ribbons
Musée des Arts Décoratifs,
Paris, collection Union
française des arts du costume,
Gift of Henri Lavedan, 1951,
UF 51.12.96

"a quilted bodice covered in brown fabric."[11] A number of examples and sources from Arles[12] confirm the use of whalebone stays in this large provincial town in the eighteenth century—but it was a prosperous town and such fashions were probably a concern essentially of the local nobility.

In the nineteenth century, the development of the fabrication and sales by mail order allowed for a wider circulation of corsets among the urban middle classes and the provincial petite bourgeoisie. Many crudely made stomach bands in simple materials might even attest to a popular use of them. Whatever the case, the restricted body remains a supreme symbol of the aristocracy and the bourgeoisie and the values with which they were associated.

The forming of a child's body echoes that of his or her mind, with the two ideally working in tandem. The treatises on *savoir-vivre* (good manners) that multiplied during the second half of the nineteenth century were very interested in this question, and chapters were often devoted to bodies. In 1860, the countess of Drohojowska wrote in her treatise *De la politesse et du bon ton* (On politeness and good upbringing): "[A child's] mind, like his body itself, is a soft wax that you fashion to suit your taste, and just as you teach him to hold himself erect . . . you model his young mind and easily point him toward either good or evil."[13] The child must learn to stand up, certainly, but also to have "good" carriage, and walk accordingly. Hence the association with upstanding thoughts and virtue. This aspect was especially pronounced in the education of young girls, as virtue was a quality expected in a woman.

In the nineteenth century, the restrained body and the virtue it implied were adopted by the bourgeoisie as a mark of distinction. A good upbringing was in fact central to bourgeois values. But by the end of the century the corset had become an object of ambivalence: it was simultaneously a guarantee of modesty and virtue and charged with eroticism.

CRITICISM AND LASTING CUSTOMS

The idea of forming a child's body from the seventeenth until the nineteenth century was not without its critics. The arguments against the wearing of whalebone stays began during the ancien régime and were principally medical in nature. As early as the sixteenth century, Ambroise Paré, considered one of the founding

fathers of modern surgery, expressed his disagreement. He dedicated an entire chapter to "Accidens qui adviennent par trop lier et serré les parties du corps" (Accidents due to the overly tight binding and squeezing of various parts of the body), in which he underscores the respiratory problems associated with swaddled infants and constricting bodies: "Squeezing too tightly the stomach and parts [of the body] related to breathing, is a cause of suffocation and sudden death."[14] Obstetrics and pediatric medicine first developed over the course of the following century. Parallel to this consciousness of a child's needs, the traditional concept that a child's body was limp and feeble began to be questioned. Arguments against whalebone stays continued during the eighteenth century with works bearing impassioned titles such as *Dégradation de l'espèce humaine par l'usage des corps à baleines, Ouvrage dans lequel on démontre que c'est aller contre les Loix de la Nature . . . que de le mettre à la torture, dès les premiers instans de son existence, sous prétexte de le former*" (Degradation of the human species due to the use of whalebone stays, a work demonstrating that this goes against the laws of Nature . . . torturing a child as of the first moments of life, under the pretext

of forming him).[15] However, such criticism had little impact, and in general people leaned more toward moderation in the use of whalebone stays than their suppression. Indeed, the idea that they were necessary to accompany a child's growth persisted; "they provide children with an excellent means of support, and keep them from skeletal deformations, so common at this tender age," wrote Johann Zacharias Platner in 1735.[16]

In the late eighteenth century, Jean-Jacques Rousseau's theories on children and nature were added to the medical criticism. In 1762, he suggested a new approach to education in his work *Émile, ou De l'education* (Emile, or on education). Based on a respect for nature, it favored a sensitive discovery of the world, giving an important place to the body. Rousseau criticizes "all that hampers and constrains nature," including whalebone stays, on grounds that were both aesthetic and medical. Georges Vigarello explains that this concept, aside from its philosophical implications, corresponds to a new vision of the child, whose body is no longer considered limp and has no need of support to develop. Henceforth people considered that "a child has enough innate strength to go without a corset: hence the role that muscles play in holding up

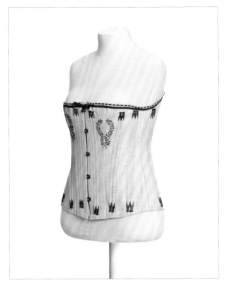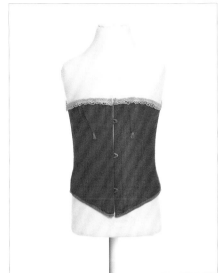

the body."[17] The authors of the *Encyclopédie*, published between 1751 and 1772, made critiques along the same lines in two entries devoted to whalebone stays. Their arguments were based on the idea of respect for the natural body from both aesthetic and medical points of view.

Criticism of stays became all the more prevalent at the end of the eighteenth century. Enlightenment thought and the theories of Jean-Jacques Rousseau were widely read in aristocratic circles, but few people applied them as such. They did, however, contribute in the long run to modify the status of the child and the relationship to his body. The critiques became stronger and more diversified in the nineteenth century and were formulated by doctors, moralists, and feminists. The medical arguments, which were the most prevalent, acquired new weight in the context of a new faith in scientific research and medicine. The critics henceforth based their arguments on scientific method, using schemas demonstrating the harmful effects of the corset. Opposition to the garment ran on demographic lines: the wearing of the corset was considered a cause of reproductive weakness, inhibiting a woman's ability to breed soldiers to defend France. The corset was also seen as a threat to

moral standards: in 1857, Charles Dubois placed the abuse of corset wearing on the same level as abuses of tobacco, gambling, strong liquor, and speculation.[18] Moralists denounced the vanity of women who were more preoccupied with small waistlines than with their duties as wives and mothers.

Yet, as in the eighteenth century, it was first and foremost the excesses of the corset that were criticized, and not the corset as such. Hence the manuals of etiquette could become ardent defenders of a corset that was well made, which embodied bourgeois values. The baroness of Staffe devoted an entire chapter to it. After criticizing the "bad" corset, she wrote: "If a woman considers the corset as a mere support of her frail torso, it becomes on the contrary useful."[19]

With little immediate effect, such critiques nonetheless contributed to the gradual changing of people's concept of a child's body. Suspicion of the corset, both for the adult and for the child, increased in the beginning of the twentieth century, and the construction of women's undergarments evolved considerably after the First World War.

The traditional notion of the child's body did not disappear totally, however, and the practice

TOUS LES MÉDECINS VOUS DIRONT :

Il faut à Bébé un corset

...un corset B.B. qui le maintienne sans le gêner.

4 fois plus solide qu'un corset ordinaire - et moins cher - le Corset B. B. est indispensable pour soutenir la délicate charpente de Bébé, dont il suit la croissance grâce à des bretelles ajustables.
Le Corset B. B. se porte avec toutes les culottes... et surtout avec la culotte ou le slip B. B.

VENTE EXCLUSIVE par les spécialistes en layettes.

★ *Demandez l'adresse du spécialiste le plus proche de votre domicile aux*

BB

Établissements
B.B. TEXTILES
MANTHES (Drôme)

of swaddling was still found in the countryside up until the 1950s. The term "corset" also continued to be used for clothing similar to the stomach bands of the nineteenth century. A sales pitch in an advertisement from the 1950s touted the supporting characteristics of the B.B. Corset for "baby's delicate frame" (fig. 110). This example bears witness to the continuation of customs and terms, even while the status and conception of the child had for the most part evolved.

The specificity of the child was henceforth taken into account, and an appropriate wardrobe was developed little by little. Children's fashions worn today emphasize comfort, while the corset, in becoming eroticized, has become a symbol of femininity.

1. Jean-Jacques Rousseau, *Émile; or On Education* (1762; London: Penguin Books, 1991).

2. Jacques-Bénigne Bossuet, *Œuvres de Bossuet*, vol. 2, *Oraisons funèbres—sermons* (Paris: Firmin Didot Frères, 1852), 500.

3. Alphonse-Louis-Vincent Leroy, *Recherches sur les habillemens des femmes et des enfans* (Paris: Le Boucher, 1772).

4. François Mauriceau, *Traité des maladies des femmes grosses et de celles qui ont accouché* (1694), quoted in Jacques Gélis, Mireille Laget, and Marie-France Morel, *Entrer dans la vie* (Paris: Gallimard / Julliard, 1978), 116.

5. France Borel, *Le Vêtement incarné: les métamorphoses du corps* (Paris: Calmann-Lévy, 1992), 59.

6. Docteur Collineau, "corset," in Marcellin Berthelot et al., *La Grande Encyclopédie: inventaire raisonné des sciences, des lettres et des arts* (Paris, H. Lamirault, 1885–1902), 2: 1108.

7. Oil on canvas, ca. 1699, Minneapolis Institute of Arts, inv. 77.26.

8. Elizabeth Ham, *Elizabeth Ham by Herself*, 1793, quoted in Anne Buck and Emily Phillis Cunnington, *Children's Costume in England* (London: A. and C. Black, 1965), 128.

9. Antoine-Martin Bureaud-Riofrey, *Éducation physique des jeunes filles ou Hygiène de la femme avant le mariage* (Paris: Librairie des sciences médicales de Just Rouvier et E. Le Bouvier; London: Chez Duleau et Cie, 1835), 218.

10. Madame de Maintenon, *Lettres et entretiens sur l'éducation des filles* (Paris: Charpentier Libraire-éditeur, 1861), 148.

11. Paris, Archives nationales, F15 2470, "Mémoire sur l'hôpital des Enfants trouvés de Paris," A *droguet* is a plain white inexpensive fabric made of wool.

12. *Façon arlésienne: étoffes et costumes au XVIIIe siècle*, exh. cat. (Arles: Museon Arlaten, 1998).

13. Antoinette-Joséphine-Françoise-Anne Drohojowska, *De la politesse et du bon ton ou Devoirs d'une femme chrétienne dans le monde* (Paris: Nouvelle librairie classique, Victor Sarlit Libraire éditeur, 1860), 166.

14. Ambroise Paré, *Œuvres complètes* (Paris: J.-B. Baillière, 1840), 2: 292–93.

15. Jacques Bonnaud, *Dégradation de l'espèce humaine par l'usage des corps à baleine* (Paris: Hérissant le fils, 1770).

16. Johann Zacharias Platner, *De Thoracibus*, 1735, quoted in Fernand Libron and Henri Clouzot, *Le Corset dans l'art et les moeurs du XIIIe au XXe siècle* (Paris: F. Libron, 1933), 50.

17. Georges Vigarello, "Corps, beauté, sexualité. Rencontre avec Georges Vigarello," *Sciences humaines* 132 (November 2002); http://www.scienceshumaines.com/corps-beaute-sexualite_fr_23076.html.

18. Charles Dubois, *Considérations sur cinq fléaux: L'abus du corset, l'usage du tabac, la passion du jeu, l'abus de liqueurs fortes, et l'agiotage* (Paris: Dentu, 1857).

19. Blanche Staffe, *Le Cabinet de toilette* (Paris: V. Havard, 1893), 218.

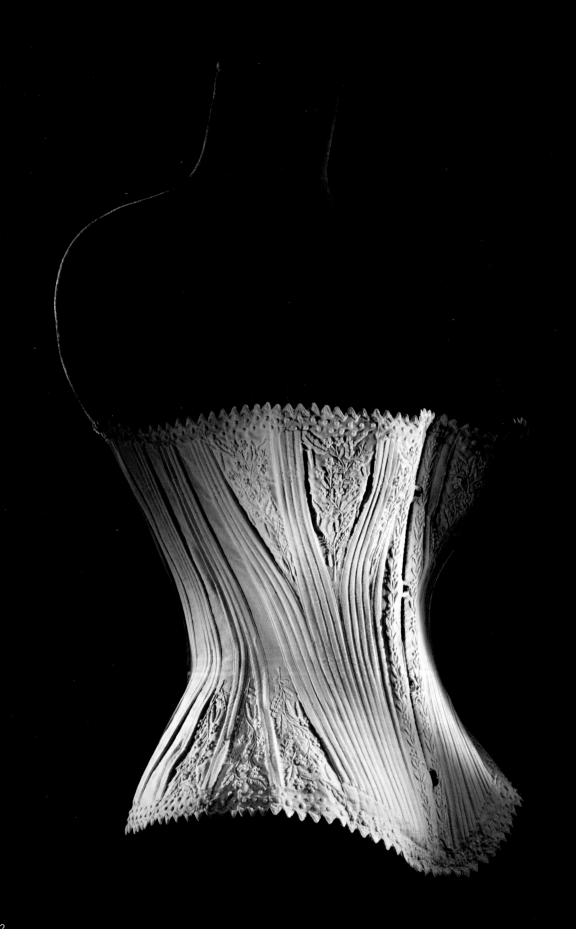

19th
CENTURY

False calves — "Stomach belt"
Corset — Crinoline — Bustle
Sleeve-plumpers — Bustle cushion

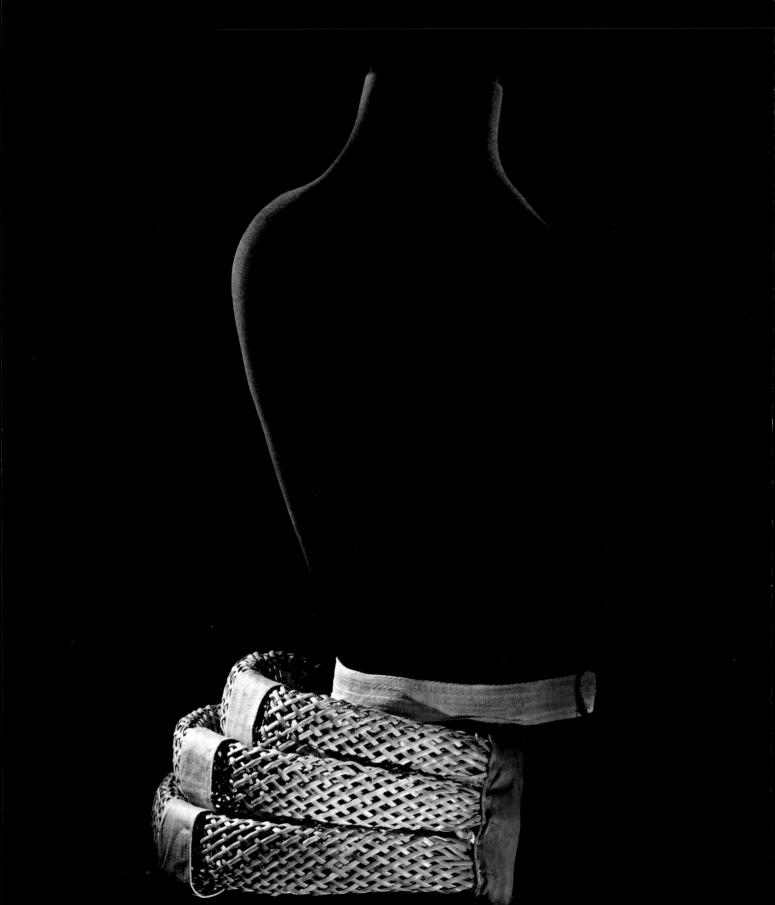

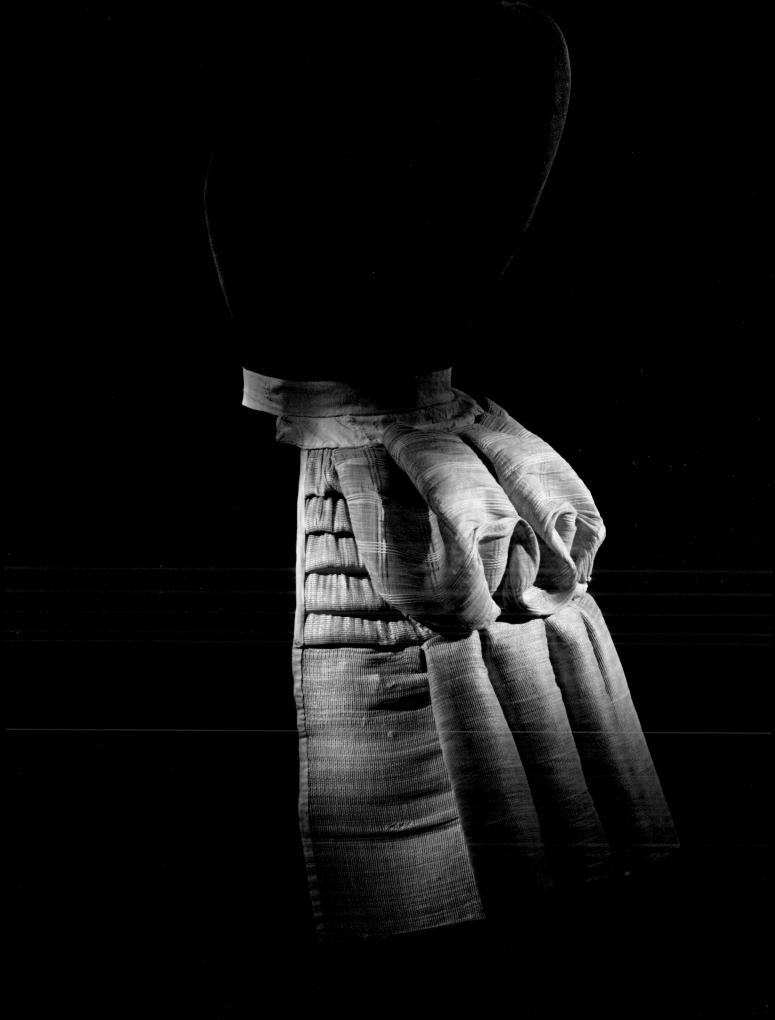

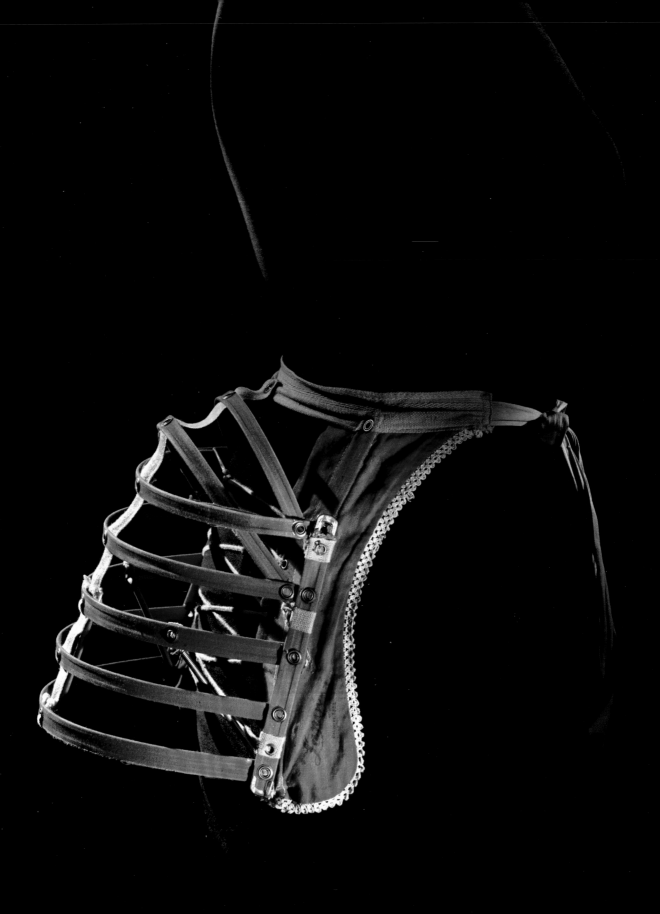

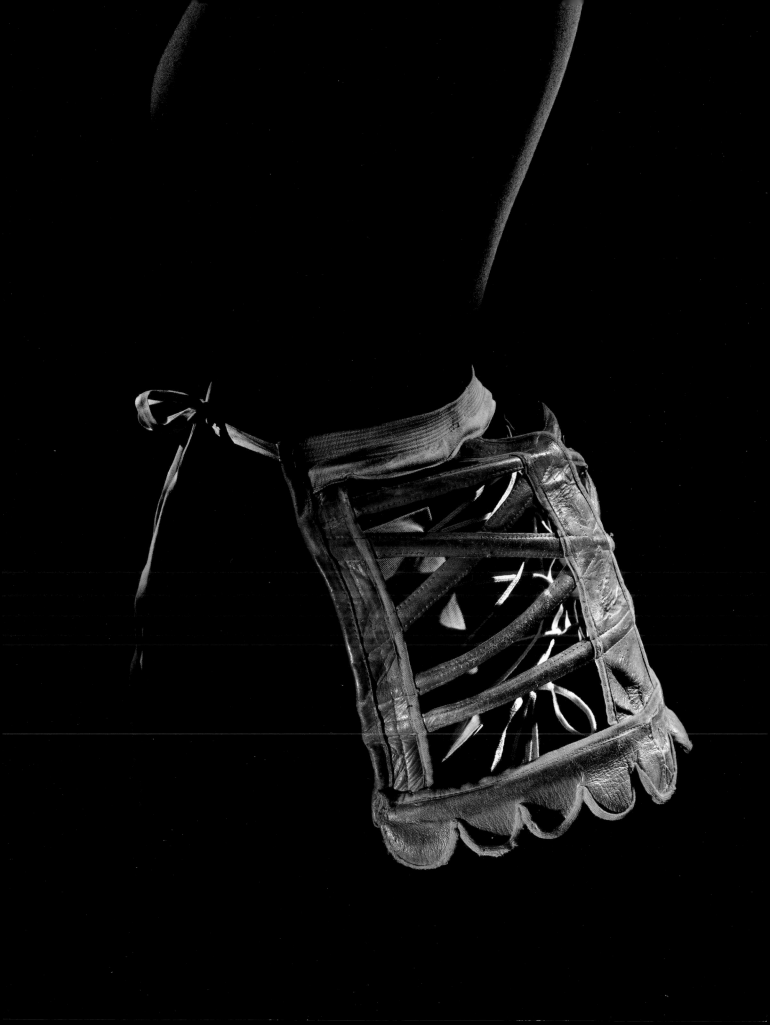

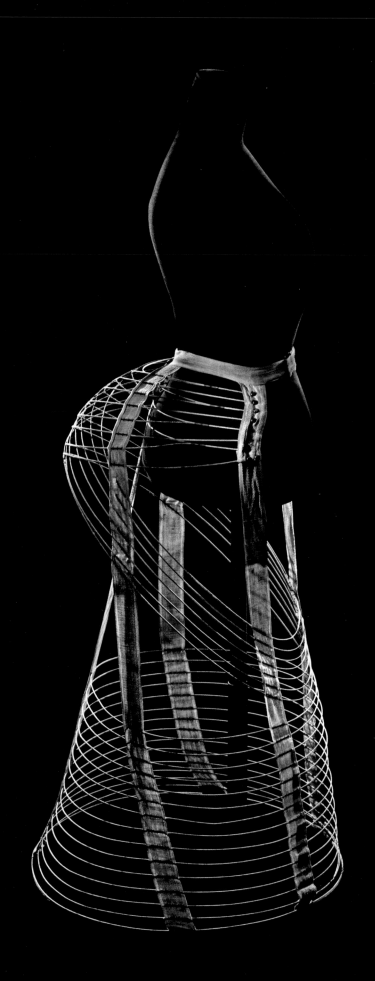

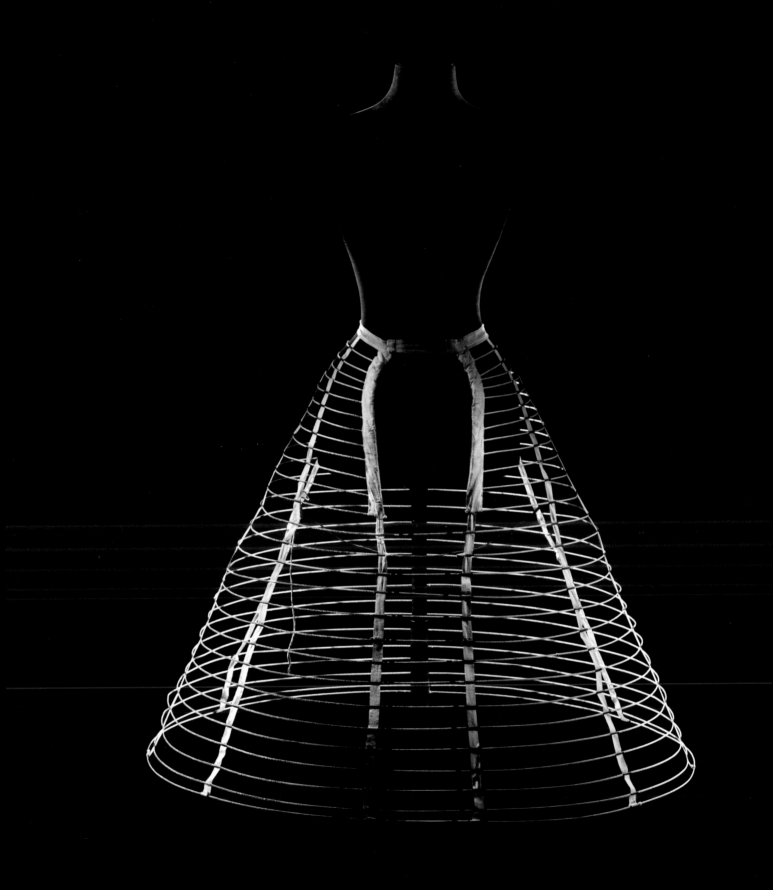

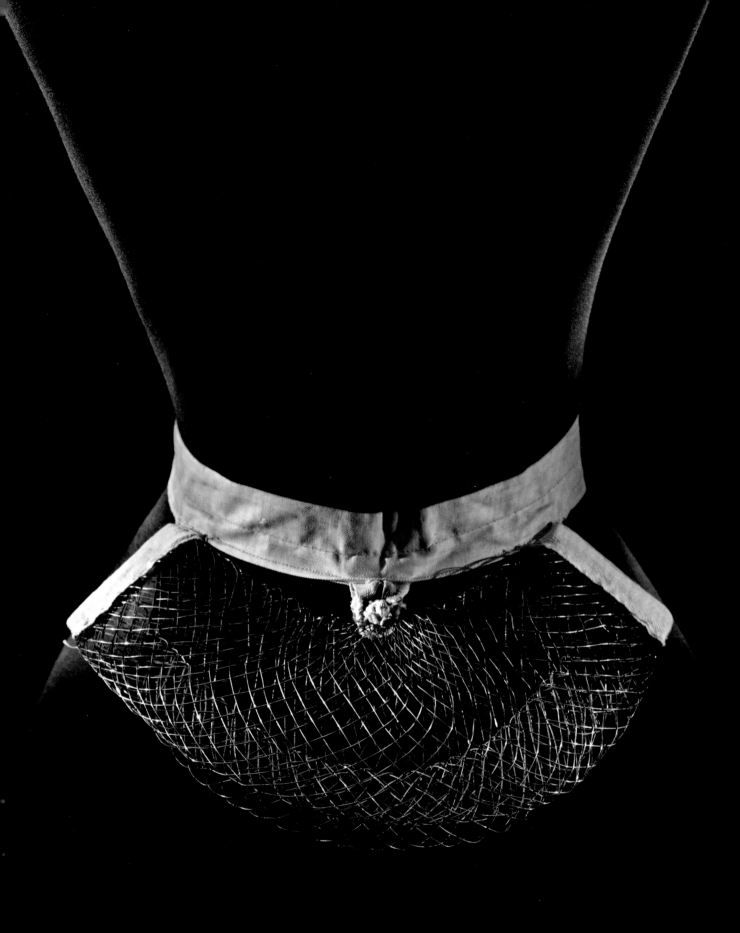

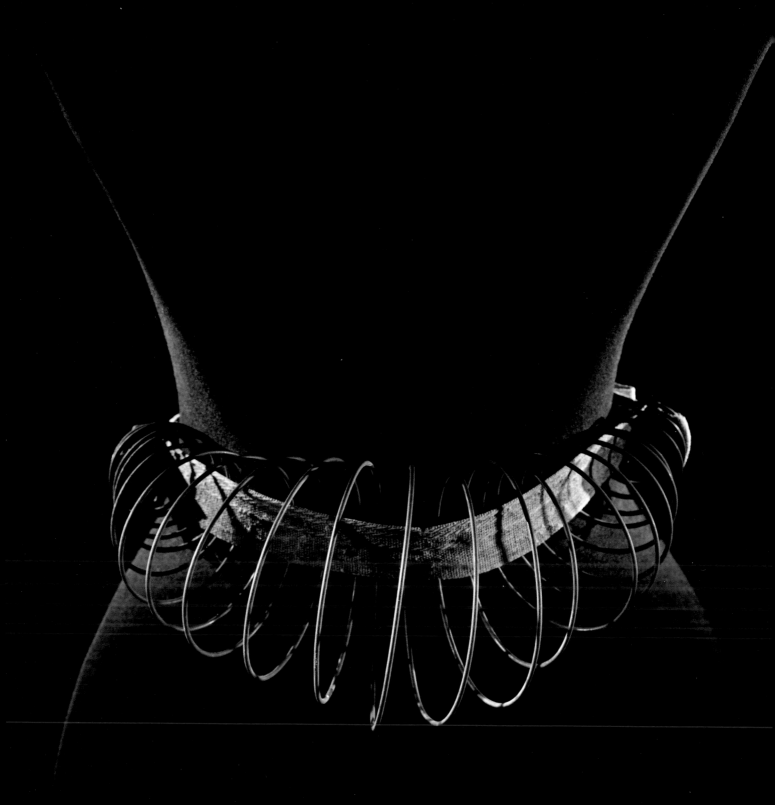

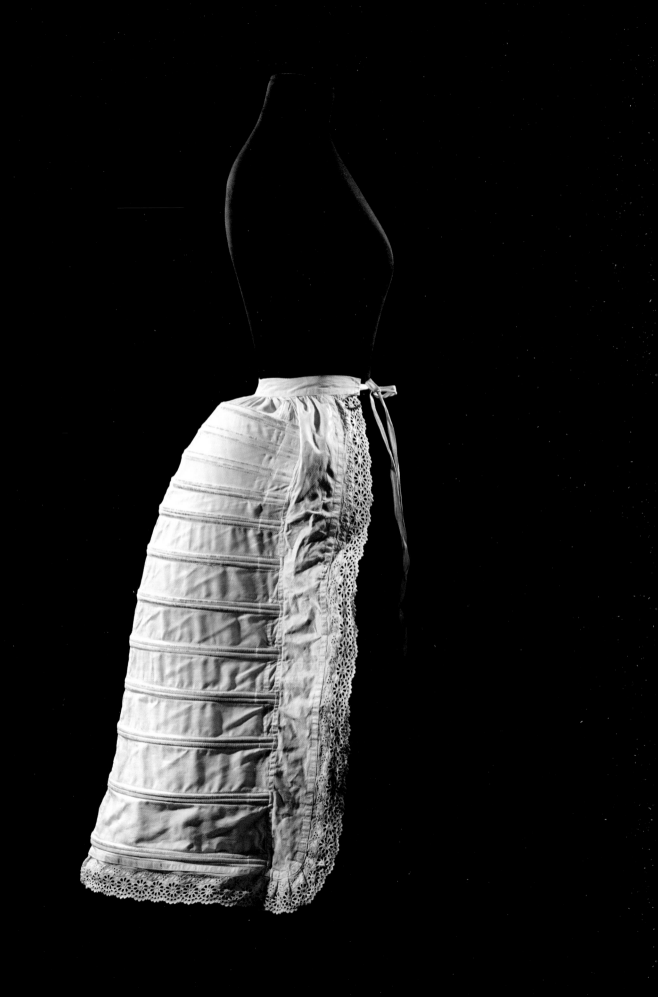

THE NINETEENTH CENTURY: FROM ARTIFICE TO ANONYMITY

—

Georges Vigarello

Without question, figures and fashions suggest a cultural sensibility. They can never be limited to lines alone: they encompass a vision of the world, embody social mores, and cement relations between things and people. In other words, this is more than simple formalism. In the representation of women, for example, their role and status are immediately present in the way in which their looks and bearing are established. From this derives the importance of the "mechanics of the undergarment"—the very thing that orchestrates and "stages" the garment worn on top of it. This importance would grow even greater during the nineteenth century as the culture multiplied its rigid procedures, the better to sculpt what was expected of the female body. The fact remains, however, that the nineteenth century marked a decisive evolution in the "mechanics" corresponding quite directly with that of the status of women.

THE END OF THE EIGHTEENTH CENTURY AND THE INVENTION OF FLUIDITY
A move toward fluidity and "liberation" occurred at the end of the eighteenth century. A twofold dynamic, justified by the culture of the time, transformed women's clothing through the importance given to the function of the organs and a defiance of direct physical forms of oppression. A demand emerged to "liberate" the organs. The image of the future *citoyenne* was in no doubt: "freedom" of form for a greater "freedom" of being. Aim was taken at the instruments themselves, the constraining, hidden structures: swaddling, cushions, and corsets, the devices traditionally used to squeeze woman's waists, chests, and torsos. Freeing women from them would lead to other freedoms.

The corset persisted,[1] of course, but was gradually transformed. The criticism bore results. At the end of the nineteenth century, the *Gallerie des*

modes et costumes français dessinés d'après nature (Gallery of French costumes and fashions drawn from nature) described a corset made of taffeta and stripped of whalebone known as a *casaquin* bodice.[2] So definitions were updated too. *The Nouveau Dictionnaire français*, which claimed in 1793 to document "words entering our language over recent years," emphasized the changes evident in corsets: "stays usually made of quilted cloth without whalebones, which women wear in a state of undress."[3] Stiffness was evidently in decline, and movement was becoming easier.

THE RETURN OF ARTIFICE

The constraints of dress inevitably follow those of the times: traditional "stiffness" for women regained its prior legitimacy with the Restoration and the July Monarchy (1830–48). Restriction of liberty created an emphasis on rigidity: belts cinched over a corseted torso; dresses whose panniers recovered their former breadth; balloon sleeves to better balance the two volumes cut at the waist; *jupe en cloche* (bell-shaped skirt); "wasp" waist.[4] Lastly, the shoulders, more emphasized, loomed over hips drowning in folds. Gathers and folds once more masked forms that the Revolution had made more visible. Social mores rediscovered their tradition and movement its restriction. Once again, the garment "artificialized" the anatomy: the upper body became fixed while the lower body was hidden beneath gathers, linings, hoops, and hems.

The corset at mid-century was a rigid shell created by industrial manufacture: more compact than it was at the end of the eighteenth century, it was centered around the waist and hips. Corsets were marketed as more comfortable because they were "without gusset"[5] or "seamless"[6] or "without eyelets"[7]; and they were considered more "manageable" because they featured laces "without tips"[8] or "lazy"[9] devices to facilitate lacing and unlacing, "by herself, in an instant."[10] The reality was, of course, more prosaic.

DESIGNING FULLER FORMS

Yet more structures were added around mid-century, with the bustle, a stiff article accentuating the curve of the back, and the material of the crinoline, designed to swell dresses as never before. Both items served to accentuate the firmness of the upper body while broadening the wearer's bottom half: anything but functional, anything but light, decorum demanded stiff carriage and measured gait.

There were, of course, criticisms of these overblown garments, usually coming from women: "skirts of moderate breadth were desired by a number of naturally well-shaped women, but the majority of less shapely

(p. 142)
111. Corset
United States, ca. 1860–70
Cotton interwoven with wood and whalebone stays, cotton embroidery, metal
Collection of Melanie Talkington, Vancouver

(p. 144)
112. Bustle
Europe, ca. 1880
Woven rattan, cotton satin, metal
Collection of Melanie Talkington, Vancouver

(p. 145)
113. Bustle
France, ca. 1880
Linen and horsehair
Musée des Arts Décoratifs, Paris, collection Union française des arts du costume, UF 2013-010-1

(p. 146)
114. Bustle, known as a "strapontin"
France, 1887
Metallic armature, springs and eyelets, cotton serge, cotton straps and laces, crocheted lace
"Langtry. Brevetée"
Musée des Arts Décoratifs, Paris, collection Union française des arts du costume, Gift of Madame Osmont, 1953, UF 53.49.59

(p. 147)
115. Bustle
France, ca. 1883
Armature of steel covered in leather, wool galloon, cotton straps, and laces
Falbalas collection, Paris

waists won the day."[11] Caricatures by Cham, Bertall,[12] and Honoré Daumier[13] depict the perils of wearing such "overly" broad outfits: dresses bumping into passersby, burning on contact with fireplaces, getting caught under carriage wheels. "Constraining" artifice nevertheless continued into the 1860s, favoring a decorative, stiff profile with form taking precedence over freedom.

THE SLOW ELIMINATION OF "EXCESS"

The changes in dress that occurred in the last third of the nineteenth century could be viewed as indicating a slow liberation of female movement and dress. The transformation of the female silhouette appeared to confirm this, but it depended upon new underlying structures. Clothes began to embrace the body's forms in the mid 1870s: dresses became *collant* (form-fitting)[14] and hips suddenly asserted themselves beneath *foureau* (sheaths).[15] It was a "slow elimination" of excess, according to Stéphane Mallarmé. This change took aim at those accessories that distorted the body: "The bustle is on its way out, the bustle cushion is disappearing."[16] Historic rigid structures arranged under the fabric to make it splay out were called "scaffoldings," "terrible things" compared in some personal diaries to vague remembrances of the "inquisition."[17] In their absence, women would gain greater sleekness and mobility.

There were several stages to this emergence of the "lower" part. The front part of the body appeared first, while the back remained raised and enveloped. In Zola's description of Nana at the Grand Prix de Paris, we hear of "the small bodice and blue silk tunic clinging to the body, raised behind the back by an enormous puffed bustle, outlin[ing] the thighs in a bold manner for these times of bloated skirts."[18] Evidently an inversion has taken place. Curves have emerged: thighs and pelvis "touch" the fabric. Anatomical forms are revealed and a discreet eroticism is combined with a new fluidity.

One had to wait until the late nineteenth century for the artifices lifting the rear of dresses to disappear. The "promenade dress"[19] mentioned in *Le Petit Messager des modes* in 1876 is "tight-fitting," the very first of its kind. The whole has become "simple."[20] Slenderness has become "sinuous."[21] Dresses became tighter under a "fitted bodice" or "tailored jacket"[22]—all of it favoring "thin people" and to the "despair of everyone else."[23]

It must nevertheless be pointed out that this curvaceous slimness was not the same as today's. The silhouette of "form-fitting" dresses and rounded hips was achieved thanks to the control of the corset. What changed was the mechanism that replaced the curves created by a bustle. The corset narrowed the waist and buttressed the back. The most visible contours

relied on support, as feminine firmness still required assistance. Thus corsets with elongated curves became widespread during the 1890s: "We need long corsets that are more enveloping than ever, with baleens that descend far down the hips."[24] Hence the growing number of patents that reflect this demand—three to five per month at the start of the twentieth century.[25] The long uninterrupted lines of the princess dress demanded a different type of undergarment. The silhouette had gained coherence if not firmness.

One had to wait until the start of the twentieth century for the advent of a truly radical change in the "mechanics of undergarments"—symbolized by the eclipse of the corset. The straight line asserted itself: the profile "I" replaced the curved "S"—a significant consequence only made possible by female emancipation, and an outcome that, as we know, went far deeper than the simple transformation of external features.

1. The tradition of the woman's corset was maintained in any case. The letters of Kageneck from 1781 speak of the duchesse de Mazarin and her "mania for having a slender waist which, despite her physical constitution, had her continually using one of those unnatural molds that are called 'stays'"; quoted in Odile Blanc, *L'Amour à Paris au temps de Louis XVI* (Paris: Perrin, 2002), 229.

2. *Gallerie des modes et costumes français dessinés d'après nature*, 1786.

3. *Nouveau Dictionnaire français composé sur le Dictionnaire de l'Académie française, enrichi d'un grand nombre de mots adoptés dans notre langue depuis quelques années*, vol. 2 (Paris, 1793), see "Corset."

4. Louis Maigron, *Le Romantisme et la Mode d'après des documents inédits* (Paris: H. Champion, 1911), 180.

5. *La Mode, revue des modes, galerie des moeurs*, 1845, 59.

6. *Le Petit Messager des modes*, August 16, 1842, 123.

7. *Le Bon Ton*, 1838, 944.

8. Ibid., 1837, 686.

9. See Philippe Perrot, *Le Travail des apparences. Le corps feminine: XVIIIe–XIXe siècle* (1984; Paris: Le Seuil, 1991), 271: the corset "that allows you to get dressed and undressed without the help of a servant, a husband, or a lover."

10. *Le Bon Ton*, 1837, 686.

11. T. de Beutzen, "La mode," in *L'Illustration*, June 16, 1860.

12. Bertall [Charles-Albert d'Arnoux], "Essai sur la beauté des crinolines," *L'Illustration*, September 24, 1864, 26.

13. Honoré Daumier, "Effet des tourniquets sur les jupons crinolines," *Charivari* (1855).

14. "The dress won't pass muster today unless it is well-fitted: snug, in a word," *Le Caprice*, July 1876, 9.

15. *Almanach de L'Illustration*, 1878, 60.

16. Stéphane Mallarmé, *La Mode de Paris* (1874), in *Oeuvres complètes* (Paris: Gallimard, 1961), 831. The bustle is a rigid device placed at the back of the dress to accentuate the curve.

17. Constance de Castelbajac, *Journal de Constance de Castelbajac, marquise de Breteuil, 1885–1886* (Paris: Perrin, 2003), 223.

18. Émile Zola, *Nana* (1879; Paris, Gallimard, 1977), 348.

19. Ibid., 1876, pl. no. 668.

20. The word "simple" invaded the fashion magazines along with the "straight" forms of late century.

21. *Femina*, 1905, 491.

22. *Le Caprice*, January 1, 1897.

23. *Le Caprice*, January 1, 1890.

24. *Le Messager des modes*, 1910, 133.

25. See *Les Dessous élégants* (Elegant underwear), a periodical reporting regularly on the patent requests filed.

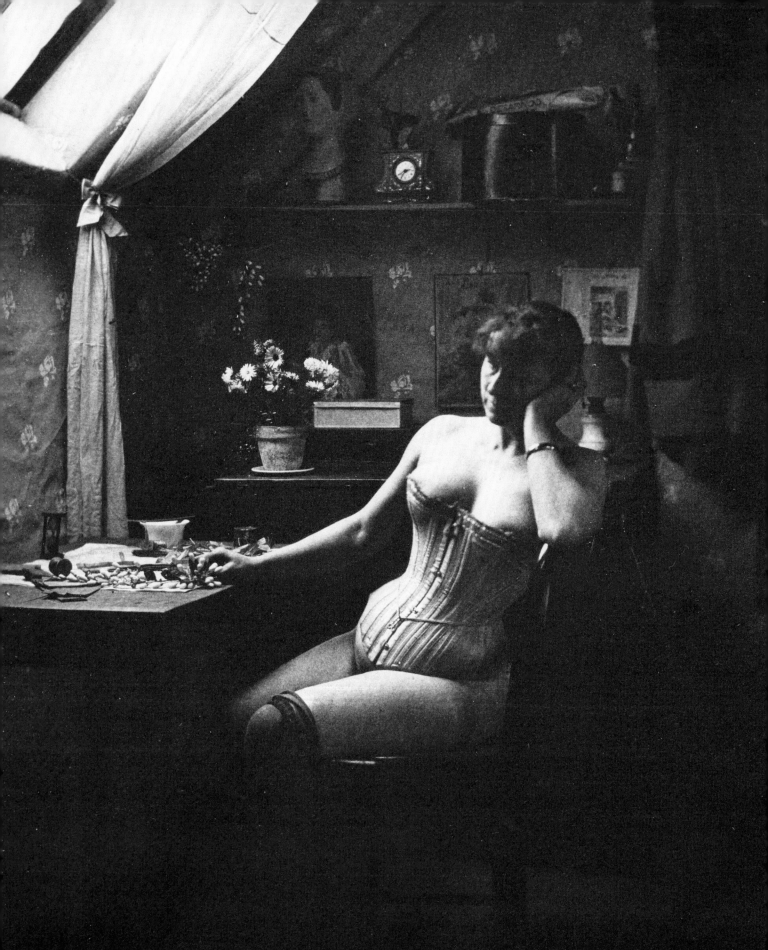

Aurore Bayle-Loudet

THE CORSET, ESSENTIAL PROTAGONIST OF MODERN FEMININITY

Women's fashion in the nineteenth century cannot be studied without examining the shape and construction of undergarments. For the first time, undergarments became the "model"[1] of women's dress. At once hidden and omnipresent, the corset gradually reappeared during the first third of the century, gaining ascendancy over the female body as well as the day-to-day conception of bourgeois lifestyles.

The transformation and innovation of the corset reflected wider socio-economic upheavals. The industrialization and urbanization of society brought with it a new rhythm of life and new conventions within which women's dress played a leading part. The bourgeois woman assumed a new role, asserting herself in the public arena within which her bearing and dress were seen as marks of success and good breeding. Furthermore, she acquired a new sense of her body in both public and private affairs.

For this reason, we must ask ourselves in what ways the corset, a vestige of the constraints formerly visited upon a woman's body, assumed a modern shape in the nineteenth century, an era during which certain innovations advertised comfort, while the garment imposed itself as a potential means by which any woman could attain the ideals of youth and beauty.

FROM ONE EMPIRE TO THE NEXT, BETWEEN FLOWING LINES AND VOLUME

The nineteenth century opened with a violent reaction against the excesses of eighteenth-century courtly society, associated with artifice, appearance, and constraint. From the French Revolution to the end of the Empire, society sought through the influence of antiquity to reform its principles and to express democratic ideals in politics. The fall of the aristocracy went hand in hand with the affirmation of a new social class that would make and unmake fashion trends. The bourgeoisie, which made its fortune by dint of hard work, established a new scale of values, whose force of conviction was manifested by means of constricting undergarments. Over the course of the nineteenth century, a new ideal of feminine beauty came into being with the appearance of the "hourglass" figure. The waist, emphasized in all aspects of women's dress, became a criterion of beauty, as well as social status.[2] Under the Directoire (1795–99) women's figures were straight up and down, shaped only by cotton muslin dresses worn against the skin, so much so that Octave Uzanne denounced the masculinization of women.[3] And yet, substitutes for the whalebone stays of the ancien régime were already making an appearance: strips of

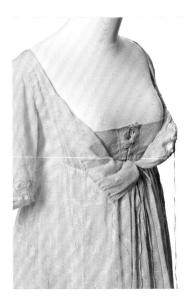

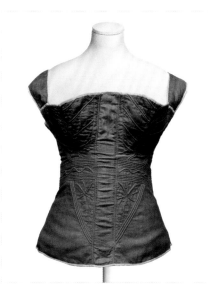

cotton or linen were sewn inside the dresses (fig. 122) supporting the bust and showing off the décolleté; while new undergarments inspired by a reinterpretation of antiquity, such as the "zona," a belt that hugged the ribs in such a way as to support the bust. After the respite enjoyed during the Directoire, the imperatives of deport-ment, modesty, and idealized canons of feminine beauty came back to the fore. The breasts were separated by a bodice known as a "divorce," or supported by the newly revived corset. In keeping with the rigors imposed by Napoleon, undergarments became standardized.[4] In 1808, Augustin Bretel filed an application for to patent the "Ninon corset,"[5] setting the tone for a cen-tury based on innovation, rigidity, and attention to detail.

This cotton envelope was characterized by the simplicity of its shape and construction. Four panels of cloth were assembled to make a sheath extending from the breasts to the hips.[6] To this structure sections of cloth, or gussets, were inserted into the body of the corset at the breasts and on the hips. The corset assumed the role of support for a woman's breasts, thanks to the wooden busk, which was slipped between the breasts, while short lengths of baleen kept the shoulder blades back, hugging the ribs. Consequently, women were forced to thrust their chests forward, keeping their shoulders down. At this point, the corsets assumed different shapes depending on whether they were homemade or fashioned by a seamstress: an example in the Victoria and Albert Museum (fig. 124) illustrates a luxury item in which the constriction was cre-ated by a play of stitching on the fabric, known as *trapunto*. The rigidified areas thus shaped a woman's breasts, redefining them.

Unlike what we will find later on, the first third of the century remained faithful to this design. The dating of these objects, often covering a decade or more, reflects this constancy. It is interesting to explore the logic behind its emer-gence. Indeed, while the simplicity of the object might appear modest compared to the richness of undergarments during the eighteenth century, with the increased interest in English "tailoring," the economy of means and the efficacy of each seam reflected an unprecedented modernity.[7] This corset introduced a trend unknown to the preceding century. Thanks to the introduction of gussets, it is distinguished from whalebone stays in following the natural curves of the bust line, accommodating and shaping the volumes of the

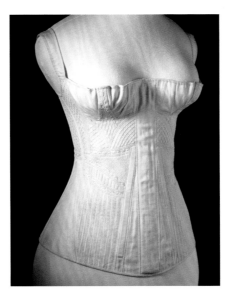
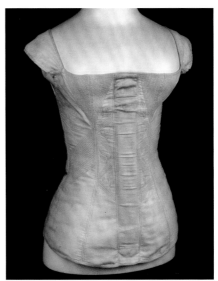

breasts and hips. Often perceived as regressive, the corset seems nevertheless to have asserted itself as a modern and innovative version of the whalebone stays.

A woman's silhouette remained long and straight, with the waistline still just under the breasts, but the return of a courtly etiquette imposed by Napoleon sparked the appearance of more costly outfits that increasingly highlighted the waist.[8] From that point on, the stiffness of the outfits went hand in hand with the emergence of new volumes, in the sleeves first of all, and then in the skirts, which became progressively more bell-shaped (fig. 126). Accompanying these evolutions, over the course of the 1820s the waist was set lower to resume its natural position. In being moved from the ribs into more fleshy areas, constriction evolved and came to act upon the redistribution of the bustline,[9] as we can see with the emergence of the notion of the "wasp waist" under the July Monarchy. Two concomitant phenomena became important: there was an increase in the dominance of undergarments over women's bodies, and the silhouette was transformed into constructions ever more subtle and complex. In order to dress herself, a woman donned first a chemise under the corset,

over which she added a petticoat of starched linen, or many petticoats one on top of the other, in order to give volume to the skirt. She finished dressing by adding sleeve-plumpers, which were attached to the shoulder straps of the corset (fig. 127). The wearing of the corset was thus justified by a surprising argument: in creating a rigid surface over a woman's torso, the corset redistributed the weight of the petticoat, while the shoulder straps were supposed to lessen the pain of the petticoat ties that were slipped under them, allowing for an unprecedented level of comfort.[10]

Following on the heels of the "masculinized" woman of the early century came the dematerialized woman, whose waist was compressed into a long corset, making it appear unrealistically small in comparison with her shoulders and skirt. Corsets were adapted to this new ideal in the evolution of their shapes. More and more pieces of fabric were added, clinging to a woman's figure ever more closely.[11] Hence an intimate bond existed between a woman's dress and the evolution of her undergarments.

In the 1840s, the silhouette became more slender and the sleeves less voluminous with the arrival of the taste for bared shoulders and plunging necklines. The décolletage became a

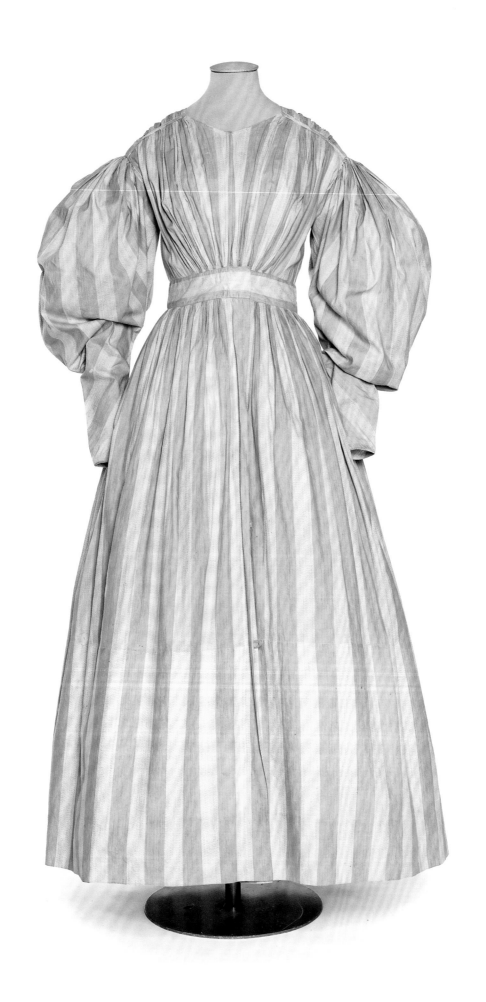

(opposite)
126. Dress
France, ca. 1830–35
Striped lawn
Musée des Arts Décoratifs,
Paris, collection Union fran-
çaise des arts du costume,
Purchased, 1949, UF 49.32.30

(right)
127. Sleeve plumpers
England, late 1820s, early
1830s
Off-white plain cotton, down
Collection of Cora Ginsburg,
New York

criterion of youth and beauty, hence the disap-
pearance of corset shoulder straps. From that
point on, and given the increasing volume of the
skirts, the corset became shorter, and "liberated
from the hips."[12] With the rise of the crinoline,
it became hidden inside the skirt; and with the
suppression of the hip gussets, the corset came
to a point over the pubic bone. The voluminous
Second Empire silhouette became the butt of
many jokes, as much among contemporaries as
later on.[13] And yet this acquisition of space seems
to express a new affirmation of women within
the imperial court. The appearance of the short
corset, as well as the corset-belt, reflects a mod-
erate grip on the female bust[14] and bears wit-
ness to the relative autonomy of women from the
July Monarchy onwards.[15] We should not mistake
the lessening of the constriction of the waist,
which from this point on is "continuous,"[16] for a
reduction in the taste for slim waists. Indeed, as
seen in the silhouette of the romantic period of
the 1830s, undergarments were adapted to the
new curvaceous silhouette. The Second Empire
is characterized by its taste for milky skin and
soft, full figures. A corset-belt now in the Musée
des Arts Décoratifs in Paris[17] is an example of this
new shape; the numerous gussets integrated at
the top and bottom of the garment attest to a
new roundness of the bust, which is accentuated
by the cut. As for the corset, the bust line is no
longer formed by two cups added to the body
of the garment; rather, its volume is created by a
new set of baleens running from the hip bone to
the fullest part of the breast (figs. 1, 111). The taste
for curves[18] dictated the creation of a rounded
contour beginning under the arm and supple-
mented by the addition of a small pad on the
breast. A new arrangement of baleens, organ-
ized in parallel groups, allowed for the creation
of a curve in contrast to the volume of the bust.
Without constricting the bosom, the baleens
gave rigidity to the corset and added support to
the plunging necklines in fashion at the time (fig.
130). Let us note in passing the diversification of
the materials used for the corset where, as with
other elements of a woman's dress, social dis-
tinction held sway. Silk and lace began to appear
on these accessories, which concern the most
intimate aspect of a woman's apparel and the
secrets of her boudoir.

From the end of the Second Empire to the
dawn of the twentieth century, the corset became
more and more complex and subtle. The middle
of the nineteenth century represents a turning

point on levels both economic and technical. Cities expanded, large thoroughfares appeared, and newspapers became a modern and accessible medium for the diffusion of fashion among metropolitan and provincial woman. Department stores became the inescapable meeting places of the lower classes, just as the bourgeoisie congregated at the theater, at balls, and inside the first shops for luxury goods. The corset adapted and responded to all of the above, as contradictory as this may seem. The new imperatives of capitalism made it an accessory subjected to constant renewal.

TECHNIQUES OF CONSTRAINT: THE CORSET DURING THE THIRD REPUBLIC

Around 1870, the abandoning of the crinoline facilitated the emergence of a part of the body previously hidden under layers of skirts: the thighs, now just perceptible under more form-fitting dresses—"the unmentionable thighs."[19] The new fashion engendered an evolution of the corset, modifying its cut and construction. The 1870s thus marked a turning point in the conception of this undergarment, which became longer, but also significantly more rigid. The baleens were distributed differently, to the point of covering the entire surface of the corset, which was not limited merely to enhancing a womans' curves, but succeeded in redefining their contours. Shaping baleens were used for this purpose; short and horizontally arranged, they could follow the contours of the breasts, and when gathered into groups of ten they formed a rigid surface over the shoulder-blades. Formerly in competition with each other, good carriage and constriction were now the two objectives of the corset. Its shape, now more complex, showed off the breast in an unprecedented fashion, becoming in and of itself an essential element in feminine aesthetics.[20]

It was as if the hourglass figure cultivated throughout the century became endowed with a new dimension: the profile. The busk, initially a rectilinear wooden rod, was transformed into a thick metal one. The year 1873 marked the first appearance of the "pear-shaped" busk, whose enlarged base flattened the bottom of the bust, while creating a volume at stomach level. The abdomen, echoing the bosom, became an important element in the "fashionable" figure at the beginning of the Third Republic. The busk became twisted, in front as well as in profile,

Les corsets sur mesure subissent une augmentation de 3.» ou de 5.» selon le genre et la qualité.

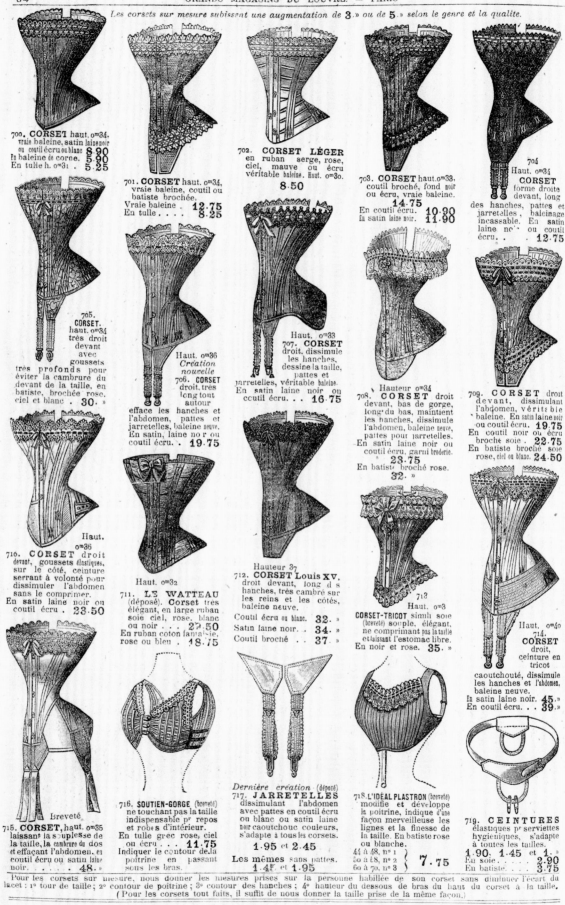

700. **CORSET** haut. 0m34, vraie baleine, satin laine noir ou coutil écru ou blanc **8.90**
En baleine de corne. **5.90**
En tulle h. 0m31 . **5.25**

701. **CORSET** haut. 0m34, vraie baleine, coutil ou batiste brochée.
Vraie baleine **12.75**
En tulle . . . **8.25**

705. **CORSET.** haut. 0m34 très droit devant avec goussets très profonds pour éviter la cambrure du devant de la taille, en batiste, brochée rose, ciel et blanc . **30.»**

Haut. 0m36
Création nouvelle
706. **CORSET** droit, très long tout autour efface les hanches et l'abdomen, pattes et jarretelles, baleine neuve. En satin, laine noir ou coutil écru. **19.75**

710. **CORSET** droit devant, goussets élastiques, sur le côté, ceinture serrant à volonté pour dissimuler l'abdomen sans le comprimer. En satin laine noir ou coutil écru . **23.50**

Haut. 0m32
711. **LE WATTEAU** (déposé). Corset très élégant, en large ruban soie ciel, rose, blanc ou noir . . . **29.50**
En ruban coton fantaisie, rose ou bleu . **18.75**

715. **CORSET,** haut. 0m35 laissant la souplesse de la taille, la cambrure du dos et effaçant l'abdomen, en coutil écru ou satin laine noir. **48.»**

702. **CORSET LÉGER** en ruban serge, rose, ciel, mauve ou écru véritable baleine. Haut. 0m30.
8.50

Haut. 0m33
707. **CORSET** droit, dissimule les hanches, dessine la taille, pattes et jarretelles, véritable baleine. En satin laine noir ou coutil écru. . . **16.75**

Hauteur 37
712. **CORSET Louis XV.** droit devant, long d s hanches, très cambré sur les reins et les côtés, baleine neuve.
Coutil écru ou blanc. **32.»**
Satin laine noir. **34.»**
Coutil broché . . **37.»**

716. **SOUTIEN-GORGE** (breveté) ne touchant pas la taille indispensable pr repos et robes d'intérieur.
En tulle grec rose, ciel ou écru . . . **11.75**
Indiquer le contour de la poitrine en passant sous les bras.

Dernière création (déposé)
717. **JARRETELLES** dissimulant l'abdomen avec pattes en coutil écru ou blanc ou satin laine noir caoutchouc couleurs, s'adapte à tous les corsets.
1.95 et **2.45**
Les mêmes sans pattes.
1.45 et **1.95**

703. **CORSET** haut. 0m33, coutil broché, fond noir ou écru, vraie baleine.
14.75
En coutil écru. **10.90**
En satin laine noir. **11.90**

Hauteur 0m34
708. **CORSET** droit devant, bas de gorge, long du bas, maintient les hanches, dissimule l'abdomen, baleine neuve, pattes pour jarretelles. En satin laine noir ou coutil écru, garni broderie.
23.75
En batiste broché rose.
32.»

Haut. 0m3
713.
CORSET-TRICOT simil soie (breveté) souple, élégant, ne comprimant pas la taille et laissant l'estomac libre.
En noir et rose. **35.»**

718. **L'IDÉAL PLASTRON** (breveté) modifie et développe la poitrine, indique d'une façon merveilleuse les lignes et la finesse de la taille. En batiste rose ou blanche.
44 à 48, n° 1 ⎫
50 à 58, n° 2 ⎬ **7.75**
60 à 70, n° 3 ⎭

704
Haut. 0m34
CORSET forme droite devant, long des hanches, pattes et jarretelles, baleinage incassable. En satin laine noir ou coutil écru. . **12.75**

709. **CORSET** droit devant, dissimulant l'abdomen, véritable baleine. En satin laine noir ou coutil écru. **19.75**
En coutil noir ou écru broché soie. **22.75**
En batiste broché soie rose, ciel ou blanc. **24.50**

Haut. 0m40
714. **CORSET** droit, ceinture en tricot caoutchouté, dissimule les hanches et l'abdomen, baleine neuve.
En satin laine noir. **45.»**
En coutil écru. . . **39.»**

719. **CEINTURES** élastiques pr serviettes hygiéniques, s'adapte à toutes les tailles.
1.90, **1.45** et **1.**
En soie . . . **2.90**
En batiste . . . **3.75**

Pour les corsets sur mesure, nous donner les mesures prises sur la personne habillée de son corset sans diminuer l'écart du lacet : 1° tour de taille ; 2° contour de poitrine ; 3° contour des hanches ; 4° hauteur du dessous de bras du haut du corset à la taille.
(Pour les corsets tout faits, il suffit de nous donner la taille prise de la même façon.)

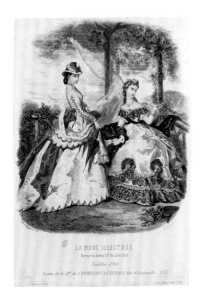

(left)
130. "Summer outfits"
La Mode illustrée, 21 (1864).
Bibliothèque des Arts Décoratifs,
Paris, Collection Maciet 214/36

(opposite)
131. Julius Cornelius Schaar-
wächter,
Agnès Sorma
1886
Photograph
Archiv für Kunst und
Geschichte, Berlin

creating a thoroughly modern, three-dimen-sional silhouette.

Over the years, wider baleens, also called busks, were placed all around the torso, notably down the sides, extending the shaping action of the corset. The tension applied by the body on the corset, and vice versa, was such that once removed, the corset adopted a rectangular shape; it was therefore the pressure formed by the volume of the torso on the constrictive struc-ture that created the long and rigid "cuirassed"[21] silhouette specific to the 1870s (fig. 133). The emergence of this new feminine ideal was made possible by new technical means. The taste for visible curves echoed the clothing designed for women's sports, which became widespread and varied and took their cues from those made for men. The new tailored suits were cut from woolen fabrics, which were austere but practi-cal for horseback riding, golf, walking, and other activities much in vogue at the end of the cen-tury. The invention of processes such as steam molding after 1868, made it possible to accentu-ate the natural contours of the bust, creating an exaggeratedly feminine silhouette.[22] Thanks to this technique, undergarments were shaped on a plaster model of a woman's torso and molded by the application of great heat. In this way, in contrast to Second Empire fashions, a woman's bust became the very foundation of a corset's functioning. If we attribute to the Second Empire a fashion that was ample but unconstricting, the years 1870–80 marked a turning point in the con-ception of a woman's body. The abandoning of the crinoline reinforced the interest in the body's natural curves seen in new "form-fitting" outfits. A woman's bust found itself encased in a rigid corset, in which the baleens covered the entire surface of the fabric. Hence, in a little over a half a century, the phenomenon of the corset was reconfigured, offering a profoundly modern ver-sion of itself that echoed a new consciousness of a woman's body, the great innovation of the nine-teenth century. These forms asserted themselves in women's figures and in their self-perception.

THE ECONOMY OF THE CORSET UNDER THE THIRD REPUBLIC

The predominance of the corset, which never waned, adapted itself to this new rhythm of life. Throughout the century different corsets had existed to be worn at different times of day[23] or

according the status of the wearer,[24] but the end of the century saw an unprecedented rigorousness in their distinction in attitude, detail, or even invisibility. The Paris luxury goods industry persisted in spite of the shock of the Paris Commune (1871), while the development of industrialization marked the end of home-made items and made way for unprecedented volumes of mass-produced goods,[25] distributed at low cost by department stores. Sales catalogues bear witness to this diversification, in which the items offered are as varied as the prices (fig. 129). In 1899, among the products available to fit every possible type of situation, we find "corset-maker's" corsets, "nursing" corsets, "supporting" corsets, "indispensable for young girls," "morning-wrap" corsets, but also "brassieres." Whalebone known as "real whalebone" became a luxury item, with many inferior substitutes on offer—mention of "real whalebone" or "real, new whalebone" increased the price of the items.[26] Comfort came at a price; a "lounging" or "sleeping" corset, "in jersey with a flexible busk and supple baleens" cost three times as much as a "rigid" corset.[27] *L'Art et la Mode* shows us the latest evolutions of this undergarment in the nineteenth century. For example, in the summer of 1899, the "latest crea-tion" was advertised as a corset "whose elasticity allows a woman to breathe freely," while the "latest model" was "flat in front with elastic gussets on the sides and waist to hold in the abdomen as much as one likes, without compressing it." The flat busk was purported to represent a healthier innovation,[28] all the while heralding new canons of beauty. A woman's figure was thrown totally off balance, as she was supposed to thrust her chest forward to emphasize the curve of the spine, which arched backwards. The action of the corset was therefore focused on the abdomen, with the bust supported only from below, and the volume of the small of the back encased. The corset became even longer, announcing the brassieres to come (fig. 142). Over the course of the century the corset went from being a simple cotton sheath emphasizing the virtues of nature and simplicity to a carapace that created a tilting body, the height of artifice.

THE INNOVATION OF CONSTRAINT AND THE ILLUSORY SEARCH FOR COMFORT

As we have noted, unprecedented economic models developed rapidly during the nineteenth century. The opening of department stores (such as Bon Marché, Samaritaine, and Grands

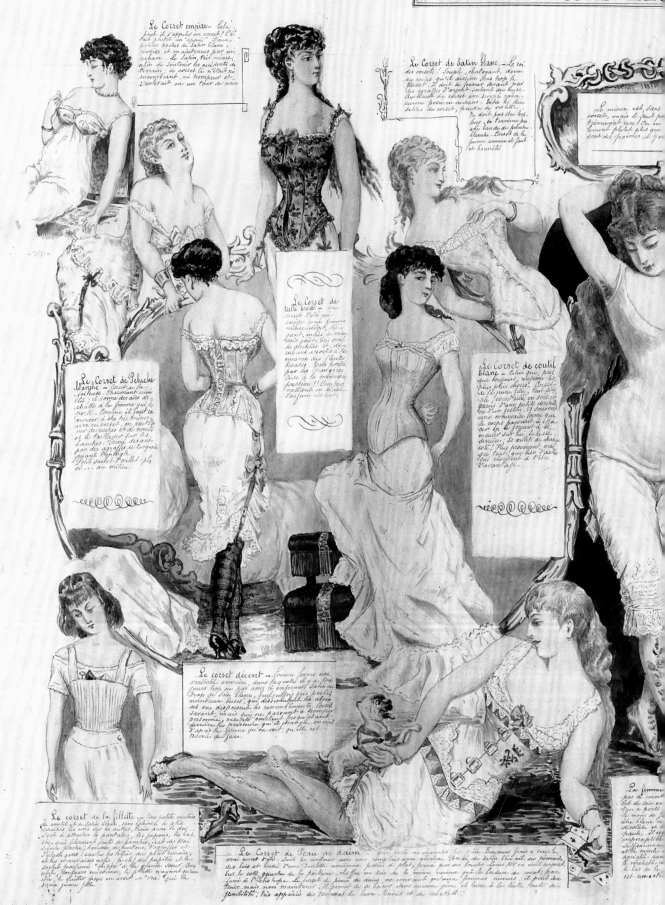

CORSETS

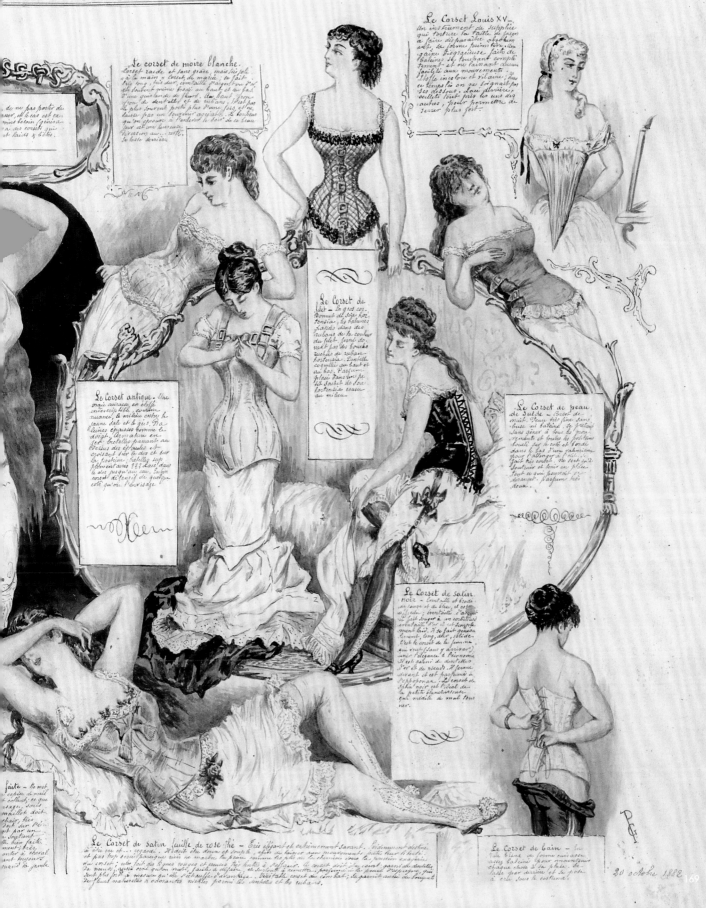

(pp. 168–69)
132. Henri de Montaut,
Études sur les femmes: les corsets (Studies of women: corsets)
1882–90
Ink and watercolor on paper
The Metropolitan Museum of Art, New York, The Elisha Whittelsey Collection, The Elisha Whittelsey Fund, 1951 (51.624.3)

(opposite)
133. James Tissot,
The Gallery of HMS *Calcutta (Portsmouth)*
1876
Oil on canvas
Tate Britain, London, 2014, N04847

Magazins du Louvre) made possible the widespread distribution of low-cost dresses according to a new system of standardized sizing. In this context, competition was stiff, with various products competing against one another. The process of registering patents accelerated this race for innovation, which in turn encouraged forms to change and techniques to evolve. The corset was the object of several innovations that were marked by a tension between the search for comfort for some, and the insistence on aesthetics for others.

In 1827, Madame Celnart presented the corset as a middle path for relieving women of some of the pain related to their manner of dress. Is comfort then to be understood as a lessening of constrictions considered necessary?

The late 1820s witnessed major innovations in terms of comfort, but also offered the possibility of increasing constrictions of a woman's torso in the metal eyelets that replaced those usually made out of cloth for the lacing of the corset.[29]

The question of eyelets involves the question of lacing, an intricate part of the daily wearing of the corset, which an affluent woman put on every morning with the help of her maid. In 1829 Jean-Julien Josselin patented the "pulley-back

to lace and unlace oneself," which gradually evolved before becoming truly established in 1840 (fig. 128). In the same vein, the busk would become the object of fundamental modifications. In 1829, Josselin patented a "locking busk," which was improved in 1837 by Pierre Nollet: the corset opened in the front, which is how it was put on, and then once closed it was tightened across the torso by means of the lacings in the back.

In 1845, *Le Petit Courrier des dames* asserted that the corset "could make a woman's life both easy and elegant."[30] And yet, over the course of the 1830s, the straps of the corset had been eliminated, sacrificing their comfort to the lines of the bared neck and décolleté. Some techniques followed in the wake of new theories of hygiene, such as, for example, the woven corsets launched by Jean Werly in 1838[31] that were reputed to have no seams. In 1878, Dr. Gustav Jaeger wrote an essay in which he expounded the use of wool for undergarments, rather than cotton and silk.[32]

Nevertheless, the mutations of the corset remained justified by concern for good health, all the while making greater constriction of a woman's body possible. Indeed, as we have noted, the century closed with the advent of the straight

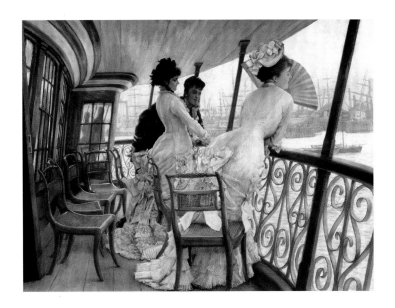

busk, which "added to the effects of nature."[33] A mythology of the corset emerged, concerning both its advantages and its flaws, defining an epoch during which it was inconceivable not to give way to its use. Women wore them in madhouses and in prisons,[34] with the corset becoming a guarantee of good conduct, a moral straitjacket.[35]

MODERNITY AND THE SYMBOLISM
OF THE OBJECT AND FEMININE AESTHETICS

In asserting itself at the beginning of the nineteenth century, the corset disregarded the numerous critiques of whalebone stays encountered in theories of hygiene put forward at the end of the eighteenth century. Although reconfigured in structure and symbolism, the corset little by little reverted to the specific codes of the previous century. In the new century the bourgeoisie distinguished itself though the details, closely following the various and ever more subtle fashions of the times. Within the bosom of this prescriptive class, arguments justifying the wearing of the corset were manifold.

First, advertisements established a specific vocabulary, undeniably intended to make sales, emphasizing the advantages attributed

to this undergarment. "Youth,"[36] "flexibility,"[37] and "gracefulness,"[38] coupled with an illusory comfort, were the hoped-for effects of the corset. It was believed capable of preserving a slender waistline, which had become a veritable criterion of beauty as it conveyed a youthful physiognomy. The corset occupied a very large place in the women's press in the years 1830–40, and then from 1870 to 1880, while it was only hinted at during the Second Empire.

By the end of the century, it was the subject of contradictory opinions: seen by some as a shackle, both physical and moral,[39] while at the same time seen by others as offering the advantages of natural posture.[40] At the heart of this ambiguity lies the image of the woman in the Third Republic. Mistreated during the years of the Commune, she enriched herself with these objects previously carefully concealed, which were to influence the highest echelons of society. Following the economic crisis of 1871, prostitution became a necessary alternative within already precarious levels of society. Courtesans and their enticing undergarments represented from then on a threat to the peace of the bourgeois household.[41] The poles had reversed, and fashion was no longer transmitted solely from the top down

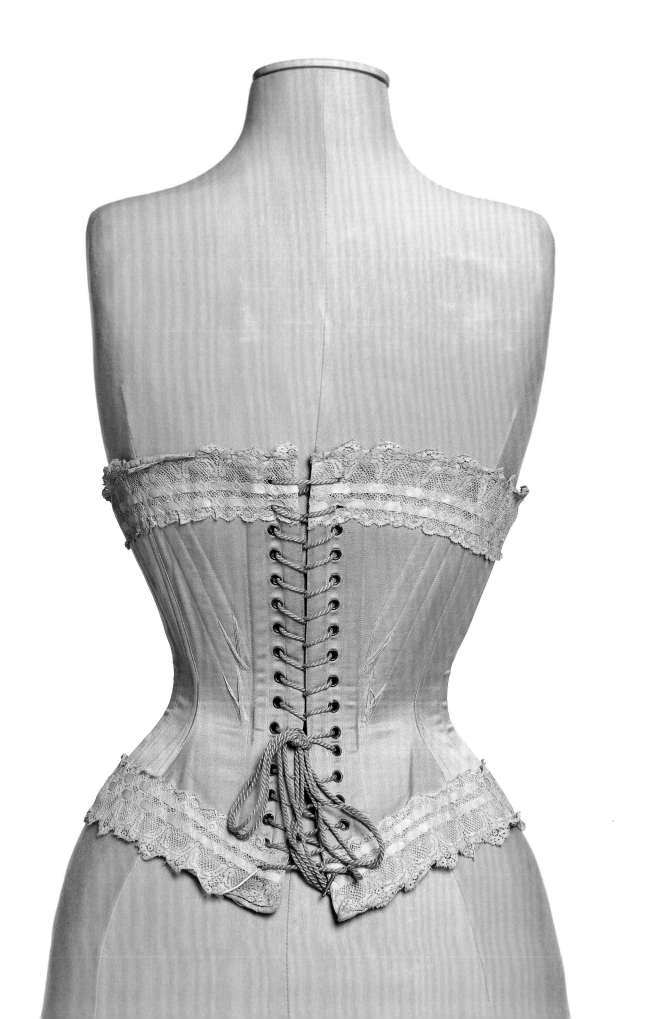

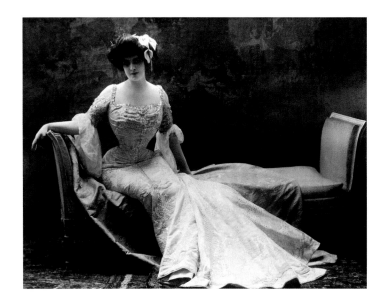

to the masses. It was in this context that colorful undergarments emerged, endowed with specific ornamentations, which were nonetheless quite codified. The taste for the hidden took hold, all the while instituting a game of new exchanges between outer and undergarments.[42] In spite of the illusion of unconstrained fashion,[43] each of these developments was strictly regulated, and undergarments were no exception to the rule: their colors, fabrics, shapes, and even their rigidity were criteria that could make or break the reputation of a bourgeois woman. Nonetheless, the corset remained a secret object, which no dress made visible over the course of the century, but which asserted itself in spite of everything in newspapers, advertisements, and department store catalogues. For the corset, whose aesthetics grew in importance, was also an element of intimate feminine apparel that became more

and more widespread throughout the century. Perhaps the enticing aspect of this undergarment compensated for the constraint endured on a daily basis.

Bearer of numerous signs, in the private as well as the public sphere, the corset is a complex object. Its shape, its cut, its decoration bear witness to an occasion, but also to the social status and the age of its owner. It occupied a central role in the nineteenth century, during which it followed the evolution of fashion. Women, who concealed the rigidity of this accessory under many layers of fabric, appeared "natural" when in society.[44] This notion took on unprecedented meaning: this "naturalness" was achieved not by the rejection of artifice, but, on the contrary, by the wearing of such accessories—a contradiction fundamental to the nineteenth century, which the corset went along with and reformed.

1. "The corset and the skirting, which are in a sense the 'maquette' of the outfit"; quoted in Violette [Alice de Laincel], *L'Art de la toilette: Bréviaire de la vie élégante* (Paris: E. Dentu, 1885), 55.

2. Leigh Summers, "Yes, They Did Wear Them," *Costume* 36 (2002): 65–74.

3. "The women of the Directory did not in any case have any of the delicacy and languid grace that were later to become what one called 'distinction.' Almost all of them were masculinized tomboys, with strong opinions, rough complexions, and overflowing fat—big-bosomed women with hearty appetites and greedy guts dominated by their senses"; quoted in Octave Uzanne, *La Française du siècle: La femme et la mode: Métamorphoses de la Parisienne de 1792 à 1892* (Paris: Librairie-imprimerie réunies, 1892), 20.

4. "French society found an organizer in Bonaparte, who was able to discipline the licentious freedom with which the population was stuffed"; quoted in ibid., 44.

5. Fernand Libron and Henri Clouzot, *Le Corset dans l'art et les moeurs du XIIIe au XXe siècle* (Paris: F. Libron, 1933), 73.

6. Élisabeth-Félicie Bayle-Mouillard [Madame Celnart], *Manuel des dames ou l'art de la toilette* (Paris: Roret, 1827), 143.

7. *Journal des dames et des modes* 51 (15 Prairial, year 13; June 3, 1805): 409.

8. *Journal des dames et des modes* 62 (10 Thermidor, year 15; July 28, 1807): 504.

9. Valerie Steele, *Fashion and Eroticism: Ideals of Feminine Beauty from the Victorian Era to the Jazz Age* (Oxford: Oxford University Press, 1985), 103.

10. "Next, you will put your skirt on, and here I have no comment except that it is best to stuff the string ribbon of the skirt's braces under the corset's straps, because they fall onto your arms, they cause unbearable pain"; quoted in Madame Celnart, *Manuel des dames*, 143.

11. *Les Modes parisiennes* (February 1844), quoted in Norah Waugh, *Corsets and Crinolines* (1954; London: Routledge, 1990), 104.

12. Ibid.

13. "We find ourselves face to face with the most graceless, the most uglifying, most mendacious, most outrageous things the human mind has ever managed to invent in its search for inner and outer garments"; quoted in Uzanne, *La Française du siècle*, 194.

14. "The corset-belt . . . perfectly supports the waist without imposing the stiffness that is the inevitable result of the discomfort caused by certain corsets"; quoted in *La Mode illustrée* (May 25, 1863): 163.

15. "Our fashionable lady, after making her visits, had the possibility of going to the painting exhibition to look at the efforts of our young school. Her being alone did not stop her, for the days were gone when a woman was afraid to appear unaccompanied in a public institution"; quoted in Uzanne, *La Française du siècle*, 130.

16. *La Mode illustrée* (May 25, 1863): 163.

17. France, 1860; cotton, whalebone, and metal. Paris, Musée des Arts Décoratifs, inv. UF 49.32.280.

18. "What is least fashionable at the moment is the straight line," *La Mode illustrée* 25 (June 19, 1864): 194.

19. Philippe Perrot, *Le Travail des apparences: Le corps féminin, XVIIIe–XIXe siècle* (Paris: Le Seuil, 1984), 175.

20. Corset. Canada, 1880. Silk, satin, steel ,and whalebone. Vancouver, Melanie Talkington collection.

21. "The fashion hasn't changed . . . still the bodice-breastplate, longer than ever, more plated than ever," *La Mode illustrée* 35 (August 27, 1876): 277.

22. *Englishwoman's Domestic Magazine* (December 1868), quoted in Waugh, *Corsets and Crinolines*, 105.

23. "In the morning, one put on a 'half-corset' so as to increase the constriction over the course of the day, so that it would be at a maximum in the evening, at the ball"; quoted in Madame Celnart, *Manuel des dames*, 143.

24. The Musée des Arts Décoratifs in Paris has a pregnancy corset, dated 1830, made of cotton, elastic, whalebone, and metal (UF 49.32.279).

25. "Between 1867 and 1889, the corset industry in France did nothing but prosper; the volume of business increased fivefold, and veritable factories were created in the provinces, where every new perfection of modern mechanics was employed. . . . At this time, France, whose annual turnover exceeded 25 million in gold, exported already more than 4 million francs worth of corsets"; quoted in Libron and Clouzot, *Le Corset dans l'art*, 159.

26. *Album illustré du catalogue des Grands Magasins du Louvre* (1894), 93.

27. *L'Art et la Mode* (September 29, 1894): 33.

28. Inès Gâches-Sarraute, a corsetière with a medical degree, thought that the curved bust was dangerous to one's health, and so she invented the straight busk, which "would support the abdomen" instead of pulling down one's internal organs; quoted in Steele, *Fashion and Eroticism*, 205.

29. "The man who designed the metal eyelets for corsets is M. Daudé, rue des Arcis, no. 22, in Paris. The makeup of these eyelets renders them impermeable to water; they are affixed to the fabric by use of pressure and present a perfectly smooth surface"; quoted in *Le Journal des dames et des modes* 25 (May 5, 1828): 200.

30. *Le Petit Courrier des dames* 25 (November 5, 1845): 194.

31. "Patent for the manufacture of seamless corsets, of J. Werly. . . . These corsets are made of a fabric of twisted yarn with whalebones from top to bottom with no seam whatsoever, and very graceful in form. The highest praise is by doctors who, despite their dislike of corsets, cannot help but approve of those of M. Werly"; from *Le Journal des dames et des modes* 38 (July 10, 1838): 606, "Annonces."

32. Eleri Lynn, *Underwear, Fashion in Detail* (London, Victoria and Albert Museum, 2010), 130.

33. Inès Gâches-Sarraute, "Le Corset: étude physiologique et pratique, 1900"; quoted in Steele, *Fashion and Eroticism*, 205.

34. Summers, "Yes, They Did Wear Them," 67.

35. Steele, *Fashion and Eroticism*, 176.

36. *Le Petit Courrier des dames* 25 (November 5, 1845): 194.

37. *Le Journal des dames et des modes* 14 (March 15, 1838): 228; ibid. 35 (June 25, 1838): 565; *Les Modes parisiennes* 257 (January 30 1848): 1693.

38. *Le Journal des dames et des modes* 44 (August 10, 1838): 717; *Les Modes parisiennes* 271 (May 7, 1848): 1808.

39. Uzanne, *La Française du siècle*, 113.

40. *La Mode illustrée* 30 (July 27, 1879): 239, "Variétés—imperfections et défauts de jeunes filles."

41. Mrs Pritchard, "The Cult of Chiffon" (1902), quoted in Steele, *Fashion and Eroticism*, 154.

42. "In the past, when a lace stuck out from a dress, one was told discreetly of the unpleasant development. . . . Nowadays, the lace asserts itself, advertises itself, and to make certain that everyone notices, it is striking in color"; from *La Mode illustrée* 50 (December 17, 1876): 411.

43. "Nowadays, when a women is poorly dressed, it's because she wants it that way"; from ibid. 32 (August 12, 1883): 253, "Modes."

44. "To say everything, one word suffices: to be simple and natural"; from ibid. 28 (July 17, 1871): 219.

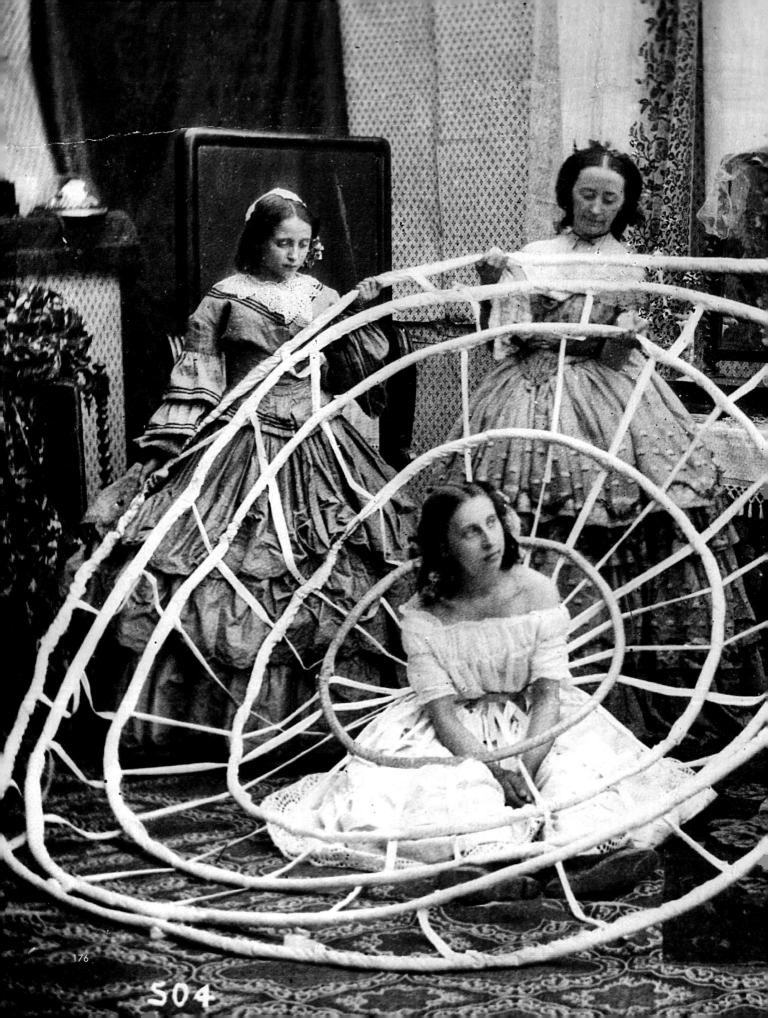

Lina María Paz

CRINOLINES AND BUSTLES: THE REIGN OF METALLIC ARTIFICES

The crinoline and the bustle defined the unmistakable silhouettes of the Second Empire and the first decades of the Third Republic. These two items came to the fore during a time of profound ideological, social, and economic change. They became symbols of the higher aristocracy and the new classes of the emerging bourgeoisie, for whom the notion of self-image was fundamental to the construction of a personal identity, as well as serving as an important means of social legitimization.

The rhythms of daily life were profoundly shaken by the changes that took place over the course of the nineteenth century, characterized by the growth of industry, the mechanization of the workplace, and the rural exodus leading to the expansion of urban populations. Fashion experienced these changes and evolved under their influences. The textile industry took advantage of technical developments and a more abundant workforce to manufacture greater quantities, faster than ever before and at less cost. Society's conception of itself adapted to this in accelerated lifestyles, as the century of inventions instilled a curiosity and love of novelty, which in turn allowed for fashions to be adopted and easily replaced. Fashion trends, silhouettes, and accessories followed each other in quick succession, heralding cycles of change that set the pace for the fashions of today.

The crinoline and the bustle are fashion objects that serve as reference points in establishing a society's taste at a precise moment in history, as well as understanding the evolution and fluctuation of the silhouette between 1850 and 1890.

THE CRINOLINE, BETWEEN STRUCTURE AND SILHOUETTE

Between 1845 and 1890 the silhouette underwent two major innovations corresponding to the type of undergarments worn: the crinoline between 1845 and 1870, and the bustle between 1870 and 1890. The salient fashion trends of the 1830s, inspired by the Gothic period, began to undergo changes, and around 1840 a new style known as "Pompadour" emerged in the decorative arts and fashion. The crinoline dress to some extent recalls the dresses worn during the ancien régime and, in a visual and symbolic manner, can be seen as an object that made it possible to legitimize the magnificence and luxury of the Second Empire and associate it with the monarchic power of the eighteenth century.

Nonetheless, the appearance of the crinoline, which dates back to the year 1842, preceded the reign of Napoleon III. Indeed the women who popularized this fashion during the Second Empire, among them the Empress Eugénie, had already been wearing crinolines for several years (fig. 137).

Originally "crinoline" was the name of a rigid fabric woven with a cotton or linen warp and a horsehair weft, used for the construction of underskirts to create volume beneath the overskirt. During the 1830s, the bell-shaped petticoat or underskirt itself became know as a "crinoline." During the following decades, the word described a metal cage used to create a woman's silhouette. During the 1840s, the skirt became progressively larger and heavier, and the petticoat alone was not enough to create the desired shape, and so it was replaced by layers of underskirts, up to seven in number. In 1856, Auguste Person introduced the crinoline-cage, which replaced the layers of underskirts, which were cumbersome and extremely heavy. The crinoline-cage was made of steel hoops, smaller at the top and progressively larger toward the bottom. These hoops were inserted directly into an underskirt, or were joined together by means of thin straps, in such a way as to be able to be flattened as needed (figs. 117, 136).

The advantages of this technical innovation in the fabrication of more solid structures are manifold, as skirts became more and more voluminous, and required greater support. But at the same time, tastes were moving away from the choice of lighter, less-expensive fabrics. Practicality was a factor as well; the crinoline-cage was much lighter than skirts, and offered the advantage of liberating the legs, which were previously constrained. In an article defending the wearing of crinolines, Emmeline Raymond, editor of *La Mode illustrée* (Illustrated fashion), explained things in the following terms: "If we're dealing only with the cause, we maintain the puffiness criticized in current fashions, as well as the comfort and economy resulting from the use of steel hoops which dispense the wearer from bearing the weight of an indefinite number of starched underskirts whose consistency can be compared to cardboard, and which form straight, hard pleats . . . ; but if we wish to get rid of the effect, we go even further, going so far as women in horrible cases that encumber their freedom of movement."[1]

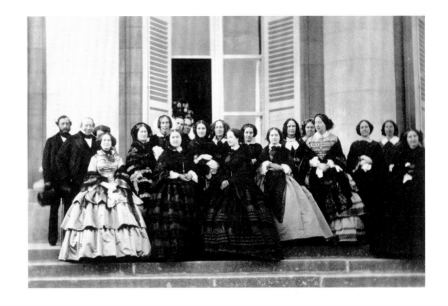

(p. 176)
136. *Young woman waits patiently whilst the hoops to support her crinoline are prepared*
1860
Hulton Archives, London Steresoscopic Company Comic Series-504

(right)
137. Édouard Delessert, *L'Impératrice Eugénie à Compiègne et les dames de la 3ᵉ série de 1856 sur la terrasse du palais* (The Empress Eugénie at Compiègne and the ladies of her court on the terrace of the palace)
1856
Print on albumen paper
Château Compiègne, C95.005

During the twenty-five years in which the crinoline found favor in women's fashion, it was modified into three distinct silhouettes. Between 1845 and 1860 the crinoline was round, as the Pompadour style reinterpreted its shape based on the panniers of the eighteenth century and as the skirt assumed a dome shape. Other "historic" features included a bodice ending in a point reminiscent of the stomachers, and fabrics with motifs such as garlands of flowers, with lace at the sleeves suggesting *engageantes*, or false sleeves (fig. 138). One feature of this period is the popularization of the two-piece dress, in which the skirt and bodice were separate; the same skirt, and thus the same crinoline, could be used for all occasions both day and night, while the bodice could be changed according to the circumstance.

Between 1860 and 1866, the crinoline became more supple and ergonomic, flattening in front and projecting out toward the back, attaining its greatest scope at around 10m in circumference (fig. 140). The train became one of the most recognizable characteristics of this new silhouette. The decoration was as ever-present as before, but the emphasis shifted to the back. The flattening of the front modified the bodice, which remained pointed at the beginning of this new trend, but was later transformed to favor the wearing of a tunic, an overskirt narrowed toward the back, exposing the underskirt, often of a contrasting color.

At the end of the 1860s, the silhouette was transformed yet again (fig 141). Around 1867, the skirt became less puffy, and the crinoline became cone-shaped, losing volume at the top, and with a few hoops at the bottom. Then hybrid items began to appear: crinolines with bustles. The bottom of the skirt retained several complete hoops, while a few half-hoops of reduced diameter were added at the back, creating the bustle.

The change affecting the fashions between the Second Empire and the Third Republic did not result from a process of rejecting one trend in favor of another in acts of rebellion or opposition to established norms, as might have been the case before that time. Here, the evolution of the silhouette demonstrates quite clearly the gradual progression from voluminous shapes to another silhouette, which preserved the characteristics of the preceding one, while adding features of its own. The result was a new system of women's dress (fig. 139).

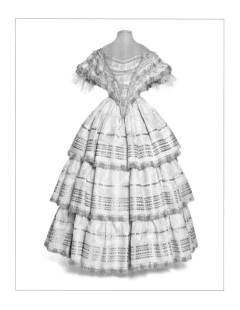

THE BUSTLE, A PLAY OF UNDER- AND OVER-SKIRTS

The bustle took over from the crinoline in supporting the weight of dresses that were more and more heavily ornamented (fig. 143). Structurally speaking, the crinoline did not undergo any changes other than those qualified as minor ones with regard to the bustle. The latter indeed presents an impressive number of derivations that did not follow one after the other, but overlapped in time, and were worn simultaneously between 1870 and 1890.

The weight and the volume of the skirts continued to be concentrated toward the rear, around the small of the back, with the addition of an over-structure called a pouf. The objective of the different types of bustle was, on the one hand, to create the visual effect of volume, and on the other to support the weight of the fabric construction. The weight of the fabric was increased by the "tapestry style" very much in fashion at this time, due to the profusion of ornamentation such as tassels, ribbons, flounces, and so on (fig. 144).

It is possible to identify three principal types of device identified with the term bustle: the classic or crayfish tail, the "faux-cul" or small bustle, and the bustle cushion. We should note, however, that the different silhouettes characteristic of the years 1870 to 1890 were created by the association of the bustle and the pouf, used in conjunction with each other.

The objective of using the bustle was the same as that of the crinoline: as a means to create volume as well as to support fabric constructions. Unlike the crinoline, however, the variety of bustle shapes is explained by the different effects desired by the woman wearing them, by modifying the volume according to the dresses worn. An early idea of the bustle can be found in a description by François Boucher in his famous *20,000 Years of Fashion: The History of Costume and Personal Adornment*, where he defines it as

a type of whaleboned half-cage assuming shapes which varied according to the current fashions, and which, placed under the skirt, after the disappearance of the crinoline, supported the volume of the back of the skirt at the small of the back and served as a support for a more or less voluminous puffed bustle pouf.[2]

Between 1870 and 1890, there were three distinct periods of the bustle, creating three different types of silhouette. Between roughly 1870 and

Mᵐᵉ Aglaée surnommée Planchette, cherche à remplacer les charmes que la nature lui a refusés. Naissance de la crinoline.

Mᵐᵉ de Carcassonville, nourrie de bien plus fortes études sur le beau, inventa le jupon crinoline à baleines.

Mais c'est Mᵐᵉ la comtesse d'Esbroufferas qui a le plus mérité la reconnaissance du beau sexe; c'est elle qui a inventé la fameuse crinoline en fer.

Mon cher, je suis femme de chambre à présent, j'em-bellis le beau sexe. — Tiens, ça m'irait un poste comme ça.

Vive la crinoline! ils ont beau dire, c'est cossu, et puis ça vous avantage joliment.

FABRIQUE DE Crinolines.

Travaillons, mesdemoiselles, grâce à nos heureux talens.

Les dames seront plus belles, et les messieurs plus galants.

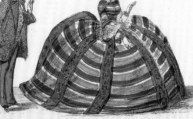

Oh! pour le coup, ma chère amie, vous conviendrez qu'il y en a un peu trop.

Vraiment Mⁱˢˢ vous êtes d'un ridicule... vous n'avez jamais que des choses désagréables à me dire, certes je suis trop modeste, au contraire.

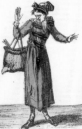

Ah mon dieu! j'ai oublié ma crinoline.

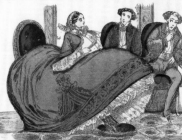

Satanée crinoline va! On voit les mollets de ma femme...

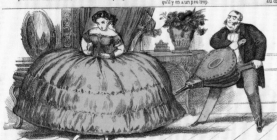

Encore..... encore..... encore mais allez donc! allez donc!!

Ouf! je suis éreinté.

Ces architectes sont tous des imbéciles: ils font des portes si étroites qu'on ne pourra bientôt plus entrer dans nos maisons.

Jésus madame! vous ne pourrez jamais passer.

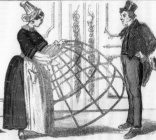

Devinez voir à quoi que ça sert, ça? et ben! c'est une crinoline; c'est avec ça que no dame s'habille. — I n'est pas dieu possible!

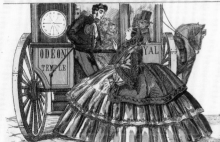

6 Sous? non, madame, c'est 24 sous, parceque vous tenez de la place pour quatre.

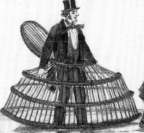

Ma chère amie, je t'ai ménagé une surprise; je t'ai acheté ceci pour faire une crinoline.

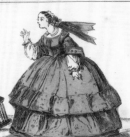

Cela! mais c'est une cage à poulets!

Il y a que ma femme fait le tapage à la maison, elle veut une crinoline, il lui en faut une, n'y a pas. — Je ne te dis que ça, ça qu'une femme a dans la tête....

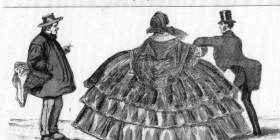

Tiens! les femmes de la ville à présent, c'est comme les escargots de cheux nous; elles portent tout sur le dos.

Mais, monsieur, est-ce que vous n'allez pas vous tenir mieux que cela? Eh! M¹ᵉⁿⁱⁱⁿ, vous croyez peut-être que c'est amusant de vous donner le bras avec votre crinoline qui me tape dans les mollets.

Je veux une crinoline aussi moi, na...

Pourquoi pleures-tu comme ça toi?

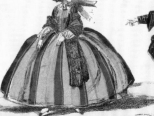

C'est parceque tu es jalouse, veux-tu deux sous pour t'aider à en acheter une?

En voilà une qui est gracieuse avec sa crinoline, comme un cent de fagots.

Imprimerie Lith. de Pellerin à Epinal.

Propriété de l'Editeur Déposé.

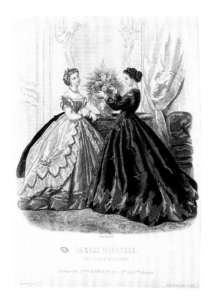

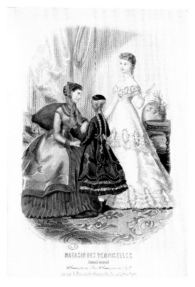

1875, the emergence of a new, transitional silhouette became popular with the use of a first bustle whose shape retained the characteristics of the Second Empire silhouette; then, between 1876 and 1882, the bustle disappeared almost completely in favor of a silhouette molded to the hips with a volume placed lower on the back of the body; then, between 1882 and 1890, the bustle made a big comeback. At that point it was even bigger than before, with the contrast between the back and the legs reaching angles up to 90 degrees (fig. 142).

The classic bustle, or crayfish tail, is one of the most emblematic models of imaginative fashion under the Third Republic (fig. 120). It earned its name due to its structure in successive sections and the red color of the cloth used in its fabrication; today, the name crayfish tail encompasses all structures with such characteristics, except for the notion of color, which was not necessarily red in the later models.

The bustle is ever present between 1870 and 1890, except between 1876 and 1882. The "crayfish tail" was made by superimposing a variable number of half-circles whose circumference increased in descending order. It was placed on the back of the body, and attached by straps tied around the waist. These devices often included a second pair of elastic bands, lower down, to provide additional fastness around the hips. Some models included devices placed inside, along the back, made of black squares of fabric. Situated on either side of the bustle, they had eyelets on the inside edge, which permitted an adjustable lacing to produce the desired effect. In fact, this mechanism made it possible to adjust the roundness of the metal hoops based on how tight or loose the lacing was. A loose lacing produced little visual effect, while a tight lacing produced a marked contour. We should note that this type of lacing did not exert any pressure on the body, unlike a corset, but only on the structure itself, and consequently modified the silhouette without modifying the body itself. The objective of this type of device was to adapt the shape according to the different daily activities, each requiring a specific outfit. Hence, whereas the daytime dress was moderate in volume, a special evening dress was in general considered an occasion to present more ample forms. An evening dress, more voluminous and therefore heavier, required an appropriate structure to reinforce the opulence of its puffed bustle pouf.

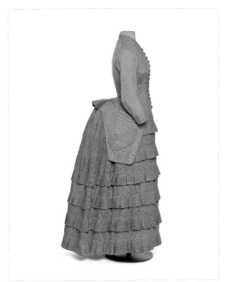

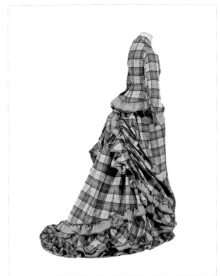

The small bustle known in French as a "faux cul" in our inventories include certain bustles with specific characteristics that differed from those of the crayfish-tail bustle. Although traditionally grouped under the same heading—the bustle—we must make finer distinctions among the group of structures that followed.

"The bustle is not about to disappear. We even see some which are quite comical: some have the same shape as the horn of a rhinoceros; others are like two spread wings placed on the lower back."[3] Such variations of structure differ from each other in shape, the materials used to make them—fabric, steel, with feather or horsehair stuffing—as well as the techniques of construction (figs. 112, 114, 115). We find tubular structures, overlapping rows of small or large flounces, pliable structures or woven metal or wicker strips (figs. 118, 119). These bustles are reduced in length, as opposed to the crayfish tail: they do not follow the length of the dress, concentrating their volume at the curve of the back and the buttocks. In general, these small devices were attached to the waist by a system of knotted straps often outfitted with a hook at the top to attach it to the corset. Some of them used the same system of interior laces as that previously described for the crayfish-tail bustles, permitting the modification of volume according to the tightness of the lacing.

A category to note within this subdivision is the retractable bustle (known in French as a *strapontin*). A novelty of the 1880s, it was heralded as a scientific discovery. Made of metal semicircles, the *strapontin* was a small, light structure nevertheless capable of creating considerable volume (fig. 115). This bustle was supposed to offer more protection to the spine, thanks to a mechanical system that functioned around one or more hinges, folding like the hood of a convertible car.

The bustle cushion, another type of undergarment designed to create volume, was essentially a rudimentary structure (fig. 147). With its extremely simple construction, it was accessible to a large number of women due to its modest production cost and subsequent low retail price. The simplicity of the idea also made it possible to make one at home (fig. 148). This type of item, emblematic of the fashion of the times, was affordable to women of more modest means who wished to imitate the trends of the more affluent classes.

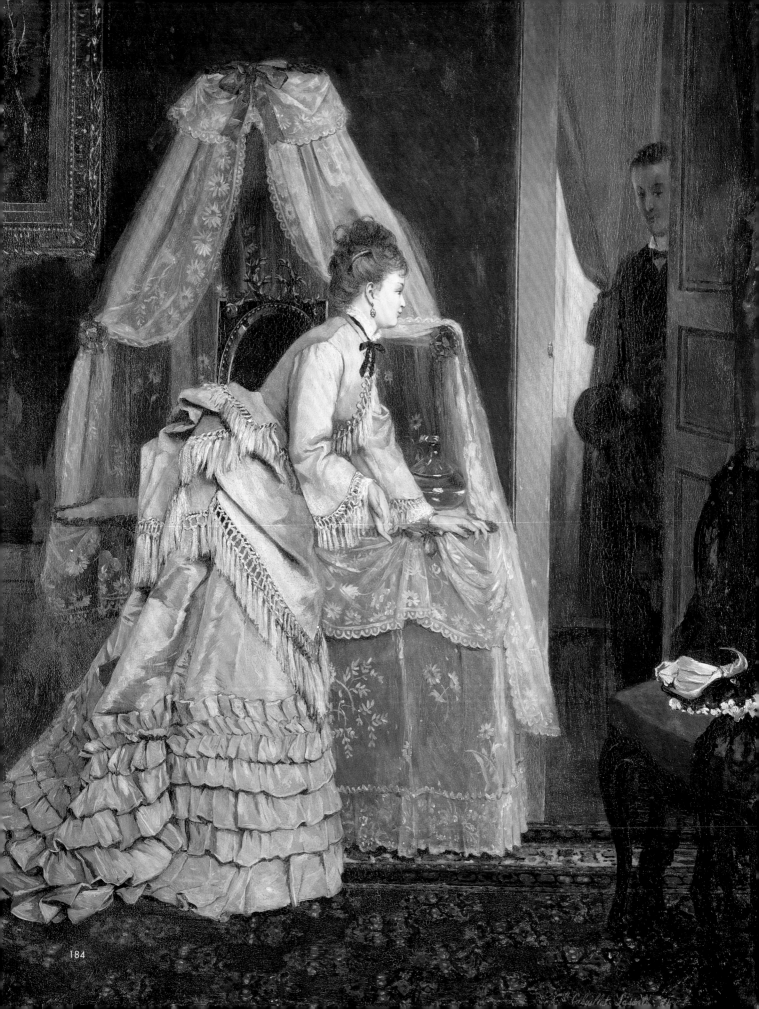

(opposite)
144. Camille-Léopold Cabaillot-
Lassalle,
The Vision
1874
Oil on panel
Hinton Ampner, Hampshire;
National Trust Images

(p. 186)
145. H. F. Eaton,
Patent for a bustle (detail)
United States, 1886
Collection of Melanie Talkington,
Vancouver
See p. 150

(p. 187)
146. J. L. Wells,
Patent for a bustle (detail)
United States, 1885
Collection of Melanie Talkington,
Vancouver
See p. 151.

This year saw the invention or renewed a new article [of dress]. The cushion filled with horsehair, cotton batting or even feathers, is used to hold up panniers. A cushion is nothing more than a square, oval or rectangular item, according to the cut of the skirt. It can be made out of sateen, jaconet, sarsenet—in a word, a flexible and light fabric. Between two pieces of cloth the same size, one places a layer of horsehair, batting or feathers, stitching it like a padded lining. One gathers the upper edge and attaches it to a sash or bustle, so that it puffs out. On either side of the item one makes a pleat, in order to be able to attach it to the bustle. Nothing could be easier than making a cushion for oneself at home.[4]
Types of cushioning ranged from the modest ones made of simple squares of cloth stuffed with straw, horsehair, and so on, to the very elegant bolsters made of quilted silk. This type of bustle, small in size and very light, was used for informal occasions, often in conjunction with less heavy dresses made of light fabric, or in the more private and intimate sphere of the life of a bourgeois woman, in her boudoir garments.

During the period of the second bustle (1882–90), it was the custom to systematically combine the bustle with the bustle cushion. The aim of this combination was to obtain an important volume around the buttocks, in order to reinforce the curve of the hips as required by the aesthetic norms of the times. Little by little these norms evolved, as the curve of the hips was lessened and the volume diminished in order to correspond to the emergent new fashion. Around 1888, it was no longer absolutely necessary to combine the massive elements of the bustle and the bustle cushion, with the latter now sufficing to produce the desired effect. An important element in the creation of the characteristic silhouette during these years was the pouf (fig. 152).

Used in conjunction with the bustle, this was an external construction made out of cloth held up by the bustle underneath the skirt. François Boucher gives us a definition of it in his *20,000 Years of Fashion*: "Pouff, pouf, puf, after the fall of the crinoline in 1867, and until 1890, the pouf was a voluminous drapery formed by the overskirt, or *la polonaise*, over a support called a bustle, worn under the skirts."[5] The *polonaise* was an overskirt, an influential trend at the time of Louis XVI, which showed the front part of the underskirt, with the excess fabric hitched up at the sides and secured at the back through a system of flounces

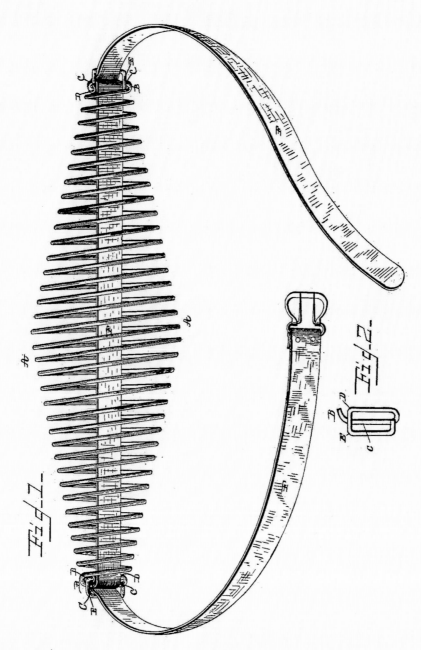

Fig. 1.

Fig. 2.

J. L. WELLS.

BUSTLE.

No. 325,031. Patented Aug. 25, 1885.

Fig.1.

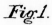

Fig.2.

Fig.3.

Fig.4.

Fig.5.

WITNESSES:

N H Culver

John Nolan,

INVENTOR

Joseph L. Wells,

per Joshua Pusey att'y.

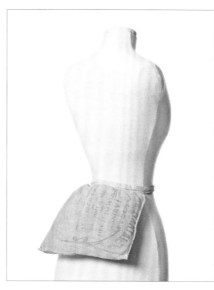

(far left)
147. Bustle cushion
France, ca. 1890
Calico, straw
Musée des Arts Décoratifs, Paris,
collection Union française des arts
et du costume, Gift of Madame
François Boucher and her cousins
from Burgundy, 1973, UF 73.34.58

(left)
148. Bustle cushion
France, ca. 1890
Printed calico, straw
Inscription: "Lacta Nantaise/ Farine
remplaçant le lait dans l'élevage
et l'engraissement des veaux et
porcelets" (Lacta from Nantes/ Flour
replacing milk in the rearing and
fattening up of calves and piglets)
Musée des Arts Décoratifs, Paris,
collection Union française des arts
et du costume, UF 2013.010.3

and ruching. Women had the option of reusing the underskirts of old dresses made for crinolines to make poufs. The pouf could therefore be formed with a volume of fabric attached around the waist, like a sash.

THE DEMOCRATIZATION OF OSTENTATION

The second part of the nineteenth century was a time of profound political, social, and economic upheaval. The evolution of society had a very concrete influence on physical appearance as a symbol of social status. One of the most striking changes of this century was without doubt the very visible divergence between men's and women's dress. A man's dress expressed the ideal of elegance centered on restraint and through a palette of neutral colors; white, gray, and especially black gained a prominent place in the wardrobe of any distinguished man. A man's social status was no longer reflected in his dress or appearance. A woman, on the other hand, became the visible sign of her husband's wealth. In direct opposition to the sobriety of men's outfits, women's fashions overflowed with color, opulent shapes, and rich fabrics and decorations in particular. The highest quality of cloth, ornamentation, and yardage of fabric

thus represented the price a man could afford to pay.

The wearing of crinoline dresses, which could reach huge proportions, required, as we have seen, a large quantity of fabric and the help of domestic servants to put them on (fig. 136). This apparently superfluous act in fact concealed a strong symbol of hidden economic status: a woman who wore such cumbersome clothing could only do so with the help of servants, a luxury in itself that a woman could only afford thanks to the economic power of her husband. Idleness and feminine fragility thereby came to be models of behavior and aesthetic beauty: a fragile woman who did not exert herself physically and was constantly assisted by servants suggested a wealthy husband of high social status. This expression of rank perhaps helps to explain why women were prepared to wear an undergarment as cumbersome, even uncomfortable, as the crinoline. The crinoline rendered the most basic movements extremely complicated, such as, for example, the simple act of walking through a doorway. It could, moreover, make some activities dangerous—going up or down stairs, or getting out of a horse-drawn carriage—and in the most extreme cases, it could

149. Franz Xaver Winterhalter, *L'Impératrice Eugénie entourée des dames d'honneur du palais* (The Empress Eugénie surrounded by the ladies of her court)
1855
Oil on canvas
Château Compiègne,
MMPO 941; RF 2307

be deadly, as was the case for numerous women who perished, imprisoned in their outfits when their crinolines caught fire.[6] Wearing the crinoline could also lead to indecent situations during certain movements, such as bending forward or even sitting down, exposing more than was morally acceptable. This forced women to pay more attention to their lingerie, which became embellished to tone down any possible indiscretion.

The many critiques of the crinoline were expressed in the multitude of caricatures published in the press at the time. Its detractors did not hesitate to mock the grotesque quality of the daily scenes caused by this "unwieldy object" (figs. 150, 151). Certain illustrations represented the comic aspect of the outsized proportions of the object, which forced the husband, for example, to contort himself in order to offer his arm to his wife, in spite of the distance between them, when out for a stroll with her. Prosper Mérimée, in his correspondence with the countess de Montijo, mother of the Empress Eugénie, wrote the following: "You cannot possibly imagine anything more comical than a crinoline getting into a gondola."[7] The crinoline nevertheless had its supporters. First of all there were women, and in particular those from the aristocratic milieu, who

frequented the court. They saw the crinoline, worthy successor to the panniers of the eighteenth century, as a means to restore the notion of court dress, following in the tradition of the ancien régime, where opulence and luxury were mandatory. One of the principal enthusiasts was the Empress Eugénie herself, a fashion icon and great admirer of Queen Marie-Antoinette, the very embodiment of eighteenth-century fashion (fig. 149).

The few male supporters of the crinoline defended it for aesthetic reasons, judging that a pyramidal silhouette conferred a superior beauty on a woman: "They are right to prefer ample, heavy, and powerful skirts, which expand before the eye, to the narrow sheaths worn by their mothers and grandmothers. . . . The waist appears elegant and slim; the upper body is detached to its advantage, and the whole person becomes pyramidal in a most gracious manner. This mass of rich cloth acts like a pedestal for the head and torso, the only important parts now that nudity is no longer acceptable. A more serious objection might be that of the incompatibility of the crinoline with modern architecture and furnishings. . . . Very well! Let us make larger salons, and change the shapes of furniture

and carriages, and demolish the theaters! A fine affair! For women will no sooner give up the crinoline than rice powder."[8]

French life changed profoundly after the fall of the Second Empire in 1870. A new way of thinking emerged, one that shunned the luxury of the court of Napoleon III, favoring instead good conduct, the importance of family, austerity, and traditional values. In fashion, this change was in reality quite superficial: the apparent simplification of women's dress, due to the suppression of the crinoline, simply deflated the shape of the skirt. Although the silhouette evolved considerably, luxury was as present as ever in the enormous quantity of ornamentation and the quality of the fabrics. Fashion became progressively democratized over the course of this period, with technological advances and department stores making fabrics more accessible to a larger population (fig. 153). More women of different social classes had the opportunity to buy dresses, accessories, and bustles available within a large range of prices, which consequently created a certain standardization of the silhouette. Nonetheless, even though the popular silhouette superficially resembled that of the bourgeoisie, a practiced eye could easily judge the social class

of a woman based on the degree of sophistication of her dress and the materials used in her outfit. Paradoxically, the bustle, which was easy to manipulate for a single person given its small size, would, unlike the crinoline, lose the symbolic connotation of economic ease linked to the employing of servants. Yet this did not prevent high-society women from wearing them.

The force of the Industrial Revolution during the second half of the nineteenth century led a new social class to dominate the economic and political sector. The *grand bourgeois* was the principal actor in this upheaval, with its wealth and social recognition based first and foremost on its work. Their social ascendency rested on a moral concept of life and stricter codes of conduct. The question of a man's self-image and how he wished to present himself in society was of capital importance in the construction of this public facet of success, respectability, and financial prosperity. The bourgeois woman, like her aristocratic counterpart before her, was the visible sign not only of her husband's moral respectability, but also of his economic status.

The elegant woman became the major reference point in French fashion. After a tradition based on a single predominant female

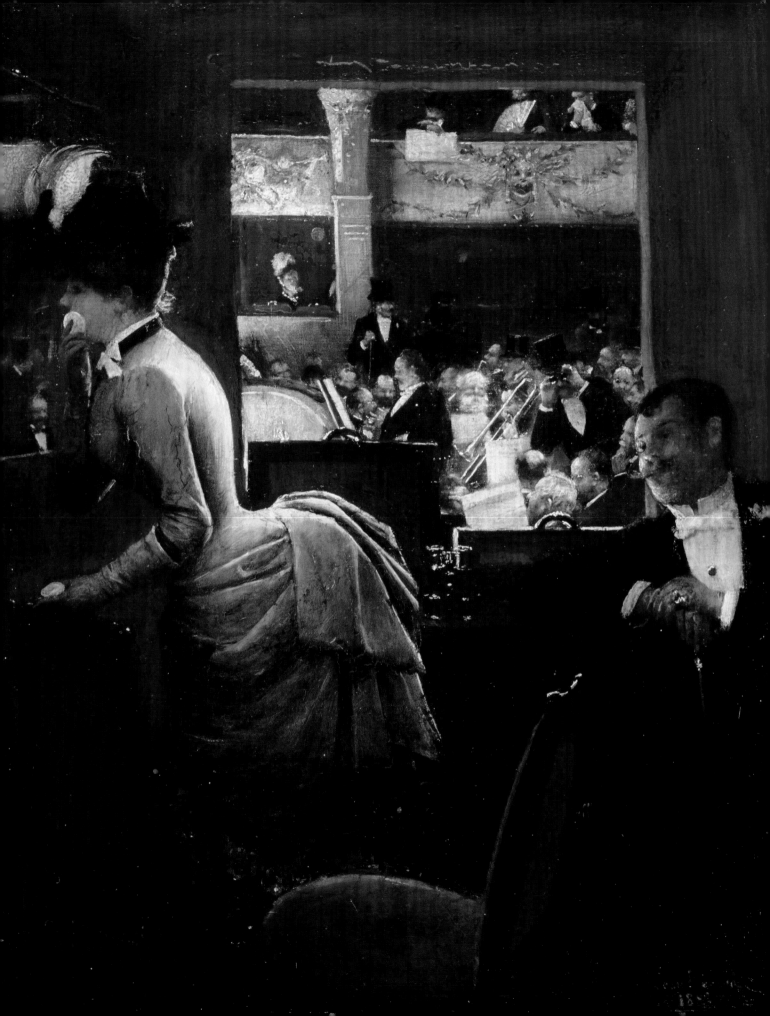

152. Jean Béraud,
La Baignoire, au théâtre des Variétés
(detail)
1883
Oil on canvas
Musée Carnavalet, Paris, P1743

figure, such as Marie-Antoinette, Joséphine de Beauharnais, or the Empress Eugénie, who made certain styles and trends popular, fashion henceforth was defined by a number of women of the haute bourgeoisie of the times. The eclecticism of the period, evident in the decorative arts, was also applicable to fashion: the mixing of fabrics, motifs, and colors can be explained by the fact that several women with different tastes and styles were influencing fashion. The great couturiers created certain fashions that were later popularized by department stores, which made them more accessible to the public at large. The fashion press and the diffusion of patterns enabled the petites bourgeoisies as well as the working woman to follow fashion, even modestly, through local dressmakers, or dresses made at home.

The life of the bourgeois woman became extremely codified: each precise moment of the day required different outfits of varying degrees of elegance according to the circumstances or her activities. A woman could change clothes—into morning dresses, walking dresses, and dresses for dinner, the theater, and balls—as many as five or six times a day. To know how to adapt her wardrobe to the social situation was

a mark of breeding, elegance, and good taste. The choice of the volume of the bustle or pouf was therefore adapted, with the volume and the length reduced for the morning hours, and amplified for the more formal gatherings in the evening. The dress and its pouf were thus indications of social codifications. The degree of variation of the outfit was proportional to social rank; a woman of a lesser rank possessed fewer articles of clothing.

CRINOLINE, BUSTLE, AND THE FEMALE BODY

Over the course of a day, a woman's body was slowly uncovered, with the chaste outfits of the morning slowly giving way to the sensuality of evening dress, which revealed plunging necklines, bared shoulders, and dresses whose volumes were amplified to convey an erotic charge.

On the surface, the dresses appear modest; the spirit of the times was more moralizing, while sobriety replaced ostentation. Nevertheless, sensuality remained ever-present, evoked more in what the crinoline hid and suggested to male fantasy than in the object itself. Indeed, the crinoline by itself seems devoid of eroticism; made of a complex mechanism, stripped of decoration, it did not enter into the arena of eroticism

153. *Grands Magasins du Louvre*
"Album d'été, modes d'été"
(Summer catalogue, summer
fashions), 1886, pp. 18, 19
Bibliothèque des Arts
décoratifs, Paris, XE 1

in the same way as the corset, and was gener-
ally taken off by a woman before she showed
herself to her husband. It thus represents some-
thing more like a hidden, sensual play in society,
where it gives the dress it holds up exaggerated
curves and volume, thereby reinforcing the slim-
ness of the waist and accentuating the sexual
dimorphism between a man's silhouette and a
woman's.

As for the bustle, it drew attention to the legs,
buttocks, and hips for the first time. It gave a
woman a more balanced silhouette, molding
the hips and exaggerating the curves of the
buttocks, while flattening out the front, reveal-
ing the outline of the legs. The sexual aspect is
more obvious than with the crinoline, as it not
merely suggests curves, but exaggerates them.
Sensuality appears through a play of more or
less accidental indiscretion, whereby a glimpse
of a slip or an ankle might become visible for a
few seconds during certain movements, opening
a little window into the world of fantasy to an
attentive eye. Nonetheless, as with the crinoline,
it is not the object in and of itself which is sen-
sual or a source of fantasy, but rather the effect
it produces, which is all the more true of the
bustle which, above and beyond the silhouette

it produced, gave a dress an undulating move-
ment around the hips.

One of the main differences between the cor-
set and other undergarments such as the crino-
line and the bustle lies in the relationship they
establish with the body. The corset does not work
against the body, but rather modifies and main-
tains it in complementary fashion. After a long
process of lacing, often begun in childhood, it
changed the body little by little as the laces were
pulled tighter and tighter. The body was altered
in its morphology, as the corset slimmed the
waist by displacing the fat toward the bottom of
the breasts and the top of the hips, and even,
in certain extreme cases, generating a displace-
ment of the internal organs. It thus exercised a
true, and lasting, modification of the body itself.
The bustle and the crinoline, on the other hand,
did not act directly on the body; they succeeded
in creating volume and support without compro-
mising the anatomy. The effect they produced
was simply a changing of the external, visual per-
ception of the body, which returns to its natural
state once the apparatus is removed. Only the
silhouette, and not the morphology, was altered.

The forty-five years between 1845 and
1890 were marked by a constant fluctuation

MANTEAUX ET CONFECTIONS POUR DAMES MANTEAUX ET CONFECTIONS POUR DAMES

in women's silhouettes. The aesthetic search for volume, opulence, and ornamentation was translated into the wearing of structuring undergarments such as the crinoline and the bustle. Fashion reached such a point of saturation with volume and decoration that the most interesting and innovative ideas were expressed in a return to simpler and more supple outfits. Paradoxically, the new inspiration of fashion of the 1890s would have its roots in the Romantic fashions of the 1830s, with the simplification of the bell-shaped skirt, refocusing the interest back to the top of the dress, and more specifically the sleeves, once again in the leg-of-mutton style (fig. 154). Hence the crinoline and the bustle, great protagonists in nineteenth-century fashion, would take a bow and leave the stage, remaining in people's memories as symbols of the exuberance of a time gone by.

620

154. *La Mode de style*
1895
Bibliothèque des Arts décoratifs, Paris, Collection Maciet
214/67

1. Emmeline Raymond, in "Modes," *La Mode illustrée* (1860): 13, thus explains the advantages of stell hoops compared to past fashions. In the past, volume was either created by a heavy, uncomfortable layering of underskirts, or else the volume disappeared in favor of the tighter fashions that impeded leg movement.

2. François Boucher, *20,000 Years of Fashion: The History of Costume and Personal Adornment* (1975; New York: Harry N. Abrams, 2008).

3. Raymond, "Modes," *La Mode illustrée* (September 25, 1887): 310.

4. Ibid. (October 22, 1882): 341.

5. Boucher, *20,000 Years of Fashion*.

6. Lucy Johnstone, "Corsets and Crinolines in Victorian Fashion"; http://www.vam.ac.uk/content/articles/c/corsets-andcrinolines-in-victorian-fashion/.

7. *Lettres de Prosper Mérimée à la comtesse de Montijo* (Paris: Édition Privée, 1930), 2: 119.

8. Théophile Gautier, *La Peau de tigre* (Paris: Michel Lévy, 1866), 357–58.

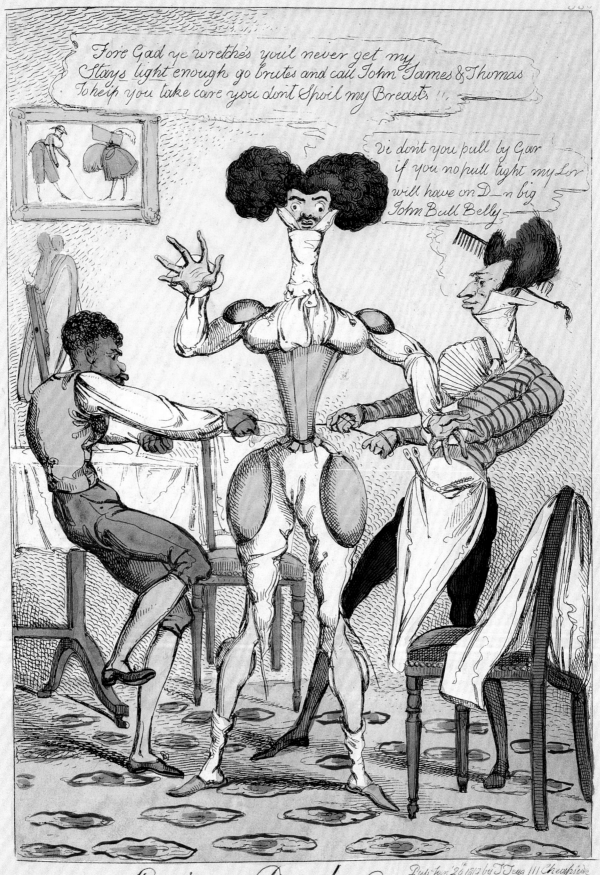

Laceing a Dandy

Sophie Lamotte

CORSETS, STOMACH BELTS, AND PADDED CALVES: THE MASCULINE SILHOUETTE RECONFIGURED

By the nineteenth century, a new man had begun to take shape, combining elegance and virility. A solitary conqueror, he built his own success and fortune, but also his look, which was to be in the image of his identity. At the same time, the "balance and design"[1] of the male figure was turned on its head: posture became erect, the waist small, the torso protuberant, the shoulders drawn back, and the calves prominent. It was in this context that corsets, stomach belts, and calf padding were used to create the desired appearance.

Analyzing these expedients, with their intimate connection to the body, is a complex task. They oscillate between private and public spheres, between undergarments and overgarments—sometimes considered intimate apparel, sometimes accessories, sometimes articles of clothing. Wavering between masculine and feminine, they were quite often criticized. They evolved and adapted in response to prevailing mentalities and degrees of modesty. They served a purpose at once aesthetic, morphological, medical, sociological, and cultural, satisfying desires for thinness, erectness, and comfort. Advances in medicine, science, and industry lay behind these mutations. Designed to remain hidden, these devices fashioned appearance, but in an ephemeral way. They had no beauty of their own. These are perhaps some of the reasons why they are still rarely studied by fashion historians.

DESIGNING A NEW MAN IN THE NINETEENTH CENTURY

In the nineteenth century the dandy was a marginal figure—artist, poet, or writer—at first criticized, then admired, whose raison d'être differed from that of his contemporaries. He was distinguished by the perfect cut of his clothes, which took the pursuit of elegance to outrageous extremes. A variety of artifices (corsets, stomach belts, calf padding, or false calves, as well as padding for chest, thighs, and shoulders) allowed him to highlight his forms to perfection. Originating in England, the dandy emancipated himself in France and then spread to the rest of Europe. The precursor was supposedly George "Beau" Brummel, followed by other emblematic figures such as Jules Barbey d'Aurevilly,[2] sporting his emblematic redingote, with its pronounced waistline (fig. 156) fashioned from high-quality fabrics.

Clothes played a large part in the presentation of the dandy, by cinching the waist or

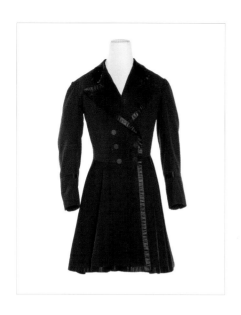

padding the chest and shoulders. Such was the result likewise sought by waistcoats laced in back, squeezing the waist and lending vigor to the torso. Since the 1800s, the names given to these elegant men have varied: they've been called Romantics,[3] lions, fops, and "fashionables," and even dandies in the twenty-first century.

To discover the undergarments worn by these men, one can refer to the literature of the period as well as to satirical publications. While exaggerating certain features, these representations drew their inspiration from reality. The engraving *Lacing a Dandy* (1819), which portrays a fop getting dressed, marvelously illustrates the game of inflation and deflation achieved by padding around the calves, thighs, and shoulders, and with the waist laced up by the two manservants to the point where the dandy can barely breathe (fig. 155). Dandies were usually portrayed at their vanity table, a sign of passing time, pushing coquettishness to almost feminine limits.

The *Diary of a Dandy* (1818) stresses the unreliability of corsets for men, and the discomfort owing to the whalebones in the back. The diary thus warns the uninformed: "It [the corset] prevented me from picking up Lady B's glove."[4] The military man was also admired, as much by men as by women, for his upright posture. Accentuated by clothing, and perhaps even by corsets, such bearing became the norm, passing from the bodies of military men to the nobility and bourgeoisie. Its influence on fashion was considerable. In the 1840s, *Le Professeur ou Journal raisonné du tailleur* (The professor, or the tailor's reasoned diary) presented, in each new issue, four engravings and patterns of men's garments, one of them always military (fig. 157). Understandably nicknamed the "military dandy," the well-groomed hussar wore a dolman, a stiff jacket that became ever more tucked in at the waist, forming a "V" silhouette. Padded around the chest with quilted flock and fabric to protect the wearer from sword thrusts (its primary function), it conferred a proud appearance on its subject. Worn over the dolman, and fastened tightly, the broad belt in crimson wool accentuated the slenderness of the waist.

There is other literary and painterly documentation of men having worn constrictive undergarments. The Saint-Simonians,[5] for example, symbolically wore a corset of the same name, which would be laced up at the back by another member of the brotherhood. In the 1830s a number of Romantics also used an article reminiscent

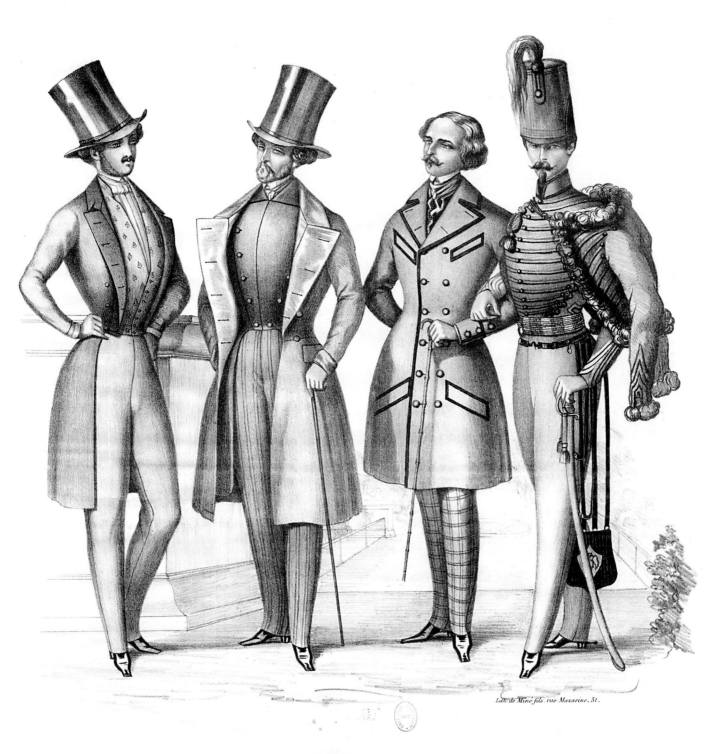

LE PROFESSEUR OU JOURNAL RAISONNÉ DU TAILLEUR.

On s'abonne à la Direction, Rue Richelieu, 34.

Octobre 1843.

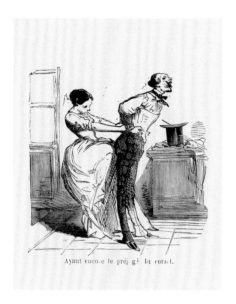

Ayant encore le préjugé du corset.

(left)
158. "Quand un homme essaie
un corset" (When a man tries
on a corset)
Le Charivari, October 31, 1852
Bibliothèque nationale
de France, Paris, Rés. Est.
Fol-LC2-1328

(opposite)
159, 160. Man's corset
(obverse and reverse)
Germany(?), early twentieth
century
Linen, cotton, machine lace,
regenerated cellulose, metal
Germanisches National-
museum Nuremberg, T6973

of a medieval pourpoint. The problem is that no corset, according to the definition of the term, has yet been found and identified as having belonged with any certainty to a man. And so one can legitimately question whether male corsets ever actually existed. Nevertheless, a number of hypotheses can be advanced. The first would be that men did not wear corsets but rather bodices, girdles, or corseted belts. By the early nineteenth century, corseted belts were used to hold in the fat and to keep the body upright, a symbol of moral rectitude. Brighton Museum and Art Gallery holds a replica of the belt of George IV, made up of whalebones and laces in back and on the sides. The Musée des Arts Décoratifs in Paris owns a similar example. This model lasted throughout the century, as attested by a specimen from the first half of the twentieth century at the Germanisches Nationalmuseum Nuremberg (figs. 159, 160).

The second hypothesis leans toward the possibility that men did wear corsets. They may have been fashioned by the wearer, by a specialized corset-maker, or by a tailor. We know for a fact that men's tailors took great interest in the waist and produced belts, to the point

that we can surmise they might similarly have diversified into the production of a few corsets. But then why don't we find any in public or private collections, whereas women's corsets are amply represented? Given the fact that men's undergarments have not yet been studied in any depth, perhaps they simply haven't been classified and inventoried. It is possible, moreover, that certain male corsets were inadvertently placed in reserves of women's garments. Finally, their less sexy appearance—compared to their counterparts for women—may have led to their being discarded. Some detective work could be done in the stores of museums holding collections of these sorts of undergarments. And the last hypothesis might be that only women's corsets were produced, and that men who wished to procure such an object would have had to choose them from the available female models. If this was indeed the case, such a corset would have been very uncomfortable for their gentlemen wearers, since not they were not designed for the male body (fig. 158).

Though little known, padded calves or false calves introduced by the Macaronis in the 1770s in England[6] were worn throughout the

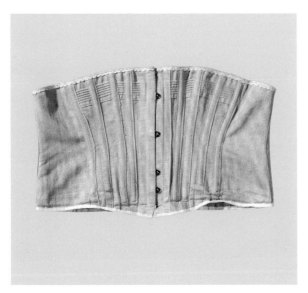
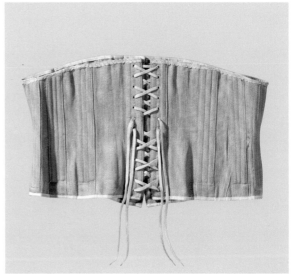

nineteenth century and into the early twentieth. The appearance of physical strength was viewed as a reflection of moral strength, and one could judge a man's virility from the circumference of his calves.

According to the *Dictionnaire de l'Académie Française*, a *faux-mollet* is a "stocking padded in the area of the calves."[7] There were two kinds. The less common kind, used in the late eighteenth century and the first quarter of the nineteenth, were thick paddings of fabric placed against the calves and fastened with straps. Padded stockings, supplemented by a lining stuffed with fabric (also called false calves), must have been more widely used, because they were more discreet and in keeping with the fashions in men's hosiery. The Musée des Arts Décoratifs owns two pairs from the 1880s, one of which is in white wool jersey, rough and stitched (fig. 161). Wool was still very much used at this time, in keeping with theories of hygiene and the recommendations of physicians such as Gustav Jaeger. Being artificial, padded stockings had to be discreet: "How silly of them to hang their padded stockings from windows and doors: it means letting the whole world in on their secret," wrote the *Journal des dames et des modes* on July 5, 1819; at the same time, however, they were recommended by such manuals of elegance and dress as the *Code de la toilette: Manuel d'élégance et d'hygiène* (1828),[8] which advised those who have "skinny legs and who dare not show themselves in the light of day, and take refuge inside their trousers," to take advantage of the "very comfortable expedients" offered by the hosiery producers.

Outer garments necessarily felt the repercussions of the use of these sorts of "modeling" artifices. Stockings required prominent calves, and tight breeches demanded a shapely male leg. Thus with the arrival of "classic" trousers around 1850, we understandably notice a decrease in the use of padded calves. Nevertheless, stockings were still sometimes de rigueur on certain occasions (such as balls or sporting events).

Legs played an important role in the nineteenth century; they were signs of success in the eyes of society, seen as much from a professional point of view by men as from a personal point of view by women. "No sooner would a young man enter the salon than people would look at his legs to see if they were natural or artificial; woe unto him if he had borrowed calves."[9]

"TIGHTENING ONE'S BELT":
THE EXPRESSION OF AN IDEAL

Stomach belts began to be worn in the nineteenth century by a few bourgeois and aristocratic men as a way to adjust to the new model of silhouette that was coming to the fore. The belt became more present than ever in the first half of the twentieth century, corresponding to the upheavals taking place in society. Men were supposed to be slender and muscular, signs of their adaptability to a faster and faster world, where speed became a symbol of the times. At the same time they were increasingly subjected to medical discourse, an attractive appearance becoming synonymous with good health, virility, and efficiency. At the start of the nineteenth century, bourgeois portliness was still attractive, but it gradually became a symbol of bourgeoisification, vanity, and softness: "the circumference of the belt has vaulted from girth to obscenity."[10] The discovery of the figures and measurements for the circumference of different body parts would lead to discourses on obesity. Having a svelte body was essential, and particular importance was given to the belt. In response to these new criteria, accessories and artifices of appearance were dissimulated under one's clothing so as not to reveal the newly highlighted flaws.

Though not a medical doctor, Anthelme Brillat-Savarin must have been one of the first to recommend wearing a belt in order to slim the figure. He called men with prominent bellies and spindly legs "gastrophores," a term often typifying the bourgeois. About himself, he wrote: "I would look at my belly like a formidable foe I had to combat."[11] To fight this "curse that undermines one's strength and health,"[12] he recommended physical activity and a diet accompanied by an "anti-obesity" belt that holds the stomach in and gives one the strength necessary to shrink it.

The primary function of this sort of belt, which was called a "stomach belt," was to create a slimmer silhouette. The first examples must have been simple bands of fabric held together by lacing or buttons, and were worn notably by overweight bourgeois. But one also finds more elaborate belts with baleens, buttons, and laces that narrowed the silhouette by keeping it erect. Certain long johns had the same advantages: they were topped by a belt of thicker or lined fabric, buttoned in front and sometimes on the sides, and adjusted by lacing in back.

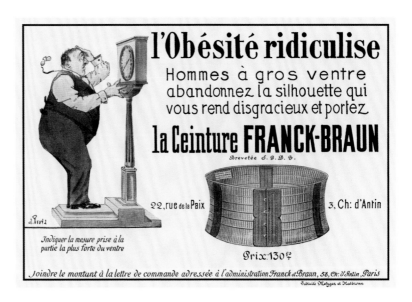

The 1880s saw the rise of the hygienic dress movement, first in Great Britain and Germany, and then across Europe. Its chief proponent, Dr. Gustav Jaeger,[13] recommended wearing only un-dyed animal fibers directly against the skin and warned of the dangers of fibers made from plants. His ideas had a great impact, and in 1878 he consented to the creation of a company, "Dr Gustav Jaeger's Sanitary Woolen System Co," which opened stores in all the major European capitals and sold items in keeping with these principles. Since the arguments in favor were quasi-scientific, numerous brands began to add the qualification of "doctor" to their names, Docteur Gibaud and Docteur Rasurel being two examples.

The growth of the industry fostered the spread of woolen and flannel belts. We find them in the advertisements as well as the sales catalogues of the department stores. By the end of the nineteenth century, and in the first half of the twentieth, two models of belt predominated: the first, which was broader in the middle, compressed the stomach; the second, tubular in form, squeezed in the stomach as well as the waist and covered a large part of the chest. The point was to protect the body even while supporting it and making it slimmer (figs. 163, 164).

By the first half of the twentieth century the use of stomach belts by men was firmly lodged in people's mentalities, corresponding at once to a desire for slenderness, erect carriage, hygiene, and comfort. The arrival of rubber and elastic materials, forerunners of modern-day synthetic fabrics (such as Nylon, Lycra, and elastane), allowed them to act more firmly upon the silhouette.

The most popular models in the 1910s were, for example, the Franck-Braun belts, or such products as L'Esthétique des Galeries Lafayette: conical in form, these aimed to improve the wearer's appearance by compressing the stomach and supporting the back and sides. These were in fact the descendants of corseted belts, with rubber having replaced whalebone stays. This kind of model could still be found up until the 1950s. The producers sometimes offered rather original models, such as a belt perforated with holes of different sizes (fig. 170). One can consider such belts as girdles. The girdle defined as "a woman's undergarment of elastic fabric that squeezes the waist and hips, for the purpose of making her figure slimmer"[14]—a definition that well describes these belts, except for the fact that they were intended for men. Girdles for men thus exist as

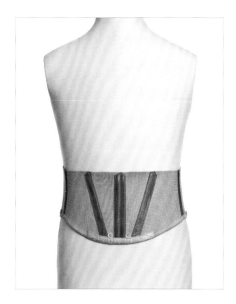

of the early twentieth century, ranging from the Linia belt of the 1920s and '30s—made of long-lasting, elastic knit—to the Gibaud-brand lumbar belts of the 1980s, made of wool, polyamide cotton, and elastane. Their purpose remained the same: to support the body for aesthetic ends.

As they improved, marketing techniques began to target potential clientele, sometimes pointedly: in 1928 the Franck-Braun brand ran the following advertisement: "Obesity makes you ridiculous. Big-bellied men, give up the figure that makes you ugly and start wearing the Franck-Braun belt" (fig. 162).

THE TWENTY-FIRST CENTURY: THE HERITAGE OF PAST CENTURIES

The start of the twenty-first century raises a complex question: do we need to reinvent the codes of masculinity? Men want to be more and more elegant, slender in build, but also muscular. With the emancipation of women, ideas and mentalities are changing, as is the male wardrobe. Once again men are placing great importance on their appearance and figure. The predominant model is broadcast more than ever through omnipresent media (television, internet, advertising) in their sociocultural representations of male beauty. In the 2000s, men have adapted the codes of manliness to their look. The ideal man would be slim but muscular, authoritarian but understanding, virile but sensitive, who blends femininity and masculinity in a subtle mix.

"Shapewear" has become inescapable when talking about the new generation of men's undergarments, which are derived from women's girdles and sheath-like underpants but adapted to a male morphology (tank tops, long T-shirts, briefs, boxers, etc.), and into which is integrated a girdle that squeezes the waist, disguising plumpness and highlighting muscles by means of compression panels arranged over the abdominal area and sometimes the chest. The objective of such an undergarment is to improve a man's figure effortlessly: they make the body slimmer, tone it, and support the back. It is fashioned from innovative materials: elastic fabric (cotton blended with elastane, polyester, and Lycra) that is also thermal, keeping the body warm or cool; it absorbs perspiration and prevents body odor. These undergarments, the successors of the elastic anti-obesity belts, are invisible, since they are similar to traditional underwear.

Brands such as ES, Addicted, Nutriderma, and Andrew Christian have integrated the girdle into

some of their models of briefs and boxers (fig. 155). For T-shirts and tank tops, the Spanx and Equmen brands offer highly innovative products that allow a man to rediscover his virility while keeping his body straight, his shoulders back, his torso on display, ensuring a well-built, powerful appearance, suppressing ungainly flab in order to fashion a "perfect" body.

Another innovation, the Lytess belt, features millions of friction-activated microcapsules, which release active elements of caffeine, with slimming properties, and shea, with toning properties, promising the wearer soft, better hydrated skin.

These slimming undergarments for men are becoming more and more visible in the press. In 2004, *Libération* devoted an article to them entitled "Des dessous masculins gainant pile-poil" (Men's undergarments sheathe to a T),[15] in which the writer states that "the material commands the form."

The corset is an object of fantasy that certain manufacturers have taken the trouble to adapt to men's fashions over the last few years. One of the first to question the austerity of men's fashion and to incorporate femininity into the male wardrobe was Jean Paul Gaultier, when he introduced his "L'homme-object" (Man as object) collection in 1984. At the time the press spoke of a "kick at conventional ideas," while the designer affirmed that "men's [clothing] could evolve." Among the articles he presented were waist-cinchers, corselets, and a corset, which played on manufacturing techniques, materials, and forms.[16] John Galliano presented three models reinvented according to his own imagination at the men's prêt-à-porter show of autumn/winter 2010. One of these, in the form of an orthopedic corset softened by its constituent pink silk, was worn by a contemporary dandy reminiscent of a nineteenth-century British fop (fig. 167). Worn over the garment for aesthetic purposes, the orthopedic belt thus moves from the ordinary to the exceptional. That same year, the designer also presented a corset-vest, an easy garment to wear, as an element of a four-piece suit. The rules of corset-making were adapted to the demands of designers and everyday life: since the man of the twenty-first century is always "in a hurry," the lacing was replaced by a zipper. Corset-makers are now specializing in menswear. The corset-vest is incorporated into the garment, becoming a much appreciated practical and comfortable form. French corset-maker Sylvain Nuffer has

166. Advertisement for "slim Addicted" boxer shorts
2012
Photograph by Christian Herrera

adapted techniques of women's corset-making to the male morphology, using the technique of stiffening the garment with canvas. He invents his articles and then creates them, calling some of his creations "Saint-Simonian," alluding to the nineteenth-century philosophical order.

The corset is steadily earning a place in the minds of men of all ages and all social classes, often in the form of the corset-vest. Its use springs from an intimate desire. Sometimes it is worn for all to see, sometimes more discreetly. From undergarment to outerwear, the corset, while still limited to a minority of wearers, is slowly gaining on men's bodies, highlighting their feminine side with a virile grace. Will this masculine elegance step down from the runways to dress the twenty-first-century man?

167. John Galliano,
Prêt-à-porter fall/winter
2010–11
Photograph by Guy Marineau

1. Georges Vigarello, *Histoire de la beauté: Le corps et l'art d'embellir, de la Renaissance à nos jours* (Paris: Le Seuil, 2004), 145.

2. Jules Barbey d'Aurevilly, *Du dandysme et de George Brummell* (1845; Paris: Rivages, 1997).

3. Annabel Benilan and Emmanuelle Lepetit, *Modes du XIXe siècle: Les romantiques* (Paris: Falbalas, 2011), 17.

4. Cecil Willett Cunnington and Phillis Emily Cunnington, *The History of Underclothes* (New York: Dover Publications, 1992), 107.

5. The Saint-Simonians were partisans of the teachings of reformist philosopher Claude-Henri de Rouvroy de Saint-Simon (1760–1825). See Philippe Regnier, *Études saint-simoniennes* (Lyon: Presses universitaires de Lyon, 2002), 51.

6. Cunnington and Cunnington, *The History of Underclothes*, 30.

7. *Dictionnaire de l'Académie française* (Paris, Institut de France, 1835), 221.

8. Horace-Napoléon Raisson, *Code de la toilette: Manuel complet d'élégance et d'hygiène: contenant les lois, règles, applications et exemples, de l'art de soigner sa personne, et de s'habiller avec goût et méthode* (Brussels: Grignon, 1828), 56.

9. Shaun Cole, *The Story of Men's Underwear* (London: Parkstone, 2010), 163.

10. Georges Vigarello, *Les Métamorphoses du gras: Histoire de l'obésité du Moyen Âge au XXe siècle* (Paris: Le Seuil, 2010), 176.

11. Anthelme Brillat-Savarin, *Physiologie du goût* (Paris: Gabriel de Gonet, 1826), 211.

12. Ibid., 218.

13. Farid Chenoune, *Des modes et des homes: Deux siècles d'élégance masculine* (Paris: Flammarion, 1993), 49.

14. *Dictionnaire Larousse* (Paris: Larousse, 2011).

15. Renaud Lecadre, "Des dessous masculins gainant pile-poil," *liberation.fr*, January 27, 2004.

16. Farid Chenoune, *Jean Paul Gaultier* (Paris: Assouline, 2005).

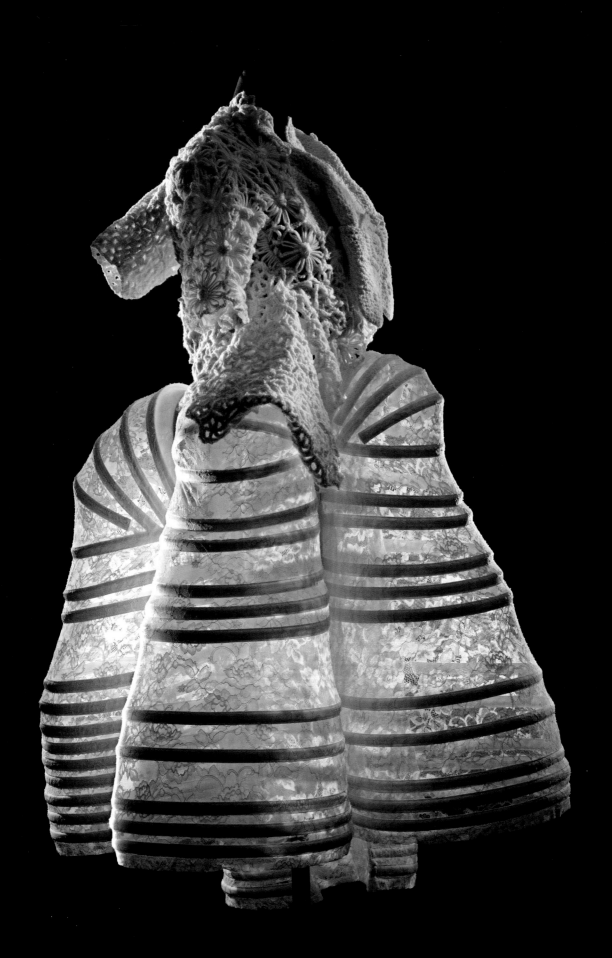

20th — 21st CENTURY

Body — Boxers — Combinations
Girdle — Waspie — Panties
Push-up bra — Shapewear — Jockstrap

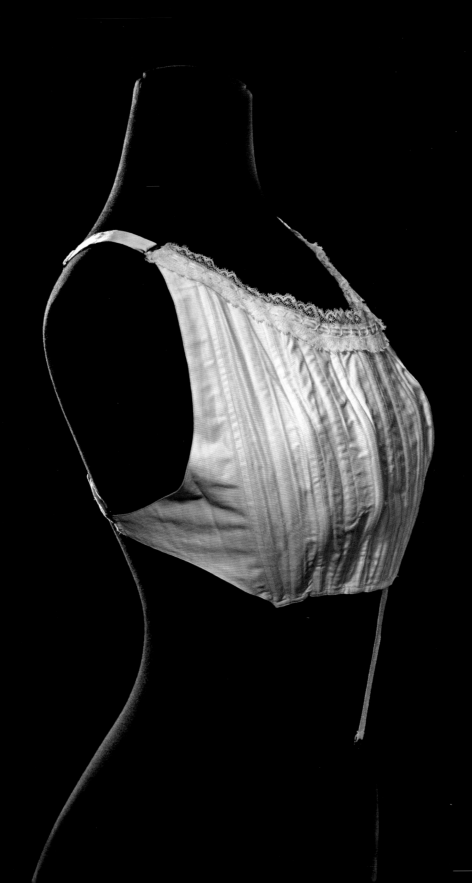

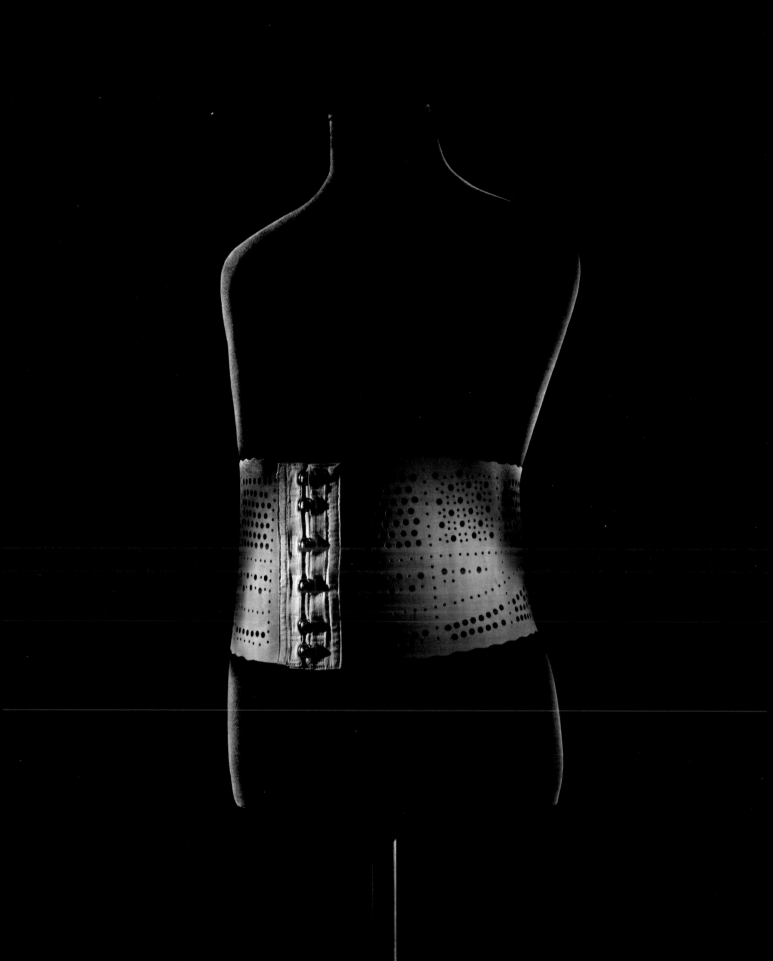

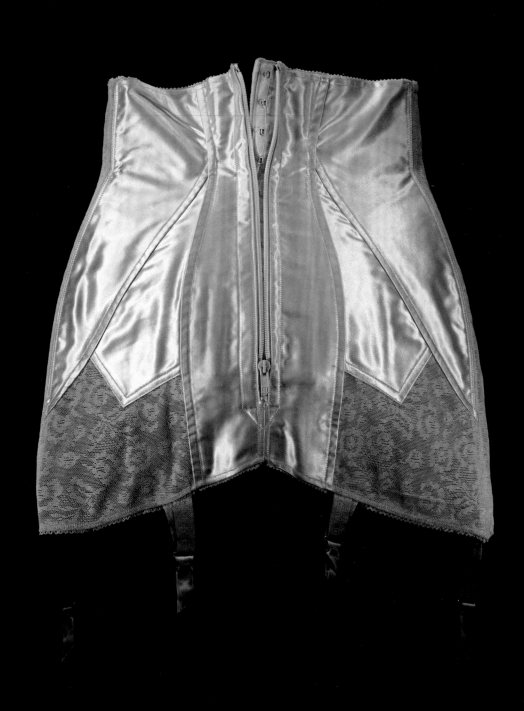

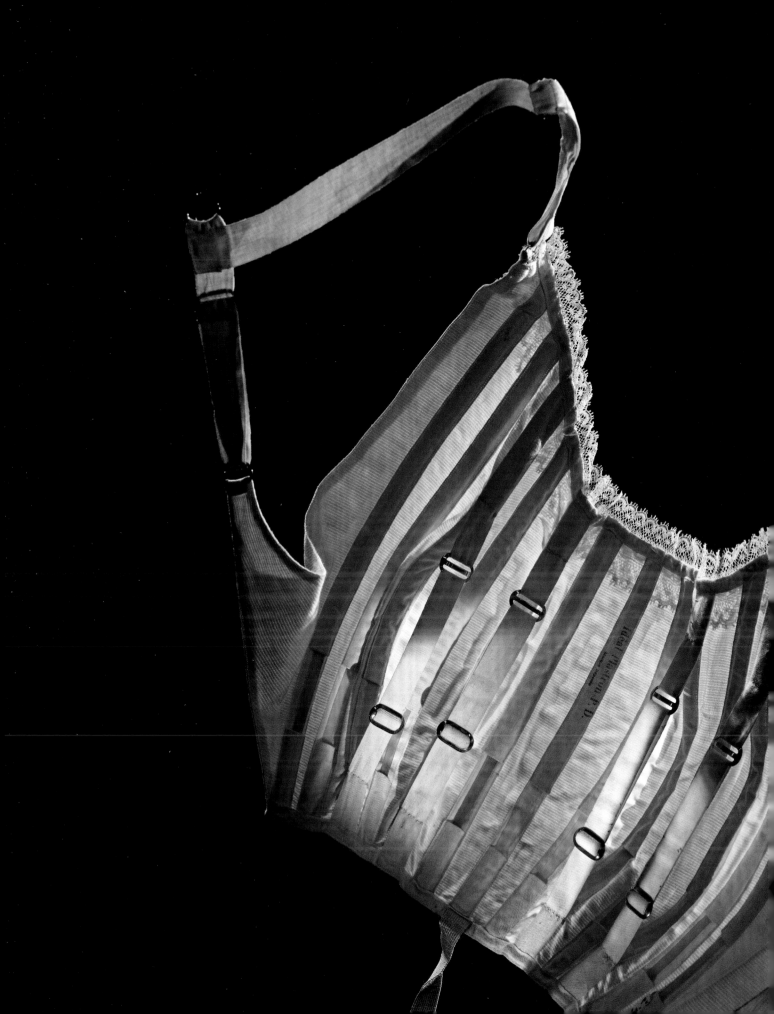

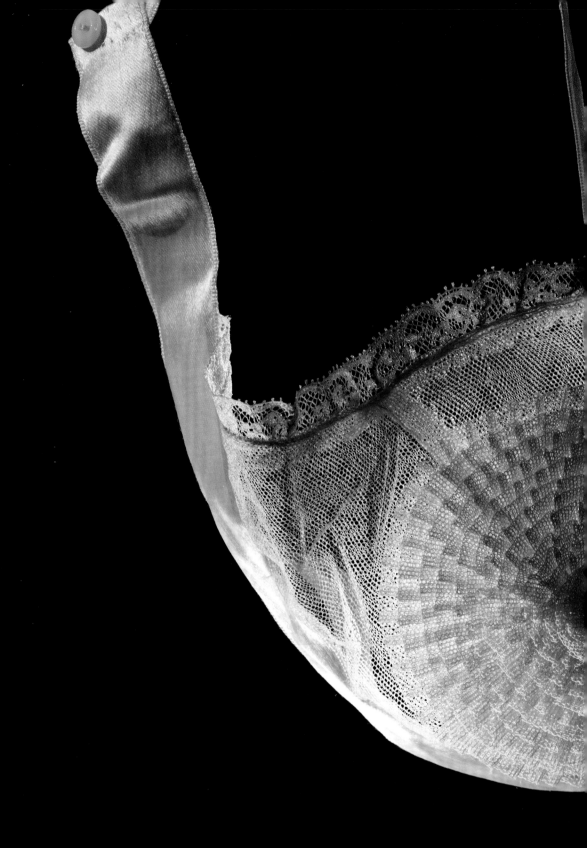

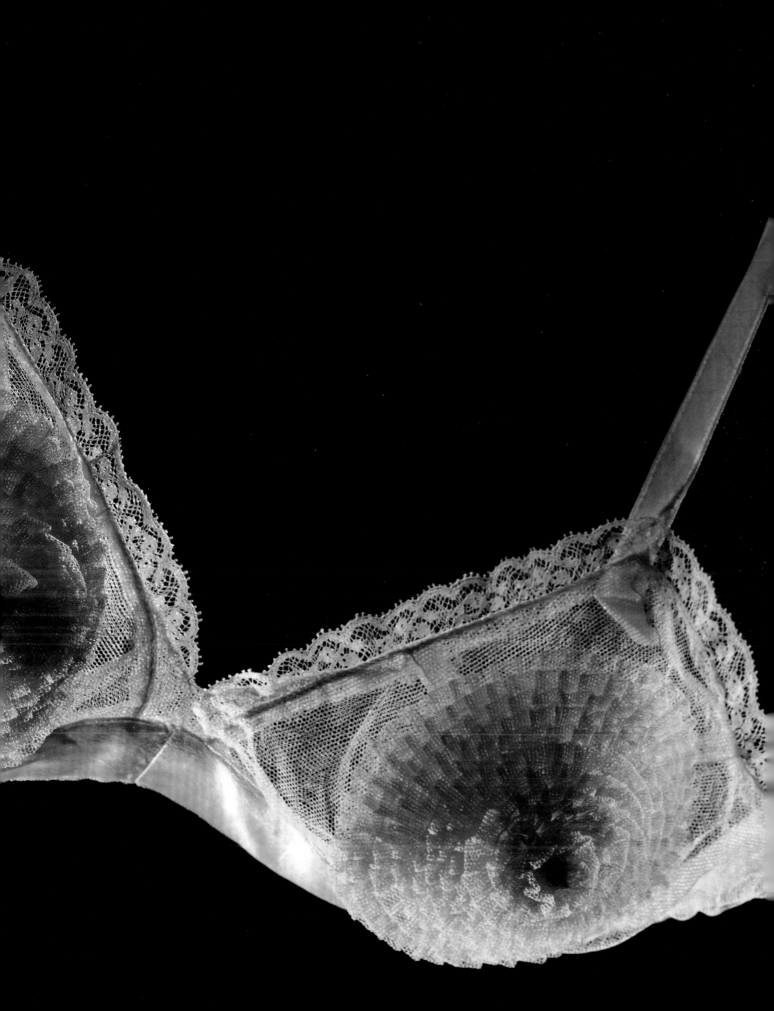

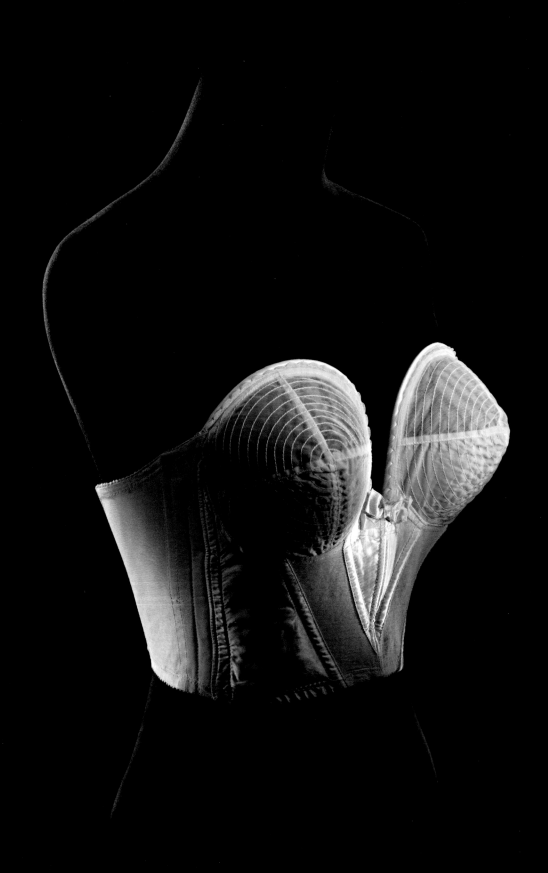

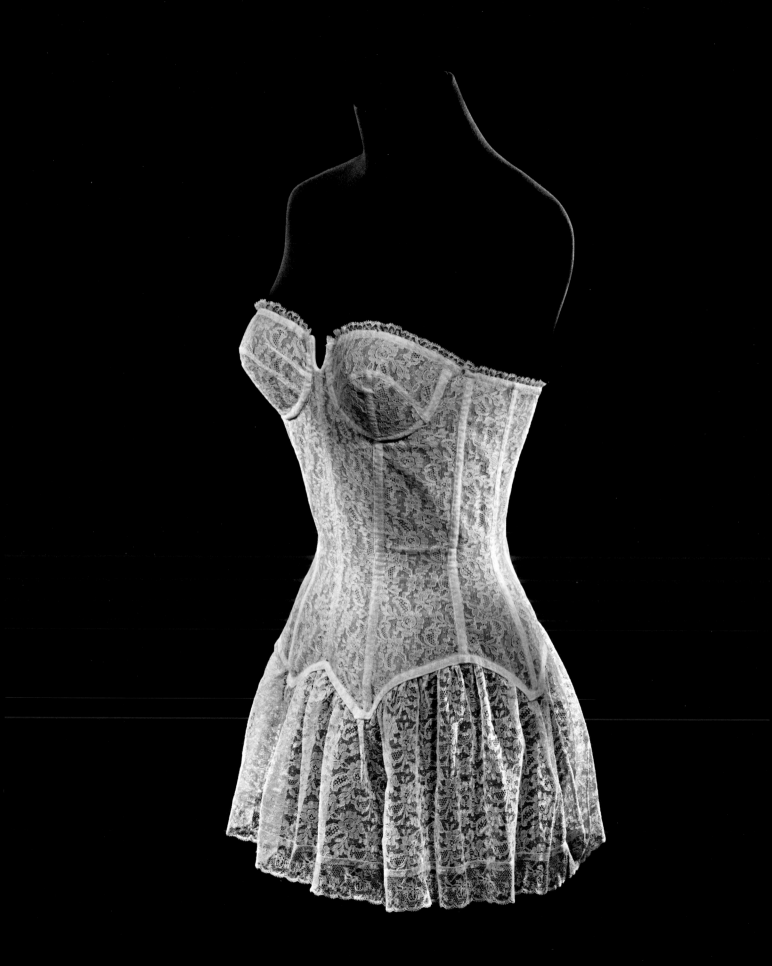

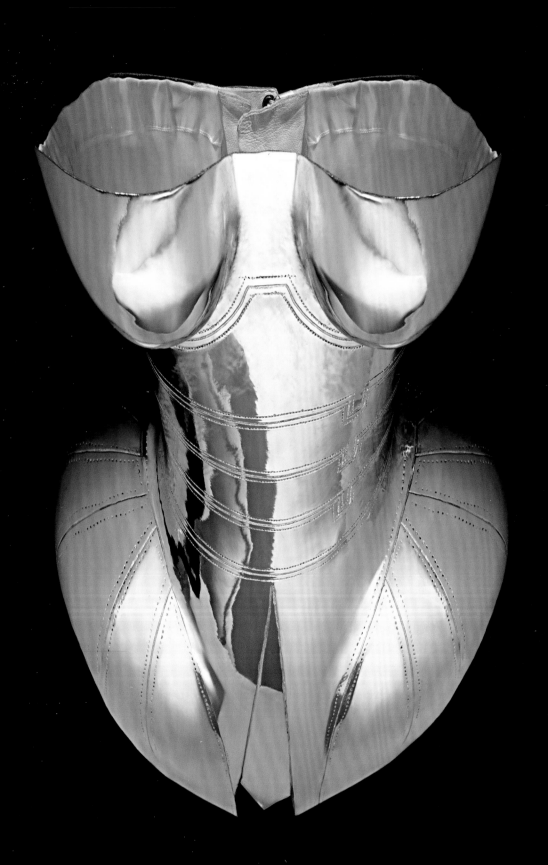

CONTEMPORARY UNDERGARMENTS

—

Anne Zazzo

Between the late nineteenth century and the late twentieth, several new types of lingerie appeared: cami-panties, the brassiere, the girdle, briefs and panties, the slip, the waspie, the corselet, the garter belt, the baby doll, the panty girdle, and panty hose. All of these remain in current use, in different forms and fabrics, with varying degrees of success. At the same time other, older, articles such as the crinoline, the bustle, and the corset have been brought back into circulation—at least in a high-fashion context, and in fetishistic rites and practices, and certain other reappropriations have also broadened the repertoire: in the 1980s, for example, boxer shorts appeared as a item in women's wardrobes—indeed sportswear and undergarments now constitute rather flexible categories. Our own time is rarely considered in the history of undergarments, since it has not been very inventive: indeed, one could argue that the only real novelty since the 1980s has been the bodysuit, or "body" for short. Probably derived from dancers' leotards, it covers the body from bust to thigh, denying access. As a garment that can be worn as either underwear or outerwear, the "body" intersects the taxonomy of intimate apparel.

Sociologists since the 1960s, particularly Pierre Bourdieu, have made us familiar with the concept of incorporation[1]—a key element in any history of undergarments: clothes and, by extension, cosmetics have become "incomparable social signifiers."[2] Any glimpse into the mechanics of contemporary undergarments should be taken from this angle. Any attention paid to the range available and to the undergarments themselves is inseparable from the study of the customs, projections, and transgressions associated with them.

Between the mid-nineteenth century and our own era we can distinguish three distinct periods in relation to underwear and the body. Up until

1910–20, accumulation was the rule. The layering of skirts, bloomers, chemises, and corsets, as well as the trompe-l'oeil effect of corsets and bustles, made it possible to describe the undergarment as a sort of subterranean article of clothing, an architectural underpinning of the outfit seen in society. A precisely ordered dress code clearly determined what was hidden and what was shown: the undressed and the dressed. The clothed body was buried under layers of clothing, without concern for its real morphology. From the early twentieth century to the 1960s and '70s, the modeling of human anatomy itself became important. The undergarment—the most direct intermediary between the body and the garment—rigorously disciplined the figure. Women's forms were shaped according to the dictates of fashion, through the reinforcement of undergarments.

A third phase, at the end of the twentieth century, punctuates this history. The division between under- and overgarments, between the visible and invisible, began to seem more unsettled. The skin itself had become the new frontier of "undress." The interface of lingerie no longer served only to receive or hold back what spills out from the body—on the contrary, the undergarment now worked to modify the surface and even the inside of the body. It was capable of cleaning, tanning, scenting, moisturizing; it cared for the epidermis and tightened, renewed, and compressed the flesh.

The undergarment makes what it modifies conspicuous and visible to all: the same care is taken to ensure that beauty, health, strength, and flexibility are suggested—or, better still, seen. The undergarment no longer hides; its purpose is to "reveal" artfully a body's potential, and thereby confirm the ideal of malleability. In response to the prudishness and hindrances of nineteenth- and twentieth-century undergarments, we have the twenty-first century's tyranny of the visible. Instead of the values of constraint, those of pleasure, of flourishing are promoted—including role-play, as humor is another form of flexibility. The uneasy response to the injunction of outward display is the concealment of the female body under the Islamic hijab. On the other hand, the just-visible undergarment suggests complicity but is never without ambiguity. One has only to think of the outfits emblazoned with designer labels during the years just after the millennium. On the face of it, an article made in 2008 adorned with the name of star designer John Galliano in huge lettering on the waistband of the underpants was simply vulgar self-promotion; but on another level, it was a bold, even "intellectual" response to aggressive marketing, a mocking critique of the irrepressible desire for media celebrity.[3] Men's underpants that are marketed by focusing on the genitals are another example of undergarments that are both amusing and serious.

(p. 212)
168. Comme des Garçons,
Prêt-à-porter spring/summer
2012
"White Drama" collection
Crocheted wool, nylon, cotton
blend, silk satin, Chantilly-type
embroidery, semi-hoops
covered in grosgrain ribbon
Musée des Arts Décoratifs,
Paris, département Mode et
Textile, Purchase thanks to the
support of Louis Vuitton, 2012,
2012.5.1.1-2

(p. 214)
169. Bust improver
France, ca. 1900–10
Quilted cotton, cotton serge,
machine lace, silk, metal,
elastic, stays
Musée des Arts Décoratifs,
Paris, département Mode et
Textile, purchase thanks to the
support of Louis Vuitton, 2012,
2012.4.1

(p. 215)
170. Man's belt
France, early twentieth
century
Perforated rubber, metal, silk
Musée des Arts Décoratifs,
Paris, collection Union française des arts du costume, Gift
of Monsieur et Madame François Boucher, 1951, UF 51.20.76

(p. 216)
171. Créations Caprice
Girdle with garter belt
France, ca. 1950
Silk satin, elastic mesh,
machine lace, metal, zipper
Inscription: "Créations
Caprice/Paris London [...]"
Musée des Arts Décoratifs,
Paris, collection Union française des arts du costume, Gift
of Jacqueline Cremmer, 1973,
UF 73-40-13

It is tempting to draw a parallel between the three "eras" of under-wear outlined here and the three cultural periods corresponding to the types of Western capitalism analyzed by sociologists Luc Boltanski and Eve Chiapello.[4] According to Max Weber, whom the authors cite, this eco-nomic system does not impose itself simply through constraints and the interaction of force and exploitation; it also requires complicity—that is, people's consensual belief in certain values, the personal involvement of "protagonists" in the name of a common good. In this way, social agents no doubt "incorporate" in their lifestyles, which makes it possible to draw pertinent similarities; the dominant values feed the imagination, lifestyles, and representations of the self put forward by the universe of the objects that mark the "territory of the ego."[5] Undergarments would thus become the privileged signposts of these territories. Analyzing how these objects have assumed a gender, in this case female, is another matter.[6]

The first, patriarchal form of capitalism was said to be based on the principle of the concentration of property and power into the same hands. It demanded of its leaders a set of contradictory qualities so that such accumulation would be at once prudent and audacious. And "it is precisely this confusion of arrangements and values that are highly diverse, even incompatible—lust for profit and moralism, greed and charity, scientism and family-oriented traditionalism—at the origin of the division of the bourgeois class with itself . . . that is at the bottom of what will become the most unanimously, most lastingly denounced aspect of the bourgeois spirit: its hypocrisy."[7] A "double discourse" dress code was a fundamental part of this bourgeois "hypocrisy." Amidst the "soft" layers of undergar-ments, quite distinct from the outfits worn by women in society, surprising innovations occurred that would have created a scandal on the outside: drawers, cami-panties, bra-corsets. A clear visual partition separated the hidden undergarments from the outer garments. The lingerie repertoire, a vast wardrobe of undergarments, encompassed all possible replicas "in black and white" of the wardrobe of outer garments—as if the dressed body were merely covering pale doubles of itself. Certain late-nineteenth-century *déshabillé* garments resemble fashionable close-fitting urbane outfits, in two parts. But they are made of white cotton trimmed with English embroidery. Underskirts adorned with Valencienne lace inserts are cut the way the fabric of the skirt itself would be. But the materials for the underskirts, are cotton, batiste, or muslin for the finest among them. The closer one gets to the surface, the more the ornamentation changes, and the underskirt closest to the skirt itself is made of colored satin.

The second age of capitalism distinguished capital from power, which was delegated to leaders, directors, and bureaucrats. This economic and

cultural system, solidly in place from the 1930s, hinged on strong disciplinary, hierarchical, and bureaucratic constraints tolerated in exchange for the promise of security and a promising future for its participants. It was this disciplinary corset that was so hotly contested in the French protests of May 1968, and in a general fashion by the libertarian spirit of the times—at the price of greater "flexibility" and a less secure "mobility." The rhetoric of the "liberation" of bodies became dominant.

One of the noticeable effects of this ideology was that transgression became more difficult in contemporary underwear culture. In the first lingerie era, layering, the stolen glance, the surprise were highly eroticized disturbances predicated on the stratified system of dress. In the second era, the shunting of desire could play out in a stylistic distancing indicated by the drab panoply of new flesh-pink lingerie, through a series of clichés. Fetishistic displays of historic undergarments such as the corset are one example of this—stereotyped, for example, by the erotic photographs of Yva Richard published in Paris in the 1930s.[8] Certain brands elegantly played on this form of cultivated historicism through deviant fetishism. Oh brand stockings marketed by the designer Jacques Fath in the mid-1950s were typical. Their lacy ornamentation around the thigh was invisible when the wearer was dressed. This hidden border exalts the fantasy associated with this sort of article. The name "Oh" suggests the playful delight of discovery.

In the late 1960s, the provocative pose (sometimes rhetorical and sometimes demonstrative) was to do without undergarments and to reject the various harnesses worn by the previous generation. And yet, twenty years later, these garments had become acceptable again: they no longer represented social or sexist constraints, but fantasies in action. In the pages of so-called women's magazines, the free and changing expression of one's personality, the following of one's own peculiar desires, were celebrated exhaustively. In a variety of social contexts—the work environment, for example—individuals were expected to "play the game."[9] And an untenable contradiction arose from the dual demands of play and authenticity. Unexpectedly, the resolution of this contradiction, and the critique of this ambivalent norm, began to appear in the rediscovered play of appearances—fashion, in other words. A fitting mask for recreating the imaginary undergarment.

1. Dominique Memmi, Dominique Guillo, and Olivier Martin, eds., *La Tentation du corps, corporéité et sciences sociales* (Paris: Éditions de l'École des hautes études en sciences sociales, 2009).

2. Ibid., 70–94.

3. A program for the essay by Nathalie Heinich, *De la visibilité: Excellence et singularité en régime médiatique* (Paris: Gallimard, 2012).

4. Luc Boltanski and Ève Chiapello, *Le Nouvel Esprit du capitalisme* (Paris: Gallimard, 2010).

5. Erving Goffman, *The Presentation of Self in Everyday Life* (London: Penguin, 1959; rev. ed. 1990).

6. Élisabeth Anstett and Marie-Luce Gélard, eds., *Les Objets ont-ils un genre? Culture matérielle et production sociale des identités sexuées* (Paris: Armand Colin, 2012).

7. Boltanski and Chiapello, *Le Nouvel Esprit du capitalisme*, 55.

8. Catherine Örmen and Chantal Thomass, *Histoire de la lingerie* (Paris: Perrin, 2009), 168.

9. See the essay by Mathieu Trachman in *Le Travail pornographique—Enquête sur la production de fantasmes* (Paris: La Découverte, 2013).

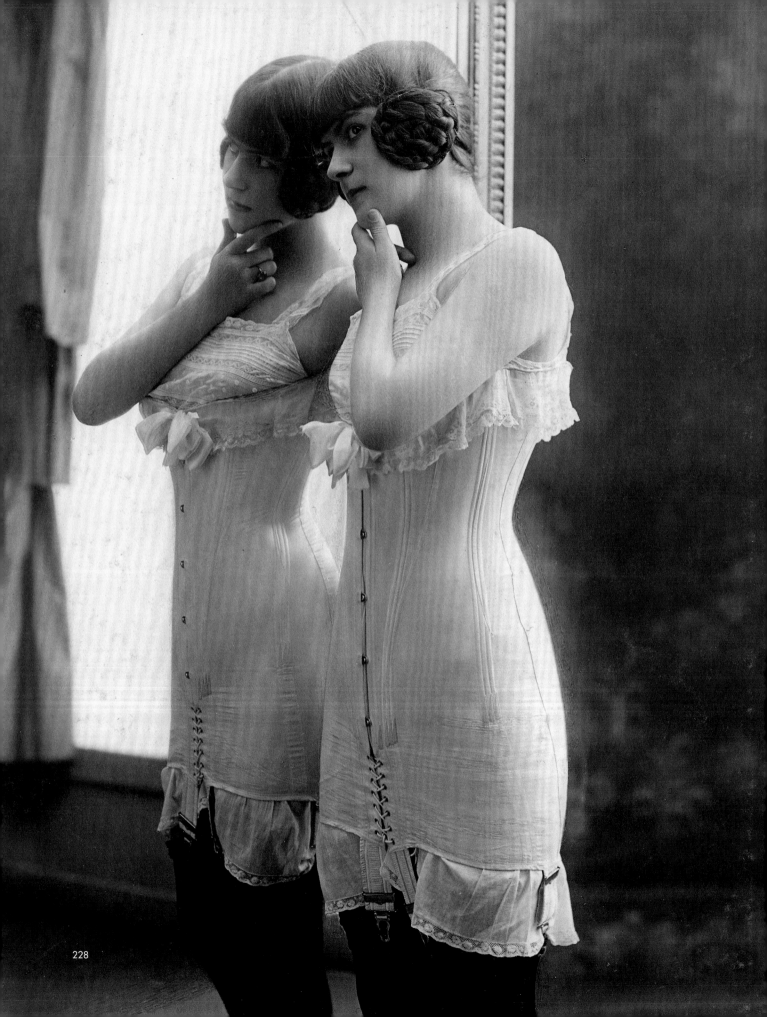

Charlotte Delory

BRASSIERES, GIRDLES, WASPIES, AND CAMI-PANTIES SINCE 1900

Women's underwear underwent unprecedented changes at the beginning of the twentieth century. After centuries of whaleboned corsets, modern undergarments appeared with the advent of the girdle and the bra. The nineteenth century has long been considered the age of the disappearance of the corset, a first step toward the progressive liberation of women's bodies, in conjunction with the emergence of a new role model: the active woman. But although women began to occupy a new place in society, they did not give up shaping their bodies according to the demands of fashion. Far from disappearing, constricting undergarments evolved and took on new forms.

FROM THE CORSET TO THE GIRDLE

During the 1890s the corset became longer and narrower, creating what was known as the "S" silhouette. At the beginning of the twentieth century, women's silhouettes were transformed: the Belle Époque favored the "empire" line: the sinuous lines of the century's first decade giving way to a straighter, more "natural" shape. Corsets continued to mutate in the early twentieth century, becoming progressively longer to encompass the abdomen and hips. Instead of being concentrated on the waist or the bust, the new type of corset acted from the waist to the top of the thighs, as seen on the model in figure 177.

This mutation gave rise to the girdle. This new name, which appeared around the time of the First World War, originally described a short corset that extended from the waist to the hips and stomach. For some time, the distinction between corset and girdle remained vague. The sheer number of names used in newspapers and fashion magazines clearly illustrates the lack of clear distinction between them.

As late as 1930, terms such as "girdle," "corset," "corset-belt," "hip corset," and "girdle belt" were used interchangeably in department store catalogues (fig. 180). Later, the girdle became distinguished from the corset essentially in the materials used; more flexible than the corset it was fabricated from new, innovative materials allowing for greater flexibility and adaptability, such as rubber, which was used in the form of elastic.

The death of the corset had been proclaimed for a long time, yet in reality the girdle was simply its latest evolution. It did nevertheless reduce the stiffness: the top of the body and the hips henceforth moved independently of each other.

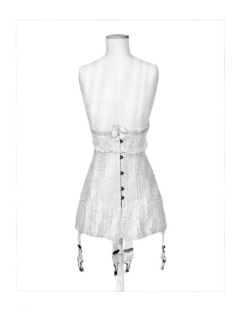

Yet a woman's body continued to be constrained by well-entrenched practices.[1]

THE GENESIS OF THE BRASSIERE

The emergence of the brassiere is linked to the transformation of the corset during the Belle Époque. The earliest form of bra can be traced back to antiquity, when a band of a fabric known as an apodesme was used to support the breasts by compressing them.[2] The modern bra came into being at the end of the nineteenth century[3] but was not adopted by women until the 1920s. In the first years of the twentieth century, the corset still supported the breasts from below, compressing the bust. When, at the beginning of the century, the corset evolved and left the bust uncovered, the breasts had to be supported by other means.

Patent applications filed in the United States[4] during the 1860s attest to the research conducted with a view to creating an undergarment whose exclusive function was to support women's breasts. During period 1880–90, the number of inventions multiplied and led to the creation of the brassiere. The first models were most often presented in conjunction with the wearing of a corset, and were rigid, full-cut, and reinforced. Such was the case with the famous "corselet-gorge" invented by Herminie Cadolle, a French corset-maker living in Buenos Aires.[5] First exhibited in the World's Fair in 1889, it was a reinforced garment, with cups for the breasts and lacing at the front and back. The real innovation of this model lay in the way in which it supported the breasts; while the corset had supported the breasts from below, the brassiere used the shoulder straps to support the breasts from above.[6] The idea of supporting the breasts from the shoulders may have come from the "cache-corset," a type of vest made out of light cotton, which buttoned in front (figs. 181, 182). This evolved into the brassiere characteristic of the 1920s. The shape of the brassiere thus remained indeterminate for a long time, wavering between corsetry and lingerie.

THE FLAPPER UNDERGARMENT

After 1910, the lines of the body continued to lengthen; slenderness gradually became the desired form, while at the same time the fashion for participating in outdoor pursuits such as swimming revealed the body in new ways. Between 1915 and 1925, the archetype of the flapper dominated, as women sought an androgy-

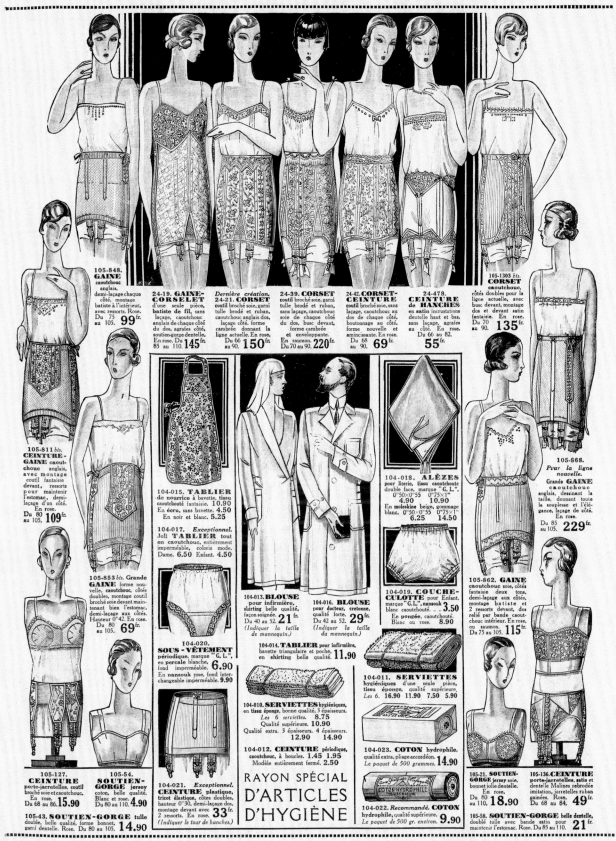

105-848. GAINE caoutchouc anglais, demi-laçage chaque côté, montage batiste à l'intérieur, avec ressorts. Rose. Du 75 au 105. **99** fr.

24-19. GAINE-CORSELET d'une seule pièce, batiste de fil, sans laçage, caoutchouc anglais de chaque côté du dos, agrafes côté, soutien-gorge dentelle. En rose. Du 85 au 110. **145** fr.

Dernière création. **24-21. CORSET** coutil broché soie, garni tulle brodé et ruban, caoutchouc anglais dos, laçage côté, forme cambrée donnant la ligne actuelle. En rose. Du 66 au 90. **150** fr.

24-39. CORSET coutil broché soie, garni tulle brodé et ruban, sans laçage, caoutchouc soie de chaque côté du dos, forme cambrée et enveloppante. En saumon. Du 70 au 90. **220** fr.

24-42. CORSET-CEINTURE coutil broché soie, sans laçage, caoutchouc au dos de chaque côté, busc devant, forme nouvelle et amincissante. En rose. Du 68 au 90. **69** fr.

24-478. CEINTURE de HANCHES en satin incrustations dentelle haut et bas, sans laçage, agrafes au côté. En rose. Du 66 au 82. **55** fr.

105-1303 bis. CORSET caoutchouc, côtés doubles pour la ligne actuelle, avec busc devant, montage batiste devant et devant satin fantaisie. En rose. Du 70 au 90. **135** fr.

105-811 bis. CEINTURE-GAINE caoutchouc anglais, avec montage coutil fantaisie devant, ressorts pour maintenir l'estomac, demi-laçage d'un côté. En rose. Du 80 au 105. **109** fr.

104-015. TABLIER de nourrice à bavette, tissu caoutchouté fantaisie. **10.90** En écru, sans bavette. **4.50** En noir et blanc. **5.25**

104-017. *Exceptionnel.* Joli **TABLIER** tout en caoutchouc, entièrement imperméable, coloris mode. Dame. **6.50** Enfant. **4.50**

104-018. ALÈZES pour literie, tissu caoutchouté double face, marque "G.L." 0"50×0"55 0"75×1" **4.90** **10.90** En moleskine beige, gommage blanc. 0"50×0"55 0"75×1" **6.25** **14.50**

105-868. *Pour la ligne nouvelle.* Grande **GAINE** caoutchouc anglais, dessinant la taille, donnant toute la souplesse et l'élégance, laçage de côté. En rose. Du 85 au 105. **229** fr.

105-853 bis. Grande **GAINE** forme nouvelle, caoutchouc, côtés doubles, montage coutil broché soie devant maintenant bien l'estomac, demi-laçage aux côtés. Hauteur 0"42. En rose. Du 80 au 105. **69** fr.

104-020. SOUS-VÊTEMENT périodique, marque "G.L.", en percale blanche, fond imperméable. **6.90** En nansouk rose, fond interchangeable imperméable. **9.90**

104-013. BLOUSE pour infirmière, shirting belle qualité, façon soignée. **21** fr. *(Indiquer la taille de mannequin.)*

104-016. BLOUSE pour docteur, cretonne, qualité forte. **29** fr. *(Indiquer la taille du mannequin.)*

104-014. TABLIER pour infirmière, bavette triangulaire et poche, en shirting belle qualité. **11.90**

104-019. COUCHE-CULOTTE pour Enfant, marque "G.L.", nansouk blanc caoutchouté. **3.50** En pongée, caoutchouté. Blanc ou rose. **8.90**

105-862. GAINE caoutchouc soie, côtés fantaisie deux tons, demi-laçage aux côtés, 2 ressorts devant, et relié par bande caoutchouc intérieur. En rose ou saumon. Du 75 au 105. **115** fr.

104-011. SERVIETTES hygiéniques d'une seule pièce, tissu éponge, qualité supérieure. Les 6. **16.90 11.90 7.50 5.90**

104-010. SERVIETTES hygiéniques, en tissu éponge, bonne qualité, 3 épaisseurs. Les 6 serviettes. **8.75** Qualité supérieure. **10.90** Qualité extra. 3 épaisseurs. **12.90** 4 épaisseurs. **14.90**

104-012. CEINTURE périodique, caoutchouc, à boucles. **1.45 1.95** Modèle entièrement fermé. **2.50**

104-021. *Exceptionnel.* **CEINTURE** plastique, tricot élastique, côtes doubles, hauteur 0"30, demi-laçage dos, montage devant avec 2 ressorts. En rose. **33** fr. *(Indiquer le tour de hanches.)*

104-023. COTON hydrophile, qualité extra, pliage accordéon. Le paquet de 500 grammes. **14.90**

104-022. *Recommandé.* **COTON** hydrophile, qualité supérieure. Le paquet de 500 gr. environ. **9.90**

RAYON SPÉCIAL D'ARTICLES D'HYGIÈNE

105-127. CEINTURE porte-jarretelles, coutil broché soie et caoutchouc. En rose. Du 68 au 86. **15.90**

105-54. SOUTIEN-GORGE jersey coton, belle qualité. Blanc et rose. Du 80 au 110. **4.90**

105-43. SOUTIEN-GORGE tulle double, belle qualité, forme bonnet, garni dentelle. Rose. Du 80 au 105. **14.90**

105-21. SOUTIEN-GORGE jersey soie, bonnet jolie dentelle. En rose. Du 80 au 110. **18.90**

105-136. CEINTURE porte-jarretelles, satin et dentelle Malines rebrodée imitation, jarretelles ruban gainées. Rose. Du 68 au 84. **49** fr.

105-58. SOUTIEN-GORGE belle dentelle, doublé tulle avec bande satin pour maintenir l'estomac. Rose. Du 85 au 110. **21** fr.

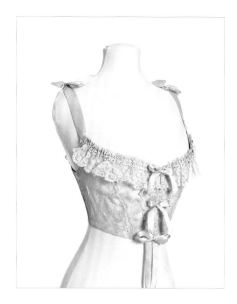 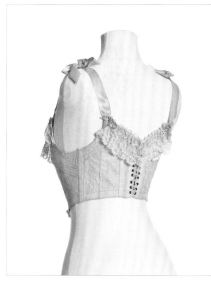

(p. 231)
180. "Comptoir des corsets"
Sales catalogue, Galeries
Lafayette, January 1930
Bibliothèque des Arts décora-
tifs, Paris, CC 8/19

(far left and left)
181, 182. Bra
(obverse and reverse)
France, ca. 1908–9
Cotton satin damask, spindle
lace, silk ribbon, stays, metal
Musée des Arts Décoratifs,
Paris, département Mode et
Textile, Gift of Alma et Margue-
rite Bruguière, 1980, 48221

nous look. The silhouette no longer emphasized traditional feminine attributes and the new undergarments, the brassiere and the girdle, allowed women to construct this new silhouette.

The bra was thus not intended to emphasize the breasts. For a while it retained its minimalist shape, a simple band of fabric to which straps were added (figs. 5, 183). Its decoration could, however, be ostentatious, as seen in the model presented in the Exposition Internationale des Arts Décoratifs in 1925 and now in the Musée Galliera. This example illustrates the absence of structure: the garment is flat, without gussets or whaleboning. Here, it is the decoration that schematizes the separation of the breasts.

For women with heavier breasts, more radical solutions existed. The reducing bra used compression to diminish the volume of the breasts. Like the corset, it included whaleboning and was laced up the back; the principle of lacing remained the most effective means of slenderizing the body.

The bra was worn with a girdle, which was intended to slim down the hips rather than cinch in the waist. The flapper silhouette was thus a vertical, columnar line, uninterrupted by a nipped-in waist. The line of the waist, indicated

by the clothing, was displaced and lowered, now situated around the hips.

In due course the girdle and the brassiere were joined, forming a single piece of lingerie, the cami-panty (or camiknickers), which had the happy advantage of avoiding the roll of fat around the waist, sometimes caused by the wearing of a girdle[7] (figs. 184–86). Making its appearance in the 1920s, it was still simply called "girdle" or "girdle-corselet" in commercial catalogues, and its use became more widespread during the 1930s.

Women found emancipation in refusing the traditional images of femininity. But this emancipation did not necessarily include a liberation of the body. The flapper danced, exposing her legs and acquiring new levels of activity, but still her silhouette remained the result of artificial construction by her undergarments.

BETWEEN THE WARS:
TOWARD A CONQUEST OF MOVEMENT

The flapper silhouette progressively softened over the course of the 1930s. Women's figures remained long and slim, but the waist was again emphasized by fitted waistlines. The long dresses designed by Madeleine Vionnet accen-

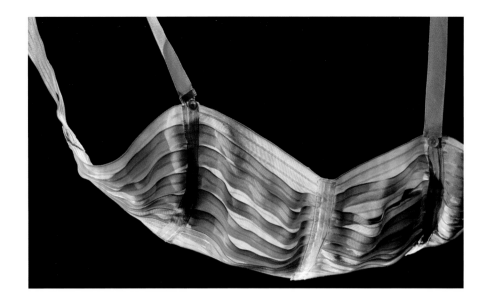

183. Brassière
Argentina, 1920s
Rayon Pekin (satin and taffeta)
Collection of Melanie Talkington, Vancouver

tuated the slenderness and elongation of a pared-down silhouette.

The girdle or the cami-panty continued to constrict the hips and compress the waist, while the bra became definitively distinguished from the brassiere by adopting a more systematic structure. In this case it had two independent cups separating the breasts. The Kestos bra is undoubtedly the most representative of this period, with the characteristic shoulder strap system crossing at the back and attaching to the front of the torso. Its triangular cups, molding the breasts into a pointed shape, are the precursors of the trends of the following decades.

The interwar period saw the emergence of a new role model: the active woman. After centuries of constriction and laced-up support, the female body slowly discovered movement as women began to practice gymnastics, cycling, and tennis. Work, sports, but also the experience of war led to a more practical approach to dress and prompted its simplification.[8] New concerns, such as comfort and practicality at work, led to more ergonomically designed clothing and undergarments. But there was a contradiction between the desire to remodel the body and the desire for greater freedom of movement. Corset-making

had always been based on a modeling of the silhouette through rigidity and fettering. When the idea of the active body emerged, new undergarments were needed to support the body while allowing more freedom of movement. It was therefore necessary to reconcile two opposing needs: rigidity and flexibility, constraint and movement. New materials and technical innovations were sought to enable this shift from rigidity to flexibility. Thanks to new textile fibers, the girdle became lighter and more supple. The use of whaleboning became rare after the 1940s. The use of new materials such as rayon or Nylon, commercialized in 1938, led to a democratization of lingerie. Rubber began to be used in the fabrication of girdles, initially in the use of elastic bands sewn into the fabric. Successive improvements followed from the 1940s, and soon Latex thread was produced that could be woven, enabling the creation of entirely elasticized fabrics. In the 1950s, the famous panty-girdles Scandale and Chantelle were produced in this fashion.

"IT'S THE FASHION: TIGHTEN YOUR BELT"[9]

This new flexibility did not prevent corsetry from constricting the body extensively in the following decade: by the late 1940s, the corset had

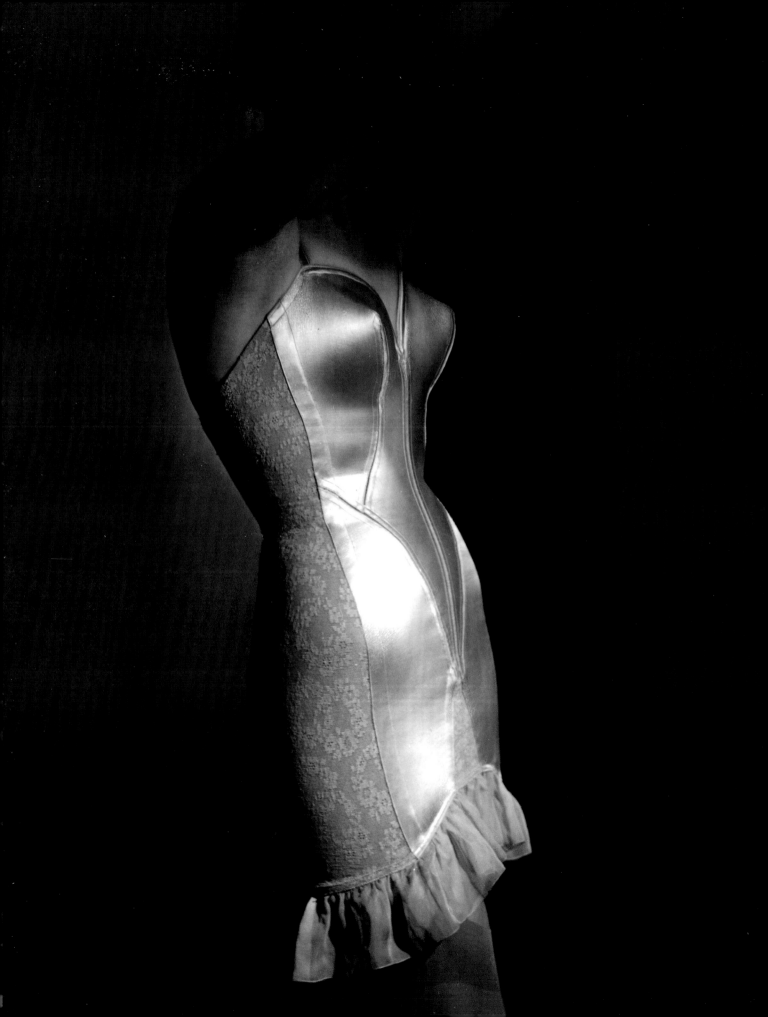

made a real comeback. In 1947, Dior launched the "New Look," characterized by a very slim waist and rounded hips. Traditional feminine curves came to the fore once again and undergarments consequently became quite structured. "To be fashionable this year, women must have a waist slimmed by a corset and natural-looking, curvy hips, which the slimness of the waist will make look even fuller. The breasts will be featured, high and quite separate,"[10] proclaimed the corset-maker Marie-Rose Lebigot in 1949.

To this end, a new garment was created: the waspie or waist-cincher. Perfected by Marcel Rochas in 1947,[11] it looked like a more supple version of the whaleboned corset, with the addition of a bra with an armature (fig. 187). Its effect on the silhouette was enhanced by the addition of tulle flounces, which gave volume to the hips under the dress (fig. 175). In 1942, Marcel Rochas, perhaps inspired by the curvy forms of the American actress Mae West,[12] featured the return of the bustier, which allowed for the redefining of curves in his new collection. The waspie became the perfect accessory with which to sculpt the silhouette demanded by the fashions of the times. Sometimes curved whalebones were inserted on the front of the bust in order to accentuate the

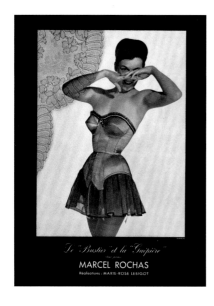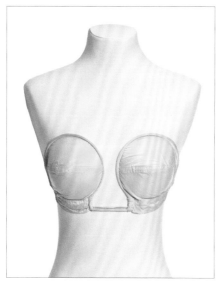

(far left)
187. "Le Bustier et la Guêpière,"
advertisement for Marcel
Rochas
L'Officiel de la mode 319–20
(1948): 17
Les Editions Jalou, L'Officiel

(left)
188. *Extase* (ecstasy) bra
ca. 1950
Nylon, elastic, wire
Musée des Arts Décoratifs,
Paris, département Mode
et Textile, Purchase, 1996,
996.74.48

visual slimness of the waist, creating the illusion of a small rounded belly and shaping the famous *creux stomacal,* or "hollow stomach," favored by Christian Dior.

The girdle also remained a fundamental instrument in the creation of the new silhouette. "The elegance of your line depends on your girdle," declared the periodical *Les Dessous Élégants* (Elegant undergarments) in 1955.[13] This model was shorter on the hips, and, like the waspie, was intended to emphasize the waist in particular.

Along with the girdle and the waspie, the bra became akin to an article of corsetry as it became endowed with a metallic structure. A bustier-bra from 1950 now in a private collection is a revealing example (fig. 174). The concentric rows of top-stitching created a rigid cup, giving the breasts the torpedo shape typical of the era. A metallic armature, placed not under the breasts but over them, helped keep the bra in place. The straps, which had become superfluous, could be removed, baring the shoulders for evening dresses, as seen on the model called Extase (ecstasy) (fig. 188). From that point on cups were "pre-formed" into a desirable shape. The function of the bra was not only to support the bust, but also to remodel its natural forms.

There are a number of theories to explain these pointed breasts, likened to "nuclear bombs" during the Cold War.[14] Psychoanalysts have proposed that during the wartime years (1939–45), women's breasts became hypertrophied, becoming "a type of nurturing and consoling pillow."[15] It is interesting to note that the bust tends to become less obtrusive when women attempt to conquer new areas of activity, and break away from their roles as mothers, as they did in the 1920s (and later during the 1970s), compared to periods during which the traditional model of the family is revalorized, such as during the 1940s and '50s.

THE 1960S AND 1970S—THE END OF CORSETRY?

In the 1960s the movement for the emancipation of women sought new role models, as the pin-up girl made way for the androgynous reed-like woman, heralding new fashion icons such as Jane Birkin and Twiggy. Comfort became a more pressing demand, while the new dictates of fashion revealed the body to a greater extent. Consequently, undergarments became more discreet. Structured undergarments still existed, but they were subjected to the dynamism of youth and were no longer synonymous with constraint (fig. 189).

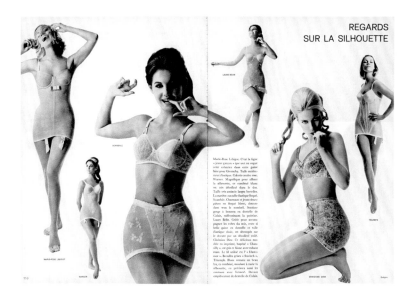

189. "Regards sur la silhouette"
(Ideas for the figure)
L'Officiel de la mode, 513–14,
1964, p. 200
Les Editions Jalou, L'Officiel

Thanks to new textiles, lightness and invisibility were increasingly possible. In 1959, a new fabric, Lycra, made its first appearance. Its elasticity and fine drape continued to erode the distinction between undergarments and the clothes worn over them. In the 1970s, many undergarments were made entirely of this fiber, creating a "natural" look. The idea was not merely to accommodate an active body, but to follow its every movement. Modern fabrics in this way fused lingerie and corset-making into a single entity (figs. 190–91).

The fabrics produced for the most practical girdles were knitted in a circular shape. These were rendered obsolete by the creation of pantyhose launched by Dim in 1964: obviating the need for stockings and suspender belts, pantyhose replaced the girdle's shaping functions, while granting more freedom of movement. The girdle underwent its last transformation during the 1960s with the panty-girdle, before disappearing altogether.

Full-cut undergarments came to contradict the idea of the free and "natural" body required by the various social movements at the end of the 1960s. For a new generation of women, the rejection of constraint became henceforth total,

with the liberation of women leading to a liberation of their bodies. In 1968, American feminists symbolically discarded their bras, emblem of the bodily constraint imposed on women.

Nonetheless, the wearing of bras was far too anchored in the customs of society to disappear altogether.[16] The makers of lingerie responded to the new demands by making the bra as minimal as possible, characterized by fluidity and absence of internal structuring. As during the 1920s, the bra did not emphasize the breasts, and was used merely to support them in a summary fashion. The difference, however, lay in the fact that women during the 1920s "used" the fetters to which they were accustomed (as young women during the 1920s had worn corsets) while women during the 1970s refused them, without however abandoning the bra.

THE 1980S—MODERNITY AND HISTORICISM

After the liberation movements of the 1960s, corset-making had lost a large part of its function. The girdle and other larger undergarments had for the most part fallen out of use, as the body was henceforth sculpted by sports or diet. The silhouette of the 1980s was overtly sculpted, accentuating square shoulders and a V-shaped torso,

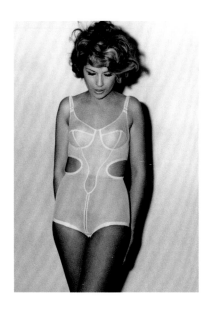

balanced by a thin waist and generous bust. The bra, as opposed to other elements of support, became a veritable symbol of femininity. And yet we find more structured models such as the balconnette and the shelf bra, which reshaped and accentuated the bust.

In reaction to the minimal and functional lingerie of the 1970s, fashion called for a return to the lingerie of the past. Once again, ornamentation became important, with lace and ribbons defining the arsenal of the femme fatale. The growing importance of the lingerie market is also explained by the growing number of available models, aimed at more and more various categories of age and social class. The main types of bra during the 1980s included the brassiere and the athletic bra, but also the balconnette and corbeille bra. The waspie, with the addition of a garter belt, was redesigned to fit the tastes of the times, in an aesthetic nostalgic for the 1950s and appreciated for the erotic fantasies with which it was associated.

The "body," or bodysuit was very popular at the time, and could be considered a modern reinterpretation of the cami-panty. Making its appearance during the previous decade, it consisted of a hybrid article combining bra and panty in a single piece. It generally did not have added support, with the sculptural or slimming aspect contained in the properties of the fabric itself.

THE "BUILT-IN" CORSET[17]

The progressive disaffection with supporting undergarments did not, however, mean that the body was no longer sculpted. The corset was replaced by an invisible, psychological corset: women's silhouettes since the beginning of the century had never stopped becoming more elongated and leaner, with thinness imposing itself as a lasting standard. Sports, diet, and cosmetic surgery henceforth sculpted the body, replacing the corset. Physical activity and the fashioning of anatomy through its musculature, contributed to the development of another beauty standard, that of the athletic body.

But the breast (which is not a muscle) is more resistant to the efforts of sports than the rest of the body. The bust became endowed with greater importance than the rest of the body, becoming more androgynous and smaller. The breast therefore became the most visible symbol of femininity, while distancing itself from its nurturing aspects.[18]

192. Advertisement for
Wonderbra
1994
TBWA agency
Musée des Arts Décoratifs,
Paris, département Publicité,
Gift of CB News TV/Culture
Pub, 2002, 2002.30.547

As a result, whereas compressing undergarments became less popular during the 1980s and 1990s, the bra continued to shape the breasts. In contrast to a body that was still athletic and thin, large breasts became fashionable again. The most notable model of the decade was the Wonderbra, launched by Playtex in 1994, which has remained emblematic of the vogue for padded and other push-up bras (fig. 192). The Wonderbra creates a plunging décolleté based on a simple principle: the two cups are joined by a narrow band, whose effect is to bring the breasts closer together, thrusting them forward, creating more volume. Cups molded from a single piece enable the bra to remain invisible under a woman's garments.

This trend continued into the 2000s. Push-up bras multiplied, using ever more advanced techniques. These models were invisible under clothes thanks to molded, seamless cups, which were rigid and more or less padded (fig. 193).

SHAPEWEAR, OR THE RETURN OF THE GIRDLE

The past few years have seen a surprising return of undergarments. "Shapewear" and "body-design" are some of the many terms designating this new tendency that finds its inspiration in the corset-making of the past. Lingerie has returned to models that had been eclipsed: girdles, camipanties, corselets and girdle dresses. The aim of this new type of corsetry is to improve the figure, but also to create a unified line under clothes. The girdle of the 2010s was the panty-girdle, cut high over the stomach, and made out of highly technical fabrics without seams (fig. 195), it offers an alternative to dieting, camouflaging heavy hips or rolls of fat on the stomach while slimming the waist.

The modern-day girdle tends to continue its action inside the body. Indeed, a new type of body-sculpting lingerie seems to be emerging, known as "cosmetic" lingerie. Thanks to "micro-capsules," we have new fabrics enriched with aloe vera and caffeine that are capable of combating cellulite or moisturizing the skin. As a second skin, lingerie has acquired an organic dimension. Undergarments now act not only upon the external contours of the body, but on the organism itself. This return to the "former" types of corsetry is at the same time redefined by a new modernity. The return of the girdle is only possible through a distancing from yesterday's girdles, while references to the past are allied with contemporary technologies in response to the

(far left)
193. Hema, bra "2 x Push-up"
The Netherlands, 2011
Polyamide, elastane
Private collection, Paris

(left)
194. Advertisement for the
"2 x Push-up" bra by Hema
2011
First advertisement for a bra
worn by a male model
Andrej Pejic
Photograph by Wendelien
Daan
Chupa Presse

modern woman's demands for comfort. Divided between the effectiveness of remodeling and the need for products adapted to the requirements of twenty-first-century women, in the intimate space between the body and the garment, corsetry seems to want to regain its former position.

Thus transformed, our system of undergarments continues to construct the silhouette of today. The return of compression garments leads one to conclude that the transformation of the natural body is integral to the practices of our society. The great increase in ways with which to work the physique, along with the resurgence of constructed undergarments, is proof enough of the impossible, utopian dream of a body totally emancipated from the past. Women still feel the need to discipline their bodies by various means, and the practices employed to achieve this end continue to be transformed and renewed.

195. Simone Pérèle,
High-waisted panty, "Top model"
Lycra® beauty microfiber and lace, microcapsule of slimming agents (caffeine, retinol, eramides, vitamin E, fatty acids, and aloe vera) "released on contact with the skin, reducing the appearance of cellulite"

1. Valerie Steele, *The Corset: A Cultural History* (New Haven and London: Yale University Press, 2001), 145.

2. Béatrice Fontanel, *Corsets et soutiens-gorge: L'épopée du sein de l'Antiquité à nos jours* (Paris: La Martinière, 1992), 11.

3. Here we must mention the recent discovery in Austria of textile fragments dating from the Middle Ages whose form resembles that of a bra. This surprising discovery leads us to wonder: did the bra exist before the corset? Did it have perhaps a prior existence in the Middle Ages, before disappearing with the spread of corset-wearing, which made it unnecessary? All the same, given the absence of other sources attesting to the wearing of bras in the Middle Ages, these questions remain speculative in nature, which is why we have decided here to date the appearance of the bra to the late nineteenth century. This dating is based on confirmed sources such as patents, illustrations, fashion magazines, catalogues, and advertisements.

4. Jane Farrell-Beck and Colleen Gau, *Uplift: the Bra in America* (Philadelphia: University of Pennsylvania Press, 2002), 2–3.

5. See the patent she filed in 1899 (European Patent Office, patent no. US16).

6. Fontanel, *Corsets et soutiens-gorge*, 77.

7. Farid Chenoune, *Les Dessous de la féminité: Un siècle de lingerie* (Paris: Assouline, 1998), 68.

8. Georges Vigarello, "S'entraîner": "The mode of labor and industry with its accelerated rhythms, the office milieu with its codes of adaptability, orient people more toward the tonic and the thinning"; quoted in Jean-Jacques Courtine, ed., *Histoire du corps*, vol. 3, *Les Mutations du regard: Le XXe siècle* (Paris: Le Seuil, 2006), 175.

9. *Elle* 95 (September 9, 1947): 5.

10. Marie-Rose Lebigot, interview, "L'évolution de la ligne dans la corsèterie parisienne," *L'Officiel de la mode* 319–20 (1948): 173.

11. Françoise Mohrt, *Marcel Rochas: 30 ans d'élégance et de créations, 1925–1955* (Cachan: Jacques Damase, 1983), 94.

12. Ibid., 90.

13. Chantal Beaucourt, "La gaine magicienne de la ligne 55," *Les Dessous élégants* (January-February 1955): 10–11.

14. Fontanel, *Corsets et soutiens-gorge*, 117.

15. Ibid., 118.

16. Catherine Örmen, "Les sous-vêtements féminins 1968–1972," in Jean Cuisenier, ed., *Destins d'objets* (Paris: La Documentation française, 1988), 372–87.

17. ". . . the corset did not so much disappear as become internalized through diet, exercise, and plastic surgery—known euphemistically as "body sculpting"; quoted in Steele, *The Corset*, 143.

18. Élisabeth Azoulay, interview, in Marie-Joëlle Gros and Catherine Mallaval, "Chirurgie esthétique, le sacro-sein," *Libération* 9553 (July 28, 2012): 2–4.

Sophie Lemahieu

CORSETS, CRINOLINES, AND BUSTLES IN TODAY'S FASHIONS: DRAWING CREATIVE INSPIRATION FROM THE HISTORY OF UNDERGARMENTS

THE DELIBERATE RETURN OF CONSTRAINT

During the 1970s, new ideals of sexual and social liberation presaged the definitive abandoning of tailored clothing. Bras had been burned, clothing became loose and flowing, while men and women became interchangeable in their androgyny.

Ten years later, however, the runways once again featured structured undergarments. In contrast to the preceding decade, the designers of the 1980s imposed a new physical ideal, especially for women. Squared shoulders for both sexes were amplified by the wearing of shoulder pads[1] and to compensate, the waist was cinched, emphasizing the hips. What could be better suited to sculpting the desired silhouette than a corset?

Very quickly, crinolines, bustles, and farthingales followed the return of the corset in fashion shows, amplifying the lower body and narrowing the waist. Aside from the desire to launch new fashion trends, couturiers and fashion designers gave free rein to the expression of varied inspirations. Much like painters copying the great masters, they began to research models of clothing from the past, from Greek and Roman drapery up to the fashions of the 1950s. The eighteenth and nineteenth centuries became an inexhaustible source of inspiration. The constraints of the corset, and the irrelevance of the crinoline with regard to the lives of women of today, were of little concern.

This trend was not a simple flight of fancy. One need only look at Alexander McQueen's spring/summer 2013 collection to be convinced: bodies squeezed into corsets, hips amplified by wide crinolines—the undergarments of the nineteenth century came back to life.

After women's struggles for their liberation in 1968, one cannot help wonder at such a rapid and enthusiastic return to the constraints of which they had so proudly rid themselves. Why such an attachment in the contemporary world to objects now almost archaic and considered for most of the twentieth century as instruments of torture or the submission of women? In reusing these complex forms, the designers followed various lines of reasoning.

The first, and most obvious, is the historicist manner of viewing these articles of clothing. In this case we see rather faithful transcriptions of the structures of the past, but with different objectives, depending on the designer, from nostalgia to provocation. Some reworked the corset and other tools for (de)forming the body in order

(p. 242)
196. Thierry Mugler,
Carapace ensemble
Haute couture spring/summer
1997
"Les Insectes" collection
Photograph by Dominique
Issermann

(opposite)
197. Alexander McQueen,
Prêt-à-porter spring/summer
2005
"It's Only a Game" collection
Photograph by Guy Marineau

to eroticize its curves, or to forge an ideal and desirable silhouette. New uses could be found for undergarments, such as wearing them on top of the clothing. From another perspective, couturiers could push sensuality to the point of fetishism. And lastly, it is surprising to see the most cutting-edge couturiers return to the corset, crinoline, and bustle, paying homage to them by means of new materials and new technologies, creating fashion anchored in the present.

HISTORICISM

The true renaissance of the corset as we know it today did not happen overnight. Designers have slowly adapted and sanctified it over the course of the past few decades. Christian Lacroix featured the corset upon his arrival in high fashion in 1981. His creations were not only rooted in his origins in Arles, but are also reminiscent of a more distant past. The designer himself admits a certain nostalgia for the nineteenth century: "The past, always the past, the splendor of Visconti's *Leopard*, the albums of the fashions of Napoleon III found in the attic, disguise."[2] His education in part explains his concern for historical detail: it was not until after studying art history that he went into the world of high fashion. He contin-

ued to apply those early experiences to examine the shape of every garment from petticoats to headpieces. The historical nature of his dresses and corsets is its creative expression. Although the whalebone has been replaced by stays of metal or plastic, corsets by Christian Lacroix remain formally faithful to their eighteenth- and nineteenth-century models (fig. 197).

The corset was not his only obsession. Many evocations of the nineteenth century are present in his work. Lacroix has also reworked the dress with puffed bustle or pouf, also known as the *faux cul*. Avoiding an exact transcription, the designer updated the structure by showing a mini-version of it. Nonetheless, such recreations tilt the pelvis, creating an "S" silhouette worthy of the Belle Époque. Vivienne Westwood followed the same trend, going so far as naming her 1985 collection the "Mini Crini."

Proof that this taste is still in vogue can be seen in the use of forms of the corset or crinoline in contemporary wedding dresses. The Meringue wedding dress nevertheless represents a historicizing fantasy still alive in our contemporary imaginations.[3] The Western world's difficulties in regaining a stable economy during the last few decades has perhaps augmented the

(left)
198. Christian Lacroix,
Haute couture spring/summer
1994
Photograph by Guy Marineau

(opposite)
199. Vivienne Westwood,
Bustle and underpants
ensemble
Prêt-à-porter fall/winter 1995
Metal cage, gold-plated,
Nylon netting, satin
Musée des Arts Décoratifs,
Paris, département Mode et
Textile, Gift of Vivienne
Westwood, 2013, 2013.16.1.1-2

significance of the "princess" dream, translated into the wearing of such dresses.

In a more neo-Romantic trend,[4] Alexander McQueen also evoked silhouettes reminiscent of the nineteenth century in his fashion shows. His penchant for emphasized curves was clearly coupled with a taste for their mise en scène. The corset, crinoline, and the bustle, each in its own way, induce a precise manner of movement. The corset does not permit the slightest bending of the torso, assuring a complete vertical rigidity of the bust and hips. Alexander McQueen heightened the effect in certain of his creations by stretching it up to the top of the head, as in his prêt-à-porter "It's Only a Game" collection of 2005 (fig. 197). The crinoline, like the bustle, balances this immobility through the undulation it produces around the legs, giving the silhouette a slightly teetering movement. McQueen had the distinction of formally reworking articles from centuries past, while remaining faithful to the historical aspect of the movements of the clothing, the body, and the clothing around the body. He demonstrated brilliantly that a silhouette is not a static element, but makes sense only when animated.

In applying the rules of previous centuries to their own collections, the designers have made their collections an exercise in the reconstruction of the history of art. Alexander McQueen, in his neo-Romantic approach and in spite of his contemporaneity, evoked a sense of nostalgia and longing for a time now past. As for Christian Lacroix, his gaze is almost like that of a museum curator with regard to his collection of costumes.[5] Far from the creations of Lacroix and the joie de vivre[6] exemplified in his exuberantly large poufs, Vivienne Westwood consciously engages in provocation in her use of the structures of the garments of the past (fig. 199). In the early 1980s, the Punk movement, of which she was one of the first proponents, became more democratized before losing steam. Its demands became less strident, while the punk style, which had become more and more watered-down, became increasingly popular. "Antiestablishment has become the norm, and thus inoffensive,"[7] she wrote. This prompted a sudden about-turn in her work. After a year spent studying the rich costume collection in the Victoria and Albert Museum, the designer created collections abounding in corsets, puffed bustles, and "Mini-Crinis." But if

Vivienne Westwood tapped into eighteenth- and nineteenth-century sources in 1981, it was not through a sense of conservatism, but rather the opposite, in a new take on anti-conformism. She used historicism as a way to distance herself from the world of conformism by deliberately showing an affirmation of a sexual body. The opulence of her prêt-à-porter creations is really a call for opulence and subversion, in a spirit of libertinism, itself a by-product of eighteenth-century thought.

EROTICISM

The corset, crinoline, and bustle each have a place in the celebration of curves at the beginning of the twenty-first century. It is not a question of returning to the chaste wearing of the corset, but rather of renewing the fantasies associated with it, by reviving feminine sensuality. The moral aspect of the corset as something that straightens the body, thereby elevating its wearer, is now obsolete. The metamorphosis of the silhouette it produces entails a new perception of the body, a new sense of desire. In transforming the body, the addition of clothing allows for the focusing of attention on a minutely determined element of the anatomy.

"An article of clothing has no sex, unless it hugs the body tightly,"[8] affirms Jean Paul Gaultier. While not the first,[9] the designer gives the most masterly example of the reappearance of the woman's corset in the early 1980s, especially the new way of wearing it: on top of the clothing. For his collection entitled "Dadaism," for spring/summer 1983, the young couturier put a woman on the runway clothed in the famous corset-dress that would subsequently punctuate his entire career (fig. 200). The garment is simple; light pink in color, the bustier dress is worn very close to the body. The stays go all the way down to the hips, and the ensemble is compressed by a system of lacing with eyelets placed along the spine. The garment is not lined with a corset, it becomes a corset itself. Its originality is accentuated by the treatment of the bust, separated into two cones generously pointed forward, and accentuated by concentric top-stitching. The aggressive aspect of the breasts created a scandal, before becoming emblematic of Jean Paul Gaultier's art. This outfit evokes both the cinched waist of the New Look launched by Dior in 1947, and the "torpedo" breasts of 1950's pin-up girls.

The designer set the stage for the refeminization of the body, in accentuating the specifically

200. Jean Paul Gaultier,
Gaultier Paris, haute couture
spring/summer 2013
"Les Indiennes Gypsies"
collection
Photograph by Guy Marineau

feminine aspects of a woman's figure. He sees the possibility for the "weaker sex" to assume her femininity like a new power. The strong woman is comforted in her position by the corset supporting her; Jean Paul Gaultier "imposes the image of a woman in full possession of her sexuality."[10]

The theme of the power given to women is also present in "Insects," Thierry Mugler's haute couture collection for spring/summer 1997. Here the designer immerses himself in the domain of female animality. Instead of dealing with the more familiar images of the cat-woman or woman as exotic bird, however, he finds his inspiration in entomology. A woman's body is protected by a carapace, an excellent pretext for using the corset and its wasp-waisted effect. It is, of course, this undergarment, emblematic of the New Look which sets the tone for the whole collection. Black solid materials, such as leather, or shiny materials, such as vinyl, are well employed here. The crinolette is also used to evoke the bodies of insects, notably in the Carapace dress, in which the laced corset is completed by an amplification of the hips (fig. 196).

The "fly" corset worn by Violeta Sanchez, in the same collection, allows the model to show off a waist measuring a mere seventeen inches.[11] A whole mythology is implied by these evocations of animals. These manipulations of bodies and silhouettes convey the vulnerability of insects, even though they look like miniature monsters. We see first of all the evocation of the praying mantis, metaphor for the dangerous woman, with a thin body, who attracts her partner and then devours him. When Mugler's women assume insect forms, they embody their refinement and elegance, but evoke their destructive quality as well. Corsets, crinolines, and bustles make possible an astonishing association of natural shapes and the garments of centuries gone by. They confer a disturbing sense of fascination to the women wearing them, transforming a terrifying sense of animality into a feminine ideal.

This obsession with the constricted body leads us to fetishistic tendencies, of which the corset still represents a true symbol for the twenty-first century. The crinoline and the bustle are also articles of clothing that push the body's silhouette and curves to extremes; the bustle arches the back excessively; the crinoline amplifies the lower body to form a bell shape down to the feet. As for the corset, it compresses the waist, reducing it by as many as eight inches or

so. Paradoxically, in deforming the body, these articles construct the silhouette. The eroticism is maintained by techniques of dress far from natural. The article itself thus becomes a cultural artifact; instead of adapting itself to the body, it obliges it to yield to its constrictive shape.

Silhouettes with neatly defined curves and the articles of dress that create them, the corset in particular, are recurrent themes in fetishism, a term that deserves to be redefined here. Generally speaking, it is synonymous with "deviant" sexuality linked to an object, on which the fetishist focuses their desire. Nonetheless, the Latin root, *facticius*, often translated as "artificial," reveals a more complex notion.[12] The fetishism of the corset reflects the artificiality of the body wearing it. Unlike other obsessions, the corset is rarely an object of fetishism in and of itself; the result of wearing it—that is, a waist artificially reduced and the breasts compressed—is what arouses the interest of the fetishist.

Tight lacing is the extreme expression of this desire to mold the waist artificially. As in the nineteenth century, this technique remains quite marginal. Mark Pullin, known as "Mr. Pearl," has had the most media coverage for contemporary tight-lacing. The extreme practice of this

corseted corset-maker allowed him to acquire a waist twenty inches in circumference (46 cm), and he is the only man to be able to make such a claim today.[13] He speaks of tight lacing as in-depth work on his body and his mind, through which he acquires a certain sense of well-being. The suffering he endures is in proportion to the self-control he acquires. The body at its limit is the height of eroticization. The silhouette is transcended, almost stylized, but all freedom of movement and activity is violated.

FUTURISM

The end of the twentieth century provided a moment of reflection for designers and the rest of society alike. The political instability of many countries and successive economic crises had eroded the confidence in the future which characterized the 1950s. Designers therefore gave clothing a new role: not merely to protect the body, but also to repair it. The armatures of the corset, crinoline, and bustle became indispensable supports.

Designers have returned to one of the first functions of the corset, its orthopedic aspect. Alexander McQueen explored this possibility several times by using materials whose

primary use lies outside the world of fashion. One of the corsets in his collection "Banshee," from fall/winter 1994–95 is made out of plaster. The shifting of the world of high fashion toward the world of medicine represents McQueen's radical objective: to take responsibility for and to assist the bodies he dresses. The Prosthetic Corset in leather, from the "No. 13" collection, presented in the spring/summer show of 1999, reworks this same problem. The leather, which is essentially a skin, is sewn diagonally, suggesting the suture points closing a deep wound. The body is supported by the rigidity of the corset, or attentively mended. Both the allure and the silhouette are saved.

Instead of healing, others prefer prevention; it is in protecting the body that one can assure a life without knocks. Following his exaltation of the strong woman, Mugler palliates feminine fragility with resistant materials, all the while conscious of the eroticism this suggests. In 2007, he dressed a model in a single piece of metal, molded into the shape of a corset and farthingale. Protected by shiny armor, offensive in its outrageously seductive shape but defensive in the materials used, the woman moves and imposes herself in a contemporary world.

Recourse to unusual materials is a recurrent theme among contemporary designers. As early as 1980, Issey Miyake proposed a plastic bustier, molded onto the model's body. Twenty years later, for his autumn/winter collection of 1999–2000, Hussein Chalayan put a model on the runway wearing the famous fiberglass Airplane Dress (fig. 204), lined with an electronic system allowing the back of the dress to open upwards, like a teleprompted bustle. The back of the body is amplified and the silhouette assumes a new profile. Far from the curves of the 1880s, an angular and geometric aspect is accentuated here. From this shell fit for a machine, Chalayan succeeds in drawing a poetic sense from the symbolism of flight, or fleeing skyward. Here we have the bustle revisited, escaping from the day-to-day reality, all the while exploring contemporary technologies.

A younger generation continues this interest in innovation, all the while keeping the history of fashion in mind. Iris van Herpen, for example, focuses her activity on high technology. The collection "Capriole," from fall/winter 2011–12, required work in other professional fields, notably for the Skeleton Dress (fig. 205). Van Herpen first designed the dress on a computer, then with

205. Iris Van Herpen,
Dress "CP0051 Skeleton Dress"
Haute couture fall/winter
2011–12
"Capriole" collection
Photograph by Guy Marineau

the help of the architect-designer Isaie Bloch, succeeded in creating a model using three-dimensional printing on polymer. The final product is made of an extremely fine network of stiff, white filaments, recalling the spinal column, hip bones, and ribs defining the body. In spite of the technological concerns of the designer, the Skeleton Dress echoes the basic shape of a corset, emphasizing the bust, nipping in the waist, and equipped with little baskets accentuating the hips. This fantastic outfit recalls another skeleton made by her mentor Alexander McQueen, who created the Spine Corset, shaped like ribs and the human spine. Nods to the past are combined with extreme innovation, evoking, according to Van Herpen, "the feeling before and during a leap into the void."[14] This is also a metaphor for the apprehension of the future, including the paradoxical and irrepressible desire to plunge into it, thanks to the avant-garde techniques used in the creation of the piece.

Another metamorphosis is possible in the world of high fashion: the imposition of a new silhouette. To dare to propose a new silhouette implies a radical position on the part of the designer. The appreciation of a garment is inherent in the forms it accentuates, amplifies, or constrains. The silhouettes we know or recognize are landmarks for the eyes to identify. In going beyond these limits, the designer runs the risk of disorientating the spectator. The difficulty lies in demonstrating to the public that the new silhouette he or she has created, however unusual, proposes a different type of aesthetic.

In this regard, Rei Kawakubo has put herself directly in the line of fire on several occasions. Recently, she was directly inspired by the garment structures of the nineteenth century in creating her "White Drama" collection (spring/summer, 2012) for Comme des Garçons, which included a skirt made of four bustles slung across the hips, giving the impression of undulations across the legs (fig. 175). Or again, in "Dress Meets Body–Body Meets Dress," from 1997, the designer sculpted the body to her own liking (figs. 206, 207). By inserting padding inside the garment, she deformed the body in unexpected ways, not without a nod to the stuffed and cambered pourpoints of the fourteenth and sixteenth centuries. Here, like an inversion of the "S" silhouette of the end of the nineteenth century, a protuberance placed on the back modifies the natural curves. But one should not see this as a "hump-back"; we see an unusual beauty

206. Comme des Garçons,
Top and skirt
Prêt-à-porter spring/summer
1997
"Dress Meets Body—Body
Meets Dress" collection
Synthetic jersey, padding
Collection of the Kyoto
Costume Institute, Kyoto,
AC9416 1996-32-12AB

of bodily structures. The designer creates a new kind of harmony of sinuous lines, another type of equilibrium for the body, which, pulled toward the back, causes an entirely new type of gait and movement. Kawakubo establishes a visual code that is both original and renewed within the heart of the problematic of contemporary fashion: more than an equalization, it represents the interaction between the garment and the body wearing it.

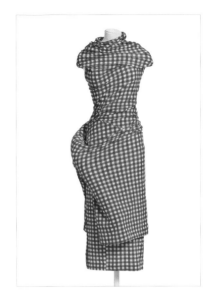

207. Comme des Garçons,
Bump Dress
Prêt-à-porter spring/summer
1997
"Dress Meets Body—Body
Meets Dress" collection
Printed synthetic jersey,
padding
Musée des Arts Décoratifs,
Paris, département Mode
et Textile, Purchase, 2005,
2005.7.4

1. François Boucher, *A History of Cosume in the West* (London: Thames and Hudson, 1970; rev. ed., 1996), 436–38.

2. Bernard Costa, "Christian Lacroix, le grand 'petit couturier' des couturiers," *La Croix* (July 27, 1987).

3. Anne Zazzo, *Mariage: Une histoire cousue de fil blanc* (Paris: Assouline, 1999), 75.

4. Andrew Bolton, *Alexander McQueen: Savage Beauty*, exh. cat. (New York: Metropolitan Museum of Art, 2011), 12. On the occasion of the exhibition in homage to Alexander McQueen after his suicide in 2010, the Metropolitan Museum highlighted all the features that made him an archetype of contemporary romanticism.

5. Christian Lacroix, *Christian Lacroix on Fashion* (London: Thames and Hudson, 2008), 9.

6. Christian Lacroix and Patrick Mauriès, eds., *Pieces of Pattern: Lacroix by Lacroix* (London: Thames and Hudson, 1997), 53: "I also thought that in the end, there was a place for them in the world of fashion, for the joie de vivre and imagination they represent."

7. Éric Dahan, "L'étoffe d'une punk," *Libération* (August 21–22, 2010); http://www.liberation.fr/culture/2010/08/21/l-etoffe-d-une-punk_673361

8. Thierry-Maxime Loriot, *La Planète mode de Jean Paul Gaultier* (Paris: La Martinière, 2011), 18.

9. Chantal Thomass also brought the corset back into the limelight in the late 1970s.

10. Valerie Steele, in Loriot, *La Planète mode*, 150.

11. Olivier Saillard, *Histoire idéale de la mode contemporaine: Les plus beaux défilés de 1971 à nos jours* (Paris: Textuel, 2009), 247.

12. "By a strange irony that has nothing to do with chance, the word 'fetishism' comes from the Portuguese feitiço, which itself derives from the Latin facticius, which means artificial"; quoted in France Borel, *Le Vêtement incarné: Les métamorphoses du corps* (Paris: Calmann-Lévy, 1992), 21.

13. Hubert Barrère and Charles-Arthur Boyer, *Corset* (Arles: Rouergue, 2011), 118–19.

14. Explanation of the "Capriole" collection: http://www.irisvanherpen.com/site/about

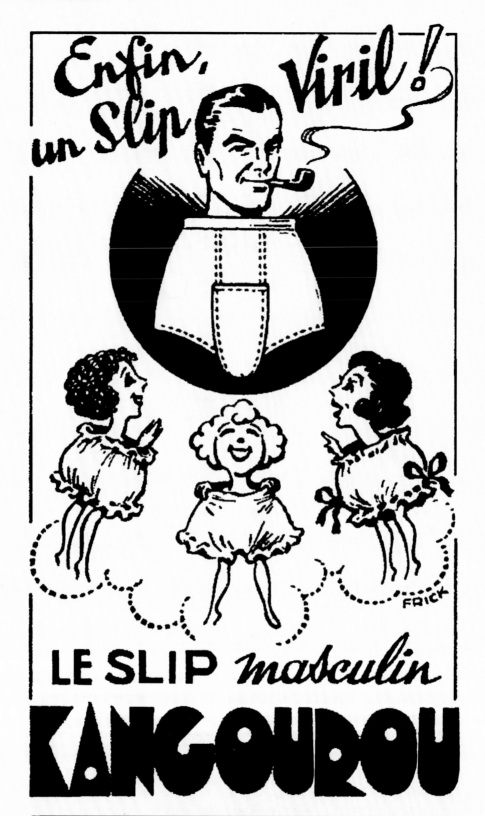

Shaun Cole

NEW UNDERWEAR AND NOTIONS OF VIRILITY IN CONTEMPORARY SOCIETY

The early twenty-first century has seen a fascination with notions of virility expressed through the design and promotion of men's underwear. In 2007 Australian swim and underwear brand aussieBum introduced the "Wonderjock," which founder Sean Ashby said was created to meet a demand from customers who "expressed an interest in looking bigger, just like women using the Wonderbra."[1] To achieve this effect the Wonderjock used seams around the pouch and an additional pocket within the pouch front to push up the genitals. The Wonderjock was advertised with images of enhanced thrusting crotches, accompanied by text that noted "When size matters." Similarly, the British brand Shreddies used a variation in fabric weave for a strip that ran under the genitals, pushing them upwards and outwards. Indeed, one of their 2009 advertisements directly referenced the controversial 1994 advertisement for Wonderbra with the text "Hello Girls."

The emphasis on the crotch and male virility in underwear was not new in the early 2000s. Throughout the second half of the twentieth century a number of advertising campaigns made reference to the crotch through the description of the styling of the pouch front of their briefs.

The 1943 ads for Reiss Scandals, for example, used the taglines "New Crotch Comfort" and "New Comfort—plus support" and the 1948 ad for Kangarou's Slip Masculin announced "Enfin un Slip Viril!"[2] The 1993 Calvin Klein campaign featuring rap musician Marky Mark grabbing his genitals clearly drew the viewer's attention to his crotch, reinforcing Wolfgang Fritz Haug's 1986 assertion that the "purchase of underwear is provoked by emphasising the penis."[3] Despite some underwear brands' attempts to promote genital enhancement, other campaigns, such as Emporio Armani featuring David Beckham in 2007 (fig. 210), have been accused of using digital manipulation to alter the crotch size.

In other attempts to enhance the appearance of genital size and perceptions of male virility, some brands have created garments with padding built in to the pouch front; Gregg Homme's "Push-Up" range of briefs, trunks, and jockstraps being one example.[4] American companies Andrew Christian and C-In2 have included an integrated ring of fabric attached to the waistband that encircles the genitals, pushing them upwards and forwards, in garments marketed as "Show-It Technology" and "Sling-Support." Initially all Andrew Christian's

SHOW- IT
WITH FLASHLIFT TECHNOLOGY

andrew christian +

LIFTING POCKET

LIFTING STRAP

underwear included Show-It technology but this was discontinued just a few months after its launch, because it "seem[ed] like [Show-It] freaked out some people who are a little more conservative."[5] Rather than including design elements to push up or pad out, Swiss fashion designer Athos de Oliveira has used a trompe-l'oeil effect on his flesh-colored range of trunks, that were printed with images of a sizable penis (erect or flaccid).

Despite a number of brands producing crotch-enhancing garments, the one area that Ruth Stevens, Jockey's marketing manager, believes is almost too taboo is that of universal sizing for the crotch pouch: "there are no actual pouch sizes, as there are with women's bra cup sizes.... Men are a bit shyer than women. Can you imagine having to ask for a double-A size?"[6] But with an increasing number of garments that offer such enhancements, perhaps it is only a matter of time before men overcome their shyness and pouch sizes are introduced to provide the same end result.

212. Advertisement for Andrew
Christian
Top: Show-It Technology jock
Below: Show-It Technology brief
Photograph by Gregory Frye

1. Founder of aussieBum Sean Ashby quoted in Freya Petersen
"Aussiebum: Down Under designs in more ways than one,"
International Herald Tribune, January 21, 2008.
2. The word "slip" was used for the first time in the September
20, 1913, edition of *L'Illustration*, where it was described as a "slip
for athletes in fine cotton jersey, with elastic belt and thighs"
(*slip pour athlètes, en jersey cotton fin, avec* élastique *serrant la
ceinture et les cuisses*) which offered "support without hindering
any movement. Very useful for vigorous exercise" (*soutient
sans gêner aucun des mouvements. Très utile pour les exercices
violents*).
3. Wolfgang Fritz Haug, *Critique of Commodity Aesthetics*
(Cambridge: Polity Press, 1986), 84.
4. The original athletic supporter was invented in 1874 by C. F.
Bennett of Chicago of the sporting goods company Sharp and
Smith and patented in 1887 by Bennett's newly formed Bike Web
Company. The garment, which was designed to give support to
bicycle jockeys who had to navigate the heavily cobbled streets
of Boston, was made of a protective cup of fabric with a
waistband and straps that ran across the buttocks. It was initially
called the Bike jock strap, but the name soon became colloquially
abbreviated to "jockstrap."
5. Andrew Christian quoted in Michael A. Knipp, "Andrew
Christian: From rags to britches," *Gay & Lesbian Times* 1043
(December 20, 2007).
6. Quoted in Susie Rushton, "A brief history of pants: Why men's
smalls have always been a subject of concern," *The Independent*,
January 22, 2008, p. 4.

General Bibliography

Anderson, Ruth Matilda. *Hispanic Costume, 1480–1530*. New York: The Hispanic Society of America, 1979.

Anstett, Élisabeth, and Marie-Luce Gélard, eds. *Les Objets ont-ils un genre? Culture matérielle et production sociale des identités sexuées*. Paris: Armand Colin, 2012.

Ariès, Philippe. *L'Enfant et la vie familiale sous l'Ancien Régime*. Paris: Le Seuil, 1973.

Arizzoli-Clementel, Pierre. *Fastes de cour et cérémonies royales: Le costume de cour en Europe 1650–1800*. Exhibition catalogue. Paris: Réunion des musées nationaux, 2009.

Arnold, Janet. *Patterns of Fashion 3: The Cut and Construction of Clothes for Men and Women c.1560–1620*. London: Macmillan; Los Angeles: Costume & Fashion Press, 1995.

_____. *Queen Elizabeth's Wardrobe Unlock'd*. Leeds: W. S. Maney, 1988.

_____. *Patterns of Fashion 4. The Cut and Construction of Linen Shirts, Smocks, Neckwear, Headwear and Accessories for Men and Women c.1540–1660*. London: Macmillan; Los Angeles: Costume & Fashion Press, 2008.

Ashelford, Jane. *The Art of Dress: Clothes through History 1500–1914*. London: National Trust, 1996.

Azoulay, Élisabeth, ed. *100,000 ans de beauté*. Paris: Gallimard, 2009.

Barbier, Muriel, and Shazia Boucher. *Les Dessous féminins* New York: Parkstone International, 2004.

Bard, Christine. *Les Femmes dans la société française au XXe siècle*. Paris: Armand Colin, 2001.

Barrère, Hubert, and Charles-Arthur Boyer. *Corset*. Arles: Éditions du Rouergue, 2011.

Bäumel, Jutta, and Gisela Bruseberg. "Eine gestrickte Seidenhose des Kurfürsten August von Sachsen: Unikaler Beleg für die fürstliche Strickmode im 16. Jahrhundert." *Jahrbuch der Staatlichen Kunstsammlungen Dresden* 22 (1991): 7–14.

Beaulieu, Michèle. *Contribution à l'étude de la mode à Paris: Les transformations du costume élégant sous le règne de Louis XIII* Paris: R. Munier, 1936.

Bibliothèque Forney. *Rayon lingerie: Un siècle de publicité*. Exhibition catalogue. Paris: Syros, 1992.

Biehn, Michel. *Cruelle coquetterie, ou Les artifices de la contrainte*. Paris: Éditions de La Martinière, 2006.

Bijlokemuseum, Ghent. *Textilia, Kostuums en accessoires uit eigen bezit*. Exhibition catalogue. Ghent: Stad Ghent, 1986.

Blanc, Odile. "Le pourpoint de Charles de Blois, une relique de la fin du Moyen Âge," *Bulletin du CIETA* 74 (1997): 65–82.

_____. *Parades et parures, l'invention du corps de mode à la fin du Moyen Âge*. Paris: Gallimard, 1997.

_____. "Pourpoints, gilets et corsets: Invention d'une plastique du Moyen Âge au XIXe siècle." In Danielle Allérès, *Mode, des parures aux marques de luxe*, 104–20. Paris: Economica, 2003.

Bluche, François. *La Noblesse française au XVIIIe siècle*. Paris: Hachette, 1973.

_____. *La Vie quotidienne au temps de Louis XVI*. Paris: Hachette, 1980.

Blum, Stella. *Victorian Fashions and Costumes from Harper's Bazar 1867–1898*. New York: Dover Publications, 1974.

Bologne, Jean-Claude. *Histoire de la coquetterie masculine*. Paris: Perrin, 2011.

Bolton, Andrew, ed. *Alexander McQueen: Savage Beauty*. Exhibition catalogue. New York: Metropolitan Museum of Art; New Haven and London: Yale University Press, 2011.

Borel, France. *Le Vêtement incarné: Les métamorphoses du corps*. Paris: Calmann-Lévy, 1992.

Boucher, François, ed. *A History of Costume in the West*. London and New York: Thames & Hudson, 1970; revised edition 1996.

Bricard, Isabelle. *Saintes ou pouliches. L'éducation des jeunes filles au XIXe siècle*. Paris: Albin Michel, 1985.

Buck, Anne, and Phillis Emily Cunnington. *Children's Costume in England*. London: Adam & Charles Black, 1965.

Burgelin, Olivier, Philippe Perrot, and Marie-Thérèse Basse. *Parure, pudeur, etiquette*. Paris: Le Seuil, 1987.

Carter, Alison. *Underwear: The Fashion History*. New York: Drama Publishers, 1992.

Celnart, Mme [Élisabeth-Félicie Bayle-Mouillard]. *Manuel des dames ou l'art de la toilette*. Paris: Roret, 1827.

Chenoune, Farid. *Des modes et des homes: Deux siècles d'élégance masculine*, Paris: Flammarion, 1993.

_____. *Les Dessous de la féminité: Un siècle de lingerie*. Paris: Assouline, 1998.

Cité internationale de la dentelle et de la mode de Calais. *Esprit lingerie*. Exhibition catalogue. Calais: Cité internationale de la dentelle et de la mode de Calais, 2010.

Cole, Shaun. *The Story of Men's Underwear*. London: Parkstone International, 2010.

Coppens, Marguerite. *Mode en Belgique au xixe siècle*. Brussels: Les Amis des Musées royaux d'art et d'histoire, 1996.

Corbin, Alain, Jean-Jacques Courtine, and Georges Vigarello. eds. *Histoire du corps*. Volume 1: *De la Renaissance aux Lumières*. Volume 2: *De la Révolution à la Grande Guerre*. Volume 3: *Les mutations du regard: Le XXe siècle*. Paris: Le Seuil, 2005–6.

_____. *Histoire de la virilité*. Volume 1: *De l'Antiquité aux Lumières: L'invention de la virilité*. Volume 2: *Le triomphe de la virilité: Le XIXe siècle*. Volume 3: *Virilité en crise? XXe–XXIe siècles*. Paris: Le Seuil 2011.

Cox, Caroline. *Lingerie: A Lexicon of Style*. New York: Macmillan, Thomas Dunne Books, 2001.

Crubellier, Maurice. *L'Enfance et la Jeunesse dans la société française, 1800–1950*. Paris: Armand Colin, 1979.

Cumming, Valerie, Cecil Willett Cunnington, and Phillis Emily Cunnington. *The Dictionary of Fashion History*. Oxford: Berg Publishers, 2010.

Cunnington, Cecil Willett. *English Women's Clothing in the Nineteenth Century*. London: Faber and Faber, 1937.

Cunnington, Cecil Willett, and Phillis Emily Cunnington. *The History of Underclothes*. London: Michael Joseph, 1951; revised edition, New York: Dover Publications, 1992.

Cunnington, Phillis Emily, and Alan Mansfield. *English Costume for Sports and Outdoor Recreation: From the Sixteenth to the Nineteenth Centuries*. New York: Barnes & Noble, 1970.

Delbourg-Delphys, Marylène. *Le Chic et le Look: Histoire de la mode féminine et des moeurs de 1850 à nos jours*. Paris: Hachette, 1981.

Delpierre, Madeleine. "L'élégance à Versailles au temps de Louis XV." *Versailles* 55 (1974): 6–14.

_____. *Se vêtir au XVIIIe siècle*. Paris: Adam Biro, 1996.

Duby, Georges, Michelle Perrot, and Geneviève Fraisse, eds. *Histoire des femmes en Occident*. Volume 4: *Le XIXe siècle*. Volume 5: *Le XXe siècle*. Paris: Plon, 1991–92.

Duby, Georges, Michelle Perrot, and Françoise Thebaut. *Histoire des femmes en Occident*. Paris: Plon, 1992.

Dupuis André. "Crinolines, poufs et tournures." *Bulletin de la société archéologique, historique et artistique le Vieux Papier* 234 (1970): 21–24.

Esnauts et Rapilly. *Gallerie des modes et costumes français dessinés d'après nature, gravés par les plus célèbres artistes en ce genre*. Paris: Esnauts et Rapilly, 1778–87.

Estham, Inger. "The Sture Garments." In Lena Rangström, *Modelejon Manligt Mode 1500-tal 1600-tal 1700-tal*, 302–5. Stockholm: Livruskammeren, 2002.

Ewing, Elizabeth. *Dress and Undress: A History of Women's Underwear*. London: B. T. Batsford, 1986.

Farcy, Louis, ed. *Le Pourpoint de Charles de Blois: Collection J. Chappée*. Le Mans: Impr. Beneditter, 1910.

Farrel-Beck, Jane, and Colleen Gau. *Uplift: The Bra in America*. Philadelphia: University of Pennsylvania Press, 2002.

Fashion Institute of Technology. *The Undercover Story: The Galleries at Fashion Institute of Technology*. Exhibition catalogue. New York: Fashion Institute of Technology, 1982.

Fingerlin, Ilse. "Seltene Textilien aus Kloster Alpirsbach im Nordschwarzwald." *Waffen und Kostümkunde* 39 (1997): 99–122.

Flandrin, Jean-Louis. *Le Sexe et l'Occident*. Paris: Le Seuil, 1981; revised edition 1986.

Flügel, John Carl. *The Psychology of Clothes*. London: Hogarth Press, 1930.

Fontanel, Béatrice. *Corsets et soutiensgorge: L'épopée du sein de l'Antiquité à nos jours*. Paris: Éditions de La Martinière, 1992.

Fouquet, Catherine, and Yvonne Knibiehler. *Histoire des mères du Moyen Âge à nos jours*. Paris: Montalba, 1980.

Franklin, Alfred. *La Vie privée d'autrefois. Arts et métiers, modes, moeurs, usages des Parisiens, du XIIe au XVIIIe siècle, d'après des documents originaux ou inédits par Alfred Franklin*. Paris: Plon / Nourrit, 1887–1902.

Fukai, Akiko. *Fashion: A History from the 18th to the 20th Century*. Cologne: Taschen, 2006.

Galeries nationales du Grand Palais. *Les Fastes du gothique. Le siècle de Charles V*. Exhibition catalogue. Paris: Réunion des musées nationaux, 1981.

Garsault, François-Alexandre-Pierre de. *Art du tailleur, contenant le tailleur d'habits d'hommes: les culottes de peau; le tailleur de corps de femmes & enfants: la couturière & la marchande de modes*. Paris: L. F. Delatour, 1769; revised edition, *L'Art du tailleur*. Geneva: Slatkine Reprints, 1984.

_____. *Art de la lingerie*. Paris: L. F. Delatour, 1771.

Gélis, Jacques, Mireille Laget, and Marie-France Morel. *Entrer dans la vie: Naissances et enfances dans la France traditionnelle*. Paris: Gallimard Julliard, 1978.

Genlis, Stéphanie-Félicité Ducrest [countess of]. *Dictionnaire critique et raisonné des étiquettes de la cour, des usages, des Français, depuis la mort de Louis XIII jusqu'à nos jours, contenant le tableau de la cour, de la société et de la littérature du dix-huitième siècle, ou l'esprit des étiquettes et des usages anciens comparés aux modernes*. Paris: Pierre Mongie aîné, 1818.

_____. *Mémoires inédits de madame la comtesse de Genlis, sur le dix-huitième siècle et la Révolution française, depuis 1756 jusqu'à nos jours*. Paris: Ladvocat, 1825.

Godart, Frédéric, ed. *Penser la mode*. Paris: Éditions du Regard, 2011.

Goffman, Erving. *La Mise en scène de la vie quotidienne*. Volume 1: *La présentation de soi*. Paris: Éditions de Minuit, 1973; revised edition 2009.

Goulet, Denis. "La vigueur retrouvée. La promesse des ceintures électriques." *Caps-aux-Diamants: La revue d'histoire du Québec* 69 (2002).

Groom, Gloria Lynn. *Impressionism, Fashion & Modernity*. Exhibition catalogue. Chicago, Art Institute of Chicago, 2012.

Guido, Laurent, and Gianni Haver, eds. *Images de la femme sportive aux XIXe et XXe siècles*. Geneva: Georg Éditeur, 2003.

Hollander, Anne. *Seeing Through Clothes*, New York, Viking Press, 1978; revised edition, Los Angeles: University of California Press, 1993.

Johnston, Lucy. *Nineteenth-Century Fashion in Detail*. London: Victoria and Albert Museum, 2005.

Kaufmann, Jean-Claude. *Corps de femmes, regards d'hommes: Sociologie des seins nus*. Paris: Nathan, 1995.

Kayser, Christine, Xavier Salmon, and Laurent Hugues. *L'Enfant chéri au siècle des Lumières*. Exhibition catalogue. Paris: Editions l'Inventaire, 2003.

Kevill-Davies, Sally. *Yesterday's Children: The Antiques and History of Childcare*. Woodbridge, UK: Antique Collectors' Club, 1994; revised edition 2005.

Koda, Harold. *Extreme Beauty. The Body Transformed*. Exhibition catalogue. New York: Metropolitan Museum of Art; New Haven and London: Yale University Press, 2003.

Kraatz, Anne. *Catalogue des dentelles*. Musée national de la Renaissance, château d'Écouen, Paris: Réunion des musées nationaux, 1992.

Lacroix, Christian, and Patrick Mauriès, eds. *Pieces of a Pattern: Lacroix by Lacroix*. London: Thames & Hudson, 1992; revised edition 1997.

La Mothe Le Vayer, François, ed. *Opuscules ou petits traictez. Le VI, Des Habits, & de leurs modes différentes: Le VII, Du Secret, & de la fidélité*. Paris: Antoine de Sommaville et Courbé, 1643.

Laver, James. "Fashion, Art and Beauty." *Metropolitan Museum of Art Bulletin* (November 1967): 117–28.

_____. *Costumes and Fashions: A Concise History*. London and New York: Thames and Hudson, 1982; revised edition, 2012.

Leloir, Maurice. *Histoire du costume de l'Antiquité à 1914*. Volume 8: *Époque Louis XIII, 1610 à 1643*. Volume 9: *Époque Louis XIV (1st partie), 1643 à 1678*. Volume 10: *Époque Louis XIV (2e partie), 1678 à 1715, Époque Régence, 1715 à 1725*. Volume 11: *Époque Louis XV, 1725 à 1774*. Volume 12: *Époque Louis XVI et Révolution, 1775 à 1795*. Paris: Henri Ernst, 1933–49.

Leloir, Maurice, and André Dupuis, eds. *Dictionnaire du costume et de ses accessoires, des armes et des étoffes, des origines à nos jours*. Paris: Gründ, 1951; revised edition, 1961.

Léoty, Ernest. *Le Corset à travers les ages*. Paris: Paul Ollendorff, 1893.

Lévy, Marie-Françoise. *De mères en filles: L'éducation des Françaises, 1850–1880.* Paris: Calmann-Lévy, 1984.

Libron, Fernand, and Henri Clouzot. *Le Corset dans l'art et les moeurs du XIIIe au XXe siècle.* Paris: Fernand Libron, 1933.

Loux, Françoise. *Le Jeune Enfant et son corps dans la médecine traditionnelle.* Paris: Flammarion, 1978.

_____. *Le Corps dans la société traditionnelle.* Paris: Berger-Levrault, 1979.

Luttenberg, Thomas. "The Cod-piece: A Renaissance Fashion between Sign and Artefact." *The Medieval History Journal* 8 (2005): 49–81.

Lynn, Eleri. *Underwear: Fashion in Detail.* London: Victoria & Albert Museum; New York: Harry N. Abrams, 2010.

Maigron, Louis. *Le Romantisme et la Mode d'après des documents inédits.* Paris: Honoré Champion, 1911.

McDowell, Colin. *The Man of Fashion.* London and New York: Thames & Hudson, 1997.

Memmi, Dominique, Dominique Guillo, and Olivier Martin, eds. *La Tentation du corps, corporéité et sciences sociales.* Paris: Éditions de l'École des hautes études en sciences sociales, 2009.

Menkes, Suzy, and Nathalie Bondel. *The Fashion World of Jean Paul Gaultier: From the Sidewalk to the Catwalk.* Exhibition catalogue. New York: Harry N. Abrams, 2011.

Mikhaila, Ninya, and Jane Malcolm-Davies. *The Tudor Tailor: Reconstructing Sixteenth- Century Dress.* London: Batsford; Los Angeles: Costume and Fashion Press, 2006.

Monnas, Lisa. "The Cloth of Gold of the Pourpoint of the Blessed Charles de Blois: a Pannus Tartaricus?" *Bulletin du CIETA* 70 (1992): 116–29.

Musée de la Mode; Marseille. *Mode et sport* Exhibition catalogue. Marseille: Musées de Marseille, 1998.

Münchner Stadtmuseum. *Mode sprengt Mieder: Silhouettenwechsel.* Exhibition catalogue. Munich: Hirmer Verlag, 2009.

Musée d'Art et d'Histoire. *L'étoffe du relief: Quilts, boutis et autres textiles matelassés.* Exhibition catalogue. Geneva: Musée d'Art et d'Histoire, 2006.

Musée de l'Assistance publique. *Hommage à Robert Debré: L'épopée de la médecine des enfants.* Exhibition catalogue. Paris: Musée de l'Assistance publique, 1988.

Musée des Arts décoratifs. *Christian Lacroix. Histoires de mode.* Exhibition catalogue. Paris: Les Arts Décoratifs, 2008.

_____. *Hussein Chalayan.* Exhibition catalogue. Paris: Les Arts Décoratifs; New York: Rizzoli, 2011.

_____. *Fashioning Fashion: Deux siècles de mode européenne, 1700–1915.* Exhibition catalogue. Paris: Les Arts Décoratifs, 2012.

Musée des Beaux-Arts et de la Dentelle, Calais. *25 ans de lingerie: La dentelle sans dessus-dessous. Préfiguration du musée de la Dentelle et de la Mode.* Exhibition catalogue. Calais: Musée des Beaux-Arts et de la Dentelle, 1997.

Musée du Costume de la Ville de Paris. *Poufs et Tournures: Costumes français de femmes et enfants, 1869–1889.* Exhibition catalogue. Paris: Les Presses artistiques, 1959.

Musée du Textile, Cholet. *Small couture (5). À fleur de peau.* Exhibition catalogue. Cholet, Ville de Cholet, 2011.

Musée Galliera. *Secrets d'élégance, 1750–1950.* Exhibition catalogue. Paris: Imprimerie moderne du Lion, 1978.

_____. *Modes enfantines, 1750–1950.* Exhibition catalogue. Paris: Musée de la Mode et du Costume, 1979.

_____. *Femmes de fin de siècle, 1885–1895.* Exhibition catalogue. Paris: Éditions Paris-Musées, 1990.

_____. *Au paradis des dames: Nouveautés, mode et confection 1810–1970.* Exhibition catalogue. Paris: Éditions Paris-Musées, 1993.

_____. *Mariage: Une histoire cousue de fil blanc.* Exhibition catalogue. Paris: Assouline, 1999.

_____. *La Mode et l'Enfant, 1780–2000.* Exhibition catalogue. Paris: Éditions Paris-Musées, 2001.

_____. *L'Empire des crinolines.* Exhibition catalogue. Paris: Éditions Paris-Musées, 2008.

Musée historique de Lausanne. *Du secret à la transparence: Histoires de dessous.* Exhibition catalogue. Lausanne: Musée historique de Lausanne, 2000.

Museen der Stadt Wien. *Die Frau im Korsett, Wiener Frauenalltag zwischen Klischee und Wirklichkeit 1848–1920.* Exhibition catalogue. Vienna: Museen der Stadt Wien, 1984.

Neret, Gilles. *Les Dessous de la pub.* Toulouse: Daniel Briand; Paris: Robert Laffont, 1986.

Noël, Jean-Luc. *L'Invention du jeune enfant au xixe siècle: De la salle d'asile à l'école maternelle.* Paris: Belin, 1997.

Norris, Herbert. *Tudor Costume and Fashion.* New York: Dover Publications, 1997.

Örmen, Catherine. "Les sous-vêtements féminins, 1968–1972." In *Destins d'objets,* edited by Jean Cuisenier, 372 –87. Paris: La Documentation française, 1988.

_____. *Comment regarder la mode: Histoire de la silhouette.* Paris: Hazan, 2009.

Orsi-Landini, Roberta, and Bruna Niccoli. *Moda a Firenze, 1540–1580: Lo stile di Eleonora di Toledo e la sua influenza.* Florence: Pagliai Polistampa, 2005.

Page, Christopher. *Foundations of Fashion, The Symington Collection: Corsetry from 1856 to the Present Day.* Leicester: Leicestershire Museums Publications, 1981.

Paresys, Isabelle, and Natacha Coquery, eds. *Se vêtir à la cour en Europe, 1400– 1815.* Colloquium, château de Versailles, June 3–5, 2009. Lille: Presses de l'université Charles de Gaulle-Lille 3; Versailles: Centre de recherche du château de Versailles, 2011.

Perrot, Michelle, ed. *Histoire de la vie privée: De la Révolution à la Grande Guerre.* Paris: Le Seuil, 1987.

Perrot, Philippe. *Les Dessus et les Dessous de la bourgeoisie: Une histoire du vête-ment au XIXe siècle.* Paris: Fayard, 1981.

_____. *Le Travail des apparences. Le corps féminin. XVIIIe–XIXe siècle.* Paris: Le Seuil, 1984; revised edition, 1991.

Picard-Cajan, Pascal. *Façon arlésienne: Étoffes et costumes au XVIIIe siècle.* Exhibition catalogue. Arles: Museon Arlaten, 1998.

Piponnier, Françoise, and Perrine Mane. *Dress in the Middle Ages.* New Haven and London: Yale University Press, 1997.

Pluvinel, Antoine de. *Le Manège royal.* Paris: Bibliothèque des Introuvables-Claude Tchou, 1623. English-language edition, translated by Hilda Nelson, London: J. A. Allen, 1989.

Probert, Christina. *Lingerie in Vogue since 1910.* London: Thames & Hudson, 1981.

Puy-en-Velay. *Paraître et se vêtir au XVe siècle.* Colloquium, Puy-en-Velay, September 2005. Saint-Étienne: Publications de l'université de Saint-Étienne, 2006.

Quicherat, Jules. *Histoire du costume en France depuis les temps reculés jusqu'à la fin du XVIIIe siècle*. Paris: Hachette, 1875; revised edition, 1877.

Ribeiro, Aileen. *Dress in Eighteenth-Century Europe, 1715–1789*. London: B. T. Batsford; New York: Holmes & Meier, 1984; revised edition, New Haven and London, Yale University Press, 2002.

Roche, Daniel. *La Culture des apparences: Une histoire du vêtement, XVIIe–XVIIIe siècles*. Paris: Fayard, 1989; revised edition, Paris: Le Seuil, 2007.

Roy, Hippolyte. *La Vie, la mode et le costume au xviie siècle. Époque Louis XIII: Étude sur la cour de Lorraine, établie d'après les mémoires des fournisseurs et artisans*. Paris: Édouard Champion, 1914; revised edition, 1924.

Ruppert, Jacques, et al. *Le Costume français*. Paris: Flammarion, 1996; revised edition, 2007.

Saillard, Olivier. *Histoire idéale de la mode contemporaine: Les plus beaux défilés de 1971 à nos jours*. Paris: Textuel, 2009.

Saint-Laurent, Cecil. *Histoire imprévue des dessous féminins*. Paris: Herscher, 1966; revised edition, 1986.

Schoefer, Marie. "Le pourpoint de Charles de Blois: Remarques faites au cours de sa restauration." *Histoire et images médiévales. Thématique* 6 (2006): 79–82.

Simon, Marie. *Les Dessous*. Paris: Éditions du Chêne, 1998.

Snyders, Georges. *La Pédagogie en France aux XVIIe et XVIIIe siècles*. Paris: Presses universitaires de France, 1965.

Sorber, Frieda. "Clothing in Antwerp Archives in the First Half of the Seventeenth Century." In Johannes Pietsch and Anna Jolly, *Netherlandish Fashion in the Seventeenth Century*, 51–62. Riggisberg: Abegg-Stiftung, 2012.

Steele, Valerie. *Fashion and Eroticism: Ideals of Feminine Beauty from the Victorian Era to the Jazz Age*. Oxford: Oxford University Press, 1985.

_____. *Fetish: Fashion, Sex & Power*. Oxford: Oxford University Press, 1996.

_____. *The Corset: A Cultural History* New Haven and London, Yale University Press, 2001.

Stewart, Mary Lynn, and Nancy Janovicek. "Slimming the Female Body? Re-evaluating Dress, Corsets and Physical Culture in France, 1890–1930." *Fashion Theory* 5 (2001): 173–94.

Summers, Leigh. *Bound to Please: A History of the Victorian Corset*. Oxford: Berg, 2001.

_____. "Yes, they did wear them." *Costume* 36 (2002): 65–74.

Terret, Thierry, and Pierre Arnaud. *Histoire du sport féminin*. 2 volumes. Paris / Montreal: L'Harmattan, 1996.

Thienen, Frithjof, and Sophie Van Willem. "Een silvre portefraes. Een zeventiendeeeuws kostuumonderdeel." *Antiek* 3 (1969): 482–87.

Thomass, Chantal, and Catherine Örmen. *Histoire de la lingerie*. Paris: Perrin, 2009.

Tiramani, Jenny. "Three Multilayered Ruffs in the Historisches Museum Basel." In Johannes Pietsch and Anna Jolly, *Netherlandish Fashion in the Seventeenth Century*, 93–106, Riggisberg: Abegg-Stiftung, 2012.

Uzanne, Octave. *La Française du siècle: La femme et la mode. Métamorphoses de la Parisienne de 1792 à 1892. Tableau des moeurs et usages aux principales époques de notre ère républicaine*. Paris: Librairie imprimerie réunies, May et Motteroz, 1892.

Vigarello, Georges. *Le Corps redressé: Histoire d'un pouvoir pédagogique*. Paris: Jean-Pierre Delarge, 1978; revised edition, Paris: Armand Colin, 2004.

_____. "Corps, beauté, sexualité: Rencontre avec Georges Vigarello." *Sciences humaines* 132 (2002); http://www.scienceshumaines.com/ corpsbeaute-sexualite_fr_23076.html.

_____. *Histoire de la beauté: Le corps et l'art d'embellir de la Renaissance à nos jours*. Paris: Le Seuil, 2004; revised edition, 2007.

_____. *Histoire du corps. Volume 1: De la Renaissance aux Lumières*. Paris: Le Seuil, 2005.

_____. *The Metamorphosis of Fat: A History of Obesity*. New York: Columbia University Press, 2013.

_____. *La Silhouette du XVIIIe siècle à nos jours: Naissance d'un défi*. Paris: Le Seuil, 2012.

Vincent, Susan J. *The Anatomy of Fashion: Dressing the Body from the Renaissance to Today*. Oxford: Berg, 2009.

Waugh, Norah. *Corsets and Crinolines*. London, B. T. Batsford, 1954; revised edition, New York: Routledge, 1993.

_____. *The Cut of Men's Clothes, 1600–1900*. London: Theatre Arts Books, 1964; revised edition, London: Faber and Faber, 1994.

Werner, Alex, ed. *London Bodies: The Changing Shape of Londoners from Prehistoric Times to the Present Day*. London: Museum of London, 1998.

Zazzo, Anne. *Dessous: Imaginaire de la lingerie*. Paris: Solar, 2009.

Index

Figures in italics refer to illustration captions.

Photographic Credits